The Future of Luxury Brands

CH00656648

The Future
of Luxury Brands

Artification and Sustainability

Edited by
Annamma Joy

DE GRUYTER

ISBN 978-3-11-073761-5
e-ISBN (PDF) 978-3-11-073275-7
e-ISBN (EPUB) 978-3-11-073281-8

Library of Congress Control Number: 2021949860

Bibliographic information published by the Deutsche Nationalbibliothek
The Deutsche Nationalbibliothek lists this publication in the Deutsche Nationalbibliografie;
detailed bibliographic data are available on the Internet at http://dnb.dnb.de.

Typesetting: Integra Software Services Pvt. Ltd.
Printing and binding: CPI books GmbH, Leck

www.degruyter.com

Advance Praise for *The Future of Luxury Brands: Artification and Sustainability*

Never has the luxury industry gone through more disruptive changes than today. Through the themes of artification and sustainability, this book captures the forces that are shaping the luxury sectors – from fashion to hospitality – and provides the reader with a map to navigate the landscape of luxury in the next decade.

—Dr. Federica Carlotto
Sotheby's Institute of Art

What will happen to the economy and culture of luxury in an age of climate crisis? This rich and stimulating collection of papers shows us how elite consumerism is meeting, and even thriving amidst the challenges of an economy moving towards sustainability. The authors confront the key intersection between ethics, the arts, and growing economic inequality.

—Richard Wilk
Distinguished Professor and Provost's Professor Emeritus
Indiana University

In *The Future of Luxury Brands: Artification and Sustainability*, Annamma Joy has collected a variety of essays that explore the interactions between luxury goods, artistic sensibilities, and the ecological impacts of our consumption habits. As adumbrated in a variety of contributions from top-notch scholars in marketing and related areas, luxury goods carry aesthetic resonances that shape the concerns and meanings of our material and spiritual environment. These imbrications gain new dimensions in the age of COVID and find vivid illustrations in the worlds of fashion, oenophilia, and tourism. The resulting implications for consumer value in a changing arena of consumption experiences deserve this kind of careful scrutiny as a key to the essence of the human condition.

—Morris B. Holbrook
W. T. Dillard Professor Emeritus of Marketing
Graduate School of Business
Columbia University

This book illuminates how luxury brands today navigate the interrelationship between aesthetics and ethics. It investigates the cooptation of art and sustainability by fashion and luxury brands in a bid to reinvent their future, highlighting both the bright side and the dark side of this endeavor. Through a collection of chapters dealing with very different contexts, Professor Joy's book opens a window onto the possible future of luxury in a changing world.

https://doi.org/10.1515/9783110732757-202

—Bernard Cova
Professor of Sociology of Consumption and Marketing
Kedge Business School
Bordeaux-Marseille-Paris

Luxury needs always to defend its legitimacy and respectability as it represents the most visible facet of social stratification, economic inequality, and the exceptional lifestyle accessible only to some. Yet its demand is growing in the world as no one wants to be left behind. To offset clients' guilt and build social acceptance luxury must be exemplary: It does it by always redefining the notion of the utmost quality (sustainability) and now presenting itself as a cultural sector far from mere materialistic values (artification). This is what A. Joy's book demonstrates with talent.

—Jean-Noel Kapferer
Pernod-Ricard Chair on the Management of Prestige Brands
Professor Emeritus, HEC, Paris

As, the editor writes, "The time is past due for a complete re-invention of the fashion industry. . . . Luxury brands, with their global reach, hold on the public's imagination and aspirational dreams, and deep pockets can and should lead the way." Via the marriage of a globally inclusive aesthetics and the emergent principles of sustainable resource circulation detailed in this impassioned collection, the tools to effect this re-invention are in place.

—Eric Arnould, PhD, Dr.h.c.
Aalto University School of Business

This collection of innovative studies details how the meanings and value of luxury brands are constituted in a cultural matrix of aestheticizing processes, normative ideals, and societal concerns over sustainability. This book is a must read for anyone interested in the complex social, aesthetic, and moral allure of luxury brands.

—Craig Thompson
Churchill-Bascom Professor of Marketing
University of Wisconsin-Madison

To my beloved Anniks

Acknowledgments

This book is a labor of love, and I'm deeply grateful to everyone involved in its creation and publication:

- John Stewart, Commissioning Editor and Steve Hardman, Acquisitions Editor (Business and Economics) at De Gruyter offered invaluable support in clarifying my ideas and bringing my plans to fruition.
- Jaya Dalal, Content Editor (Social Sciences), and the cover page designer, Uta Oettel brought patience and professionalism to the proceedings as we finalized how to convey the concepts of luxury, artification, and sustainability in images.
- The members of the team at De Gruyter were to a person invaluable in getting this book into print.
- Each of our contributors, for their hard work, patience, good humor, and timely submissions.
- My colleagues, staff, and friends at the University of British Columbia who were supportive of this research. There are far too many to name; you know who you are.
- The Office of Research Services UBC Okanagan, in recognition of their $2,500 grant.
- The Social Sciences and Humanities Research Council of Canada, who awarded me and my co-applicants several grants to research art, luxury fashion, and wine. In particular I gratefully acknowledge the most recent one on wine consumption: SSHRC grant number: #435-2017-0958.
- My editor Marina Hirsch, who has assisted with everything from the most prestigious journal publications to citations in local newspapers.
- My sisters Jolly and Kochu and my brother Joecha, as well as their children and grandchildren, have championed me through this entire process. Thank you for your unwavering support and unconditional love.
- Baba Vishwanath, Professor and former Dean of the DeGroote School of Business, who has believed in me in all these years and cheered me on in every one of my endeavors. I can only say "thank you for being there."
- To Brenda E. F. Beck who inspired, guided and mentored me right from the start.

And finally,
- My daughter Annika Joy, my wellspring of hope and joy, took the high-resolution photograph and then created the image for the cover. I love the work of Mark Rothko; with this cover image, she captured the spirit of one of his most famous works, *No. 6 (Violet, Green and Red)*. Thank you very much darling! Words cannot express my love for you – this one's for you . . .

https://doi.org/10.1515/9783110732757-204

Contents

Annamma Joy

Chapter 1
Artification and Sustainability: Foundational Pillars of the Luxury Worlds of Art, Fashion, and Wine

Luxury brand goods have long embodied aesthetics, style (whether timeless or of the moment), and artisanal quality (Kapferer and Bastien 2009; Venkatesh and Meamber 2006). In recent years, two concepts have taken hold as foundational in the world of luxury goods and services: artification – the process through which objects that were historically not considered art become recognized as art (Shapiro 2019) – and sustainability (Winston 2016; Bendall and Kleanthous 2007), related to both the environment and ethical labor. The centrality of artification and sustainability in how luxury is perceived and experienced reflects a craving, from both customers and often from the brands themselves, for the gravitas and authenticity of art; and, in an era suffused with anxiety related to a changing world, a growing turn to sustainability – not only as a moral ideal, but increasingly as a necessity (Kovesi 2015). In this compendium, we examine the contemporary meanings of these two key concepts in today's luxury brands, through a wide-ranging variety of perspectives. From narratives relating to the environmental and social ethics of Canadian diamond mining, to how fine wines are marketed and experienced as an evanescent form of artistic endeavor, to the impact of a global pandemic on consumption patterns of luxury goods and services, this curated collection offers fresh insights into the future of these rarefied worlds.

Luxury in the Past

To discern the future, we first look to the past. Regardless of how deep into human prehistory we search, it is reasonable to assume that luxury in some form has always been with us, for the simple reason that class hierarchal structure has always been with us as a bedrock feature of social communities (Ellis 2017; Trench 2017). Class and luxury are inextricably intertwined; an individual, a family, a dynasty, all had to possess a fortune – in tandem with their venerable lineage – to enjoy the finer things in life (Bourdieu 1984). Not only were those things pleasurable, they also confirmed and signaled status, cementing an individual's position at the pinnacle of the social order (Morhart, Felicity, and Czellar 2020). Featherstone (2016) identifies the ubiquity of luxury goods in society, as well as the general condemnation of such goods when a large proportion of society does not have access to them. The relationship of art to luxury is already seen in the context of the church, where

https://doi.org/10.1515/9783110732757-001

artists were enlisted to paint murals of religious art on chapel walls and ceilings. Later, when aristocrats such as the Medicis replaced the church and its priests as patrons of the arts, this change was reflected in the type of paintings and furthered the idea of creating art for art's sake (Kapferer 2014). Consequently, art was divested from function, which in turn helped to raise its value. Central to this snapshot view of art is the connection between art and luxury via patronage of the church and nobility, and its subsequent rupture from it, which encouraged the creation of new institutions that sustained art's growth (Becker 2008).

The blurring of boundaries between art and commodity has become a central issue in our post-modern world (Firat and Venkatesh 1995). The ubiquity of images of luxury goods and of art has also begun to erase the difference between *veneer* and *aura* – where the signs of luxury float over all consumer goods (Baudrillard 1983). Consumer culture thus generates a process of aestheticization of everyday life that can lead to aesthetic banality (Sassatelli 2002; Firat and Venkatesh 1995). Sassatelli (2002) sees a distinction between the aesthetic of the sensible and the sensational, with luxuries in fact being able to engage people on a deeper level.

Walter Benjamin's (1999) description of the concept of aura was restricted neither to art nor luxury, but rather was applied to any commodity that has the ability to gaze back and speak to us. However, as Featherstone (2016) reminds us, luxury, unlike other commodities, allows the viewer/consumer to engage on a deeper sensory level. The involvement is more intense and immersive, involving a fuller sensory appreciation and not just the roving or scanning eye that can lead to longing (Featherstone 2014: p. 11). In this deeper appreciation, the promise of luxury goods merges with works of art. In this context it is important to make the distinction between artisanality and art. Luxury goods depended on the highly skilled work of craftsmen and artisans in their metiers. Louis Vuitton, for instance, had a métier in Paris where the bulk of the work was done. To this day, luxury brands support craftsmen and women who do the work that makes a commodity a luxury – a work that has *aura* in Benjamin's (2010) terms (https://www.theartstory.org/movement/arts-and-crafts/history-and-concepts/). What is also important to note is that the movement not only opposed the industrial production of goods, but also believed that the fine line between art and craft should be elided such that craftsmen could gain the title of artist.

The first luxury brands can arguably be traced back to the early- to mid-1800s. Hermès opened its doors in Paris in 1837, the same year Tiffany debuted in New York City; a jeweler named Louis-François Cartier set up shop in Paris 1847, as did a trunk maker, one Louis Vuitton, in 1854 (Elen, Chamaret, and Rigaud 2013). Initially, luxury goods consisted primarily of luggage; only the wealthy could afford the time and cost of travel (Kovesi 2016). By the late 1800s, however, couture had taken hold, as the growing phenomenon of international fashion houses catered to affluent women eager to wear the latest fashions, popularized through media of the day. Luxury served multiple purposes from the beginning, combining the artisanality of well-made items

(Louis Vuitton trunks from the 1880s still occasionally appear in international auctions), with the pleasure of aesthetic design; the whole implicitly confirming social status. With the advent of electric light in the later 1880s, shopping became ever more of an aesthetic event (De Jean 2014); consumers could finally clearly see the merchandise, regardless of weather and the time of day – and the glass-roofed Victorian arcade, which let in whatever natural light was available, was now an artifact of the past (Williams 1982).

Post-World War I, the massive International Exhibition of Modern Decorative and Industrial Arts, held in Paris over six months in 1925, introduced the world through its 15,000 exhibitors to the streamlined curves of Art Deco, and heralded a sea change from the Gothic and Rococo designs popular in the Victorian Era (Palermo 2014). Art Deco ushered in a modernism both austere and elegant, an aesthetic embodied by countless luxury brand products, from the new slender silhouettes of flapper fashions through perfume bottles, jewelery, leather goods, and home furnishings. Importantly, the Exhibition implicitly conferred the status of art on such products: they were on display as objects of art, imbued with beauty, and served as harbingers of the modern age to come (Benjamin 1999).

By the second half of the 20th century, awareness of luxury brands and goods had spread throughout the industrialized world – images of luxury were everywhere: in magazines and advertising images, on television shows, and in the movies – and possessing the ability to afford such goods became a near-universal aspiration (Belk and Pollay 1985). As air travel across oceans became increasingly within reach of upper middle class consumers, the democratization of luxury similarly took flight. While few could afford couture fashions, many could nonetheless content themselves with branded accessories such as key fobs, wallets, perfume, and perhaps a handbag (Wierzba 2015). Possessing such goods highlighted an individual's refined and artistic taste, thereby conferring inclusion in the club of the elite.

Concurrently, the lines between art and luxury continued to blur, as artists such as Elsa Peretti and Paloma Picasso became in-house brands for Tiffany (Brara 2020); Warhol designs appeared on commercial greeting cards and in print advertisements; and cutting-edge designers, once celebrated for their artistry only by the cognoscenti, became household names – think Halston, Calvin Klein, Ralph Lauren, or Mary Quant (the woman who introduced the world to the mini skirt in 1963, heralding an era of Pop Art, youthful rebellion, and free spirits) (Steele 1997).

It is important to note that luxury embodied meaning for those outside the standard luxury demographics of the upper middle class and the outright affluent (Hudders et al., 2013). A need for status signaling extended far beyond the well to do, with far higher stakes. There is a reason the American author, professor, and sociologist Tressie McMillan Cotton, addressing the issue of Black women living in poverty purchasing designer clothing and accessories, stated: ". . . there was a price we had to pay to signal to gatekeepers that we were worthy of engaging." A carefully selected luxury item or two – a handbag, or perhaps a well-cut suit or silk blouse – could

make the difference between success and failure in important interviews, because interviewees left a better impression when the interviewer, however subconsciously, perceived the candidate as a member of her own class, and therefore deserving of the position at hand (https://tressiemc.com/uncategorized/the-logic-of-stupid-poor-people/).

Luxury in the Present

From the late 1980s through the early 2000s, a dramatic cascade of fundamental changes in how the industrialized world worked, studied, entertained itself, and shopped unfolded. The first home computer debuted in 1977; online shopping started in the early 1990s; Amazon launched in 1994, followed by eBay in 1995, and Google in 1996; and the iPhone – a computer with built-in telephone capabilities, so small and slender it fit in consumers' pockets – was introduced in 2007. The Internet officially debuted in 1983, but its full power for good, ill, and all points in between became apparent only once anyone with a smartphone or a home computer could access it. Thanks to the Internet, consumers could, in effect, browse a marketplace comprising much of the world, searching for precisely what they wanted rather than settling for whatever was available locally or, God forbid, waiting, in hopes of the longed-for item someday appearing on local shelves. The endless variety on tap could be dazzling or paralyzing, or both: Consumers could now shop anytime and anywhere, and consumption of luxury goods as well as most all other goods, would never be the same. The era of accelerated consumption had arrived.

Online shopping can result in consumers making more frequent and larger purchases, because indulging oneself is fast and easy; it can also result in consumers making fewer and smaller purchases, since individuals in front of a screen are no longer buoyed by the giddy flow of an in-store experience (Belk 2020) – in thrall to an attentive sales representative, affected however subconsciously by elegant atmospherics, soft lighting, cooler temperatures, hushed music, and the like. Instead, a different scenario unfolds: an individual, perhaps wearing pajamas, perhaps at midnight, focused in isolation before a glowing screen. Other than the obvious fact that one of these consumption experiences is not like the other, the overall impact is as yet unknown (Batat 2019). Impetuous decision-making remains a possibility.

Whether or not the atmospherics of physical stores may be effectively replaced by well-designed websites, the lure of luxury remains, and is likely elevated by the anonymity of Internet shopping: consumers need have no fear, however irrationally, of being watched, judged, or pegged as other. A global pandemic inevitably affects consumption practices, as discussed in Russell Belk's "Luxury Consumption and Covid-19" (Chapter 2). It undoubtedly is serving, as of this writing, to increase traffic to websites in general, including luxury brand sites; and to normalize the

idea of shopping online as almost a default – as opposed to driving to a local store. In sum, luxury in the present is in a state of flux. In a time of emotionally destabilizing uncertainty ("What are the latest infection rates?" "What is today's air quality index?" "Are there any floods in the forecast?"), consumers want more from their luxury goods than aesthetic pleasure and gratification – they want meaning. And because they want meaning, the ideas of artification and sustainability offer a deep resonance, despite the fact that artification has all but replaced the artisanality of the past.

In this context, it is important to note that artisans became generally less important and artists were more involved in the strategic orientation of luxury goods. Louis Vuitton had a list of artists that worked with the company since the late 80s: James Rosenquest in 1987, Jean-Pierre Raynaud in 1992, Stephen Sprouse in in 2002, Yayoi Kusama in 2002, Takashi Murakami in 2003, Olafur Eliasson in 2005 and 2006, Cindy Sherman in 2014, and Jeff Koons in 2018, to name just a few. The idea was to increase the perceived exclusiveness and prestige of luxury brands via art-based activities (Mase and Cedrola 2017: p. 164). More recently, with Takashi Murakami and Yayoi Kusama, artists are not only involved in product design but also advertising, sponsorship, and even in the creation of pop-up stores and window displays (p. 175).

Luxury in the Future

Consumers appreciate both beauty and security, and the increasing artification of luxury items offers the affirmation that beauty as art is a safe and therefore justifiable investment; moreover, while possessing a luxury object may strike some as frivolous, possessing a work of art is often experienced as deeply meaningful. The term *artification* (Kapferer 2014; Shapiro 2019; and Naukkarinen 2012) emphasizes the discrete, collective, and institutional processes by which artification occurs. When luxury goods are presented to and perceived by the public as objects not only of desire, but also of art, their innate meaning enters a new and more exalted realm (Joy et al., 2014). As a pure expression of emotion and passion, of both the personal and the political, art transcends time, marketing forces, and fashion trends, even as artists themselves are manipulated by the marketplace to become both business and brand savvy to survive in a globalized economy (Erraranta, Moisander, and Pentilla 2020; Ekstrom 2020; Holbrook and Hirschman 1982).

Figure 1.1 provides a snapshot of how we can variously conceive of luxury in the past, present, and future.

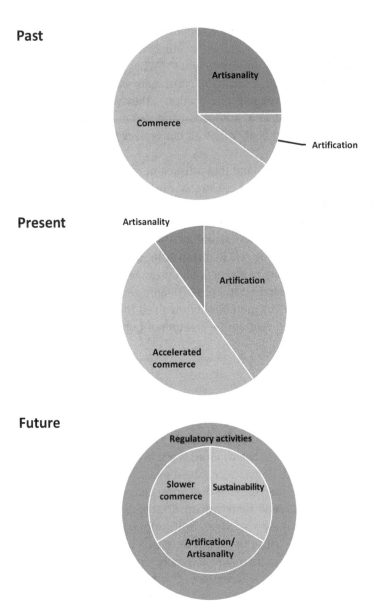

Figure 1.1: Models of Luxury – Past, Present, and Future.

Artification

To talk about artification in the context of luxury is, inevitably, to confront whether luxury is itself art (Andrzejewski 2015). When the artist Takashi Murakami designed a line of handbags in collaboration with Louis Vuitton beginning in 2002, were the

resulting products art (Elen, Chamaret, and Dion 2013)? If they were, then perhaps a cartoonish ten-meter-high Pop Art statue, "Flower Parent and Child," featuring the artist's trademark Pop Art '60s "flower power" smiley faces, temporarily on display during 2020 at the Tokyo real estate/mega complex development Roppongi Hills (https://www.timeout.com/tokyo/news/artist-takashi-murakami-has-added-a-10m-tall-golden-statue-to-roppongi-hills-112720), was also art (Mendes and Rees-Roberts 2015)? Or perhaps the instantly Instagrammable hamburgers, lattes, rolls, chocolates, and other menu options, featuring the same smiley faces perched cheerfully atop each dish, at the also limited-time-only pop-up Murakami Flower Parent and Child Café, were also art? Yes, yes, and yes, depending on the eye of the beholder. The concept of art is, after all, malleable, changing with the times (Shapiro 2004). Dogmatic definitions of what comprises art, with immutable lines drawn between the commercial and the artistic (sacred), have long since dissolved (Belk, Wallendorf, and Sherry 1989). Museums, the regulators of the creation, communication, and critique of art, themselves welcome the deconstruction of traditional definitions of art; art includes business, as it also does in the context of museums, and as such the customer is always right (Ekstrom 2020). If sales of cupcakes with smiley petal faces spur interest in art, and are themselves perceived by the children who lick the frosting off first as art, why would anyone complain? Art should shock, awaken, fling open the metaphorical doors of self-perception and open the windows wide: is doing so not essential to its innate purpose (Hagtvedt 2020)?

Are Luxury Products Art?

The term "luxury" is derived from the Latin "luxus," meaning "excess" or "abundance." The idea of luxury originally referred to lust and debauchery (Kovesi 2015). Only in the 17th century did the concept of luxury as indulgent, sumptuous, and comfortable come into play (https://www.etymonline.com/word/luxury). Today, luxury can be a catchall term referring to high cost, high value, and aesthetics that trigger pleasurable emotions. The original meanings of luxury remain relevant; consumers crave the pleasures of luxury, with a drive akin to lust, and a heedlessness not unrelated to debauchery – we want what we want (Hagtvedt 2020). Every element of luxury feeds that drive, that we as individuals deserve what we want, have a moral right to self-indulgence, and that, in any event, luxury is in some sense sensible: a luxury good will likely hold or increase its value over time, and given the high artisanal quality of its manufacture, will last through generations. Armitage and Roberts (2016: p. 3) suggest that the question of whether luxury products can be perceived as art can be answered in purely economic terms: What will the wealthy pay for a work of art versus a luxury product? As discussed above in Murakami's product lines for Louis Vuitton, the lines between the two have indeed been deliberately blurred. As a case in point, consider the auction price of a Hermès Matte White Niloticus Crocodile

Himalaya Birkin handbag featuring 10.23 carats of diamonds. This item sold in Hong Kong in 2017 for USD $384,285 (Madori-Davis, 2020). Hermès Kelly bags – named in honor of Princess Grace of Monaco, in an early example of informal and perhaps un-witting brand ambassadorship (the former Grace Kelly carried one in the 1955 Hitch-cock movie *To Catch a Thief* and was seldom seen thereafter without one) – have enjoyed an average increase in value of 240 percent over ten years (https://www.col lectorsquare.com/en/bags/hermes/kelly/). How many works of art, with the obvious exceptions of such artistic superstar perennials as Monet, Modigliani, and Picasso, or blue-chip relative newcomers including Basquiat, Hockney, Koons, and Warhol, have reliably accrued such hefty financial returns?

How Does Aestheticization Happen?

How objects that have not been deemed art become recognized as art is a complex process, involving multiple steps, as discussed in detail in Chapter 7, "Wearing the Writing on the Wall: Street Wear and Street Art." Dagalp and Hartmann (2020) iden-tify three specific processes in this transformation:
- consumer processes
- brand processes
- market forces

The authors refer to *aestheticization* rather than *artification*, although both terms encapsulate one another. As Naukkarinen (2012) notes, artification is not only aes-theticization, nor is aestheticization only artification, even if they frequently over-lap; thus the terms are to a degree interchangeable.

Consumer Processes

In consumer processes, individuals, in their responses to standard, mass-produced products, can create an aura around them, thereby transforming them into meaningful aesthetic products. In so doing, consumers resist, however subconsciously, dominant discourses regarding a given narrative as they themselves become the creators of aes-theticizing processes. Consumer action in the form of discourse, sensory experiences, re-articulation of meanings, and animation of objects transforms these objects into art. This process can happen at the level of the individual (e.g., consumers creating aes-thetic practices around a Harley Davidson motorcycle), or of the collective (e.g., biker gangs creating new meanings and recontextualized aesthetics (Schouten and Alexan-der 1995).

Brand Processes

Brands and branding narratives play an important role in consumer processes; artification does not occur in a vacuum, but instead is shaped by various interconnected marketing forces (Schroeder 2005; Brown 2018). When brand managers create an aura around a brand, they are engaging in "scripting" (Dalgalp and Hartmann 2020), i.e., creating a specific look and feel, and perhaps even a specific color (e.g., Tiffany blue), which in turn results in brand-driven aestheticization. Scripting is then echoed by other marketing elements, such as websites (Tiffany's website, for example, prominently features the color now known as Tiffany blue in its website palette, print advertisements, and all packaging, including shopping bags. The color alone sells both the brand, and the brand's mythology.

Brand mythologization involves highlighting a brand's historical past, thereby adding nostalgic elements to a brand's aesthetics, providing brands with an aura of authenticity (Brown, Kozinets, and Sherry 2003; see also, Betty Crocker, an entirely fictional brand image, who in 1945, according to *Fortune* magazine, was "the second-best known woman in America" (the first was Eleanor Roosevelt) (https://www.betty crocker.com/about-us). As the fictional Ms. Crocker demonstrates, brands can draw on aestheticized modes of production (craftsmanship and artisanal work) combined with ways of consumption, such as ethical and responsible consumption, to make these brands come to life.

Market Processes

Institutional efforts, such as work published or otherwise disseminated by art critics, historians, wine writers, and journalists, can help legitimize aesthetics as an essential attribute of particular markets (Smith-Maguire 2018). Consider the impact of refinement through the example of a wine market. A process of refinement happens in this market when a wine's provenance conveys authenticity, transparency, and sincerity, amplified by a healthy dose of mythical narratives (ibid.). Accumulation is a process by which resources, moods, and experiences are woven together by various relevant actors (Dagalp and Hartmann 2020). A good example is the Nordic food market that embodies a national aesthetic and thereby brings a coolness factor to how a given country's foods are perceived through touting the sourcing of food locally, which in turn reinforces the concepts of good taste and authenticity drawn from local culinary traditions (Ulver 2019). Finally, re-enchantment can be ignited by marketers in the nostalgic market through three processes: re-instantiation, re-enactment, and re-appropriation (Hartmann and Brunk 2019).

All the processes described above, in combination, result in what Dagalp and Hartmann (2020) term aestheticization. Minor differences aside, similarities between aestheticization and processes of artification, are readily apparent. Through artification,

objects consumers use on a daily basis can be transformed, with mundane commodities such as, for example, handbags, keychains, or scarves reconceived as sources of deep and sustained aesthetic pleasure (Joy et al. 2014).

Artification is based on two basic assumptions. The first is belief in the superior value of art and art works, although that belief is less concerned with the intrinsic value of art as in the processes of how non-art becomes art. The second is the number of legitimizing bodies involved in such transformation. From a sociological perspective, artification allows for self-expression and authenticity (Massi and Turrini 2019: p. 4). From a political perspective, it is an outcome of the cultural democratization process (Shapiro 2004). Like aestheticization, artification does not rest on the essentialist belief in "art-in-itself" but only on a historically situated, collectively accepted, and relatively stabilized notion of what consumers define as art (Shapiro and Heinich 2012: p. 12). Artification needs art as a point of reference in order to make non-art into art. There is thus a blurring of the boundaries of art and commodity, as is the case in aestheticization processes.

Shapiro (2019) identifies the following processes that reflect actions taken by consumers, as well as those taken by brands, markets, and political entities.

Displacement requires the transformation and removal of works from their original environment to create the conditions for it to circulate. An example would be photographs of site specific and environmental art shown in art galleries.

Renaming generally accompanies displacement. Bordeaux wines from wineries classified in 1855 (e.g., first growths) are to this day considered inimitable premium wines (Yeung and Thach 2019: p. 61). Reshuffling rankings also goes hand in hand with renaming. While the 1855 classification is still the premier form of Bordeaux wines, other accepted nomenclatures are seen as close to this classification system, such as Cru Bourgeois, which has been reclassified and renamed several times. The term Cru Bourgeois applies for five years before it is re-evaluated and carries with it three additional tiers – Cru Bourgeois, Cru Bourgeois Superior, and Cru Bourgeois Exceptional (https://www.bordeaux.com/us/Our-Terroir/Classifications).

Organizational change often follows from such renaming. *Haute couture* (a French term meaning "high dressmaking," referring to apparel designed and produced only and specifically for a single client) was very important before World War II, but shed its significance in a new and more democratized fashion system post-war (Crane 2019). Differentiations of functions often follow disruptive events. Crane (2019) describes how the power of the couturier was reduced and fashion designers became more important in orchestrating the entire system (Dion and Arnould 2011). Normative and legal consolidation often follows, requiring administrative and regulatory oversight that hastens the process of artification. In this process the concept of time is also altered. For instance, art exhibited in a gallery must be shown for a certain period of time in a particular venue.

Aesthetical formalization is another feature of artification, often drawn from an adjacent art form, i.e., fashion borrowed from art movements such as Surrealism,

Pop Art, and more recently street art (art created on the fly for the general public and displayed in public, i.e., drawings by Keith Haring on available surfaces in subways in New York City (see Visconti, Sherry, Borghini, and Anderson 2010). Patronage of the arts today falls on the shoulders of the government, private donors, or corporate foundations. Finally, when an art movement is written about by critics and art writers the process is called *intellectualization*, which can be equally important in the wine and fashion worlds.

When applied to luxury brands, according to Kapferer (2014: p. 376) artification can create value in the luxury world in four ways: (1) a constant renewal of the image of the brand based not only on its past, but also on its present and future; (2) presentation of the brand as a cultural agent and not merely a commercial one; (3) reducing the obligation of rarity in an era of reproducible works of art, which necessitates a deep understanding of contemporary art in different parts of the world; and (4) helping to create a barrier to entry against newcomers, primarily *masstige* (mass prestige, i.e., mid-level) brands developed by young designers. Louis Vuitton, Hermès, and Chanel, for instance, created an aura around their respective brands in Japan in the early 2000s, consecrating spaces in their stores for art exhibits, supporting artists through foundations, and creating retail architecture and interior design that allowed for a growing culture of adoration (Dion and Arnould 2011); they continue to do so in other flagship stores in Paris, London, and Shanghai. The stores thus become art institutions themselves, exhibiting art alongside their own products. Joy et al. (2014) refer to these institutions as *M(Art)worlds*.

As Kapferer (2014) notes, the strong connections to artists and art institutions are central to the strategies of luxury brands – it is no accident that multiple art auction houses are owned by luxury brand owners (e.g., Francois Pinault of Kering, a multinational corporation whose luxury goods brands include Gucci and Yves Saint Laurent, bought Christie's Auction House in 1998) (https://www.economist.com/business/2019/06/20/the-western-worlds-auction-house-duopoly-is-now-in-private-hands). In return, art galleries rent their spaces to runway shows by famous brands in major cities such as New York and Paris. Museums have organized shows for many well-known designers such as Giorgio Armani. Murakami showed his work at museums: handbags he created for Louis Vuitton were then sold in the museums, in effect creating a commercial luxury venue within a museum (Lezama 2019; Joy et al. 2014). Most of the flagship stores have spaces to show works of art, and many artists partner with designers to create collaborative works. Artists are not simply creating limited editions; they are involved at every stage of the design process, the best example being Takashi Murakami's collaboration as an artistic designer for Louis Vuitton (2003–2015) (https://www.rebag.com/thevault/louis-vuitton-101-takashi-murakamis-monogram-multicolor-collection/). As Kapferer (2014: p. 379) notes, "Artification means that every act including advertising should be artful." Luxury brands are educating a new breed of consumer on social media and, since Covid-19, through massive digitalization, becoming the curators of their own

content and experiences, including of events, media advertisements, and books, which are all part of the process of artification (Armitage and Roberts 2016b).

Further, according to Kapferer (2014), the transformation of luxury brands from small enterprises to mega-corporations with their own set of competitors requires that luxury turn to art for its legitimization, both moral and otherwise. Luxury is not necessarily art, but needs to be viewed as art (Kapferer 2014) argues (p. 374), in order to legitimize its existence and growth. What used to be an entirely artisanal product is no longer the case, since luxury goods are now sometimes produced in factories rather than entirely by hand, despite the narrative that accompanies them. The story that is told now emphasizes creativity: artistic creativity and artists as generators of such creativity (Hagtvedt, Chapter 6). Many of these artists, particularly in America, collaborate with luxury brands. The best example of this new connection between art and commerce is exemplified in the life and works of Andy Warhol, whose silk screens and representations of banal objects/commodities have become the iconic symbol of mass production in a capitalist society (Schroeder 2005). Warhol's art was consecrated by multiple shows at museums around the world. As Kapferer (2014: p. 375) notes, "Art is that which is consecrated as such by institutions of art. Luxury brands have learnt this lesson." The implication is that luxury brands that want to be seen as art can follow a similar path.

Since then, a number of well-known artists have collaborated with major brands such as Louis Vuitton and have had their works exalted in the halls of museums. Christian Dior, Gucci, Fendi, and the like, have long-standing relationships with art and artists such as Judy Chicago and Nico Vascellari (Massi and Turrini 2019). These artists have willingly collaborated with large corporations with multiple brands, lending their names to the brands. The success of such collaborations depends on the kind of creativity required by both industries. Original creations (or variations thereof) are expensive and target an elite class.

Art and luxury both focus on timelessness, and art's importance arises from its lack of function: art for art's sake (Kapferer 2014). Luxury would like to do the same, a fact emphasized by many of their ads (e.g., the watchmaker Patek Phillipe describes their timepieces as objects that are not owned but rather must be taken care of for the next generation, implying that such timepieces are rare, exclusive, and collectible works of art). However, while luxury brands cater to a connoisseur class, they also have a large following among the newly rich. How can luxury brands keep their core clientele of wealthy connoisseurs happy, given the exponential growth of luxury goods consumption among the nouveau riche, who lack the former's knowledge and style? Conspicuous consumption is associated with the latter, whereas the few super elites with knowledge have moved toward a post-materialist luxury (Rambourg 2020).

Further, neoliberalism and the market economy have made luxury goods available globally. China and Japan, and more recently India, have seen a growth in consumer culture and an avid consumption of luxury goods (Bryson and Atwal 2017;

Wang et al. 2019). In these contexts, luxury companies face a dilemma: How can they enter new markets? Part of the strategy is to make themselves incomparable to other brands with their emphasis on exclusivity, which is done effectively by collaboration with art and art institutions. Luxury brands often pay homage to the culture of the host country. Hermès, for example, sponsored an exhibition, "Heavenly Horses," that celebrated the culture of horses in China (Rambourg 2020); the brand has carried out similar cultural events in India and Japan. The elite they are targeting in these locations are, in turn, impressed by the high culture connections.

However, in the process, artisans have not been left out of the equation. While artists might be involved in design, direction, and strategic processes, it is the craftsmen and women who see the product through to its repair and reuse. It is increasingly difficult to find artisans to do this labor of love – older artisans are dying and their knowledge is not continued by the younger generation. Artisanality is therefore critical to the strategic success of luxury brands in the future. Many of these brands (e.g., LV) recognize the value of these artisans and include them in their environmental and social impact reports.

Multiple interpretations surround luxury and are discussed in the consumer literature:
- As an expectation of individuals who feel they have worked for it and earned it (Roberts and Armitage 2019)
- As a reward for competing and succeeding in a neoliberal market system that touts the importance of belonging to a community of self-made others
- As imagined spaces (ibid.)
- As experience (see Batat 2019 for an interesting description of the marketing of luxury experiences)
- As access (Bardhi, Eckhardt and Samsio 2020)

Luxury as experience builds on Pine and Gilmore's (1998) research on the experience economy. *Liquid luxury* is an extension of Baumann's (2007) notion of liquid modernity and has been developed by Bardhi, Eckhardt, and Samsio (2020) wherein the experience is more significant than the ownership of these products. They call it "liquid luxury." Being a member of an exclusive car club suggests accessibility to multiple luxury automobiles even if you might not own any of them. The authors question the impact of this phenomenon on luxury brands and consumers and whether exclusivity and rarity have been replaced by novelty and accessibility. Will the concept of speed become associated with luxury, superseding timelessness and slowness (ibid.: p. 33)? Luxury is decoupled from conspicuousness in the West, with status signaled by knowledge and creativity, and in investments of self-improvement.

Fine wine is an example of a product that may be stored but whose primary value is in drinking and in the exchange of information (knowledge) about the wine with other knowledgeable consumers. It is ephemeral in the true sense of the word – it has to be imbibed to be truly appreciated – and is therefore an ephemeral luxury (Yeung

and Thach 2019: p. 81; see also Chapter 11). However, even such an ephemeral luxury is dependent on (1) a sacred location and geography; (2) the master vigneron (a cultivator of grapes for winemaking) and the viticulture team; (3) a view that considers a balance between nature and technology; (4) quality craftsmanship to highlight the vintage; (5) the aging process; (6) the art of the blend; (7) authentic luxury service; and (8) a wine for entry-level dreamers. For instance, in Bordeaux, the first growth is not accessible to young consumers, but a fifth growth might be (Yeung and Thach 2019).

Thus far we have looked at what artification means and its indispensability to the strategy of luxury brands in the worlds of art, fashion, and wine. Next, we examine a second factor essential to luxury, both currently and in the future: sustainability.

Sustainability

The concept of *sustainability,* according to the Bruntland World Commission UN (1987), refers to development meeting the needs of the present without compromising those of the future; to engage in sustainable practices is thus to be a citizen of the world. Sustainability sites luxury goods within the purview of the common good – purchase an object designed and manufactured to last, incorporating fair labor and responsible environmental policies, and know that, in whatever small way, your consumption choices have not contributed to human and environmental degradation (Keinan, Krenner, and Goor 2020). As of this writing, extreme weather events have driven home hard truths to those willing to listen; the climate crisis is actively upon us, not some vague disaster looming safely in the distant future, and the time in which to act is rapidly diminishing. Sustainability could not be more relevant (Martin and Schouten 2012; Thompson and Coskuner Balli 2007).

Nature as pastoral, timeless, and nurturing (Canniford and Shankar 2013; Soper 1995); the divine mother and goddess (and thus implicitly female) (Strang 2014) is a comforting socially constructed concept, but the escalation of the climate crisis has revealed a new interpretation: nature as a force that must be protected, rather than a force that protects us. The concept of a male-centric view of nature, in which strength equals power, is likewise far past its sell-by date (Mies and Shiva 1993; Strang 2014). Today, as the price of humanity's use of fossil fuels since the dawn of the industrial age becomes ever more devastatingly clear, domination over all things, including nature, is revealed as the deeply anthropocentric and destructive approach it always was (Carson 1962; Gagnon and Barton 1994);

In *technocentrism*, nature is a resource to be exploited, a commodity like other commodities (Warren 1994). That economic growth in and of itself is laudable has long been a central tenet of laissez-faire capitalism (Joy and Pena 2017); the idea of interdependence between humans and nature is simply lost. *Ecocentrism,* in contrast, supports coexistence and collaboration between humanity and nature, prioritizing

the environment in its totality, regardless of whether elements of that environment benefit humanity; while *sustaincentrism* refers to coexistence and collaboration between humanity and nature, thereby ensuring the survival of both (https://www.re searchgate.net/publication/275010799_Theorizing_Firm_Adoption_of_Sustaincen trism). As such, sustaincentrism is concerned with far more than avoiding or mitigating environmental degradation; it also encompasses human exploitation (Gladwin et al. 1995), as in, for example, the production of fast fashion apparel, which depends on low wages and substandard working conditions (Joy et al. 2012).

In the wine world, the concept of *terroir* embodies the idea of nature in collaboration with humans. Originally a French term, terroir refers to the specific elements of nature, such as shade, climate, and soil that, in tandem with human endeavor, produce the flavors of a wine unique to a given region. But this view is not shared by all (De Mossier 2018).

Terroir

Terroir by definition is a socially constructed concept as a result of nature, knowledge, and viticulture practices specific to a particular place. While oenologists and chemists focus on the natural side of terroir, our interest lies in the social science of terroir (Ulin 2013). The two specific regions in which terroir is deemed most important, due to the historic high quality of the wines produced there, are Bordeaux and Burgundy (De Mossier 2018). Ulin (2013) argues that the popularity of the idea of terroir is its capacity to link wine to particular places and wineries, which is unusual in light of the general anonymity of many commodities in our era, such as apparel and home goods, which are typically manufactured in low-wage countries far from where they will eventually be sold. De Mossier (2018) however reminds us that the globalization of wine requires more than selling it – positioning wine within a competitive framework requires effective brand narratives. With the concept of terroir, consumers can more easily conceive of the labor involved in the cultivation of the vineyards and the production of wine, bringing a multidimensional appreciation that complements a fine wine's aesthetic appeal (Black and Ulin (2013: p. 13).

A good wine offers distinctive flavors that reflect the specific terroir in which the wine grapes were grown, even including the specific year of production. Terroir is not just an expression of place, but rather a magnification of it (Daynes 2013: p. 18) of that particular place in a particular time frame. Like an object of art, a given vintage or variety of wine can be considered unique and thus impossible to reproduce (De Mossier 2013). While artification is implicit in understanding wine as an object of art, sustainability is critical to the creation of organic/biodynamic and natural wines (Charters 2007). Even natural wines reflect the terroir and wine practices, despite the fact that the winemakers insist they simply allow wine to happen with very little intervention (Goode and Harrop 2011).

The tendency of wine connoisseurs to focus on terroir's physical elements when discussing fine wines is not surprising given that such wines are produced in specific locales and have enjoyed sustained commercial success. In the case of Bordeaux wines, the classification of 1855 from the first growth to the fifth (a reference to the rankings, based on reputation and price, of Bordeaux wineries) was the turning point toward more large-scale commercialism, with first growths commanding very high prices to this day. The fact that all first growth was allocated by the Bordeaux Chamber of Commerce to the vineyards of people with aristocratic lineage comes as no surprise (Mathews 2019). The apparent naturalization of these wines to physical terroir dominates wine discourses, naturalizing that which is social (Ulin 2013: p. 82). While wine contributes to distinction in society, given that mass-produced wines with no connection to terroir are viewed as commodities in an age of mass production, there is a tendency in the social science literature to use the term "natural" to mystify that which is social. Brand *storytelling* is implicit in this process (Visconti 2020).

Traceability

Traceability allows corporations and consumers to track the supply chain of a given product, affirm the safety and security of food items, and guarantee that a given product was sustainably manufactured – in both environmental and labor terms. Thus, in the fashion industry, traceability can track a garment's production cycle from cotton crops through textile production, apparel manufacture, and finished garments appearing on store shelves – bringing the environmental impact of clothing production and related labor conditions out into the open. The supply chain must be transparent and open to certification by third-party assessors to avoid the appearance of greenwashing (marketing a company as environmentally conscious unaccompanied by implementing any actual relevant policies). Certain types of activities might be easier to highlight, such as sustainable water use, but judging working conditions of employees, animal welfare, and safety policies might be more difficult. For ethical consumers, traceability enables aligning purchases with their values (Robert-Demontrond 2009). Today many corporations feel an obligation to provide customers with at least the appearance of a commitment to sustainability values (Joy and Pena 2018), although some may excuse lapses based on the activities of subcontractors. The cost of traceability is high and is passed on to the consumer, who may be unwilling to pay a premium (Tsakiridou et al. 2011).

The sustaincentric model (Joy and Pena 2107 and Pena 2021) calls for the recognition of nature as a symbolic source in the creation of fashion apparel; once consumers are aware of the different stages of apparel production, their connection to nature can potentially be strengthened and their commitment to the common good intensified.

The Rise, Fall, and Rise of Environmentalism

The idea of recycling first took root in consumer consciences in the 1970s, when interest started building in environmentalism (Cooper 2009; Pellow 2002; 2007; Tavinor 2019). Waste, whether industrial or individual, was now reframed as an actual environmental threat as opposed to an annoyance. Litter and trash could be tossed into the garbage and forgotten, while the concept of waste and its impact on the environment were far more memorable (Hawkins 2005).

During World War II, frugal life styles were in vogue as consumers made do with what they had and engaged in what would now be termed slow consumption. It was a different world post-war, as ideals of thrift gradually gave way to a culture of abundance: new and bigger everything from cars to televisions, homes, and aspirational dreams (Cooper 2009). With the ascent of Ronald Reagan to the U.S. presidency in 1980, interest in living in harmony with nature, active during the 1960s and 70s, gave way to individualism, nature be damned. The American nature photographer Ansel Adams personally met with the then-President in 1983, hoping to encourage environmental stewardship. He failed, telling a reporter that the President had ". . . a totally different concept of the world," i.e., technocentric versus ecocentric (https://www.washingtonpost.com/archive/politics/1983/07/03/the-critique/32064a44-add8-4ea1-8564-3c7eb09e79cb/). In the mid-1980s, solar panels installed on the White House roof by Reagan's predecessor Jimmy Carter, were unceremoniously taken down (https://yaleclimateconnections.org/2008/11/jimmy-carters-solar-panels/).

The Issue of Waste

How societies manage their waste clearly reflects that society's values, norms, and beliefs (Melosi 2005; MacBride 2012). In industrial societies, the old adage of "waste not, want not" faded away, swept aside by a sense of affluence and a carefree disdain for potential consequences (Oldenzeil and Weber 2013). In our new era, with awareness of those consequences now considerably heightened, the concept of "waste not, want not" is making a comeback among consumers of every variety, and particularly among luxury consumers, whose consumption is often driven by desire more than need, and is therefore more likely to allow for purchase decisions incorporating altruism (O'Brien 2008). While previously brands had little incentive to focus on sustainability, today they assuredly do, as companies such as Stella McCartney, Tiffany, Kering, and LVMH have made sustainability a key element of their respective corporate ethos.

Circularity

The *circularity* model is a natural outcome of sustaincentrism: regenerative by nature and incorporating a closed loop approach embodying the cradle-to-cradle principle (Niinimaki 2017), the end goal is to eliminate waste via innovative design (see Chapter 9). In this model a given product, even if not biodegradable or recyclable, may be capable of multiple uses. In the case of clothing, ideally a given piece of apparel is made with sustainable fibers. Since neither composting nor landfills are viable options for discarded clothing, the circularity principle is exemplified in extending the life of the garment all materials being recycled over the course of its life through disassembling and reusing (Ellen MacArthur foundation 2017; Weber 2013).

Garments can be designed to last. To do so, they must be more than well made – they must also offer timeless style that transcends time-limited fashion trends (see Chapter 10). Clothing that lasts has meaning for consumers, who make purchases not only out of need or to feel fashionable; they respond to items that speak to and reflect their own tastes, interests, and personalities, through colors, patterns, textures, cut, and fit.

Approaches that keep apparel items out of landfills might vary by consumer age. For example, younger consumers might be open to renting or swapping items of clothing, while research shows that older consumers prefer repairs and redesigns (Niinimaki 2017). Gen Zers decisively prefer second-hand clothing over fresh-off-the rack options – as of this writing, consumers under twenty-six comprise an astonishing forty percent of the re-commerce market, now a $28 billion industry, with the market expected to double within five years (https://www.thredup.com/resale/ #size-and-impact) (see Chapter 10). The mid-range clothing designer Eileen Fisher, a U.S. company committed to sustainability, includes a tag on its clothing asking customers to return the garment to the company once they are ready to discard it. The clothes can be brought back to useful life, through repair if needed, professional cleaning, overdyeing, and the like, and are then offered for sale at a steep discount from the original prices through the company's Eileen Fisher Renew program – each article is "ready for its next life" (https://www.eileenfisherre new.com/p/eileen-fisher-organic-linen-delave-pullover-womens/Yplvr-Z27Y5pu-1? color=green). Such a program is counter to apparel companies' usual approach to selling clothes: sell lower-priced rehabilitated items, and you risk lowering company profits. Since our focus is on luxury, we have not even approached the topic of fast fashion, which creates endless waste and exploitation of labor around the world (Joy et al. 2012; Ozadmir, Atik, and Murray 2020).

Profits can also dip when unsold articles end up in discount stores. To avoid this outcome, Burberry was widely reviled in 2018 when news broke that the company had burned clothing, handbags, and perfume that failed to sell, along with unused fabric; during 2017 alone, the company incinerated Burberry products worth more than USD $37 million (https://www.nytimes.com/2018/09/06/business/burberry-

burning-unsold-stock.html). Burberry was far from alone in burning unsold merchandise. As quoted in *Forbes* magazine (July 20, 2018), sustainable fashion advocate Christina Dean noted: "We know that around 100 billion garments are manufactured annually. Let's say the sell-through rate (both full and discounted) is a generous 90%, then potentially 10 million items of clothing become 'deadstock' every year. That's a lot of clothes to miraculously make 'disappear.'" (Not coincidentally, the R Collective (https://thercollective.com), a fashion brand founded by Dean, offers apparel made entirely from upcycled luxury brands' waste materials.) Another luxury brand implicated in destroying unsold stock was Richemont, owner of Cartier. In 2018 the company received significant negative press for the destruction of USD $572 million of luxury watches using the same excuse that discount prices can damage the aura of exclusivity associated with luxury (https://www.forbes.com/sites/oliviapinnock/2018/07/20/no-one-in-fashion-is-surprised-burberry-burnt-28-million-of-stock/?sh=38fa53a74793).

Faced with public backlash, companies such as Burberry had to weigh financial damage to the brand if the company refrained from destroying deadstock against negative perceptions of the brand if they did not. The answer was clear: in 2018 the company put a halt to the practice. That same year, Burberry signed on to the Make Fashion Circular initiative (https://www.ellenmacarthurfoundation.org/our-work/activities/make-fashion-circular), which launched in 2017 and is dedicated to transitioning the fashion industry to a circular system. Other signees included H&M and Stella McCartney.

The environmental damage from the fashion industry is significant; according to the R Collective, one dump truck of fashion waste is landfilled or incinerated every second. The following startling statistics, courtesy of the World Bank, set out the damage from the fashion industry – as a whole, not solely from luxury brands – in stark terms: "The fashion industry is responsible for 10% of annual global carbon emissions, more than all international flights and maritime shipping combined. At this pace, the fashion industry's greenhouse gas emissions will surge more than 50% by 2030" (https://www.worldbank.org/en/news/feature/2019/09/23/costo-moda-medio-ambiente).

Incorporating circularity can mitigate, and perhaps even prevent, that surge. Admittedly, circularity requires an end to fast fashion, in which new clothing items are debuted at a breakneck pace, encouraging continuous consumption of new items. Because fast fashion articles are designed to fall apart after a limited number of wearings, the clothing is more or less guaranteed to end up in landfills (Joy et al. 2012). Through reuse programs such as those of Eileen Fisher or the R Collective, consumers might end up purchasing more articles of apparel based on their relative affordability; moreover, they may well form a lasting bond with a corporate entity that shares their values, ensuring brand loyalty over time.

Multiple stakeholders can be involved in reuse programs, including collectors, sorters, and remanufacturers. In France and Finland, manufacturers and producers

are required by their respective governments to accept returns of products no longer wanted by their customers, which can then be donated to charity (Ekstrom and Salomonson 2014). These authors also argue that returned clothing can also be converted into new fibers used to create yarns and then ultimately new garments. Such reuse can require collaboration between countries, since producers, brands, collectors, sorters, spinners, and recyclers are located all over the world, and different countries will have different legislation.

While some fashion brands have integrated circularity into their corporate ethos, luxury brands have overall been slower to do so, perhaps because luxury items are less likely to be discarded. However, thanks to today's wide-open consumption ecosystem in which individuals can access endless arrays of whatever products strike their fancy at the click of a mouse or with a fingertip swipe, when such items become available at resale or auction sites (see Chapter 10), they maintain the aura of the brand, and thus their intrinsic appeal. The resale of pre-owned items dovetails well with both consumer desires for bargains, and their increasing demands for sustainability, traceability, and circularity. In 2021, Kering purchased a five percent stake in the e-commerce platform Vestiaire Collective, which sells pre-owned luxury goods, signaling their awareness that the luxury goods resale market is expected to grow (https://www.diamonds.net/News/NewsItem.aspx?ArticleID=66130&ArticleTitle=Kering+Invests+in+Secondhand+Luxury+Site). Why purchase pre-owned luxury goods? They cost less, a matter of particular importance to those seeking social acceptance from gatekeepers, as discussed earlier, and to anyone, particularly young consumers, for whom cost may be an issue. For many, a further issue is sustainability: Whatever is resold is saved from becoming waste.

The Business of Fashion Sustainability Index

The Business of Fashion's sustainability index (Kent, 2020) is the first to evaluate public documents of fifteen major companies (luxury groups, sportswear, and fast fashion) in order to create an index documenting how these companies fared on the most important sustainability criteria: transparency (e.g., the traceability of supply chains), emissions, water use and chemicals, materials (regenerative and circular materials), workers' rights, and waste minimization (Kent 2020). Among luxury conglomerates, Kering, which has taken the lead on sustainability, did well on transparency, water/chemicals through reduction, and moved toward regenerative and circular materials, but was less effective on workers' rights and waste minimization. Overall, however, Kering had the highest company score across these categories, although it scored only 49/100. Hermès, LVMH, and Richemont achieved paltry overall company scores of 32, 30, and 12 respectively (Kent 2020).

Another major concern for luxury companies has been the sourcing of raw materials (e.g., fine gold and diamonds) that requires sustainable mining, responsible

sourcing, and avoidance of child labor in the processes involved in making fine jewelry. Tiffany is a relative winner in these areas, having been identified by Human Rights Watch as a company that has done well (Subramaniam, Zlatev, and Farook 2021). With Tiffany as one of its many brands (LVMH acquired Tiffany in January 2021), LVMH's overall score will likely improve and edge closer to that of Kering.

The time for a complete re-invention of the fashion industry and for a return to the slow consumption of earlier eras is overdue. Luxury brands, with their global reach and hold on the public's imagination and aspirational dreams, along with their deep pockets, can and should lead the way. As Burberry CEO Marco Gobbetti stated at a press conference announcing an end to the company's destruction of deadstock: "Modern luxury means being socially and environmentally responsible."

While some of these companies were late to the party, metaphorically speaking, others were already there. Speaking to a group of global business leaders attending the G7 Summit (an informal consortium of seven economically advanced economies) in the UK in June 2021, Stella McCartney called for the adoption of government policies to "put hard stops on our industry," which is, as she bluntly stated, "one of the most polluting [industries] in the world" (https://www.treehugger.com/stella-mccartney-urges-world-leaders-fashion-sustainability-5189397). McCartney's own credo: "I design clothes that are meant to last. I believe in creating pieces that are not going to get burnt, that are not going to landfills and that are not going to damage the environment" (ibid.), sets out the goals for all designers.

How to incentivize corporate leaders, fashion stakeholders, and the general public to adapt practices and consumption habits to a changing world is a pressing, if daunting, question. As shown in Figure 1.1, the tripartite model of the future of luxury fashion highlights the essential nature of artification and sustainability, in tandem with profitability, to sustaining the business model; no one component is more important than the others. As the luxury industry faces the future, the twin pillars of artification and sustainability will – and indeed must – play a major role.

The Structure and Organization of the Book

Compendium details. Our compendium comprises four sections: Luxury during a global pandemic; the world of art; the world of fashion; and hospitality services, including wine. Contributors address the following:

In Chapter 1, I lay out the principles of artification and sustainability as foundational pillars of the future of luxury; both are equal in importance to the principle of profitability.

How has Covid-19 impacted the luxury world? In Chapter 2, Russell Belk, considers the "survivor's guilt" scenario, in which potential luxury consumers maintain lower profiles to avoid provoking envy from those less fortunate. A second

option is the "celebrant" scenario, in which those who have benefitted from working from home and avoiding commuting expenses experience pent-up demand. Data reveal that while luxury expenditures dipped early in 2020, they have soared in the months since. As the author discusses – rising online sales of luxury goods notwithstanding – brick and mortar luxury brand flagship stores continue to offer experiential elements unmatched by their virtual counterparts.

Pierre Guillet de Monthoux (Chapter 3) draws from the writings of Wassily Kandinsky in discussing organizational aesthetics, a means of informing and understanding organizations through aesthetics. Based on the painter's 1912 avant-garde manifesto, "Concerning the Spiritual in Art," the author defines a romantic concept of art in the development of organizational aesthetics, and addresses the novelty, beyond the design of objects and the taste of individuals, of aesthetics detached from materialism. Between subject and object, the spiritual in organizations takes on an important aesthetic value; aesthetics can thus enable interpreting social organization, providing a means of perception and shaping social reality.

In Chapter 4, John Sherry and Rob Kozinets emphasize the importance of multisensory experiences in their poetic account of their inquiries at Burning Man, an annual convocation of tens of thousands of artists and aesthetes in a liminoid encampment in the Black Rock Desert of Nevada. Participants encounter a dazzling array of art installations and thousands of performances during a week of intensive engagement in a challenging physical environment. Encounters result in profound aesthetic experiences as well as heartfelt personal transformations. Although the focus is on artification, sustainability considerations are raised in the process of the burning of art as the event shuts down.

Throughout the 20th century, Western academics and artists excluded Indigenous peoples from conversations discussing Northwest Coast belongings. Amanda Sorensen and Susan Rowley (Chapter 5) trace the history of Western perceptions of these belongings and reflect on different value systems as embodied in the exhibition, "In a Different Light: Reflecting on Northwest Coast Art," which was on display at the Museum of Anthropology in Vancouver, British Columbia, in 2017. "In a Different Light" prompted audiences to view 19th and 20th century Northwest Coast belongings within an entirely different frame, from the perspectives of descendant communities rather than from those of the non-Indigenous.

Henrik Hagtvedt (Chapter 6) questions the conceptualizations of art and aesthetics and the roles they play in luxury markets, both currently and in the future. Art can be a luxury product in its own right, or serve as a cue connoting luxury in the context of other products or brands. More broadly, luxury marketing can benefit from insights into general aesthetic appeal as well as the specific influences of aesthetic principles. As luxury markets evolve, along with other technological and social changes, new roles for art and aesthetics may emerge, even as some aspects of aesthetics may remain stable across time and cultures.

In Chapter 7, Laurie Meamber and Annamma Joy examine the interrelationship of street art and streetwear. Through artification, graffiti initially emerged as an art movement. Today both street art and streetwear inhabit the conjoined worlds of art and luxury fashion. Street art wear – fashion co-created by luxury fashion brands and street artists – exemplifies an ongoing artification process reflective of its recent emergence in the fashion industry. Fashion, luxury brands, art and brand collaborations, the rise of street art, and the origins of streetwear are discussed, as well as artification and the cultural production process associated with street art wear.

Linda Armano and Annamma Joy examine ethics and sustainability in the world of diamonds in Chapter 8. The authors explore perceptions of sustainability and ethics as embodied by Canadian diamonds within two very different socio-cultural contexts: The miners (both professional and indigenous) who extract diamonds in Canada's Northwest Territories, and the jewelers who sell such diamonds and their customers in two jewelry stores in Italy. Building on extant approaches, the authors investigate sharply divergent interpretations provided by participants. The resulting discussion highlights the revealing gaps and intersections between different cultural visions of the meanings of ethics and sustainability from opposing perspectives.

How sustainable is the luxury fashion industry? As this fashion segment confronts the ever more pressing need for sustainability, a key concern facing the industry is waste reduction. Claudia E. Henninger, Taylor Brydges, Celina Jones, and Aurelie Le Normand (Chapter 9) investigate a novel response to the challenge of waste in luxury fashion production: the artification of waste, and the different ways in which luxury fashion goods can be re-purposed once they have been discarded. As the luxury fashion industry attempts to incorporate sustainability measures in textile production and clothing manufacture, waste reduction, along with exploitative supply chains, natural resource depletion, and overproduction remain obstacles that must be overcome.

In Chapter 10, Linda Turunen examines the dynamics of the second-hand market, clarify the roles of the actors enabling the transactions – consumer-sellers, buyers, platforms, and brands – and explore the resale market's opportunities and challenges. The author discusses the rapid growth in the resale market, with resale platforms competing for partnerships with luxury brands. Those brands are themselves attempting to capture resale opportunity, thereby controlling their products' lifecycles and enhancing customer value without sabotaging their primary market. While luxury brands cannot neglect the resale market, how to best embrace the resale boom is currently a work in progress.

Does artification of a fine wine result in negative customer perceptions of corporate social responsibility? Bianca Grohmann (Chapter 11) addresses this issue with a discussion of an iconic fine wine, Opus One, and its impact on corporate social responsibility activities. In common with luxury brands, sustainability and

other socially conscious activities undertaken by fine wine producers can be perceived as mere marketing ploys. However, the example of Opus One, a fine wine that has undergone artification, illustrates that artification can actually enhance corporate social responsibility efforts, and may provide unique opportunities for extending a brand's associations in the realm of social responsibility.

In Chapter 12, Donna Senese and Darcen Esau consider issues of sustainability in wine tourism, by examining a case history sited in the Chianti wine region in Tuscany. How does wine tourism in a wine region renowned for traditional practices and products adapt to achieve transformative sustainability? The authors provide autoethnographies of experiential educational tourism as well as input from regional wine and wine tourism producers on imposing transformative and sustainable changes in this iconic region. Sustainability in the context of supply chains and wine production approaches is discussed, with a focus on the foundational power of a shared, protected cultural and ecological landscape.

Camilo Peña (Chapter 13) proposes that urban art (graffiti and street art) has similar connotations and processes to those of the natural wine movement. Following previous framings of wine as art, Pena adds to these theorizations by specifying a type of art and a type of wine. The author explains why the term "natural" can be defined beyond the physical/chemical characteristics of a wine to include the discursive and symbolic elements of nature. He suggests that three processes seen in subversive art are evident in the natural wine world movement: reclaiming spaces, rituals of resistance, and opposition to the mainstream.

Finally, Kathryn LaTour and Annamma Joy (Chapter 14) investigate artification – the process of non-art becoming art – and its potential benefits for luxury hospitality operators and academics. Artification involves more than placing artwork on hotel room walls – it represents an organizational and cultural shift in the service offering. Artification offers luxury hoteliers the benefits of authenticity, creating an emotional guest experience via aesthetics; connoting expertise and artisanality in offerings; building uniqueness and exclusivity; and highlighting scarcity, rarity, and aura – the very cornerstones of luxury. The authors further discuss the essential elements of artification found in luxury retail settings.

References

Andrzejewski, Adam (2015). "Framing Artification." *Estetika: The Central European Journal of Aesthetics* LII/VIII, no. 2: 131–51.

Armitage, John, and Joanne Roberts (2016). "Critical Luxury Studies: Defining a Field." In *Critical Luxury Studies: Art, Design and Media*, edited by John Armitage and Joanne Roberts, 1–21. Edinburgh: Edinburgh University Press.

Armitage, John, and Joanne Roberts (2016). "The Spirit of Luxury." *Cultural Politics an International Journal* 12, no. 1: 1–22. doi: 10.1215/17432197-3436283.

Armitage, John, and Joanne Roberts (2019). "The Globalisation of Luxury Fashion: The Case of Gucci." *Luxury* 6, no. 3: 227–46. doi: 10.1080/20511817.2021.1897268.

Bain & Company (2011). "Lifting the Veil of the Diamond Industry." Bain & Company, Inc., and Antwerp World Diamond Centre Private Foundation (AWDC).

Bardhi, Fleura, Giana M. Eckhardt, and Emma Samsioe (2020). "Liquid Luxury." In *Research Handbook on Luxury Branding*, edited by Felicitas Morhart, Keith Wilcox, and Sandor Czellar, 22–43. Cheltenham, UK, and Northampton, MA: Edward Elgar.

Batat, Wided (2019). *The New Luxury Experience: Creating the Ultimate Customer Experience*. Switzerland: Springer.

Baudrillard, Jean (1983). *Simulations*. New York: Semiotexts.

Bauman, Z. (2007). "Liquid Arts." *Theory, Culture & Society* 24, no. (1): 117–126. doi: 10.1177/0263276407071579.

Becker, Howard (2008). *Art Worlds*, [25th anniversary edition]. University of California Press.

Belk, Russ, and Rick Pollay (1985). "Images of Ourselves: The Good Life in Twentieth Century Advertising." *Journal of Consumer Research* 11, no. 4: 887–97.

Belk, Russ (2020). "The Changing Notions of Materialism and Status in an Increasingly Dematerialized World." In *Research Handbook on Luxury Branding*, edited by Felicitas Morhart, Keith Wilcox, and Sandor Czellar, 2–21. Cheltenham, UK, and Northampton, MA: Edward Elgar.

Belk, Russ, M. Wallendorf, and John F. Sherry (1989). "The Sacred and the Profane in Consumer Behavior: Theodicy in the Odyssey." *Journal of Consumer Research* 16, no. 1: 1–38.

Bendall, Jim, and Kleanthous Anthony (2007). "Deeper Luxury," World Wildlife Fund. Surrey, UK. https://assets.wwf.org.uk/downloads/luxury_report.pdf.

Benjamin, Walter (1999). *The Arcades Project*. Cambridge and London: Harvard University Press.

Benjamin, Walter (2010). *The Work of Art in the Age of Mechanical Production*. New York: Prism Key.

Black, Rachel, and Robet C. Ulin, eds. (2013). *Wine and Culture*. London: Bloomsbury.

Blackburn, Simon (2016). *Aesthetics*. Oxford: Oxford University Press.

Bourdieu, P. (1984). *Distinction: A Social Critique of the Judgement of Taste*. Cambridge, MA: Harvard University Press.

Brara, Noor (2020). "The Art of Craft: How Elsa Peretti designed Tiffany and Co.'s Bone Cuff to Draw Attention to the Elegance of a Woman's Wrist." *ART net news*, May 20, 2020.

Braungart, Michael, and William McDonough (2002). *Cradle to Cradle: Remaking the Way We Make Things*. New York: North Point Press.

Brown, Stephen (2018). "Retro-Galore: Is There No End to Nostalgia?" *Journal of Customer Behavior* 17, no. 1: 9–29.

Brown, Stephen, Robert V. Kozinets, and John F. Sherry (2003). "Teaching Old Brands New Tricks: Retro Branding and the Revival of Brand Meaning." *Journal of Marketing* 67, no. 3: 19–33.

Brundtland Commission (1987). *Our Common Future*. Brundtland Report, United Nations World Commission on Environment and Development (WCED).

Bryson, Douglas, and Glynn Atwal (2017). *Luxury Brands in China and India*. London: Palgrave McMillan.

Canniford, Robin, and Avi Shankar (2013). "Purifying Practices: How Consumers Assemble Romantic Experiences of Nature." *Journal of Consumer Research* 39, no. 5: 1051–69.

Carson, Rachel (1962). *Silent Spring*. New York: Houghton-Mifflin.

Charters, S.J. (2007). "On the evaluation of Wine quality". In Question of Taste: The Philosophy of Wine, Signal Books, edited by Smiith B.C, 157–182. Oxford. Signal Books, p. 157–182.

Cooper, Timothy (2009). "War on Waste? The Politics of Waste and Recycling in Post-War Britain, 1950–1975." *Capitalism Nature Socialism* 20, no. 4: 53–72.

Crane, Diana (2019). "Fashion and Artification in the French Luxury Fashion Industry." *Cultural Sociology* 3, no. 3: 293–304.

Crossick, G., and S. Jaumain (1999). *Cathedrals of Consumption, The European Department Store, 1850–1939*. Vermont: Ashgate Publishing Company.

Dagalp, Ileyha, and Benjamin J. Hartmann (2021). "From 'Aesthetic' to Aestheticization: A Multi-Layered Cultural Approach." *Consumption Markets & Culture*, 1–20. doi: 10.1080/10253866.2021.1935900.

Daynes, Sara (2013). "The Social Life of Terroir among Bordeaux Winemakers." In *Wines and Culture*, edited by R. Black and C. Ulin. London: Bloomsbury.

De Jean, J. (2014). "Shops of Gold: Advertising Luxury in Seventeenth-Century Paris." *Luxury* 1, no. 1: 23–46.

Demossier, Marion (2013). "Following Grand Crus: Global Markets, Transnational Histories and Wine." In *Wine and Culture: Vineyard to Glass*, edited by Rachel E. Black and Robert C. Ulin, 183–200. London: Bloomsbury Press.

Demossier, Marion (2018). *Burgundy: The Global Story of Terroir*. New York, Oxford: Bergahn Books.

Dion, Delphine, and Eric Arnould (2011). "Retail Luxury Strategy: Assembling Charisma through Art and Magic." *Journal of Retailing* 87, no. 4: 502–20.

Ellis Miller, Lesley (2017). "Luxury in Europe 1600–1815: Negotiating Narratives 2010–15." *Luxury* 4, no. 2–3: 115–141. doi: 10.1080/20511817.2017.1352221

Ekström, Karin M., and Nicklas Salomonson (2014). "Reuse and Recycling of Clothing and Textiles – A Network Approach." *Journal of Macromarketing* 34, no. 3: 383–399.

Ekström, Karin M. (2020). *Museum Marketization: Cultural Institutions in the Neoliberal Era*. New York: Routledge.

Eraranta, Kirsi, Johanna Moisander, and Visa Penttilä (2020). "Reflections on the Marketization of Art in Contemporary Neoliberal Capitalism." In *Museum Marketization: Cultural Institutions in the Neoliberal Era*, edited by Karin M. Ekström. New York: Routledge.

Featherstone, Mark (2016). "Luxus: A Thanatology of Luxury from Nero to Bataille." *Cultural Politics* 12, no. 1: 66–82.

Featherstone, Mike (2014). "Luxury, Consumer Culture and Sumptuary Dynamics." *Luxury: History, Culture and Consumption* 1, no. 1: 47–69.

Firat, A. Fuat, and Alladi Venkatesh (1995). "Liberatory Postmodernism and the Reenchantment of Consumption." *Journal of Consumer Research* 22, no. 3: 239–67.

Gagnon Thompson, Suzanne, and Michelle A. Barton (1994). "Ecocentric and Anthropocentric Attitudes towards the Environment." *Journal of Environmental Psychology* 14, no. 2: 149–157.

Gladwin, Thomas N., James J. Kennelly, and Tara-Shelomith Krause (1995). "Shifting Paradigms for Sustainable Development: Implications for Management Theory and Research." *The Academy of Management Review* 20, no. 4: 874–907. https://doi.org/10.2307/258959.

Goode, Jaime and Sam Harrop (2011). *Authentic Wine: Toward Natural and Sustainable Winemaking, Berkeley and Los Angeles*. California: University of California Press.

Hagtvedt, Henrik (2020). "Art and Aesthetics." In *Research Handbook on Luxury Branding*, edited by Felicitas Morhart, Keith Wilcox and Sandor Czellar, 171–89. Cheltenham, UK and Northampton, MA: Edward Elgar.

Hartmann, Benjamin, and Katja Brunk (2019). "Nostalgia Marketing and (Re-)enchantment." *International Journal of Research in Marketing* 36, no. 4: 669–686.

Hawkins, Gay (2005). *The Ethics of Waste: How We Relate to Rubbish*. Lanham: Rowman and Littlefield.

Heinich, Nathalie, and Roberta Shapiro (2012). "Qu'est-ce que l'Artification?" In *De l'Artification. Enquêtes sur le Passage à l'Art*, edited by Nathalie Heinich and Roberta Shapiro. Paris: Ehess.

Henninger, Claudia E., Panayiota J. Alevizou, and Caroline J. Oates (2016). "What Is Sustainable Fashion?" *Journal of Fashion Marketing & Management* 20, no. 4: 400–16.

Henninger, Claudia E., Panayiota J. Alevizou, Helen Goworek, and Daniella Ryding, eds. (2017). *Sustainability in Fashion: A Cradle to Upcycle Approach*. Cham, SE: Palgrave Macmillan.

Holbrook, M. and E. Hirschman. "The Experiential Aspects of Consumption: Consumer Fantasies, Feelings, and Fun." *Journal of Consumer Research* 9 (1982): 132–140.

Hudders, L.M. Pandelaere, and P. Vyncke (2013). "Consumer Meaning Making: The Meaning of Luxury Brands in a Democratised Luxury World." *International Journal of Market Research* 55, no. 3: 391–412.

Joy, Annamma, and Camilo Peña (2017). "Sustainability and the Fashion Industry: Conceptualizing Nature and Traceability." In *Sustainability in Fashion: A Cradle to Upcycle Approach*, edited by Claudia Heninger, Panayiota Alevizou, Helen Goworek, and Daniella Ryding, 31–54. Cham, SE: Palgrave Macmillan.

Joy, Annamma, Jeff J. Wang, Tsang-Sing Chan, John F. Sherry, and Geng Cui (2014). "M(Art)Worlds: Consumer Perceptions of How Luxury Brand Stores Become Art Institutions." *Journal of Retailing* 90, no. 3: 347–64.

Joy, Annamma, and John F. Sherry Jr. (2003). "Speaking of Art as Embodied Imagination: A Multisensory Approach to Understanding Aesthetic Experience." *Journal of Consumer Research* 30, no. 2: 259–82.

Joy, Annamma, John F. Sherry, Alladi Venkatesh, Jeff Wang, and Ricky Chan (2012). "Fast Fashion, Sustainability, and the Ethical Appeal of Luxury Brands." *Fashion Theory: The Journal of Dress, Body and Culture* 16, no. 3: 273–96.

Joy, Annamma, Russell W. Belk, Steve Charters, Jeff Jian Feng Wang, and Camilo Peña (2018). "Performance Theory and Consumer Engagement: Wine-Tourism Experiences in South Africa and India." In *Consumer Culture Theory*, Volume 19, edited by Samantha N.N. Cross, Cecilia Ruvalcatu, Alladi Venkatesh, and Russel W. Belk, Emerald Publishing Limited, 163–87. http://www.emeraldinsight.com/doi/10.1108/S0885-211120180000019010.

Joy, Annamma, Russell W. Belk, Jeff J. Wang, and John F. Sherry Jr. (2020). "Emotion and Consumption: Toward a New Understanding of Cultural Collisions Between Hong Kong and PRC Luxury Consumers." *Journal of Consumer Culture* 20, no. 4: 578–97.

Joy, Annamma, Russell W. Belk, Steve Charters, Jeff J. Wang, and Camilo Peña (2018). "Performance Theory and Consumer Engagement: Wine-Tourism Experiences in South Africa and India." In *Consumer Culture Theory (Research in Consumer Behavior)* 19, edited by Samantha N. N. Cross, Cecilia Ruvalcaba, Alladi Venkatesh and Russel W. Belk, 163–87. Bingley: Emerald Publishing.

Kapferer, Jean-Noël (1997). "Managing Luxury Brands." *Journal of Brand Management* 4, no. 4: 251–60.

Kapferer, Jean-Noël (2014). "The Artification of Luxury: From Artisan to Artists." *Business Horizons* 57, no. 3: 371–80.

Kapferer, Jean-Noël, and Anne Michaut (2015). "Luxury and Sustainability: A Common Future?" *Luxury Research Journal* 1, no. 1: 3–17.

Kapferer, Jean-Noël, and Anne Michaut-Denizeau (2014). "Are Luxury Purchasers Really Insensitive to Sustainable Development?" In *Sustainable Luxury*, edited by Miguel Angel Gardetti and Ana Laura Torres, 94–107. London: Greenleaf Publishers.

Kapferer, Jean-Noël, and Vincent Bastien (2009). *The Luxury Strategy: Break the Rules of Marketing to Build Luxury Brands*. London and Philadelphia: Kogan Page.

Keinan, Anat, Sandrine Crener, and Dafna Goor (2020). "Luxury and Environmental Responsibility." In *Research Handbook on Luxury Branding*, edited by Felicitas Morhart, Keith Wilcox and Sandor Czellar, 300–22. Cheltenham, UK, and Northampton, MA: Edward Elgar.

Kent, Sarah (2020). "The Sustainability Gap: Report on How Fashion Measures Up." *Business of Fashion*, London, UK.

Kovesi, Catherine (2015). "What Is Luxury? The Rebirth of a Concept in the Early Modern World." *Luxury* 2, no. 1: 25–40. doi: 10.1080/20511817.2015.11428563.

Kovesi, Catherine (2016). "The Aura of Luxury: Cultivating the Believing Faithful from the Age of Saints to the Age of Luxury Brands." *Luxury* 3, no. 1–2: 105–122. doi: 10.1080/20511817.2016.1232468.

Kozinets, Robert V. (2020). "#Luxe: Influencers, Selfies, and the Marketizing of Morality." In *Research Handbook on Luxury Branding*, edited by Felicitas Morhart, Keith Wilcox, and Sandor Czellar, 282–99. Cheltenham, UK, and Northampton, MA: Edward Elgar.

LaTour, Kathryn A., and John A. Deighton (2019). "Learning to Become a Taste Expert." *Journal of Consumer Research* 46, no. 1: 1–19.

Lezama, Nigel (2019). "Re-Thinking Luxury in the Museum Fashion Exhibition." *Luxury* 6, no. 1: 83–104. doi: 10.1080/20511817.2020.1738708.

MacBride, Samantha (2012). *Recycling Reconsidered: The Present Failure and Future Promise of Environmental Action in the United States*. Cambridge, MA: MIT Press.

Maciel, Andre, and Eileen Fischer (2020). "Collaborative Market Driving: How Peer Firms Can Develop Markets Through Collective Action." *Journal of Marketing* 84, no. 5: 41–59.

Maciel, Andre F., and Melanie Wallendorf (2017). "Taste Engineering: An Extended Consumer Model of Cultural Competence Constitution." *Journal of Consumer Research* 43, no. 5: 726–46.

Madori-Davis, Dominic (2020). "Birkins, Louis Vuitton Trunks and Vintage Chanel: Collecting rare handbags can be a lucrative investment strategy. Check out 5 of the most expensive bags ever sold at auction by Christie's." *Insider*, July 15, 2020.

Martin, Diane, and John Schouten (2011). *Sustainable Marketing*. Boston: Prentice Hall.

Mase, Stefania, and Elena Cedrola (2017). "Louis Vuitton's art-based strategy to communicate exclusivity and prestige." In *Fashion and Communication of Core Strategies of European Luxury Brands*, edited by B. Jin and E. Cedrola, 155-184. Palgrave Macmillan, US. P.

Massi, Marta, and Alex Turrini (2019). *The Artification of Luxury Fashion Brands*. Switzerland: Palgrave MacMillan.

Massi, Marta, and Alex Turrini (2020). "When Fashion Meets Art: The Artification of Luxury Fashion Brands." In *The Artification of Luxury Fashion Brands*, edited by Marta Massi and Alex Turrini, 1–32. London: Palgrave Macmillan.

Matthews, Thomas (2019). "The 1855 Bordeaux Classification." *Wine Spectator*, March 27, 2019. https://www.winespectator.com/articles/the-1855-bordeaux-classification-3491

Mendes, Silvano, and Nick Rees-Roberts (2015). "New French Luxury: Art, Fashion and the Re-Invention of a National Brand." *Luxury* 2, no. 2: 53–69. doi: 10.1080/20511817.2015.1099343.

Mies, Maria, and Vandana Shiva (1993). *Ecofeminism*. Halifax: Fernwood Publications.

Melosi, Martin V. (2005). *Garbage in the Cities: Refuse, Reform, and the Environment*. Pittsburgh: University of Pittsburgh Press.

Morhart, Felicitas, Keith Wilcox, and Sandor Czellar, eds. (2020). *Research Handbook on Luxury Branding*. Cheltenham, UK, and Northampton, MA: Edward Elgar.

Naukkarinen, Ossi (2012). "Variations on Artification." *Contemporary Aesthetics [journal archive]* 0, article 2.

Niinimäki, Kirsi (2017). "Fashion in a Circular Economy." In *Sustainability in Fashion: A Cradle to Upcycle Approach*, edited by Claudia Heninger, Panayiota Alevizou, Helen Goworek and Daniella Ryding, 151–70. Cham, SE: Palgrave Macmillan.

O'Brien, Martin (2008). *A Crisis of Waste? Understanding the Rubbish Society*. New York and London: Routledge.

Oldenziel, Ruth, and Heike Weber (2013). "Introduction: Reconsidering Recycling." *Contemporary European History* 22, no. 3: 347–70.

Ozdamar E., Zeynep, Denis Atik, and Jeff B. Murray (2020). "The Logic of Sustainability: Institutional Transformation Towards a New Culture of Fashion." *Journal of Marketing Management* 36, no. 15–16: 1447–1480.

Palermo, Lynn E. (2014). "The 1925 Paris Exposition des Arts Décoratifs et Industriels Modernes and Le Pavillon de L'Esprit Nouveau: Le Corbusier's Manifesto for Modern Man." *Modern Languages Faculty Publications* 1.

Pellow, David N. (2002). *Garbage Wars: The Struggle for Environmental Justice in Chicago.* Cambridge, MA: MIT Press.

Pellow, David N. (2007). *Resisting Global Toxics: Transnational Movements for Environmental Justice.* Cambridge, MA: MIT Press.

Pena, Camilo (2021). *Expanding Conceptualizations of sustainability through Artification, Sensoriality and Ideology: The Case of the Okanagan Valley Wine Industry* [Draft version of doctoral thesis].

Pine, B. Joseph, and James H. Gilmore (1998). "Welcome to the Experience Economy." *Harvard Business Review* 76: 96–105.

Rambourg, Erwan (2020). *Future Luxe.* Vancouver: Figure 1 Publishing.

Riot, Elen, Cecile Chamaret, and Emmanuelle Rigaud (2013). "Murakami on the Bag: Louis Vuitton and De-commoditization Strategy." *International Journal of Retail and Distribution Management* 41, no. 11/12: 919–939.

Robert-Demontrond, Philippe (2009). "Le Label Kasher: Perspectives sur la Dynamique Commerciale d'un Système de Traçabilité de Produits Sain(t)s." *Décisions Marketing*, no. Janvier 53: 19–29.

Roberts, Joanne (2019). "Is Contemporary Luxury Morally Acceptable? A Question for the Super-Rich." *Cultural Politics* 15, no. 1: 48–63.

Roberts, Joanne, and John Armitage, eds. (2020). *The Third Realm of Luxury.* London, New York: Bloomsbury Visual Arts.

Roberts, Joanne, and John Armitage (2020). "The Third Realm of Luxury: Conceptualizing the Connections Between Real Places and Imaginary Spaces." In *The Third Realm of Luxury*, edited by Joanne Roberts and John Armitage, 1–24. London, New York: Bloomsbury Visual Arts.

Rozin, Paul, Linda Millman, and Carol Nemeroff (1986). "Operation of the Laws of Sympathetic Magic in Disgust and Other Domains." *Journal of Personality and Social Psychology* 50, no. 4: 703–12.

Sassatelli, Monica (2002). "An Interview with Jean Baudrillard: Europe, Globalization and the Destiny of Culture." *European Journal of Social Theory* 5, no. 4: 521–30.

Schouten, John W., and James H. McAlexander (1995). "Subcultures of Consumption: An Ethnography of the New Bikers." *Journal of Consumer Research* 22, no. 1: 43–56.

Schroeder, Jonathan (2005). "The Artist and the Brand." *European Journal of Marketing* 39, no. 11/12: 1291–305.

Shapiro, Roberta (2004). "The Aesthetics of Institutionalization: Breakdancing in France." *The Journal of Arts Management Law and Society* 33, no. 4: 316–35.

Shapiro, Roberta (2019). "Artification as Process." *Cultural Sociology* 13, no. 3: 265–75.

Shapiro, Roberta, and Nathalie Heinich (2012). "When is Artification?" *Contemporary Aesthetics* Special Volume 4. https://quod.lib.umich.edu/c/ca/7523862.spec.409/–when-is-artification?rgn=main;view=fulltext.

Smith-Maguire, Jennifer (2018). "Taste as Market Practice: The Example of Natural Wine." *Consumer Culture Theory* 19: 71–92.

Soper, Kate (1995). *What Is Nature?* Cambridge, MA: Blackwell Publishers Inc.

Steele, Valerie (1997). *Fifty Years of Fashion*. New Look Now: Yale University Press.

Strang, V. (2014). "Lording It over the Goddess: Water, Gender, and Human-Environmental." *Journal of Feminist Studies in Religion* 30, no. 1 (Spring): 85–109.

Subramiam, Guhan, Julian Zlatev, and Raseem Farrok (2021). "LVMH's Bid For Tiffany and Co.," *Harvard Business Review*, N9-921-049, March 22, 2021.

Tavinor, Marie (2019). "Recycling Luxury: An Introduction." *Luxury* 6, no. 2: 139–43. doi: 10.1080/20511817.2020.1818947.

Trench, Lucy (2017). "Introducing the Enlightenment: The Salon." *Luxury* 4, no. 2–3: 223–236. doi: 10.1080/20511817.2017.1352222.

Thompson, Craig, and Gokcen Coskuner-Balli (2007). "Countervailing Market Responses to Corporate Co-optation and the Ideological Recruitment of Consumption Communities." *Journal of Consumer Research* 34, no. 2: 135–52.

Thompson, Michael (1979). *Rubbish Theory: The Creation and Destruction of Value*. Oxford: Oxford University Press.

Tsakiridou, Efthimia, Konstadinos Mattas, Helen Tsakiridou, and Tsiamparli Elisavet (2011). "Purchasing Fresh Produce on the Basis of Food Safety, Origin and Traceability Labels." *Journal of Food Products Marketing* 17, no. 2/3: 211–26.

Ulin, Robert C. (2013). "Terroir and Locality: An Anthropological Perspective." In *Wine and Culture*, edited by Rachel Black and Robert C. Ulin, 67–84. London: Bloomsbury.

Ulver, Sofia (2019). "From Mundane to Socially Significant Consumption: An Analysis of How Foodie Identity Work Spurs Market Formation." *Journal of Micromarketing* 39, no. 1: 53–70.

Venkatesh, Alladi, and Laurie Meamber (2006). "Arts and Aesthetics: Marketing and Cultural Production." *Marketing Theory* 6, no. 1: 11–39.

Visconti, Luca M. (2020). "Communicating Luxury Brands Through Stories." In *Research Handbook on Luxury Branding*, edited by Felicitas Morhart, Keith Wilcox and Sandor Czellar, 225–47. Cheltenham, UK, and Northampton, MA: Edward Elgar.

Visconti, Luca M., John F. Sherry Jr., Stefania Borghini, and Laurel Anderson (2010). "Street Art, Sweet Art: Reclaiming the Public in Public Place." *Journal of Consumer Research* 37, no. 3: 511–529.

Wang, Jeff J., Annamma Joy, Russell Belk, and John F. Sherry Jr. (2019). "One Country, Two Systems: Consumer Acculturation of Locals in Hong Kong." *European Journal of Marketing* 54, no. 1: 1–25.

Warren, K.J. (ed.) (1994). *Ecological Feminism: Environmental Philosophy*. London: Routledge.

Weber, Heike (2013). "Reconsidering Recycling." *Contemporary European History* 22, no. 3: 347–70.

Wierzba, Leanne (2015). "What Is Luxury?: Curating Connections between the Hand-Crafted and Global Industry." *Luxury* 2, no. 1: 9–23.

Wild, Benjamin (2019). "Liminal Luxury: Establishing the Value of Fancy Dress Costume." *Luxury* 6, no. 2: 179–187. doi: 10.1080/20511817.2020.1818948.

Williams, R.H. (1982). *Dream World: Mass Consumption in Late Nineteenth-Century France*. Oxford: University of California Press.

Winston, Andrew (2016). "Luxury Brands Can No Longer Ignore Sustainability." *Harvard Business Review*, February 8. 2016. https://hbr.org/2016/02/luxury-brands-can-no-longer-ignore-sustainability.

Yeung, Peter, and Liz Thach (2019). *Luxury Wine Marketing*. Oxford: Infinite Ideas.

Websites Consulted

https://www.bordeaux.com/us/Our-Terroir/Classifications (last accessed August 4, 2021).

https://www.businessinsider.com/most-expensive-handbags-ever-auctioned-christies-hermes-birkin-chanel-2020-7#the-most-expensive-bag-of-any-brand-ever-auctioned-at-christies-was-unsurprisingly-a-birkin-that-went-for-384285-5 (last accessed August 4, 2021).

https://www.collectorsquare.com/en/bags/hermes/kelly/ (last accessed August 4, 2021).

https://www.diamonds.net/News/NewsItem.aspx?ArticleID=66130&ArticleTitle=Kering+Invests+in+Secondhand+Luxury+Site (last accessed August 4, 2021).

https://www.economist.com/business/2019/06/20/the-western-worlds-auction-house-duopoly-is-now-in-private-hands (last accessed August 4, 2021).

https://www.eileenfisherrenew.com/p/eileen-fisher-organic-linen-delave-pullover-womens/Yplvr-Z27Y5pu-1?color=green (last accessed August 4, 2021).

https://ellenmacarthurfoundation.org/

https://www.ellenmacarthurfoundation.org/our-work/activities/make-fashion-circular (last accessed August 4, 2021).

https://www.etymonline.com/word/luxury (last accessed August 4, 2021).

https://www.forbes.com/sites/oliviapinnock/2018/07/20/no-one-in-fashion-is-surprised-burberry-burnt-28-million-of-stock/?sh=38fa53a74793 (last accessed August 4, 2021).

https://www.google.com/search?rls=en&sxsrf=ALeKk01Fkfcw8qGz7oyGgL171W8l_X_9KQ:1627084822858&source=univ&tbm=isch&q=grace+kelly+with+hermes+kelly+bag&client=safari&sa=X&ved=2ahUKEwi90oqns_rxAhVWnJ4KHV3qC6QQjJkEegQIBhAC&biw=1033&bih=799 (last accessed August 4, 2021).

https://www.hrw.org/report/2018/02/08/hidden-cost-jewelry/human-rights-supply-chains-and-responsibility-jewelry (last accessed August 4, 2021).

https://www.kering.com/en/finance/about-kering/ (last accessed August 4, 2021).

https://www.nytimes.com/2018/09/06/business/burberry-burning-unsold-stock.html (last accessed August 4, 2021).

https://www.rebag.com/thevault/louis-vuitton-101-takashi-murakamis-monogram-multicolor-collection/ (last accessed August 4, 2021).

https://www.researchgate.net/publication/275010799_Theorizing_Firm_Adoption_of_Sustaincentrism (last accessed August 4, 2021).

https://www.thredup.com/resale/#size-and-impact (last accessed August 4, 2021).

https://www.timeout.com/tokyo/news/artist-takashi-murakami-has-added-a-10m-tall-golden-statue-to-roppongi-hills-112720 (last accessed August 4, 2021).

https://www.treehugger.com/stella-mccartney-urges-world-leaders-fashion-sustainability-5189397 (last accessed August 4, 2021).

https://tressiemc.com/uncategorized/the-logic-of-stupid-poor-people/ (last accessed August 4, 2021).

https://www.washingtonpost.com/archive/politics/1983/07/03/the-critique/32064a44-add8-4ea1-8564-3c7eb09e79cb/ (last accessed August 4, 2021).

https://www.winespectator.com/articles/the-1855-bordeaux-classification-3491 (last accessed August 4, 2021).

https://www.worldbank.org/en/news/feature/2019/09/23/costo-moda-medio-ambiente (last accessed August 4, 2021).

https://yaleclimateconnections.org/2008/11/jimmy-carters-solar-panels/ (last accessed August 4, 2021).

Part 1: **Luxury in the Time of Covid-19**

Russell W. Belk

Chapter 2
Luxury Consumption and Covid-19

How do people consume in the aftermath of a cataclysmic event and what does this suggest for luxury consumption after Covid-19? In this chapter, I begin with a brief consideration of what happened during and after past cataclysms such as the 1918 Spanish Flu epidemic, the Great Depression, the two World Wars, and the Cold War. I then examine the pattern of luxury consumption during the Covid-19 pandemic as well as some new trends that have emerged due to the pandemic. Because much luxury consumption is tied to travel and tourism, the trends affecting these related industries are also discussed. Aggregate sales figures for luxury goods and services tell only part of the tale because the nature of this consumption (e.g., its conspicuousness, visibility, and ephemerality) also needs to be considered. One such change in what constitutes luxury during the pandemic has been the emergence of *digital collectables*. After unpacking trends in the nature of luxury consumption, I conclude with a discussion of the macro effects of emerging luxury consumption patterns on society.

Past Cataclysms and Luxury Consumption

One possibility is that in the aftermath of a period of deadly war, disease, famine, or other disaster is that survivors, feeling lucky to be alive, mourning the death of loved ones, and perhaps feeling a little guilty to be the ones who lived, will feel contrite in their demeanor and modest in their consumption, especially in those expenditures that might be seen as self-indulgent. Based on this line of thinking, post-cataclysm luxury spending should be rare in occurrence and inconspicuous in nature, at least until things get back to some sort of normal. Habits of frugality practiced during the cataclysm may also become life-long patterns of behavior. This is the pattern that seems to have occurred among many who survived the Great Depression (Schewe, Meredith, and Noble 2000; Witkowski 2010). In an oral history, one woman who grew up during the Depression recalled:

> It was really hard. We didn't even have money to half sole our shoes, and I wore Corn Flake boxes, cardboard in my soles for shoes. . . . I'm an organized pack rat. Well, when you went through a big Depression like that, you save everything, and when you learn that in childhood, it goes right with you, you know. (Dorfman, Méndez, and Osterhaus 2009: p. 308)

Similar patterns of learned frugality and caution following lean times have been found in Japan (Smith 2001) and China (Zanasi 2015). None of these situations seems conducive to luxury consumption.

https://doi.org/10.1515/9783110732757-002

Following the struggle of the 1930s Depression, World War II led to rationing, calls for "Victory Gardens" for self-sufficiency, and drives for donations of scrap metal to help the war effort (Fishman and McKee 2015; Jones 2009; Witkowski 2010). Even nylon stockings became an unavailable luxury, as nylon was needed for parachutes. Women instead would draw lines up the backs of their legs to imitate the seams that characterized nylons of the time. However, the curtailment of luxuries in this period was for a cause (winning the war) and promised that the resulting feelings of deservedness from often-voluntary sacrifices, not to mention the sacrifices of the men who became soldiers, would lead to a better life after the war. Besides feelings of deservedness, the sacrifices of those who participated in the war, at home as well as abroad, resulted in a generation marked by their shared experience of wartime.

Generational cohorts with shared collective memories of such life-defining events form a useful basis for market segmentation (Schewe, Meredith, and Noble 2000). It seems certain that Covid-19 will be the defining event for those growing up in the current era (Herstatt and Tiwari 2020) and that frugality may be an outcome for those in precarious positions who have lost jobs or suffered reduced employment. For those of us who are more fortunate, staying home and learning to work from home may have largely curtailed our need for new wardrobes, restaurant meals, global travel, hotel stays, annual conferences, and large gatherings in general. Instead, we have nested at home with new electronics, furnishings, gardens, various exercise equipment, and, where possible, upgraded indoor and outdoor home spaces and furnishings. These are the new luxury expenditures for those of us confined to suburban homes. They are inward-directed rather than outward-directed, for the most part, and they are subsidized by the savings from not having to go to the office or school and, for some, government stimulus checks.

An opposite response to learned frugality and resistance to what is perceived as wasteful luxury consumption is that survivors may feel that they have suffered enough and now is the time to make up for it with an orgy of luxury consumption and self-indulgence. People may feel triumphant in their survival and ready to celebrate. Long-delayed plans for travel and tourism can be realized. Planned purchases put off in an abundance of caution can now be carried out. And ostentation that was scrupulously avoided so as not to antagonize those less fortunate can now be paraded for all to see. This is the pattern apparently followed by many who survived the devastation of World War I and the Spanish Flu pandemic of 1918 that immediately followed (McNeese 2010). Their behavior and the buoyant economy led to the decade of "The Roaring Twenties." Some people predict that a similar pattern could now repeat itself, 100 years later (Terzi 2021). But perhaps this time there will be less roaring and more purring. We see some indication of this in the housing boom emerging from Covid-19. It promises inward satisfaction at home rather than outward exuberance.

In the US housing boom of the 1950s, a certain vision of consumption was seen as compensatory for the sacrifices made during World War II. Many saw a house in the

suburbs as the realization of "The American Dream" (Bennett 1996; Humes 2006; Owens 1973/1999). For the largely white American upper middle class, luxury meant a home in a nicer suburb and membership in an exclusive country club, while for the lower middle classes who aspired to any sort of suburban living, luxury often meant "Populuxe" (Hine 1986), a version of faux luxury thanks to plastics, technology, marketing, and color fashions. Another status symbol was an American-made automobile with fins imitating those of an imagined jet plane or rocket (McCracken 2005). It was a period of exuberant growth in North America, Western Europe, and much of Asia (except China).

The Cold War pitted capitalism against communism and, in 1959, the battle was symbolized in the so-called "kitchen wars" in which Soviet Premier Nikita Khrushchev and American Vice President Richard Nixon debated which country had the best consumer lifestyle as articulated by Nixon via luxury kitchen appliances (Marling 1994; Oldenziel and Zachmann 2009). The Soviet Union had its own versions of luxury goods (Gronow 2003), but ultimately they could not compete with blue jeans, rock and roll, and Western cosmetics (Drakulić 1991).

The Covid Cohort and Luxury Consumption

So, what sort of luxury consumption patterns are emerging as the post-Covid-19 world begins? We should start by noting that the sorts of changes in consumption and luxury expenditures brought about by the pandemic are not likely to be a repeat of either the Roaring Twenties (Burdekin 2020; Terzi 2021) or the 1950s (Docherty 2020). The conditions of the world and the nature of the cataclysms we face have both changed. Briefly, in both World Wars there were clearly opposed sides and definitive beginnings and ends of the conflicts. The Great Depression had a marked beginning with the stock market crash of 1929 but it was not until World War II that the US economy began to recover. Rationing for World War II was not ended until 1954 in the UK. The recovery from the financial collapse of 2008 and the strength of stock markets during Covid-19 (after a brief initial collapse) suggest that the world economy is already surging and is set to grow rapidly once the pandemic subsides.

Impacts of Covid-19

The industries affected in the Covid collapse of the 2020s are different from those impacted by Spanish Flu and World War I. Aviation, the Internet, computer electronics, television, and indoor shopping malls did not exist in 1918. Amazon, Netflix, Apple, Microsoft, Google, Facebook, Alibaba, Baidu, Walmart, Starbucks, and many other

giant corporations of the 2000s did not exist in the 1950s. During the 20th century, the affluent world moved from agricultural economies to manufacturing economies to service economies. During the last half of the century, production was increasingly outsourced to the developing world. Although early reports of the impact of Covid-19 looked at the hit that services such as air travel, hospitality, restaurants, and tourism were taking and declared that, "For luxury as a whole, the current picture is bleak" (Beauloye 2021), this judgment was premature at best. As Figure 2.1 (from Standard and Poor's Global Luxury Index of 80 top publicly traded luxury brands) shows, the luxury business has never been better. While some of this may be due to a shift back from services to products in luxury expenditures, it seems clear that reports of the death of luxury were greatly exaggerated based on a temporary dip. But the nature of our luxuries also appears to be changing.

Figure 2.1: S&P Global Luxury Index.

In pre-Covid days there was a considerable amount of evidence that preferred luxuries in the affluent world were shifting from possessions to experiences (e.g., Carter and Gilovich 2010, 2012; Gilovich and Kumar 2015; Kumar and Gilovich 2015; Kumar, Killingsworth, and Gilovich 2014, 2020; Van Boven and Gilovich 2003). Several explanations were given, and *Forbes* was especially active in offering personal and marketing implications (Bradberry 2016; Kercher 2017; Morgan 2019; Nobel 2013; Pozin 2016). One explanation is that we get accustomed to or tired of our possessions, but not of recounting our past experiences, which we may remember with increasing fondness. The initial thrill of buying something fades quickly (Belk, Ger, and Askegaard 2003). To retain some of that initial thrill without its less satisfying aftermath involving the burdens of ownership, we can temporarily rent the thing rather than buy it, whether it is an Uber limo ride, a high-end rented gown, or a vacation condo (Belk 2014). We can also tell stories about experiences. They become part of our identity. We are also more apt to engage in experiences with other people. And we can also have the experience of buying a luxurious gift to give to someone else.

Another factor explaining the greater impact of experiences versus goods is that goods foster envy from and competition with others. Perhaps telling about

travel experiences may also provoke envy, but the travel experience is not sitting in your driveway fostering comparison. Even if it were, how does someone top your experience of sunrise on the vernal equinox at Chichén Itzá? Evidence suggests that Millennials tend to be less attached to material goods, more likely to do short-term rental of things when they are needed, and more apt in housing to trade off space for greater downtown access to experiences like sporting events, entertainment, and downtown restaurants (Kercher 2017; Morgan 2019). At least before Covid-19.

Enter Covid-19 shutdowns, lockdowns, quarantines, and work from home transformations. As the four walls closed in, the restaurants, bars, sports events, theaters, bars, and music venues all closed, as air travel was curtailed, hotels and apartment elevators, Airbnbs, and public transit looked like hotbeds of the virus. Suddenly a home in the suburbs began to look a lot more attractive. The trouble is that thousands of others had the same thoughts of fleeing to the country, making that place in the country less and less affordable. At the same time, with renters, owners, and businesses and offices leaving the city, rental prices there dropped. You're trapped in a city that once seemed like paradise but is now closed for business. Your friends can't come over and you can't go to their place or meet somewhere either. Sartre's lament that "Hell is other people" seems to have been turned on its head so that now "Hell is *no* other people."

Moving On

Someday, when enough people have been vaccinated, herd immunity has been achieved, and science has overcome the variants and mutations of Covid-19, we will once again be free to roam as we will and resume old habits. But will we? Foreign travel, the downtown office, business meetings, conferences, shopping at brick-and-mortar stores, living in dorms with roommates, the bar scene, and massive sports and entertainment events may have lost some of their luster. In light of habits and lessons learned, it may not be easy to give up masks and face coverings. Marketers of luxuries are aware of these possibilities and are also striving to improve their offerings in response. This includes customer experience in acquiring luxury goods.

Luxury Retailing

In part because of the luxury store experience with its magical ambiance (Dion and Arnould 2011; Joy et al. 2014) and attentive and deferential personnel (Dion and Borraz 2017), it has been difficult to sell luxury goods online (Schüller, Dietrich, and Spielmann 2018). But this has changed thanks in large part to Covid-19 (Beauloye 2021). Luxury companies now have online stores, but they have not abandoned face-to-face sales. Besides luxury products they have also begun to offer luxury experiences in

branded hotels, restaurants, museums, cruises, and resorts (Achille and Zipser 2020). There are sponsored museum exhibits of luxury brands (Joy et al. 2014) as well as museums devoted to the luxury brand itself (Carù, Ostillo, and Leone 2017; Conlon and Jolliffe 2017; Jung and Yim 2018; Puhl, Mencarelli, and Chaney 2019). The list of luxury brand museums is long and includes Louis Vuitton, Prada, Gucci, Hermès, Ferragamo, Rolls Royce, Lamborghini, Ferrari, and many more. It is getting to the point that *not* having a museum devoted to the brand is to suggest that the brand is not worth pilgrimage and worship. Luxury retailers have also begun to prepare for the time when borders reopen to international travel and they can once more be destination attractions (Czyzewska 2020).

International travel is especially important for the growing ranks of Chinese luxury consumers who buy abroad to avoid paying high taxes in China, as well as to feel assured that they are not buying counterfeit goods. Counterfeits are common in China and even an apparent brand store may not be selling the real thing (Lin 2011). The sale of fake and knock-off luxury goods is not confined to China and is also prevalent in Europe and other global locations (Craciun 2014). The Internet has also made the sale of inauthentic luxury goods a global phenomenon. Sometimes it is clear that the items being sold are inauthentic, but sometimes it is not.

Luxury retailers have also started to pursue the short-term rental market that started without their participation (Rosenbaum 2020). While these renters can sometimes be local "clothing libraries" where members can check out fashion outfits (e.g., Albinsson and Perera 2018), they are often global online short-term renters of luxury gowns, handbags, jewelry, and other clothing and accessories (Radwan, Patsiaouras, and Saren 2019). Ventures like Rent the Runway, Bag Borrow and Steal, and My List at Bloomingdale's make such items available to consumers on both a one-time and subscription basis. Like automobile makers who have turned to short-term rental in urban areas to compete against independent firms like Zipcar (Bardhi and Eckhardt 2012), luxury fashion goods makers have decided that if consumers are going to rent rather than buy, they may as well get some of this revenue themselves. Selling an item may be less lucrative than renting it many times and at the same time avoiding the overhead of a brick-and-mortar store. Nevertheless, Covid-19 was not good for fashion. One appraisal (Silvan 2021) begins:

> The pandemic may have done wonders for purveyors of puzzles, puppies, and frozen pizza, but it's been no friend to fashion. Stay-at-home orders have reacquainted everyone with the comforts of casual dressing (goodbye power suit, hello track suit).

WFH (work from home) is likely to continue for some people, but the luxury rental business is less about everyday-wear than special-occasion-wear in any case. As being able to celebrate special occasions with others increases, so should the market for short-term rental of luxury-wear.

Digital Luxuries

Besides changes in the way luxury goods are delivered, the nature of luxury goods has also expanded. With luxury goods buyers confined to their homes and with both more time and money on their hands, luxury goods marketers have also begun to find new things for these consumers to collect and spend their money on. As they sought to offer more things to collect and as they became comfortable with the reality of digital and virtual goods, companies have found ways to create transferrable ownership of digital objects (Mardon and Belk 2018). Digital ownership of virtual goods began in gaming and virtual worlds where spending virtual currency in online games to purchase virtual clothes, weapons, and looks ("skins") for avatars was paid for with real currency converted into game currencies like Linden dollars in the virtual world of Second Life (Molesworth and Denegri-Knott 2012).

Recently the use of blockchain technology has expanded the ability to own luxury goods and digital goods through NFTs (Non-Fungible Tokens). With NFTs (or "nifties") the ideas of ownership, authenticity, scarcity, and property are all potentially revised and revolutionized. Walter Benjamin (1955/1968) worried about the loss of "aura" and the fate of the original object in an era of mechanical reproduction. In the era of digital reproduction, digital copies of art, books, music, television shows, films, letters, and greeting cards have all become infinitely reproducible as perfect copies of the original. For a time, digital rights management (DRM) made it possible to assert intellectual property rights (IPR) over such goods. But DRM as an assertion of IPR first gave way to inexpensive short-term rental and then to subscription access without ownership, and now to the tokenization (Asadi 2021), assetization (Birch and Muniesa 2020), or commodification (Belk 2020a) of luxury goods. Blockchain-backed digital ownership promises a new way of protecting property, aura, and authenticity, as we will see.

Property ownership is normally considered to comprise a bundle of rights as Alt et al. (2016) detail:

- The right to exclusive possession
- The right to exclusive use and enclosure
- The right to transfer ownership (conveyance)
- The right to use as collateral to secure a debt (hypothecation)
- The right to subdivide (partition)

These rights can be modified and can differ over cultures and political systems of capitalism, socialism, and communism. But basically they stipulate that if you own something you can do what you want with it. Perfectly fungible commodities like money are indistinguishable (one coin or bill is the same as another of the same denomination), interchangeable, and impersonal. The moment one coin begins to be valued more than others of the same denomination it ceases to be money and becomes non-fungible property. At that point, a history of object ownership or provenance may become

important. The way that digital currencies like Bitcoin have succeeded is through blockchain digital ledgers that make it possible to offer full property rights as well as fungibility and a traceable provenance. A fixed limit exists on the number of Bitcoins that will ever be produced, and this promised scarcity enhances their value as an investment.

A key feature that ordinarily increases the value of an object is its scarcity. The attractiveness of luxury goods is usually partly due to their scarcity. If they were easy to acquire, they would not be valuable because everyone could have them; they would be "cheap as dirt." Moreover, my possession and use of such an abundant thing does not preclude others from using it. I can sing a song, watch a TV show, or drink a Coke, and so can millions of other people. Economists call such a good *non-rivalrous* because my consumption of such a good does not normally reduce the opportunity for others to do so as well. It is when the object is scarce or rare and is deemed desirable that it can become valuable – original artworks by famous artists, good seats at a popular concert or sports event, or Bugatti automobiles, for example. These goods are *rivalrous*; they are valuable and expensive. There are also goods we can call *anti-rivalrous* – the more people who access them, the more valuable they become. In academia we have citation indices that count the number of times people refer to and cite or quote from a particular article, chapter, or book by a certain author; or the number of followers of a blogger; or the number of sales, downloads, or listens to a particular book, song, or podcast. These things define an alternative "inverted" status system that is not dependent on rarity or exclusive ownership. But best sellers are not usually luxury goods. Furthermore, while the author, blogger, singer, or podcaster gains status from greater use of their work, those who use, quote, follow, or play their work do not gain status from doing so. It is not rare and is not a status symbol.

Signaling status within a social status system depends on others valuing the item you regard as a status symbol. That value is normally represented by a monetary value. But there can be alternative status systems with alternative status symbols and alternative systems of value. One alternative status system is that of *coolness*. Coolness is an attitude of unflappable indifference that not everyone can convey successfully (Belk, Tian, and Paavola 2010). The successfully cool person can anoint an object of clothing, an accessory, or a certain source of consumer goods with coolness, not because these objects have certain cool characteristics but because this person's cool persona "rubs off" on them. The rarity or exclusivity here is in being able to pull off this object-aided status bluff (Belk and Sobh 2019; Newell 2012) successfully. When this is achieved, the cool person is like a Midas who creates value through the objects he or she touches. These objects can both be tangible as well as intangible digital goods (e.g., music preferred, movies liked, or tweets retweeted).

The trouble with digital goods from the point of view of those creating them is that even though great amounts of time, effort, or genius may have gone into creating them, once they are released into the digital world they can be freely copied

and distributed. With digital goods it is nevertheless possible to generate artificial scarcity through pop-up availability, limited time offers, and fixed supplies, and by making them alienable and able to be transferred from one person to another (Mardon and Belk 2018). Nevertheless, these digital goods may not be portable from one platform to another. This is a problem that nifties overcome.

It has traditionally been money, titles, and/or property assets that defined aristocracy. To the degree that these assets were potentially saleable, this can be thought of as a *wealth aristocracy*. In an artificial digital scarcity economy, there may be a *time aristocracy* in which those with the most available time to look for scarce objects that are briefly and unexpectedly available are able to acquire such rarities and the status that comes along with them (Lehdonvirta, Wilska, and Johnson 2009). But here too these assets may be sold, thereby reverting ultimately to a wealth aristocracy.

Another example of overcoming the seeming lack of profit or status potential with otherwise non-rivalrous digital artwork is the tradeable blockchain assets in the "Rare AF" exhibition in 2017 (O'Dwyer 2020; Penny 2018). By taking infinitely copyable images and short videos like "cryptokitties" and "cryptopunks" from the Internet and recording them on the Ethereum crypto blockchain, they became digital assets, some of which were traded for thousands of dollars (see Figure 2.2). They are still infinitely reproducible, but the original NFT remains the only one which is valued due to its singular scarcity. Nifties further demonstrated their potential luxury value when one collage of images from the Internet by the artist known as Beeples sold for nearly USD $70 million. While these values have since fallen, like cryptocurrencies they are likely to rise again. What this development lays bare is that in turning objects that are freely available into artificially scarce objects, there is a certain similarity to the Pop Art's appropriation of consumer branded goods (Mamiya 1992) and the appropriation of non-branded everyday objects by artists like Damien Hirst and Jeff Koons (Thompson 2008, 2017). That much is not new. But cryptoart has opened the door to scarcity without exclusion. Wark (2017) comments that "The future of collecting may be less in owning the thing that nobody else has, and more on owning things that everybody else has."

While NFTs can create artificial scarcities for digital artworks, they can also create a market for collectors who could not otherwise afford to be a part of the traditional high art world where prices are prohibitive (Belk 2020b). This can happen by *fractionalizing* the value of the artwork. For example, the company Maecenas bought Andy Warhol's *14 Electric Chairs*, divided into shares, and sold about a third of the artwork for a total of $14 million (Adam 2018; Whitaker 2019). And in a variation of this, artists may potentially retain a portion of the ownership their artwork so they may participate in and benefit from the escalation in value of their work. This may help address an issue that came to public attention in the 1973 Scull auction at Sotheby Parke Bernet which was captured in a 72-minute documentary film (Kirschenbaum 1979). In the film there is a discussion between the collector Robert Scull and

TOP COLLECTIONS

COLLECTION	▼ VOLUME	▼ TRADERS	▼ SALES
1 CryptoPunks ♦ ETH	$2.41M -52.95%	53 -3.64%	30 -18.92%
2 NBA Top Shot ⊘ FLOW	$1.63M -18.76%	16,516 -35.97%	22,937 -39.48%
3 Rarible ♦ ETH	$943.12k 48.22%	726 -5.35%	615 7.71%
4 Sorare ♦ ETH	$380.63k 7.56%	1,713 3.63%	1,952 2.09%
5 Decentraland ♦ ETH	$273.55k -22.14%	25 -26.47%	22 -12.00%

Figure 2.2: DappRadar Values April 28, 2021.

the Artist Robert Rauchenberg whose painting *Double Feature,* purchased by Scull for USD $2,500 in 1959, had just sold for USD $90,000:

> Rauchenberg: "I've been working my ass off for you to make that profit."
>
> Scull: "I've been working for you too. We work for each other."

It may well have been that each ultimately enriched the other, but the distribution of rewards in the sale was quite unequal. NFT technology may improve this balance, but it also reduces the high-end art market to money and investment considerations and ignores other functions of luxury consumption, including helping the collector enjoy their collection aesthetically and gaining status among peers.

If this net worth status system were to prevail, the subtle taste differences that mark a cultural capital system of status (Bourdieu 1979/1984) may be disappearing. We may be entering a new era of digital robber barons in which Bill Gates, Jeff Bezos, Mark Zuckerberg, Jack Dorsey, Elon Musk, Jack Ma, Robin Li, Larry Page, Sergy Brin, Steve Jobs, Steve Wozniak, and Tim Cook are new elite. They each have found ways to create huge wealth from digital goods and services. No one particularly cares about their educations, backgrounds, or tastes in consumption. It is their wealth, financial success, and creative genius that has brought them status and fame. And it is their creator genius and success rather than their displays of wealth that are the most sought-after indicators of status by the many who admire them. It is in this sense a shift back to heroes of production rather than heroes of consumption or heroes of self-promotion (self-created celebrities) who have previously been our idols (Duffy and Pooley 2019; Lowenthal 1944).

The Visible and the Invisible in Luxury Consumption

The eras of the robber barons when Veblen (1899) wrote, the pre-Depression status pursuit captured by Fitzgerald (1925) and Dos Passos (1936), and the later scrambles for money captured in books like *Bonfire of the Vanities* and films like *Wall Street*, were all eras of conspicuous luxury consumption. Even before Covid-19 there were counter-movements toward inconspicuous luxury consumption (Berger and Ward 2010; Eckhardt, Belk, and Wilson 2015). There are various reasons for this counter-trend, including not wanting to provoke others' envy and anger during bad times or times of growing income disparity which were common during Covid-19. Those who prefer inconspicuous consumption may be indulging in the self-reward of private luxury, communicating to a small group of the cognoscenti, and/or choosing not to call government attention to unreported wealth. It is also often the case that "little luxuries" like time to oneself are more appreciated than socially visible luxury (Bauer, von Wallpach, and Hemetsberger 2011; Belk 2020b; Hemetsberger, von Wallpach, and Bauer 2012; Holmqvist et al. 2020; von Wallpach et al. 2020). But there is also a more other-directed desire to communicate status horizontally to others of similar social class rather than vertically to those above and below. The idea is that those you want to know about your status and taste will be able to discern the more subtle status cues, while those whose envy you don't want to provoke will not.

A similar veiling of high-status consumption may go on by enclosure within the gated communities that are gaining popularity throughout the world (Belk 2017; Low 2004). The premise of gated communities, whether houses, condominiums, or high-rise apartments, is to leverage income by sharing the cost of luxury facilities like swimming pools, parks, and golf courses with other residents. Besides providing security, the gates and security guards prevent the gaze of others who do not belong to the community. Nevertheless, the result may be envy and resentment by those who are not allowed access. There is a status statement implicit in merely being able to afford membership within the gates (Chaudhury and Jagdale 2021). Escape within luxury estates, ranches, and yachts provide their own privacy from the eyes of others. And within the sharing economy, access to such properties may be rented rather than owned. Location is still important, but space is gaining in prominence.

One effect of being cooped up at home during Covid-19 has been to create a desire to leave the confines of small apartments in closed-down cities for the suburbs and exurbs where there are affordable homes with larger spaces both indoors and outdoors (Belk 2020c). With the increase in WFH (work from home) possibilities, home spaces became more important and commuting distances became less important or irrelevant. Avoiding elevators and public transportation was another motive for urban exodus (Whitaker 2021). This caused a shift in luxury signs. Appetites for luxury homes were also whetted by what has been called "property porn" – reality television shows about the homes of the rich and famous (Doyle 2020; see

also Klein and Leckart 2015). While the luxuries of the homes shown might not normally have been visible, clearly television broadcasts have displayed their riches for all to see. These broadcasts act a bit like the "haul videos" of YouTube bloggers who proudly display the clothing and accessories they acquired on their latest shopping trip (Harnish and Bridges 2016).

Less visible, but more luxurious, are the experiential consumption activities of those allowed "behind the velvet rope" (Schwartz 2020). Schwartz writes that, "Whatever the arena of contemporary life – health care, education, work, travel and leisure – on the right side of the rope is a friction-free experience where, for a price, needs are anticipated and cared for." This means that the consumer who can afford it can enjoy the luxury of avoiding lines at popular attractions, lying flat on long airline flights, getting children into the best schools, and securing appointments with the best specialist doctors. In Orlando, two miles from the lines of people waiting to get into Seaworld, is Discovery Cove where, for up to $1240, a family of four can enjoy swimming with the dolphins, sharks, and rays. Since daily attendance is limited to 1300, there are no lines and families enjoy private cabanas stocked with snacks and cold beverages with luxurious landscaping and an artificial beach. In California, insurers sent private firefighters to save the expensive homes that they insured, while neighboring homes were burned to ashes. Norwegian Cruise Lines, echoing the Titanic, have a separate part of the ship where high paying guests have the best views, private restaurants, their own swimming pools, and amenities such as butlers that are not available to other guests. In Doha, the capital of Qatar, there is a separate air terminal for first- and business-class passengers. These passengers are served by attendants who secure visas and stamps in their passports while they wait in the lounge, are served food and drinks, and have access to a shower. If you flew in on Air Emirates first class, the shower wouldn't be necessary since you could slip out of your Emirates pajamas and have a shower in your cabin during the flight. Meanwhile, economy-class passengers wait in long lines with none of these amenities, no doubt feeling some envy.

If luxury consumption is driven by envy (Alicke and Zell 2008; Parrott and Mosquera 2008), such privileges potentially stoke feelings of not only benign achievement-motivating envy, but malicious envy as well (Belk 2008). Visible luxury consumption creates a de facto caste system and makes evident the growing global gap between the rich and the poor. Reducing this friction is one of the reasons for separate airport terminals in the Middle East, separations between exclusive and ordinary parts of certain cruise ships, and guards and walls surrounding gated communities. It also helps explain the trend toward inconspicuous luxury. But we know that money talks. As the gap between the one percent and others widens, resentment is likely to grow at the sight of conspicuous luxuries.

Clearly Covid-19 has affected luxury consumption in ways that will have both short-term and long-term consequences. The change to online retailing is likely to continue but will not supplant the brick-and-mortar retail outlets and brand museums

created by many luxury brands. Both luxury brand stores and museums are important tourist destinations, but locals also appreciate the attentive service they receive at the stores, unless the stores become so overrun by tourists that they can no longer get service themselves (Joy, Belk, Wang, and Sherry 2020). Foreign travel, cruise ships, airlines, and hotels will likely take longer than restaurants and movie theaters to recover but they will eventually come back. WFH is likely to continue for many. This trend, as well as reduced demand for downtown office space will likely further affect the urban exodus. But, as with the foreign allure of luxury stores, the upscale retail areas where these stores are often concentrated will likely continue to provide points of urban interest.

Notably, many of the effects of the Covid-19 pandemic involve a decrease in personal service, at least in service by humans. The change to ordering online has replaced people with machines. Since personal service is so much a part of luxury retailing (Hanser 2008), it seems unlikely that luxury retail personnel will be entirely replaced in the long term. And for luxury services like day spas, cosmetic surgery, and hair care, human service is essential. Luxury service providers may not provide essential help in the way that doctors, nurses, and grocery clerks do, but for many consumers they nevertheless help safeguard their physical and mental health and well-being. Ideally these services are not just for the financially empowered, but for all. In times of cataclysm when they are in short supply, they are "necessary luxuries" – an oxymoron that makes sense in times when a frightening scarcity of medical necessities has sometimes made some form of rationing essential (Hamilton 2021).

Throughout human history there have been cycles of good times and bad. As we emerge from periods of widespread desperation, "unnecessary luxuries" – those extras that become the objects of our desire (Belk, Ger, and Askegaard 2003) – beckon. Even though inequality and fears of dissipation through luxury indulgence has prompted numerous criticisms (e.g., Berry 1994; Berg 2012; Clunas 2012; Frank 1999; Sekora 1977; Sombart 1913/1967; Urwick 1908/2018), the benign envy that spurs yearning and striving to acquire these goods has long been seen as an engine of growth and spur of consumer culture (Campbell 2018). Despite sumptuary laws, taxes, and preachers who advocate modesty, austerity, and abstention, the lure of luxury has continued to loom large in the human imagination, even among the poor (e.g., Belk 1999) and those in supposedly egalitarian societies (e.g., Drakulić 1991; Gronow 2003). For luxury, at its best, can be enlivening and uplifting.

To end where this chapter began, Covid-19 has been a cataclysmic event. A cataclysm, in its broadest understanding, brings about fundamental change. As I write this, it is not yet clear what fundamental changes Covid-19 may leave in its wake. Several possibilities have been suggested. They include serious global action on climate change (e.g., Klein 2014), global restructuring and universal basic income provisions to reduce income inequality (e.g., Kotler 2020), and ending dependence on fossil fuels (e.g., Vince 2020). Of these changes, reducing income inequality would

likely have the largest impact on luxury consumption by a "democratization of luxury." If coupled with economic degrowth, this could theoretically slow the modernist and capitalist churn by which today's luxury becomes tomorrow's necessity (think: cellular phones to smartphones). No doubt this would be politically very difficult to achieve. We should not rule it out for future cataclysms, but this one is not likely to make degrowth thinkable.

For the time being, it appears that Covid-19 has accelerated luxury consumption and brought it into the world of online digital selling. Simultaneously, new forms of digital luxuries have been created. Besides NFTs and artificial scarcities of certain online digital goods, we must include digital currency investments among these new luxuries. There is also tension between existing trends toward luxury brand museums and spectacular flagship stores on one hand, and inconspicuous consumption and often invisible velvet rope and gated community consumption on the other. Coupled with the growing gaps between the rich and poor of the world, it is likely best to favor the more modest or less visible sides of these conflicting tendencies. Covid-19 has already inflicted enough problems on the poor without arrogantly flaunting the luxury privileges of those who have come through the cataclysm relatively intact and often better off.

References

Achille, Antonio, and Daniel Zipster (2020). "A Perspective for the Luxury-Goods Industry During–and after–Coronavirus," *McKinsey & Company*, April 2020. https://www.mckinsey.com/~/media/McKinsey/Industries/Retail/Our%20Insights/A%20perspective%20for%20the%20luxury%20goods%20industry%20during%20and%20after%20coronavirus/A-perspective-for-the-luxury-goods-industry-during-and-after-coronavirus.ashx.

Adam, Georgina (2018). "Interested in a Square Inch of a Warhol? Fractional Ownership Hits the Art Market," *The Art Newspaper*, October 4, 2018. https://www.theartnewspaper.com/comment/interested-in-a-square-inch-of-a-warhol.

Albinsson, Pia, and B. Yasanthi Perera (2018). "Access-Based Consumption: From Ownership to Non-Ownership of Clothing," in Pia Albinsson and B. Yasanthi Perera, eds., *The Rise of the Sharing Economy: Exploring the Challenges and Opportunities if Collaborative Consumption*. Santa Barbara, CA: Praeger, 183–212.

Alicke, Mark, and Ethan Zell (2008). "Social Comparison and Envy," in Richard Smith, ed., *Envy: Theory and Research*. Oxford: Oxford University Press, 94–116.

Alt, Casey, Sean Moss-Pultz, Amy Whitaker, and Timothy Chen (2016). "Defining Property in the Digital Environment," in *Bitmark*, November 28, 2016. https://docs.bitmark.com/assets/pdf/bitmark-defining-property-dig-env.pdf#:~:text=Defining%20Property%20in%20the%20Digital%20Environment%20Casey%20Alt%2C,solutions%20to%20the%20curren%20problems%20of%20digital%20owner-.

Asadi, Amir (2021). "The Future of Ownership: A Disruptive Scenario," *International Journal of Business and Management Invention*, 10 (1): 66–74.

Bardhi, Fleura and Giana Eckhardt (2012). "Access-Based Consumption: The Case of Car Sharing," *Journal of Consumer Research*, 39 (4): 881–898.

Bauer, Martina, Sylvia von Wallpach, and Andrea Hemetsberger (2011). "'My little luxury' – A Consumer-Centered, Experiential View." *Marketing Journal of Research and Management*, 38 (1): 57–66.

Belk, Russell (1999). "Leaping Luxuries and Transitional Consumers," in *Marketing Issues in Transitional Economies*, Rajiv Batra, ed., Norwell, MA: Kluwer, 39–54.

Belk, Russell (2008). "Marketing and Envy," in Richard Smith, ed., *Envy: Theory and Research*, Oxford: Oxford University Press, 211–226.

Belk, Russell (2011). "Benign Envy." *Academy of Marketing Science Review*, 1 (December): 117–134.

Belk, Russell (2014). "You are What You can Access: Sharing and Collaborative Consumption Online," *Journal of Business Research*, 67 (8): 1595–1600.

Belk, Russell (2017). "Sharing without Caring." *Cambridge Journal of Regions, Economy, and Society*, 10 (2): 249–261.

Belk, Russell (2020a). "Commodification as a Part of Marketization," in Himadri Roy Chaudhuri and Russell Belk, eds., *Marketization: Theory and Evidence from Emerging Markets*, Singapore: Springer, 31–72.

Belk, Russell (2020b). "High End Contemporary Art: Art for Art's Sake or Art for Mart's Sake?" in Karin Ekström, ed., *Museum Marketization: Cultural Institutions in the Neoliberal Era*, London: Routledge, 34–45.

Belk, Russell (2020c). "Life in a Post-Pandemic World." *ResInt Research Review*, 4 (1): 20–25.

Belk, Russell, Güliz Ger, and Søren Askegaard (2003). "The Fire of Desire: A Multi-Sited Inquiry into Consumer Passion." *Journal of Consumer Research*, 30 (3): 311–325.

Belk, Russell, and Rana Sobh (2019). "No Assemblage Required: On Pursuing, Original Consumer Culture Theory." *Marketing Theory*, 19 (4): 489–507.

Belk, Russell, Kelly Tian, and Heli Paavola (2010). "Consuming Cool: Behind the Unemotional Mask," *Research in Consumer Behavior* 12, Russell Belk, ed., Bingly, UK: Emerald, 183–208.

Benauloye, Florine (2021). "Luxury in Times of Crisis: How Should Brands React to COVID-19," *Luxe Digital*. https://luxe.digital/business/digital-luxury-trends/covid-19-crisis/.

Benjamin, Walter (1955/1968). "The Work of Art in an Age of Mechanical Reproduction, in Hannah Arendt, ed., *Illuminations*, Harry Zohn, trans., New York: Harcourt, Brace, and World, 59–67.

Bennett, Michael (1996). *When Dreams Came True: The GI Bill and the Making of Modern America*. Washington, DC: Brassey's.

Berg, Maxine (2012). "Luxury, the Luxury Trades, and the Roots of Industrial Growth: A Global Perspective," in Frank Trentmann, ed., *The Oxford History of the History of Consumption*. Oxford: Oxford University Press, 173–191.

Berger, Jonah, and Morgan Ward (2010). "Subtle Signals of Inconspicuous Consumption?" *Journal of Consumer Research* 37 (4): 555–569.

Berry, Christopher J. (1994). *The Idea of Luxury: A Conceptual and Historical Investigation*. Cambridge: Cambridge University Press.

Birch, Kean, and Fabian Muniesa, eds. (2020). Assetization: Turning Things into Assets in Technoscientific Capitalism. Cambridge, MA: MIT Press.

Bourdieu, Pierre (1979/1984). *Distinction: A Social Critique of the Judgment of Taste*. Cambridge, MA: Harvard University Press.

Bradberry, Travis (2016). "Why You Should Spend Your Money on Experiences, Not Things." *Forbes*, August 9, 2016, https://www.forbes.com/sites/travisbradberry/2016/08/09/why-you-should-spend-your-money-on-experiences-not-things/?sh=6483b8fe6520.

Burdekin, Richard (2020). "Death and the stock market: international evidence from the Spanish Flu." *Applied Economics Letters*. https://www.tandfonline.com/doi/full/10.1080/13504851.2020.1828802.

Campbell, Colin (2018). The Romantic Ethic and the Spirit of Modern Consumerism. New Extended Edition, Cham. Switzerland: Palgrave Macmillan.

Carter, Travis, and Thomas Gilovich (2010). "The Relative Relativity of Material and Experiential Purchases." *Journal of Personality and Social Psychology* 98 (1): 146–159.

Carter, Travis, and Thomas Gilovich (2012). "I am What I do, not What I Have: The Differential Centrality of Experiential and Material Purchases to the Self." *Journal of Personality and Social Psychology* 102 (6): 1304–1317.

Carù, Antonia, Maria Ostillio, and Giuseppe Leone (2017). "Corporate Museums to Enhance Brand Authenticity in Luxury Goods Companies: The Case of Salvatore Ferragamo." *International Journal of Arts Management* 19 (2): 32–45.

Chaudhury, Himadri, and Sujit Jagdale (2021). "Normalized Heterotopia as Market Failure in a Spatial Marketing System: The Case of Gated Communities in India." *Journal of Macromarketing* 41 (2): 297–314.

Clunas, Craig (2012). "Things in Between: Splendor and Excess in Ming China," in Frank Trentman, ed., *The Oxford History of the History of Consumption*. Oxford: Oxford University Press, 47–63.

Conlon, Michael, and Lee Jolliffe, eds. (2017). *Automobile Heritage and Tourism*. London: Routledge.

Craciun, Magdalena (2014). *Material Culture and Authenticity: Fake Branded Fashion in Europe*. London: Bloomsbury.

Czyzewska, Barbara (2020). "What is the Future for the Luxury Industry After COVID-19?" *Glion: The Insider*, August 8, 2020. https://www.glion.edu/magazine/future-luxury-industry-after-covid19-crisis/.

Dion, Delphine, and Eric Arnould (2011). "Retail Luxury: Assembling Charisma Through Art and Magic." *Journal of Retailing* 87 (4): 502–520.

Dion, Delphine, and Stéphanie Borraz (2017). Managing Status: How Luxury Brands Shape Class Subjectivities in the Service Encounter." *Journal of Marketing* 81 (5): 67–85.

Docherty, Chris (2020). "Back to the '50s: Predictions for a Post-Coronavirus World." *Sustainable Brands*. https://sustainablebrands.com/read/defining-the-next-economy/back-to-the-50s-predictions-for-a-post-coronavirus-world.

Dorfman, Lorraine, Elizabeth Méndez, and Joelle Osterhaus (2009). "Stress and Resilience in the Oral Histories of Rural Older Women." *Journal of Women and Aging* 21 (4): 303–316.

Dos Passos, John (1936). *The Big Money*. Boston: Houghton Mifflin.

Doyle, John (2020). "Selling Sunset: The Appeal of Property Porn in the Midst of a Pandemic." *Globe and Mail*, August 27, 2020. https://www.theglobeandmail.com/arts/television/article-selling-sunset-the-appeal-of-property-porn-in-the-midst-of-a-pandemic/.

Drakulić, Slavenka (1991). *How We Survived Communism and Even Laughed*. New York: W.W. Norton.

Duffy, Brook, and Jefferson Pooley (2019). "Idols of Promotion: The Triumph of Self Branding in a Social Media Age." *Journal of Communication* 69 (1): 26–48.

Eckhardt, Giana, Russell Belk, and Jonathan Wilson (2015). "The Rise of Inconspicuous Consumption." *Journal of Marketing Management* 31 (7–8): 807–826.

Fishman, Karen, and Jan McKee (2015). "Scrap for Victory!" *Library of Congress*, January 15, 2015. https://blogs.loc.gov/now-see-hear/2015/01/scrap-for-victory/.

Fitzgerald, F. Scott (1925). *The Great Gatsby*. New York: Charles Scribner's Sons.

Frank, Robert H. (1999). *Luxury Fever: Why Money Fails to Satisfy in an Era of Excess*. New York: Free Press.

Gilovich, Thomas, and Amit Kumar (2015). "Chapter 4 – We'll Always have Paris: The Hedonic Payoff from Experiential and Material Investments." *Advances in Experimental Social Psychology* 51: 147–187.

Gronow, Jukka (2003). *Caviar with Champagne: Common Luxury and the Ideals of the Good Life in Stalin's Russia*. Oxford: Berg.

Hamilton, Rebecca (2021). "Scarcity and Coronavirus." *Journal of Public Policy and Marketing* 40 (1): 99–100.

Hanser, Amy (2008). *Service Encounters: Class, Gender, and the Market for Social Distinction in Urban China*. Stanford, CA: Stanford University Press.

Harnish, Richard, and K. Robert Bridges (2016). "Mall Haul Videos: Self-Presentational Motives and the Role of Self-Monitoring." *Psychology and Marketing* 33 (2): 113–124.

Hemetsberger, Andrea, Sylvia von Wallpach, and Martina Bauer (2012). "'Because I'm Worth It' – Luxury and the Construction of Consumers' Selves." *Advances in Consumer Research* 40: 483–489.

Herstatt, Cornelia, and Rajnish Firwari (2020). "Opportunities for Frugality in the Post-Corona Era." *Technology and Management* 83 (1–3): 15–33.

Hine, Thomas (1986). *Populuxe*. New York: Alfred A. Knopf.

Holmqvist, Jonas, Andrea Hemetsberger, Sylvia von Wallpach, Thyra Uth Thompson, and Russell Belk (2020). "Conceptualizing Unconventional Luxury." *Journal of Business Research* 116 (August 2020): 441–445.

Humes, Edward (2006). *Over Here: How the G.I. Bill Transformed the American Dream*. Orlando, FL: Harcourt.

Jones, John (2009). *All-Out for Victory! Magazine Advertising and the World War II Home Front*. Lebanon, NH: University Press of New England.

Joy, Annamma, Russell Belk, Jeff Wang, and John F. Sherry, Jr. (2020). "Emotion and Consumption: Towards a New Understanding of Cultural Collisions between Hong Kong and PRC Luxury Consumers." *Journal of Consumer Culture* 20 (4): 578–597.

Joy, Annamma, Jeff Wang, Tsang-Sing Chan, John F. Sherry, Jr., and Geng Cui (2014). "(M)Art Worlds: Consumer Perceptions of How Luxury Stores Become Art Institutions." *Journal of Retailing* 90 (3): 347–364.

Jung, Jung-hee, and Eun-hyuk Yim (2018). "The Role of Fashion Houses Museums – Focused on European Luxury Fashion Brands." *Fashion and Textile Research Journal* 20 (2): 143–145.

Kerchner, Joey (2017). Reaching the Unreachable: How Experiential Marketing Targets Brand-Savvy Millennials." *Forbes*, June 20, 2017, https://www.forbes.com/sites/forbesagencycouncil/2017/06/20/reaching-the-unreachable-how-experiential-marketing-targets-brand-savvy-millennials/?sh=228491403add.

Kirschenbaum, Baruch (1979). "The Scull Auction and the Scull Film." *Art Journal* 39 (1): 50–54.

Klein, Naomi (2014). *This Changes Everything: Capitalism vs. the Climate*. Toronto: Vintage Canada.

Klein, Zach, and Steven Leckart (2015). *Cabin Porn: Inspiration for Your Quiet Place Somewhere*. New York: Little, Brown and Company.

Kotler, Philip (2020). "The Consumer in the Age of Coronavirus." April 6, 2020, *The Sarasota Institute*. https://sarasotainstitute.global/the-consumer-in-the-age-of-coronavirus/.

Kumar, Amit, and Thomas Gilovich (2015). "Some 'Thing' to Talk About? Differential Story Utility from Experiential and Material Purchases." *Personality and Social Psychology Bulletin* 41: 1320–1331.

Kumar, Amit, Mathew Killingsworth, and Thomas Gilovich (2014). "Waiting for Merlot: Anticipatory Consumption of Experiential and Material Purchases." *Psychological Science* 25: 1924–1931.

Kumar, Amit, Mathew Killingsworth, and Thomas Gilovich (2020). "Spending on Doing Promotes More Moment-to-Moment Happiness Than Spending on Having." *Journal of Experimental Social Psychology* 88.

Lehdonvirta, Vili, Terhi-Anna Wilska, and Mikael Johnson (2009). "Virtual Consumerism: Case Habbo Hotel." *Information, Communication and Society* 12 (7): 1059–1079.

Lin, Yi-Chieh Jessica (2011). *Fake Stuff: China and the Rise of Counterfeit Goods*. New York: Routledge.

Low, Setha (2004). *Behind the Gates: Life, Security, and the Pursuit of Happiness in Fortress America*. New York: Routledge.

Lowenthal, Leo (1944). "Biographies in Popular Magazines," in *Radio Research, 1942–43*, Paul F. Lazarsfeld and Frank Stanton, eds.. New York: Duell, Sloan, and Pearce, 507–548.

Mamiya, Christin (1992). *Pop Art and Consumer Culture*. Austin, TX: University of Texas Press.

Marden, Rebecca, and Russell Belk (2018). "Materialising Digital Collecting: An Extended View of Digital Materiality." *Marketing Theory* 18 (4): 543–570.

Marling, Karal Ann (1994). *As Seen on TV: The Visual Culture of Everyday Life in the 1950s*. Cambridge: Harvard University Press.

McCracken, Grant (2005). "When Cars Could Fly: Raymond Loewy, John Kenneth Galbraith and the 1954 Buick," in Grant McCracken, *Culture and Consumption II: Markets, Meaning, and Brand Management*. Bloomington, IN: Indiana University Press, 53–90.

McNeese, Tim (2010). *World War I and the Roaring Twenties, 1914–1928*. New York: Chelsea House.

Molesworth, Mike, and Janice Denegri-Knott, eds. (2012). *Digital Virtual Consumption*. London: Routledge.

Morgan, Blake (2019). "NOwnership, No Problem: An Updated Look at Why Millennials Value Experiences Over Owning Things." *Forbes*, January 2, 2019. https://www.forbes.com/sites/blakemorgan/2019/01/02/nownership-no-problem-an-updated-look-at-why-millennials-value-experiences-over-owning-things/?sh=27f3ce5e522f.

Newell, Sasha (2012). *The Modernity Bluff: Crime, Consumption, and Citizenship in Côte d'Ivoire*. Chicago: University of Chicago Press.

Nobel, Carmen (2013). "Want to Buy Happiness? Purchase an Experience." *Forbes*, August 5, 2013. https://www.forbes.com/sites/hbsworkingknowledge/2013/08/05/want-to-buy-happiness-purchase-an-experience/?sh=1a0476da1998.

O'Dwyer, Rachel (2020). "Limited Edition: Producing Artificial Scarcity for Digital Art on the Blockchain and its Implications for the Cultural Industries." *Convergence: The International Journal of Research into New Media Technologies* 26 (4): 874–894.

Oldenziel, Ruth, and Karen Zachmann (2009). *Cold War Kitchen: Americanization, Technology, and European Users*. Cambridge, MA: MIT Press.

Owens, Bill (1973/1999). *Suburbia*. New York: Fotofolia.

Parrott, W. Gerard, and Patricia Mosquera (2008). "On the Pleasures and Displeasures of Being Envied," in Richard Smith, ed, *Envy: Theory and Research*. Oxford: Oxford University Press, 117–132.

Penny, Daniel (2018). "How Much for that Pepe? Scenes from the First Digital Art Auction." *The Paris Review*. https://www.theparisreview.org/blog/2018/01/23/much-pepe-scenes-first-rare-digital-art-auction/.

Pozin, Ilya (2016). "The Secret to Happiness? Spend Money on Experiences, Not Things." *Forbes*, March 3, 2016. https://www.forbes.com/sites/ilyapozin/2016/03/03/the-secret-to-happiness-spend-money-on-experiences-not-things/?sh=7b642b4039a6.

Puhl, Mathilde, Rémi Mencarelli, and Damien Chaney (2019). "The Consequences of the Heritage Experience in Brand Museums on the Consumer–Brand Relationship." *European Journal of Marketing* 53 (10): 2193–2212.

Radwan, Maha Baz, Georgious Patsiaourus, and Michael Saran (2019). "To Own or to Access: An Exploration of Sharing and Access Practices by Arab Millennials," in Russell Belk, Giana Eckhardt, and Fleura Bardhi, eds., *Handbook of the Sharing Economy*. Cheltenham, UK: Edward Elgar, 62–74.

Rosenbaum, Eric (2020). "Coronavirus and Luxury Retail: Shopping for Used Hermes, Cartier in Covid Era." *CNBC*, September 19, 2020. https://www.cnbc.com/2020/09/19/coronavirus-how-the-pandemic-has-impacted-luxury-retail.html

Schewe, Charles, Meredith, and Noble (2000). "Defining Moments: Segmenting by Cohorts." *Marketing Management* 9 (3): 48–53.

Schüller, Sopnie, Daniel Dietrich, and Lorenz Spielman (2018). "The Future of Touchpoints in Luxury Retailing." *Marketing Review St. Galen* 6: 84–95.

Schwartz, Nelson (2020). *The Velvet Rope Economy: How Inequality Became Big Business.* New York: Doubleday.

Sekora, John (1977). *Luxury: The Concept in Western Thought, Eden to Smollett.* Baltimore: Johns Hopkins University Press.

Shovlin, John (2000). "The Cultural Politics of Luxury in Eighteenth-Century France." *French Historical Studies* 23 (4): 577–606.

Silvan, Rita (2021). "Retail Report: A Look at Innovation in Fashion and Sustainability." *RBC Investing, Inspired Investor*, April 29, 2000. https://inspiredinvestor.rbcdirectinvesting.com/en/di/hubs/tech-and-culture/article/a-look-at-innovation-in-fashion-and-sustainability/kkr40f9g?utm_source=newsletter&utm_medium=email&utm_campaign=Newsletter52.

Smith, Kelly (2001). *A Time of Crisis: Japan, the Great Depression, and Rural Revitalization.* Cambridge, MA: Harvard University Asia Center.

Sombart, Werner (1908/2018). *Luxury and Capitalism*, W. R. Dittmar, trans. Ann Arbor, MI: University of Michigan Press.

Terzi, Alessio (2021). "The 'Roaring Twenties': Revisiting the evidence for Europe." *Vox EU*, April 2, 2021. https://voxeu.org/article/roaring-twenties-revisiting-evidence-europe.

Thompson Don (2008). *The $12 Million Stuffed Shark.* Toronto: Anchor Canada.

Thompson, Don (2017). *The Orange Balloon Dog: Bubbles, Turmoil and Avarice in the Contemporary Art Market.* Madeira Park, BC: Douglas and McIntyre.

Urwick, E.J. (1913/1967). *Luxury and the Waste of Life.* London: FB and Company.

Van Boven, Leaf, and Thomas Gilovich (2003). "To Do or to Have? That Is the Question." *Journal of Personality and Social Psychology* 85 (6): 1193–1202.

Veblen, Thorstein (1899). *The Theory of the Leisure Class.* New York: Macmillan.

Vince, Gaia (2020). "After the COVID-19 Crisis, Will We get a Greener World?" *The Guardian*, May 17, 2020. https://www.theguardian.com/environment/2020/may/17/after-the-covid-19-crisis-will-we-get-a-greener-world.

Von Wallach, Sylvia, Andrea Hemetsberger, Thyra Thompson, and Russell Belk (2020). "Moments of Luxury–A Qualitative Account of the Experiential Essence of Luxury." *Journal of Business Research* 116 (August): 491–502.

Wark, McKenzie (2017). "My Collectible Ass." *E-flux Journal* 85: https://www.e-flux.com/journal/85/156418/my-collectible-ass/.

Whitaker, Amy (2019). "Art and Blockchain: A Primer, History, and Taxonomy of Blockchain Use Cases in the Arts." *Artivate* 8 (2): 21–46.

Whitaker, Stephan (2021). "Did the COVID-19 Pandemic Cause an Urban Exodus?" *Federal Reserve Bank of Cleveland District Data Brief*, February 5, 2021. https://www.clevelandfed.org/en/newsroom-and-events/publications/cfed-district-data-briefs/cfddb-20210205-did-the-covid-19-pandemic-cause-an-urban-exodus.aspx?source=content_type%3Areact%7Cfirst_level_url%3Aarticle%7Csection%3Amain_content%7Cbutton%3Abody_link.

Witkowski, Terry (2010). "A Brief History of Frugality Discourses in the United States." *Consumption, Markets and Culture* 13 (3): 235–258.

Witkowski, Terry (2013). "World War II Poster Campaigns – Preaching Frugality to American Consumers." *Journal of Advertising* 32 (1): 69–82.

Zanazi, Margherita (2015). "Frugal Modernity: Livelihood and Consumption in Republican China." *Journal of Asian Studies* 74 (2): 391–409.

Part 2: **The Art World**

Pierre Guillet De Monthoux
Chapter 3
Organizational Aesthetics as Exploring the Spiritual of the Social
Learning from Kandinsky & Co

A Gateway to Philosophy

What can be the role of beauty in organizational matters? By introducing some works trying to tackle this question, this chapter proposes that this question opens up consideration of philosophical and spiritual dimensions of organizing that are left out by narrow rationalist and functionalist considerations dominating in social sciences applied to management. Adam Smith (1733–1790) realized that aesthetics played an important role in politics not because political strategies were made beautiful or designed to please. When we saw beauty in the politics of economy it instead made us approach the world in a new, more philosophically minded perspective. Beauty triggers us to consider something in philosophical mood and aesthetics offers approaches to what we usually call organizing, work, or consumption. When we begin to see society from this angle we equally engage in spiritual exercises of mundane phenomena. The kind of aesthetics that Kandinsky was advancing in his manifesto "Concerning the Spiritual in Art," where he asked us to consider art beyond representation, resonates with how several scholars today see "beauty" as an important organizing factor. This chapter tries to introduce such a perspective, beyond "the design of objects" and the "taste of individuals," on organizations that we could call *organizational aesthetics*.

"Aesthetics" has its historical roots in romanticism such as the philosophy of Friedrich Schiller. It has re-emerged in today's Europe where both a liberal 'Smithonean aesthetics' and materialism with its 'Marxist aesthetics' have lost their appeal. Between subject and object, the spiritual in organizations takes on an important aesthetic value. The growing interest in organizational aesthetics portends the coming importance of romanticism to understand why people organize. So when we speak of "the spiritual," inspired by Kandinsky, we opt for a philosophical – rather than theological or psychological – rendering of the term. But what does it mean to consider organizations as works of art, and how can we then embark on tuning in the spiritual of the social?

https://doi.org/10.1515/9783110732757-003

Beauty Beyond Matter

> Imagine a building divided into many rooms. The building may be large or small Every wall of every room is covered with pictures of various sizes, perhaps they number many thousands. They represent in colour bits of nature-animals in sunlight or shadow, drinking, standing in water, lying on the grass; nearby, a Crucifixion by a painter who does not believe in Christ; flowers; human figures sitting, standing, walking; often they are naked; many naked women, seen foreshortened from behind; apples and silver dishes; portrait of Councillor So and So; sunset; lady in red; flying geese; lady in white; calves in shadow flecked with brilliant yellow sunlight; portrait of Prince Y; lady in green. All this carefully printed in a book – name of artist – name of picture. People with these books in their hands go from wall to wall, turning over pages, reading the names. Then they go away, neither richer nor poorer than when they came, and are absorbed at once in their business, which has nothing to do with art. Why did they come? (Kandinsky 1977: p. 3)

Tolstoy described an artist as "a man that can draw and paint everything" but the painter Kandinsky, author of the ironical passage quoted above, prefers Schumann's definition of the artist's duty "to send light into the darkness of men's hearts." In his famous avant-garde manifesto of 1912, Kandinsky sets out to investigate "the spiritual in art." The point of this chapter is to use Kandinsky's essay to exemplify a romantic concept of art that underlies recent attempts to develop organizational aesthetics. I will do so by indicating how Kandinsky's writings coincide with conclusions drawn in four studies using an aesthetic perspective on organizational phenomena.

The scene depicted by Kandinsky is a gallery of "art for art's sake" where cool "connoisseurs" judge the methodological skills of artists in representing nature. Here those who can speak say nothing, those who can hear hear nothing and "hungry souls go hungry away," says Kandinsky. The gallery is a metaphor for the nightmare of dull materialism where facts are presented without a spark or light that might illuminate the soul. Vanity, greed, jealousy, and partisanship dominate this art-scene to the extent that onlookers finally turn away from it. Still when the "l'art pour l'art" gallery opened, its exposed objects attracted sympathetic visitors. When Kandinsky stresses that for material art "sympathy is the education of the spectator from the point of view of the artist" we recall that already Adam Smith found it important to investigate the place of "beauty" in man's sympathetic feelings for both products on a market and reforms proposed by politicians. Smith had a Newtonian passion for finding out the forces that attract us to certain objects and organizations. What makes us engage in "toilsome pursuit" of a clock, a piece of furniture, or a house? Somewhat surprisingly for the founding father of economics, he discards the possibility that any knowledge of their utilities would be decisive. How could we ever know with certainty whether an object really is a useful tool for reaching an end, he asks skeptically. He concludes that it rather is "appearance" not "factual properties" of an object that evokes the spellbinding desire to possess it. For Smith it was clear that when an object seemed artfully adjusted to fit the purpose of "promoting our convenience" it had our sympathy and attracted us.

> We are then charmed with the beauty of that accommodation which reigns in the palaces and
> economy of the great; and admire how everything is adapted to promote their ease, to prevent
> their wants, to gratify their wishes, and to amuse and entertain their most frivolous desires.
>
> (Smith 1979: p. 183)

There is no doubt that you may, in fact, sleep better in a hut and travel faster on horseback but, in fiction, a castle and carriage seem more pleasing to us. What makes us admire, acquire, and develop works of art is to Smith their aspect as toys more than their usage as tools. To Smith it is not necessity but beauty that is the mother of invention. He transfers the same reasoning to the realm of organizations and notes that

> . . . the same principle, the same love of system, the same regard to the beauty of order, of art
> and contrivance, frequently serves to recommend those institutions which tend to promote
> public welfare . . . They make part of the great system of government, and the wheels of politi-
> cal machines seem to move with more harmony and ease by means of them.
>
> (Smith 1979: p. 185)

Perhaps Smith's moral philosophy expresses the zeitgeist of early industrialization when machines for the most part were still regarded as toys for adventurous men of progress. Kandinsky, who wrote his text at the end of that mighty movement of mechanization, exclaims:

> The nightmare of materialism, which has turned the life of the universe into an evil, useless
> game, is not yet past . . . only a feeble light glimmers . . . in a vast gulf of darkness . . . and the
> soul . . . trembles in doubt whether the light is not a dream, and the gulf of darkness reality.
>
> (Smith 1979: p. 2)

While Smith saw works of art, among which we may find both products on a market and political schemes, as successful and beautiful by their surface pleasure-value, a contemporary Kantian poet – Friedrich Schiller – proposed an aesthetic theory based on the concept of playfulness. Man is constantly torn between two poles of attraction. On the one hand are nature and reality, to be grasped by the senses. On the other is reason with its desire to search for logical truth and give rational form to the world. Only thanks to his inborn playfulness can man escape the Scylla of materialism and the rationalistic Charybdis and swing between the two poles combining form and content to create a third middle way of beautiful fiction. Works of art and artistry spring out of the playfulness that can already be observed in the primitive physicality of animals using their surplus energy for play and fun. In more refined form, playfulness escapes from both matter and morals to become a purely aesthetic creation of fiction. Fiction is "free" in the sense that it does not "make believe" to be truthfully depicting material reality. Nor is it pretending to be moral goodness. This sort of fiction is, in Kandinsky's words, "spiritual" art. Friedrich Schiller goes on to develop his aesthetics into a theory for finding ideals of social organization beyond primitive naturalism and ethical moralism. This was also Kandinsky's ambition. To Schiller it is obvious that only when man plays

artfully and artists constantly have the pedagogical duty to remind us of our play-fulness does a perfect social organization have a chance of freely emerging. He calls this organization born out of aesthetics "der Staat des Schönen Scheins" (Schiller 1967: p. 188). This is the aesthetic state of romanticism (Chytry 1989).

Four Studies of Beauty and Social Organization

Students of organizations pretty frequently refer to art (Simmel 1990, Cooper/Bur-rell 1988, Guillet de Monthoux 1983, Björkegren 1990). But there are more recent studies of social organization that have chosen entirely to use insights and experi-ence from art as their main theoretical inspiration. What sort of questions do they think art theorizing is best suited to understand? Let us revisit these studies as pio-neering work in what later became called "the aesthetic turn."

England (1988) explores the nature and quality of social work. He is unhappy with the gap between what social workers really do in practice and the mainly so-cial science-based material they study in their education. The everyday practice of social work is, according to England, based on an ability first to understand the client, second to express this understanding clearly in order to provide moral sup-port for the client. The immediate communication of such an understanding is vital – it permits the client to exist.

To England this is a job far from the analytical observations and formalized re-portage of social science. Far from the administrative procedures that workers are taught. So why train social workers in this useless tradition? England refuses to equate social work with any kind of social practice we may develop with our fellow humans. This very practice is termed "work" precisely because it supposes a profes-sional organization responsible for the promotion of helping ability and quality of social work. In other words, England states that social work can be organized in some way that will improve and maintain its quality to clients. But the solution is not to ape academic institutions that further a paradigm of little relevance to prac-tice. Helping people and doing social science research is not comparable.

England proposes to organize social workers much like writers in a workshop for creative writing. Although he admits that texts and words seldom constitute the most efficient means of social communication, he thinks that social workers must learn to read and assess each other's field reports. This lecture should, however, depart from any formal bureaucratic model of reportage. What good social work shares with good art is "a particularly skilled mastery of ordinary means of commu-nication" (England 1988: p. 110) and England thinks that those who are good in un-derstanding and helping clients also "have this ability and show it repeatedly in colour and imagination, the humour and vitality of their informal description" (England 1988: p. 205).

A good social worker writes reports that have more in common with poems than factual descriptions. Instead of relying on some theoretician, England then refers to T.S. Eliot's ideas of literary criticism. Eliot sees the artist-critic as someone turning experience into an image which is then investigated, and where "the only method is to be very intelligent." To England, this implies that social workers and artist critics alike must make use of their "whole selves" in the quest for understanding and expression. There are no simple tricks or shortcuts. Social workers should not be drilled in methods but brought up to become sensitive interpreters. Now listen to what Kandinsky thought of bad artists who focused on developing their technical skills: "The question of 'what?' disappears from art, only the question of 'how?' remains. By what method are these material objects to be reproduced? The word becomes a creed. Art has lost her soul" (Kandinsky, quoted in England 1988: p. 8).

Kandinsky's remark on art indirectly articulates England's view that social work has to primarily search for the client's existential meaning and that any understanding of this search is "ultimately a unique process" that cannot follow any given methodology. What counts for England is that the account of social work can provide a clear picture of both worker and client which can be subject to critical evaluation. In art, Kandinsky states that theory at most can help us understand the art of yesterday. It absolutely could not be used as a handbook of rules for artists: "There is no 'must' in art, because art is free" (Kandinsky, quoted in England 1988: p. 32).

In a second recent study of misuse of computers in organizations Göranzon (1991), blames what he calls "the dream of the exact language." To Göranzon, this dream has nourished the optimistic hopes for artificial intelligence, from Pascal's calculating machine to modern computer technology. He describes two case studies of how work in a social insurance agency and the evaluation of forests by Swedish forest rangers have been rationalized according to such a "dream-ideology." Routine tasks were to be transferred from human calculating operators to a computer. The practices embodied in the human skills of forest rangers and insurance workers were to be translated into rules which would make up computer programs. Although the changes in work organization were carried out, Göranzon's interviews indicate that the effect on efficiency was negative. But since the "dream-ideology" so dominated the language of the organizational actors, Göranzon used a "counter-culture" strategy to voice doubts and intuitive critique.

As Göranzon has chosen to conduct action research, his main effort has not been to construct a theory and test it on observed data. His aim was instead to make people in organizations themselves reflect on their work changes. He found art to be a good way of activating their experiences and making them build alternative images of their professional practice. Drama and crafts were chosen and Göranzon claims that accounts given by a photographer and a carpenter together with reflections on plays like George Bernard Shaw's "Pygmalion" and Shakespeare's "The Tempest" helped understanding. The way in which Prospero treats Caliban and Professor Higgins treats

Eliza Doolittle indeed reveals hidden aspects of how programmers related to skilled workers on the job. But this revelation, so it seems in Göranzon's study, was made "by feelings," not necessarily by "words." Art helped "imaginate" experience that was "speechless." Göranzon concludes that

> . . . the most critical aspects of human action cannot be understood analytically, as can a problem in physics, but must be approached from an aesthetic perspective if we wish to capture the human dimension . . . tacit knowledge plays a far more important part than knowledge formulated in language. This applies particularly to professional and aesthetic knowledge. But there is no recipe for tracing tacit knowledge. Every area must be examined separately.
>
> (Göranzon 1991: p. 189)

Kandinsky also feels that most pictorial forms are too complicated to have a mathematical dimension, that a non-naturalist decorative art of the future is unlikely to be founded on geometrical form. Some twenty years before Wittgenstein, Kandinsky writes that:

> Shades of colour, like those of sound, are of a much finer texture and awake in the soul emotions too fine to be expressed in words . . . the part which the word fails to express will not be unimportant but rather the very kernel of its existence . . . words are . . . only hints.
>
> (Kandinsky 1977: p. 41)

Göranzon, expanding Wittgenstein's pessimistic attack on the "dream of exact language" to the field of work in organizations, would certainly agree with the following optimistic conclusion by Kandinsky. He would of course substitute the word "color" for "practical skills." "In this impossibility of expressing colour in words with the consequent need for some other mode of expression lies the opportunity of the art of the future" (Kandinsky 1977: p. 41f).

Göranzon shows clearly that what matters for mastering a practical task, as that of a forest-ranger calculating the value of a farmer's forest or an insurance worker helping out an insurance client, is to have an "inner picture" of what good work is. Propositional or theoretical knowledge able to be reduced to simple context-free rules account for little of the skills utilized in the researched jobs. To learn a job today, claims Göranzon, is still the same as when the craft master first showed how work was done in practice, and then asked the apprentice to make up his own practical examples. This kind of indirect learning is not a matter of rule-memorizing only but is a subtle mix of rules, skill, and familiarity where, much as in the case of social workers, informal on-the-job communication between craftsmen is important. Compare this to Kandinsky's conviction that every artist creates not by learning method but by "inner need," which consists of his personality which "calls for expression" together with the prevailing style by which he "is impelled to express the spirit of his age." Style and personality are subjective and it is important that the artist does not blindly follow taste and convention or seeks for personality. Kandinsky's artist is "the servant of art" – a medium who expresses not a subjective taste or whim but an almost Hegelian spirit (Taylor 1986). For Göranzon's skilled

modern master, the "inner picture" of good work is the guiding principle as is the "inner need" for Kandinsky's true artist. "And therefore the talk of schools, of lines of 'development,' of 'principles of art,' etc., is based on misunderstanding and can only lead lo confusion" (Göranzon 1991, 35).

In a third study (Scharmer 1990), the case investigated is that of a small private German university founded in 1982 in Witten-Herdecke to encourage a free, liberal-arts inspired education on the otherwise state-dominated German university scene. Seven years after its start, the organization went through a crisis which resulted in both faculty and students debating future strategy. The author took a very active part in this discussion as a student and his account is partly a report, partly a suggestion for an aesthetic strategic management of the university. Both faculty and students were unhappy with the development, the pioneering phase was ending and petrification had set in. The discussion centered on the need for a new constitution, "Verfassung," and some suggestions were made. Scharmer identified conservative suggestions wanting to impose precise rules based on clear professor/student separation. The authoritarians also wanted to solve financial problems by imposing a radically higher tuition fee. The immediate reaction of students was to assemble under the motto: "To study is not to fill a barrel but to light a flame" (Scharmer 1990: p. 13).

A voluntary fund for covering tuition costs was started and, on the same night, one-half million Euros was raised in contributions. A student/faculty movement was initiated and Scharmer's work has consisted in giving an aesthetic interpretation and form to the practical development work done. A lecture of Scharmer's report clearly illustrates that aesthetic considerations have shaped the content of the development movement. Scharmer presents three different ways or paradigms of getting things done in an organization; (1) moral planning, (2) scientific market management, and (3) participation. He argues that neither moralism nor a market model will do, and referring to Schiller's classical aesthetic theory, suggests a middle paradigm based on creative participation.

Schiller finds inspiration in two sources. First in Nietzsche who wanted to overcome fin-du-siècle nihilism with the motto: "to consider Science from the point of view of the Artist and Art from that of Life" (Nietzsche quoted in Scharmer 1990: p. 53).

Second, in the work and writings of the German avant-garde artist Joseph Beuys, he discovers a modern heir of the Schiller/Nietzsche legacy. Where Schiller advocates playfulness to balance materialism and rationalism, Beuys introduces art as what he calls a "social plastic" (Harlan 1984), which is a movement from chaos to order. The members of Scharmer's university organization and Beuys have a grand problem in common: "How could anyone, i.e., every living human being on earth, become a creator, a designer, a plastician of social organism?" (Beuys quoted in Scharmer 1990: p. 123)

Beuys' solution to this problem was to "expand the concept of art" into social organization. To create an organizational aesthetic. He had started out as a painter, but increasingly came to create performances and happenings where the spectators

were dragged into the action and made to experience change. Scharmer especially remembers his 1982 project for Documenta 7 in Cassel where 7,000 oaks were planted by people all over town. This was to reshape a city that was, according to Beuys, like Germany as a whole – totally dominated by modern industrial capitalism. Beuys provoked by proclaiming the modern identity: KUNST=KAPITAL. Scharmer shows how the active Witten-Herdecke students claim a responsibility for seeing learning as an art. Like Beuys, Scharmer tends to use organismic metaphors for the university-organization. A healthy organization should "breathe" regularly. The interaction of the "Verfassung," i.e., the organizational plan or constitution, and the students is "a respiratory process" to which a meaningful language of communication becomes life-giving oxygen. Scharmer observes that students active in the change process of his university attach little importance to "general theoretical reasoning." Unlike the 1960's generation, they tend today to turn away from theory and instead increasingly respect personal engagement and the ability to design practical solutions. The new generation seems more open to "form" and "shaping." Unlike the '60's generation, they also tend to abandon the overall belief in electing representative decision-making units. With Nietzsche, Scharmer tends to think that what matters is rather the "power of will" than the "power of vote." The baby-boom generation, which carries these new values, has no blind trust in the standard democratic procedures of representative participation. This new type of individualism is very much like that which Simmel (1990: p. 70f) calls the romantic model of qualitative individualism where "every individual is his own universe"; as opposed to the formal individualism of liberalism where every man is an atom in the same universe.

The idea of creating a students' fund would never have come about by such procedures. Individuals have themselves to create and argue for their solutions, they cannot be represented in a democracy that often degenerates into a hierarchical democratic centralism of a Leninist type. The organization must learn from good art that immediately opens up an aesthetic dialog with its spectators. Individuals have to be made aesthetically sensitive in order to bridge the gaps between University and Society, Organization and Individual, Knowledge and Students, and, finally, Theory and Practice. From Scharmer's work it seems that much of what happened in the university, the student fundraising, a new proposal for a participatory structure and the injection of new energy in the debate of the meaning to both students and faculty of the whole organization was inspired by the Schiller/Nietzsche/Beuys aesthetic philosophy. Aesthetics took on an active role in the creative imagination of organizational actors.

Ramirez (1991), who has presented by far the most articulate exploration into the importance of aesthetics to understand organizations, would probably look upon Scharmer's university organization as "beautiful." The starting point for Ramirez is to create an understanding for the attractive role of organizational beauty. He tells three stories of organizations that are all "radiant" or "glowing" to their members. When

listening to the case of how a Mexican folklore museum is presented by its engaged leaders he makes this very Kandinskian remark:

> . . . all of us in the session became similarly animated and excited. The atmosphere took on a kind of vibrance, their experience appearing to so beautifully illustrate how ideas that were being discussed could be when implemented. In spite of the clumsy way in which words sketch that experience, I can only say that I remember it as a beautiful one . . . I remember that first experience . . . as including a strong aesthetic element in it. (Ramirez 1991: p. 257)

It is, to Ramirez, this element that is decisive in making spectators and onlookers join and take part in the organizational action. Apart from the Mexican museum, he accounts for a summer theater festival involving some 700 volunteers in the enactment of the history of the French province of Vendée. Finally he tells the story of the Craigmillar Festival Society, which freely associates people from a small Scottish community to combat cultural poverty by a multitude of community projects starting in the area of music. Although Ramirez' case-organizations all engage people in making art in the narrow sense of theatre, concerts, or exhibitions, his main interest is not in "great art" but how aesthetics relate to other attributes that make up human life. He thinks that this has been a neglected field of western social research because love of art has been regarded as an irrational phenomenon.

The Puy du Fou festival in France seems like a gigantic modern and social alternative to erecting a cathedral. It is "sculpted" by the inhabitants of the Vendée region and lead by a conservative politician with local family roots. Each summer a "total work of art" is produced which tells the story of the region and its battle for Christian faith during the French Revolution and constant struggle for independence from Parisian centralism over the centuries. The actors are locals and the spectacular technology for the show has been mostly locally developed. The play has had many spinoffs both political and economic. Some claim the festival has become a Parisian career ladder that the leader has successfully climbed. Others note that the festival has mobilized locals and bridged gaps in both time between today and a historical past, and between generations gathered to realize the show. Another spin-off is a successful local radio station.

The Craigmillar Festival Society in Scotland has emerged in a region seriously injured by early industrialization and economic decline. The Craigmillar community was "ugly" in the social and material sense. It started when a mother wanted to provide music lessons for her child. The local schools could not meet the demand, so she engaged herself and other community members in filling-in cultural activities where public supply faltered. Over the years, the Society's program has been steadily increasing despite funding problems – perhaps related to its Labour connections.

Finally the Mexican Museo Nacional de Culturas Populares has been created to raise the Mexican population's consciousness about its local cultural roots and rich heritage. After a long period of "nationalization," Mexican intellectuals felt a strong need to revive and save some of the pluralistic local tradition in their vast country.

The need to rediscover local history in order to create local identity was begun to counterbalance the overwhelming national identity. Sixty-eight radical anthropologists turned museographers and began searching for economic and political support to document culture. To Ramirez it seems obvious that recruitment to all three organizations depend on their aesthetic attraction.

The projects documented in the four studies presented do not involve professional artists, they do not engage in "grand art," but they are nevertheless called "aesthetic." Kandinsky would have no reason to criticize them for being part of the stuffy old material "l'art pour l'art" tradition. The cases seem to indicate that an aesthetic perspective is meaningful for understanding organizations. This has little to do with what we used to call "art" and "artists," but how does then "beauty" act as a social organizer?

Signs That Don't Design, Pictures That Don't Depict

England observes that when art is alluded to, its role seems mostly to be to confirm "social science." It simply illustrates what we already know, like a superfluous picture in a novel. It becomes a representation of an object which, as Kandinsky notes, cannot be perfectly reproduced in true art. This lack of "objectivity" makes us call what cannot be perfectly communicated, or lacks conceptual precision, "an art" rather than a "science." This negative definition makes us think of art as the kind of decorations made up of color and abstract form that may be well "suited to neckties and carpets" (Kandinsky 1977: p. 47). Or we may approach art as if it did not say something but simply was telling its own story. To such an approach to art, Kandinsky has the following remark:

> Non-naturalistic objects in a picture may have a "literary" appeal, and the whole picture may have the working of a fable. The spectator is put in an atmosphere which does not disturb him because he accepts it as fabulous, and in which he tries to trace the story and undergoes more or less the various appeals of colour. But the pure inner working of colour is impossible; the outward idea has the mastery still. For the spectator has only exchanged a blind reality for a blind dreamland, where the truth of inner feeling cannot be felt. (Kandinsky 1977: p. 49)

Both Schiller and Ramirez would deny that Kandinsky's claim of truth for real art implies that aesthetics actually is "make believe." True art to Schiller was "Schein" that made no claims to represent or replace reality. Ramirez says that it creates an "illusion" but certainly no "delusion" as it shapes a world of its own. This "inner world" that Kandinsky firmly held . . . "only art can divine, which only art can express by those means of expression which are hers alone . . ." (Kandinsky 1977: p. 9) nevertheless exists beyond the private knowledge of a lonely subject. This makes Kandinsky claim that true art bears on an "inner knowledge" that can be communicated. Solipsism is proven wrong by the experienced fact that art can produce a "corresponding vibration of the human soul." For the same reason, Ramirez insists true art cannot be

sociologically defined as a matter of intersubjective taste and judgment. Aesthetics is a deep "transcultural phenomenon." If this can be accepted, the view of art as a simple illustration or fabulous decoration has to be put aside.

This was precisely what Kandinsky claimed in his 1912 manifesto. He noted that his contemporaries were socialists in economic matters, republicans in politics, positivists in science, and naturalists in art. But precisely scientific progress, where yesterday's swindles became today's facts and which had taught scientists that "there is no fortress that man cannot overcome" now made even ultra-materialists approach problems earlier passed over in silence – problems of a spiritual kind that were earlier looked upon as obscure metaphysics. Kandinsky notes that in the exploration of non-matter, both artists and scientists have gone back to half-forgotten primitive knowledge and he mentions the theosophistic rediscovery of Indian religion in much the same way as Scharmer today implies that we can learn from Buddhism and Ramirez talks of "tao-of-earth" as a source for understanding how aesthetics work on our minds. It seems as though today's ultra-materialists (e.g., neurobiologists) also confirm the idea that art carries knowledge and thus should not be confined to the domain of the irrational and unscientific.

While Kandinsky vaguely refers to "vibrations" in the "heart" or "soul" of art spectators or music listeners, the neurobiologists of today investigate the relationship between the senses and the thinking of a human brain. It seems a physiological fact that the sense input is never clearly coming from the outer world to us. The external information from, for example, seeing or listening is always mixed with internal information feedback from the brain itself. A neurobiologist draws the following conclusion: ". . . the activity of the retina at best sculpts or modulates what is going on internally in the high interconnection of neural layers and nuclei" (Varela in Ramirez 1991: p. 525).

Art and aesthetics are certainly part of an active process of thinking and constructing the world, much as has been told by phenomenologists ever since Kant claimed that we have to make our own knowledge of outer objects, since "das Ding an sich" was unreachable to us as such. In the words of another neurobiologist:

> . . . contrary to what we might suppose, the eye and brain do not simply record in a sort of photographic manner the pictures that pass in front of us . . . (but still) Many of our affairs are conducted on the assumption that our sense organs provide us with an accurate record, independent of ourselves.
> (Young in England 1988: p. 110)

Reality is constantly organized by our brains and, in that sense, humans can be called creators. Neurobiologists today legitimize this Kantian claim.

It is, moreover, unfortunate that such mental creation or thinking has mostly been seen as a kind of "writing" or "linguistic" articulation. The dominant position of this misconception of human knowledge dates back from the Enlightenment and has its contemporary counterpart in those who today claim the world to be mostly

"read as a text." Kandinsky attacked the domination of what Ramirez later refers to as "discursive symbolism" in the following words:

> In a conversation with an interesting person, we endeavour to get at his fundamental ideas and feelings. We do not bother about the words he uses, nor the spelling of those words, nor the breath necessary for speaking them, nor the movements of his tongue and lips, nor the psychological workings on our brain, nor the physical sound in our ear, nor the physiological effect on our nerves We realize. that the meaning and the idea is what concerns us. We should have the same feeling when confronted with a work of art. When this becomes general the artist will be able to dispense with natural form and colour and speak in purely artistic language.
>
> (Kandinsky in England 1988: p. 49)

This is what Kandinsky means when talking of "abstract art." He does not imply that art should resemble logical or mathematical theory. Its abstraction has nothing to do with such abstract formal languages. To Kandinsky true art acts as the ultimate raw material for human imagination. Unpolluted by naturalistic illustration or logical formalistic decoration, it directly sets the mind of the onlooker into creative vibration. This has nothing to do with a logician's business of producing and combining unambiguous signs. "In art forms are abstracted only to be made clearly apparent and are freed from their common uses only to be put to new uses, to act as symbols, to become expressive of human feeling" (Langer in Ramirez 1991: p. 117).

Again we must here liberate ourselves from the textual or semiological metaphors. Göranzon tells us why in his study of the destructive force of one such metaphor – that of an exact language of human calculation. The images we make of the world are not, and could never become, perfectly "translatable" as words, "defined" within their own system like words in a word book. Long before neurobiologists, symbolists, and modern phenomenologists finally broke out of the positivist straitjacket by clever inside tricks, Kandinsky formulated this in his little book. Remember his skepticism and caution when using words describing aesthetic effects. He has absolutely no faith in projects for tracking down the logical rules or the grammar of painting. When he wants us to understand "light red" he carefully mentions "the face of young girl" and "the singing notes of a violin," "orange" is maybe "a man convinced of his own powers" and its music "the angelus," "an English horn" sounds perhaps "violet" and the creative act of the artist could, at most, be pictured as the movement of a hand striking the key of a piano which sets in motion a corresponding vibration in the human mind.

Organizational Aesthetics?

I have tried to show Wassily Kandinsky as a good guide to what some recent students of organization have tried to say about aesthetics and organizing. Kandinsky was, of course, a painter, although he had started out as a legal scholar and had no intention

of turning away from art practice. Loudly and clearly he proclaims: "It is impossible to theorize about this ideal of art. In real art theory does not precede practice, but follows her. Everything is, at first, a matter of feeling" (Kandinsky 1977: p. 35).

He never saw his little book as a doctrine, but rather as an encouragement to struggling fellow searchers. He gives homage to Maeterlinck, Debussy, Scriabin, Schonberg, Duncan, Matisse, and Picasso. He thought that in art, literature, dance, and music were the buds of a spiritual revolution to come. There he stood, together with his friends, as the vanguard of a new kind of society. Kandinsky was, himself, not a spectator: his art was his action; written to organize fellow artists.

I do not consider it a mere coincidence that the quoted aesthetic researchers also are people of action. England is training social workers, Göranzon stages art performances to be used in work organizations, Scharmer actually reports his experience as a student activist, and Ramirez, after the completion of his thesis, started to work as a strategic management consultant. They, like Kandinsky, are all convinced that action counts, that practice precedes theory, if there is any theory at all. Their studies show that what was, perhaps, in Kandisky's time, confined to a leading vanguard has become relevant to all types of organizations.

None of the studies has explicitly taken an interest in what leaders and artists might have in common. Göranzon, however, hints at a renewed relevance of a master-apprentice model, where the master becomes an artist who provides inspiration to others. England sees T.S. Eliot as a kind of leader on the narrow path toward a constructive criticism of the practices of social work. Scharmer talks of Weberian charisma, which does not necessarily imply that the good leader has bright plans. He might actually be good due to a lack of ideas – which makes his people bring out their own visions instead. Ramirez is no doubt impressed by the leaders of the researched organizations who can create what Kandinsky would call "spiritual harmony." This lofty ideal may have something in common with Scharmer's hope for a perfectly "breathing" organization where new languages are discovered which will open up dialog between the members. To Göranzon, dialogue is also the method by which fellow workers perfect their skills in ongoing communication on the job. He has observed how traditional management kills skills by splitting up such groups of conversation, which fulfills the kind of reflective role England also praises in his study. Ramirez' study shows how leaders may have initially cultivated the idea to engage a dialog both in space and time. What is a folk museum if not a way of having a dialog with history for the sake of future generations? What is a theatre festival if not a means of bringing different people together into an organizational identity?

As in Kandinsky's booklet, there is much optimism in the case studies. Aesthetics seem to work in practice although they remain unclear in traditional causal positivistic theory. Kandinsky himself actually says more about the failure of aesthetic leadership. The bad artist lacking enthusiasm, with cold heart and soul asleep, will ultimately become so technical that the public will lose interest. To be a

spiritual leader is like swimming: one must tirelessly strive not to go under mentally and morally. Still, most visionaries remain outcasts and are regarded as eccentric. But they are not failures since they try hard to express the "inner need" that will (and this is the firm conviction Kandindsky wants to share with his artist friends) ultimately set in motion social reorganization. Only those who mechanically try to trick their public will end up falling down from the position they have undeservedly attained. Their material art might, as Adam Smith's industrial toys, have some success: ". . . the nerve vibrations are there, certainly, but they get no further than the nerves, because the corresponding vibrations of the spirit which they call forth are too weak" (Kandinsky 1977: p. 47).

Translated into the world of management, we can say that an artist must remain sincerely aware of inner needs and only then can become a leader. It is the artist's duty to repay talents by constant work and to create by deeds and thoughts, not words and theories, a spiritual climate. Kandinsky quotes Maeterlinck, saying: "There is nothing on earth so curious for beauty or so absorbent of it as the soul. For that reason few mortal souls withstand the leadership of a soul which gives to them beauty" (Kandinsky 1977: p. 55).

Ramirez makes a daring and very romantic attempt at catching the essence in a human soul's hunger for beauty. He ecologically phrases it as a need to "belong to the pattern that connects" and then concludes that his researched organizations manage to link their members aesthetically to each other. People joining took part in what Beuys called "social plastic" and acquired existential meaning by organizational sculpture. Those who might have remained outside clients to the systems now were inside catering to themselves with spiritual food for thought. Both Ramirez' organizations and Scharmer's university emerged out of inner need or demand. Actually, Kandinsky already notes that advertisers may be regarded as pioneers of the new spiritual art forms where many media, like painting, dance, and music, will support each other in the expression of inner needs. Had Göranzon's two case-organizations not been state monopolies (forest evaluation and social insurance in Sweden), the aesthetics may well have forced them to join their clients in associations, as has been done in the Universität Witten-Herdecke, Museo de Culturas Populares, Puy du Fou, and Craigmillar cases of aesthetic social systems, simply because such a social system as a work of art will create vibrations deep enough in the hungry souls to get them organized.

While Kandinsky's ideas are in line with the empirical studies and also with older philosophical investigations like the Kantian essay by Schiller, he cannot accept Adam Smith's superficial position that "pleasure" is the sole basis of attraction. Smith's philosophy seems totally dominated by a mechanical image and his "system" is really nothing but a machine. We are far from Ramirez's Batesonian system as an ecological pattern that connects mind to nature. Kandinsky would object that Smith's forces of attraction are just nerve tickling and not deep enough to make a social organization survive the first thrill of novelty. Here clever old Adam would agree and confirm that his force of attraction has little to do with the aesthetics investigated above.

For when we become old and lose our physical power our "splenetic philosophy" soon weakens the attraction and we see:

> . . . power and riches. To be what they really are, enormous and operose machines contrived to produce a few trifling conveniences to the body, consisting of springs the most nice and delicate, which must be kept in order with the most anxious attention, and which in spite of all our care are ready every moment to burst into pieces, and to crush in their ruins their unfortunate possessor.
>
> (Smith 1979: p. 185)

Romanticism Revisited

In Adam Smith's theory it was subjective taste that made us like organizations. Such a theory had the advantage of escaping a search for the beautiful object's inner value. What mattered to aesthetics was what people felt rather than how things looked. And people feel about much more than art in museums. They experience the beauty of both commodities and organizations.

If Smith's theory implied a "death of the object," Kandinsky's thought about aesthetics is marked by a Nietzschean "death of the subject." Ramirez calls the organizational aesthetics "transcultural" thereby implying that it is universal. Smith's liberal beauty dies with the subject but in Kandinsky, as in Schiller's theory, the beautiful floats freely far above subjective reason as well as objective materiality. This kind of aesthetics – to which the organizational one seems to belong – is uninterested in art and artists. It does not engage in finding out if something is "really" art or not, or if someone is a "real" artist or not. Art is not seen as a negation of science. It is not an activity possible to isolate from the rest of human enterprise. Neither is the interest in such an aesthetic motivated by, for example, the fact that activities are increasingly "artistic"; that, for instance, the record industry and TV production employment outnumbers other industries. Aesthetics is not a dimension (Björkegren 1990) that can be completed by other dimensions.

It is significant that studies in organizational design do not imply aesthetic considerations. The concept of design has a far too materialistic connotation to fit the romantic meaning of aesthetics. Neither is this kind of aesthetics likely to involve the formation of individual taste or other psychological phenomena. Therefore the studies have only rather vaguely alluded to the role of leaders or managers. Organizational aesthetics rather represent a different way of seeing existence. It is less epistemological than ontological (Daudi/Sotto 1990; Sotto 1990).

Our four quoted investigations have, each one in its own way, found aesthetics to be of great importance to interpret what makes organizations attractive to their members. To legitimize their projects students have spent much effort in referring to scientific authorities in cybernetics or neurobiology. What really seems to have attracted them is, however, the Kandinskian quest for the "spiritual" in organizations;

of course not in the sense of finding "the spirit," which is a perspective and not a thing or an attitude. Aesthetics seem to be a way to interpret social organization – a way to see and thereby shape social reality. It is highly idealistic and perhaps even belongs to the religious realm. The studies seem to approach a romantic philosophical tradition (Gusdorf 1984) that may become much more attractive once the darker Marxist and fascist sides of Hegelianism have been made obsolete by contemporary European political developments. Kandinsky wanted to stimulate an aesthetic vanguard for a new modern civilization. Today the interest in organizational aesthetics grows at a time when poets and artists, not rationalistic intellectuals, have become inspiring leaders of the reorganization of eastern Europe, much in the vein of Friedrich Schiller. Organizational aesthetics are probably a part of a coming development that will seek inspiration from romanticism.

References

Björkegren, D. (1990). *The Aesthetic Dimension, Working Paper*. Sweden: Stockholm School of Economics.

Chytry, Josef (1989). *The Aesthetic State – a Quest in German Modern Thought*. Berkeley, CA: University of California Press.

Cooper, Robert, and Gibson Burrell (1988). "Modernism, Postmodernism and Organizational Analysis." *Organisational Studies* 9/1: 91–112.

Daudi, Phillipe, and R. Sotto (1990). *Re-cognizing Ontology in Management and Organizations, Working Paper*. Lund University, Lund, Sweden.

England, Hugh (1988). *Social Work as Art – Making Sense of Good Practice*. London: Unwin Hyman.

Göranzon, Bo (1991). *The Practical Intellect – Computers and Skills*. Berlin: Springer.

Guillet de Monthoux, Pierre (1983). *Action and Existence, Anarchism for Business Administration*. München: John Wiley & Sons.

Gusdorf, Georges (1984). *L'Homme Romantique*. Paris: Payot.

Harlan, Volker (1984). *Soziale Plastik – Materialien zu Joseph Beuys*. Krefeld, Germany: Achberger Verlag.

Kandinsky, Wassily (1977). Concerning the Spiritual in Art. New York: Dover Publications.

Ramirez, Rafael (1991). *Towards an Aesthetic Theory of Social Organization*. München: Accedo Verlag.

Scharmer, Claus Otto (1990). *Ästhetik als Kategorie Strategischer Führung*, Universität Witten-Herdecke: Urachhaus.

Schiller, Friedrich (1967). *Über die Ästhetische Erziehung des Menschen*. München: Reclam.

Simmel, Georg (1990). *Philosophie de la Modernité*. Vol II. Paris: Payot.

Smith, Adam (1979). *The Theory of Moral Sentiments*. Oxford Clarendon Press.

Sotto, Richard (1990). *Man without Knowledge – Actors and Spectators in Organizations*. Täby: Företagsekonomiska institutionen Universitet Stockholms.

Taylor, Charles (1986). *Hegel*. Cambridge, UK: Cambridge University Press.

John F. Sherry, Jr., Robert V. Kozinets
Chapter 4
Being at Burning Man: Fabulations and Provocations

Introduction

Fabulation is described as "the making of fictions sufficiently vivid and intense to be capable of intervening in and shaping reality," and construes anthropology as a "fabulatory art" that can play at "the thresholds of the emergence or dissolution of the human," especially when rendered in an experimental or literary fashion (McLean 2017: p. x–xi; 47; citing Bergson and Deleuze). Such rendering seeks to understand the world "not by objectifying detachment from it but through an acknowledged immersion and participation in the world's own material substance" (p. 105). This kind of anthropology is not simply ethnography, but an effort to intervene in and change the world; it moves beyond *descriptive fidelity* to *poetic invention* (pp. 152–153). Montage is one of its principal manifestations (p. 156), and provides the structure of this chapter.

The context of our work is the Burning Man Project, a week-long countercultural arts festival and experiment in living held each year in the Black Rock Desert of Nevada, a barren expanse in the back of beyond to which tens of thousands of participants from around the globe flock first to build, then to raze, a luminous city of art in which aesthetic process and immediacy are celebrated above (frequently spectacular) aesthetic objects and permanence, and in which a gift economy serves to regulate relationships between citizens. The event culminates in the burning of the eponymous Man, a massive wood and neon figure set atop a thematic pedestal, and concludes with the burning of an ornate Temple. These monumental burns follow a host of other art installations and performances (fiery and otherwise) unfolding during the week, which are likewise consumed or dismantled and carted away (as are all other aspects of Black Rock City's infrastructure) at the festival's end, leaving no trace of the event on the desert floor. The event has been well documented by researchers (Chen 2009; Doherty 2004; Gilmore 2010; Gilmore and Van Proyen 2005; Jones 2011; Kozinets 2002a and 2003; Magister 2019; Sherry 2003 and 2009; Sherry and Kozinets 2007; Shister 2019), and its artworks catalogued by many photographers (Bruder 2007; Harvey 2017; Nash 2007; Post 2012; Traub 2006).

A liminal phenomenon such as Burning Man can be understood not only as "a void or absence, but also as a superabundant plenitude" (McLean 2016, p. 110), that allows us to "play with liminality for its own sake" (p. 112), for the "manifest delight in the plasticity and creativity of the material substance of the world" (p. 113). It is an opportunity for anthropologists to produce "new artistic engagements" with this desert

https://doi.org/10.1515/9783110732757-004

environment (p. 175) by opening themselves up to "the possibilities of . . . encounters with works of art, humans and other kinds of beings, with the past . . ., with the materiality" of the site, and by responding to the promptings of "artworks, environment and people" (p. 176).

This chapter is our effort to represent the provocations induced in our engagement with the Burning Man Project, what being us in BRC is like, and how aesthetic co-creation and appreciation work in tandem to remake the world. It is a co-imagined collage intended to evoke an artscape and provoke an *artrising*, to challenge readers to experience deep immersion and researchers to experiment with representation. We have created vignettes and images we hope strikingly capture some of our own primal experiences of the event that might draw others into the phenomenon in a creative, visceral, emotional fashion. Literary and artistic renderings – art rather than mainstream ethnography – suit the liminal event, the spirit of the book, and our own creative impulses. We combine the vignettes and images in montage fashion, and allow this brief introduction and a shorter conclusion to place a scholarly "frame" around our picture that we trust won't interfere with the kaleidoscopic effect. This chapter is an attempt to accelerate the seepage between art and anthropology (Causey 2017: p. 10), and is written in the tradition of this emergent stream of ethnography (Causey 2017; Elliot and Culhane 2017; Howes 2019; Ingold 2015; Neilsen and Rapport 2018; McGranahan 2020; Pandian 2019; Taussig 2011).

Vignettes

The trackless expanse of blue sky and white desert provides a vibrant canvas – essentially a brilliant dichromatic moonscape – for the hundreds of spectacular artworks, from gigantic sculptures to ephemeral performances, which are installed over the course of the week of the Burning Man festival. Flames flare across Black Rock City. Rain is scarce or nonexistent, but can mire the entire population when it falls; water trucks roam the city, dampening the dust clouds with a spray some burners appropriate for spontaneous showers. Swirling dust devils occasionally obscure sight and frequent whiteouts may blanket vision entirely. The passeggiata on the esplanade, down the avenues and around the streets of theme camp sectors, is a rococo procession of costumery (and/or undress) and props, often accessorized with electroluminescent wire at night and body paint and glitter at all hours. Gender- and species-bending outfits and mythological allusions abound.

This undulating ribbon has a more chaotic counterpart on the playa: a motley armada of art vehicles and hordes of tricked out bicyclists move in all directions across the desert floor, their nighttime optics often producing sensations of multicolored light streaking and blurred motion in distant spectators. Similar sensations are induced by fire dancers. Mutant vehicles manifest as dragons, galleons, spacecraft, body parts,

living rooms, altars, rubber duckies, sea creatures, and a multitude of other fantastic forms. El-wired bikes produce an array of illusions in the darkness.

Techno music pounds the playa at all hours, and many other genres emerge from theme camps, art cars, and personal boom boxes. DJs also help keep performances spontaneous and interactive. Percussion is the heartbeat of BRC, and drums of all kinds provide the rhythms that keep bodies in motion. Laughter and chatter combine to form the principal ambient sound of the city. Burner interaction rituals ("May I . . .?" "Can I have permission to . . .?" "Welcome home") are frequently verbal in nature, and can be heard hundreds of times during the day. The grind and scrape of dry and dusty bicycle chains pepper the playa. The hum of generators in the theme camps is prominent most mornings but recedes into the soundscape as the day unfolds. The propellant whoosh of a shooting flame or the roar and crackle of a burning installation and the sizzle and pop of its residual embers are among the most energizing sounds to be heard on the playa.

The haptics of the event are mediated by dust. Stinging your eyes, even behind glasses and goggles. Embedding in your skin. Powdering your hair. Forming grit on your teeth and tongue. Parching your throat. Crusting the mucus in your nose. Borne everywhere on the wind. The wind also refreshes as it blows against your face as you race your bike across the playa. You can feel the cool relief of ice cubes as you dump them in the reservoir of your hydration pack, the meltwater gradually chilling your throat on countless treks about BRC. Temperatures in the desert fluctuate wildly between hellacious daytime heat and near freezing cold at night. The loud music areas on the ends of the horseshoe-shaped encampment seem to make the very desert floor vibrate and your body feels somewhat like a tuning fork as you traverse these grounds. This thrumming sensation occurs within many of the theme camps as well.

The savor of the site is inflected in a variety of ways. Ingesting bitter alkali dust through the air or from the bite valve of your hydration pack is an inevitable transaction cost on the playa, but this is readily and deliciously mitigated by the plenitude and variety of cuisines and beverages available from generous hosts across the encampment. Hospitality is among the chief gifts that circulate in BRC. Meal sharing in the theme camps is often extended to guests, and open bars are hosted across the city. It is not unusual for itinerant servers to roam the esplanade, offering snacks, appetizers, and finger foods to passersby. Drinks are distributed in this fashion as well, with the occasional body shot being served up as performance art.

Distinctive bouquets waft throughout BRC. The aroma of coffee and chai floats in the air of Center Camp. The scent of cooking from cuisine of all kinds drifts from the theme camps. The fragrance of sunscreen emanates from thousands of participants, to be wafted on the breeze. The smell of wood smoke pervades the encampment. The sandalwood notes of joss sticks diffuse from hundreds of altars. The slightly sulfurous metallic odor of gunpowder lingers in the air of many explosive performances. The claustrophobic miasma of overtaxed porta potties baking in the desert sun is the penance burners suffer for their remote venue.

The sensuous nature of the event is intensified by occasional experiences of synesthesia in encounters with installations. For example, participants might dip their hands into a flaming fountain, cupping handfuls of fiery liquid to pour back into a flickering pool, as dripping rivulets of fire fall from tiers on high to splash into a shimmering basin. Or observers might be mesmerized by the dance of colored lights produced by el wire or other chemiluminescent sources in response to vibrations in the environment, or by the musical tones produced by interfering with light streams, in the fashion of a theremin. Many burners report a sensation of floating on the night playa as they glide through a medium of sensory inundation enhanced by sleep deprivation or psychoactive entheogen ingestion, as if moving through a dream.

<p style="text-align:center">***</p>

"Are there two anthropologists anywhere else in the world as happy as this right now?" Rob once asked me as we observed barefoot participants walk reverently over the live coals of the razed Man, and it has reverberated many times over the course of our fieldwork in Black Rock City. We have absorbed the kinetic grace of ecstatic trance dancers, their flickering eyes rolling back into their heads, their rhythmic footwork billowing dust in time with the drumbeat while shadows thrown from the burn barrels lend the tableau the aura of a dream. We have tracked gift circuits on the playa, feeding our own small offerings into them as we wander. We have received more gifts of food and drink than we can ever reciprocate. We have shared stories around burn barrels with friends and strangers, and carried these stories and our interpretations into academic settings. We have attended weddings, memorials, and book launchings. We have partied with Reverend Billy of the Church of Stop Shopping. We have roamed the theme camps, often in the company of impromptu docents and hosts who teach us that their art can best be appreciated in the making, helping us understand viscerally, not merely cognitively, by sharing their tools, guiding us in creating, and eliciting our commentary on the process. We have been laborers and gofers on some installations, and attentive neighbors in the camps. On occasion, participants wrest the direction of an interview from our hands, prodding us ethnographers for insight into our own behavior, sometimes using nuanced takes on the literature to which we hope to contribute in service to their probing. Such give-and-take provides us both a lived experience of carnivalesque inversion and aesthetic co-creation (joint storytelling), as well as additional interpretive horsepower in our analyses. It also puts us in mind of poet Gary Snyder's forsaking of anthropology in favor of becoming an informant, and of Laura Bohannon's Tiv informants "properly" interpreting *Hamlet* for her! It lends a sense of urgency and yearning for presentational novelty to our research enterprise. Our immersive engagement has been a continuous source of joy for us, even (or especially) when encounters have been emotionally challenging. It has become a periodic rite of passage for us, as it has for most repeat burners, and we return to the default world transformed, sometimes even transfigured, hoping to maintain the

afterglow in the aftermath for as long as we can. The vitality (whether through persistence or revival) of premodern rituals in hypermodern and postmodern times is a balm to the soul of contemporary anthropology.

=essence

2001, 16" × 24", acrylic on stretched digitally printed canvas (Figure 4.1)

There are many reasons to create art. For me, all of them have to do with understanding. One saying I often find myself repeating is: "I don't know what I know until I see what I say." As an academic, a lot of my understanding comes from words. Big words, new words, combination words. I'm like a toolmaker who uses words to try to poke around and find what is new or interesting about something. It's very intentional, like surgery. And words are my scalpels and sutures. But art gives me a different way to understand. When I work in a visual medium like paint, I'm usually surprising myself with what I find. When it flows, things just shoot out of me. The art comes like ectoplasm from a medium. Then I'm like a tarot card reader figuring out the meaning of the symbols that flow forth from wherever.

My art almost always starts out as directionless meandering with something else. It could be images from a magazine or a book. Or an old piece of art I made as a teenager. Or a photograph. This work, =essence began as a photograph of the man. It was one of the first photographs I took in 1999 on my first ethnographic trip to Burning Man. The man had just been erected, hoisted up by a team of grunting volunteers. He was teetering just a few hours before. But now he was locked into place and already orienteering. You can see his wires, holding him up. If you walked up to him, you could touch him. I touched his bare wooden legs that felt like bone and the smooth glass of his neon tubing. Exposed wiring, no warning labels. The built flesh and tissue of this man made of art. But as you backed off from his proximity, the sky and the baked desert, the playa, rapidly took over.

The original photo captured the blue of the Nevada sky well. Close up, the man's dimensions against that sky were intimidating and inspiring. He was open air in those days. A populist figure. You could walk right up, climb the hay bales, and stand on the wooden platform. If you look at my *Desert Pilgrim* poem that *Consumption, Markets, and Culture* published in 2002, on page 173, you can see another angle on this man. And a guy, some guy, is standing up next to him.

I took the photograph with a new digital camera I had bought specifically for Burning Man 1999 with Northwestern's money. The image resolution would be a joke today, but then it was considered pretty decent. The fact that the photo was

digital opened up whole new possibilities for my creativity. New ways to figure out questions and to save the past too.

In the original photograph, the random guy from the *Desert Pilgrim* poem photo is at the base of the man too. I remember he was up there for a while. He wouldn't come down and let me get a clean picture. So, with the wonders of Adobe® Photoshop®, I erased him. You can still see a bit of him. He's a blur in the triangle between the man's legs. More of a shadow than a man now. The date was also printed on the original, something digital cameras did by default in those days, and I zapped that too.

The isolated image of the man was cleaner and closer to its core meaning to me. I think my goal became to recapture the feeling of being in the presence of the man. And, even more, the feeling of being in the presence of the man for the first time. Which maybe was all of time, one of those eternal moments that stretches on, that unites all the moments before and following it. Every time I see any image or symbol of the man, every time I am near the man, it evokes that first time. From *Desert Pilgrim* (Kozinets 2002b), I write:

> first act
> a rite
> you go visit the man
> he's the center of the clock
> the life of the place
> rotates from his face
>
> careful, don't touch
> his neon wire's exposed
> no one there to protect you
> from yourself

For a first time, there is little awe or wonderment in these words, but there is a lot of it in my images. And that sense was something I felt I needed to recapture and elevate by turning the raw material of memory and photograph into art.

Most of my art has many stages. Usually, digital printing or painting followed by collage, more digital printing, scanning, more digital printing, painting, and drawing. =*essence* was an early work, and a simpler one. I took the digital image, altered it, edited out what was unwanted. I maintained the exact colors of the original. The sky, the wood, the pedestal, the man's head: exactly as those light rays touched the sensor chips in the camera and busted them up into digital pixels.

Then I had it printed in a distant factory using industrial equipment. A profane process for a sacred image. Like a Christmas gift, the image came back to me on stretched canvas in a big, corrugated cardboard box. I was relieved to open it up and find that the color was just right. To me, there's a great purity and simplicity to the colors in this image. The sky's blue is just right. The browns, the grays, rust, and whites. They are exactly as they should be. The shocking flash of red on the bottom left.

Then the fun began. I added the gray and white swirls and dots to reveal energy vortexes and the eye flash shimmerings we all sometimes see. They are the spirit forms of the stars and lightning on the sunny day the picture was captured. The pedestal and stairway received a refurbishing of acrylic on canvas. A person caught walking by on the left side became a geometric blur, a being of symmetry to match the geometric dimensions of the man. Swirls on the stairs show how the journey up becomes a dance of ritual and ascension, both mysterious and structured.

=*essence* is about just that: the core experience of being in the presence of the man, that day in 1999 on my first ethnographic voyage to this sacred space. Those moments, thoughts, imaginings, and impressions. Whenever I look at the image, it brings me back. It captures the fleeting thoughts and details that are hard to discern and that might be forgotten over time. It reveals and eternalizes that moment. It makes immediate the reality of my first time with the man.

My only regret is that I haven't burned it yet.

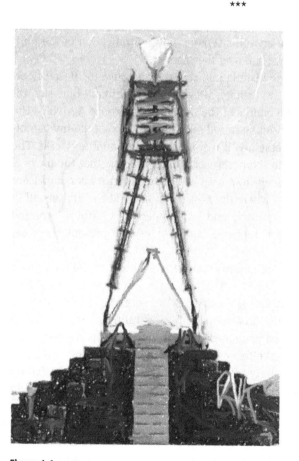

Figure 4.1: =essence.

People's premodern unwillingness to be photographed, interpreted by armchair ethnologists such as James Frazer as fear of soul capture (the concept, while quite persistent, has been criticized by visual culture scholars such as Florian Schneider as a colonial projection), finds its antithesis on the esplanade. It seems as if everyone carries a camera or video camera (or increasingly, simply a smartphone), and that almost everyone is eager to pose for photographs once permission is requested and granted. There are virtually no non-Kodak moments at the event. Bodily adornment is *de rigueur*, for purposes both of personal gratification and communal edification. Costumed burners are ambient installations, to be appreciated not only as autonomous agents, but as works of art. They are causes and consequences of communitas. Photography is a medium of soul sharing in Black Rock City, each photo becoming a soul gift. Our memory cards, hard drives, and cloud pools become a benign Pandora's box, a spiritual cornucopia, a reliquary brimming with authentic presence and revived immediacy. We are rewarded in each reopening with a reimmersion in the universal soul.

<p align="center">***</p>

I offer brief commentary on three artworks (Figure 4.2) as a reflection of the hundreds of aesthetic encounters I have had over the years.

Hovering above the base of the installation, raised high above the desert floor, an effigy in winding sheets seems to levitate, white against a brilliant blue sky. Directly below, a brazier rests in the middle of the skeleton of a Bronze Age ship. The boat is mounted on dry-dock scaffolding raised on pillars tall enough to invite foot- and bicycle-traffic beneath the vessel, as if it were a portal to another world. The maritime imagery, discordant with the desert setting, reminds us that the playa is actually a Pleistocene lake bed. Seen from afar, the entire structure is reminiscent of a chalice, the corpse suspended where the host might float. The effect sets off in me a clash of mythologies, of sky burials and last suppers, of Charon's ferry and Beowulf's funeral pyre, of sacrifice and *memento mori*, of ever-present ancestors and everything returning to dust.

The enormous Merrill Lynch® logo parody strikingly embodies the ubiquitous critique of capitalism unfolding amidst a hyper-celebration of consumption. In a flourish of culture jamming both deft and obvious, the Potemkin bull is punctuated by a pile of manure deposited near its rear hooves (anticipating the much later juxtaposition of Fearless Girl and Charging Bull on Wall Street). The artist achieves a furtive two-dimensional effect of graffiti painted against the vast backdrop of splendid desolation. By gently calling bullshit on the engine of the default world in a way that prompts a humorous epiphany (of 2 parts grin to 1 chagrin) in pilgrims wandering the playa, the artist reminds us of our complicity in our own immiseration.

Of all the colossal installations I have encountered at the event, *Crude Awakening* remains for me among the most affecting of presences. A wooden oil derrick nearly

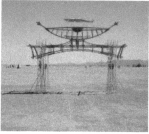

Figure 4.2: Art Installations.

100 feet tall, ringed by ginormous metal lattice sculptures of suppliant humans embodying awe – genuflecting, prostrating themselves, kneeling, praying, raising hands in devotion – created a disturbing daytime tableau, whether experienced at ground level or at the summit of the drilling rig, especially when illuminated by the rising or setting sun. The night of the burn, the tableau embodied and provoked ecstatic frenzy, as fire erupted from the hearts, hands, eyes, and heads of the giant idols, and a thousand-foot column of flame exploded from the tower. Fire in the sky, fire on the ground, fire in the souls of the installation's appreciators. The deification of petrochemistry, the hegemony of oil, and the threat of ecological cataclysm flickered in the eyes of beholders. Another god manifesting as a pillar of flame, luring the faithful on a journey of desertification. Immediately following an anticlimactic (and by most accounts disappointing) re-burning of the Man, the conflagration of *Crude Awakening* revived the bacchanalian spirit of the night and reaffirmed the citizenry's commitment to the creative destruction of destructive creation.

burning woman and man

2016, 50" × 40", mixed media and objects on canvas (Figure 4.3)

Art is always about exchanges of ideas. During the Association for Consumer Research conference in 2015, in New Orleans, Louisiana, I had a chance to visit a number of local art galleries. I was excited by the use of thick applications of paint by different New Orleans artists. I'd also been intrigued by the spatter paint technique of Jackson Pollock.

After returning home to Toronto, I decided to try a few of these techniques on a big canvas. At some point, I decided that Burning Man probably needed a soul mate. Although he stood for unity and wholeness, I felt he was getting a bit lonely.

Even God, apparently, had a wife. According to some Biblical scholars, her name was Asherah and she was mentioned in the Book of Kings. She's also mentioned in the Dead Sea Scrolls found in Sinai at a site called Kuntillet Ajrud. God,

Figure 4.3: burning woman and man.

perhaps, was getting lonely as a monotheistic being, and so the ancients gave him a wife. Voila, dualism. And He was complete.

Wouldn't it be strange to have only half of the world's available genders represented in its ultimate realization? Man giving God a wife is like God giving Eve as companion to Adam. God, talking to himself, says: "it is not good that man should be alone; I will make him a helper fit for him" (Gen. 2:18–24). So the genesis of this painting was in my related feeling that it just wasn't good that Burning Man should be alone; he needed a companion suitable for him. What to call her? Asherah? Eve? The titling came after the painting was complete, but I could think of no better name than Burning Woman.

The painting, like many of my paintings from that time, is built up of several layers. In this case, there were at least five different strata of images and paint that constituted the final product. Like an archaeology dig, most of the painting is actually under the surface. One day, I fantasize that someone will scan its layers with a

delicate laser and be able to view all of the images hidden beneath them. Like a topographer drilling for precious oils and minerals.

The painting began with a magic marker sketch of the two figures. Their arms are outstretched in unison. They are about to be burnt and the orange and black swirls on Burning Man's left side represent the rising flames and smoke of this impending event. Their arms touch – his right to her left – as they are sacrificed. And parts of her left arm shoot off into the heavens carrying his essence with it.

After drawing the two figures, I began adding collage images. Chief among these were photographs of different couples at Burning Man. I have a fairly large collection of Burning Man photos and many of them are of couples. These images were of people I had personally taken while at the event. Many of them were dressed up to go to the main event of the Man's burning. I printed these couples in black and white on regular printer paper, carefully cut them out, always keeping them together on the same piece of paper and glued them to the canvas.

Then I added a number of images from various magazines and online sources. The central face is Mitt Romney's. There is an image of Marvel's Ghost Rider, another version of the Burning Man. There are birds that also ascend to heaven and are sacrificed and burned in rituals.

I incorporated talismans and other things I had collected from Burning Man. There were cards that people who were in couples had handed me, including a tarot card that I placed in the bottom left corner. A woman's face filled the Burning Woman's head. In 2003, John and I had collected bits of burned and broken wood and ashes from the site of the Burn. I incorporated those into the painting. Sometimes I mixed them with colored paint. Other times I enclosed them in clear acrylic matte and applied them to the surface.

The next stage involved spattering paint. For this, I used thin paints, most of them purchases from either hardware or dollar stores. These were the orange, purple, royal blue, black, and pink painted sections. At various points, I poured them, dripped them, and spattered them, building up various layers.

Then, it was time to apply the thick New Orleans style paint. I used metallic blue, green, and metallic teal acrylic paints, as well as a thick crimson red, a metallic gold, and a metallic pink. The painting is about the connection between man and woman, male and female, XX and XY. I wanted to depict visually how the man was in the woman, and the woman in the man. After all of the dripping of the pink paint and the collage work, very little of the original sketching of the Burning Woman remained. I used thick lines drawn with the metallic teal pain to frame the structure of the burning woman. For the man, I used two diamonds drawn in thick crimson red to unite him with the color scheme of the burning woman and linked this with several bold lines and upraised dots.

It's difficult to communicate in a two-dimensional reproduction what is a very three-dimensional painting with many layers. In the center of the painting, between the man and woman, I glued a sacred object that I brought from New Zealand. The

object is also profane, a plastic keychain with a Maori Hei Tiki symbol imprinted on it. It's a fairly big ornament, and it sticks out quite a bit. The painting is meant to be viewed from many angles and the different elements are intended to motivate the viewer to take a deeper look to see the parts that go into the overall assemblage. Because the paint is so thick, the shadows cast new lines of their own depending upon where the viewer stands and where the light in the room is positioned.

The black swirls to man's left and above his head, and the orange spatters and drips to the woman's left and above her were some of the last layers of color and texture to be added. They represent not only fire and smoke, but also the spirals and experiences that connect each of us. Visually, they draw together the painting's various disparate images and elements into a whole image.

This was one of the first paintings in which I experimented with this thick paint style. I was still learning how to create the lines of the thickness and length that I wanted. Some of the effects, like the red, show my tentativeness with the technique. However, I've resisted the temptation to redo them. This painting has enough layers as it is.

<center>***</center>

Burning Man is a test site for the interplay of design and emergence. It is a vehicle for living in the present and for colonizing the future. It is both a reaction to and proactive engagement in urban planning. It is an experiment in translating a utopian vision into a culturally and ecologically considerate action plan for enlightened living. The ten principles that guide the Burning Man Project – radical inclusion, gifting, decommodification, radical self-reliance, radical self-expression, communal effort, civic responsibility, leaving no trace, participation, immediacy – moderate the relationship between structure and anti-structure that delivers the signature experience participants work so ecstatically to co-create. Creative challenges encountered and innovative solutions generated in the Temporary Autonomous Zone are exported beyond regional burns to the default world itself, whether in the form of Fly Ranch, Burning Man's permanent full-time think tank and arts-and-culture incubator, of transient social interventions such as the Burners Without Borders organization that aids in disaster relief and community development around the world, or of the thousands of amped imaginations returned to commercial or nonprofit settings that ultimately (and sometimes ironically) produce new products and services. Through its social media, and in particular its official web site with such features as *Burning Man Journal*, *Jackrabbit Speaks*, and *Beyond Burning Man*, the organization keeps its members and the interested public apprised of most aspects of the BMP's philosophy, intentions, and efforts; and expands its networking activity to new and varied audiences. Burners congregate online throughout the year, rekindling their evanescent IRL experience in the ether, both prolonging their playa immersion and whetting anticipation of future returns and reunions.

<center>***</center>

Theme camps set up as gated communities by uber-wealthy "participants" to ensure luxurious privacy, an exclusive form of "glamping" (glamorous camping) in the heart of immersive populism, as well as other forms of turnkey camping, have created controversy in recent years. Incidents of "artson," the unauthorized fiery destruction of artworks, as well as tagging and graffiti, are a perennial issue. Boundaries of free expression and artistic license are constantly challenged by provocative theme camps (such as the Capitalist Pigs or the Barbie Death Camp) as well as by itinerant buskers. The elasticity of aesthetic relativism seems a constant topic of debate in BRC. Can any expression, no matter how transgressive, be considered "art" if so intentionally labeled? Can such latitude sustain a city? Are canonical standards both essential and inimical to the evolution of art?

<p style="text-align:center">***</p>

An art car roars up to the shadow of the Temple, blaring Santana's version of Tito Puente's "*Oye Como Va*" at almost unbearable decibels. As if syncing the song's meaning *("Listen to how my rhythm goes/It's good for having fun")* to the somber aura of the installation, the DJ fades to dead air, and, after a long pause, cuts to a new track, a much quieter *Adagio for Strings in G Minor* by Albinoni. A cone of hushed reverence surrounds the Temple, protecting its visitants from the cacophony of the playa as they inscribe their expressions of grief and gratitude on the walls of the edifice. This musical contrast cut is a reflection of the awe engendered by the installation and the solemnity embodied in its attestants' industry.

<p style="text-align:center">***</p>

Material objects often encapsulate the essence of Burning Man. Consider the label I received from a "Dirty Name Badge Distributor" from Hello Camp, an emissary of playa personality Admiral Painjoy. The gift affixed to my shirt (Figure 4.4) provoked a wave of introspection beyond the badinage engendered in its receipt. It prompted an immediate close reading that underscored the gleefully subversive character of the larger Burning Man event. The label satirizes the ineffectual and insincere greeting embodied in the standard mundane name tag, and, by extension, all of our inert interaction rituals. It commands mutual immediate presence of interlocutors. It signals the bearer's willingness and intention to play, imparting something of a ludic license to encounters. It is an allusion to Wile E. Coyote (and indirectly to Mark Twain's book *Roughing It*), the Looney Tunes® character who is an archetypal trickster and desert innovator engaged in an endless quest. It is also an allusion to the erotogenic arousal building to the main event, again emphasizing the licentious character of the Burning Man Project and highlighting the other millions of smaller aesthetic performances and appreciations that precede the focal burn. The faux warning (or is it?) emphasizes the danger, altered consciousness, and erotic charge that animate the carnivalesque atmosphere of the playa. The label also serves as an advertisement for and invitation to the theme camp and its aesthetic attractions. Beyond close reading, the name tag stimulates additional interaction with other burners, rendering the bearer an object of

Hello... my name is:

Red E. Foreplay

Brought to you by "Hello Camp" - Admiral Painjoy - Burningman 2007
CAUTION: Do not touch the adhesive on the back of this label. It is a very powerful hallucinogen and is easily absorbed through the skin... it also has aphrodisiac properties

Figure 4.4: Name Badge.

contemplation if not an *objet d'art*. The spirit of the gift promotes circulation. The tag may even be re-gifted, encouraging extended engagements.

<p style="text-align:center">***</p>

My image of the "Three Amigos" (Figure 4.5) sits on a bookshelf altar in the company of other totems and fetishes, such as a Ball jar of ashes and detritus gleaned from the Man bedecked with a much smaller gifted amulet of similar composition to be used in healing rituals, an R. Crumb image of Abraham about to sacrifice Isaac, a ceramic companion spirit polar bear, a jawbone of an ass, a Thai whiskey flask, several Dunny Kidrobot Azteca figures, a small wire sculpture of a withered tree, a bronze plaque of Brendan the Navigator and fellow sailors, and a Hesburgh commemorative coin. The themes of spirituality, ritual, sacrifice, exploration, impermanence, alterity, connection, nature, gift, juxtaposition, altered consciousness, materiality, and cultural diversity that the curation embraces comprise a fitting context for the photo, since they reflect some of the fundamental aspects of the Burning Man Project. The altar itself is an installation in the burner tradition, and a daily reminder that the default world is really just that.

The photograph was taken after a particularly rich interview Rob and I conducted with Larry Harvey (the main co-founder of the Burning Man event) in Center Camp. We bookend *The Man in the Hat*, one of us cloaked in tie-dyed finery, sporting beads and an almost prosthetic hydration pack, and the other bearing a broad-brimmed Tilley and wearing an ironic nautical overshirt. Rob flashes his trademark congenial smile and I default to my perpetual Irish death stare. Yin and yang, comedy and tragedy, Vladimir and Estragon, peanut butter and jelly. Larry stands in the center of the photo, as he did/does of the event itself, an impresario of ideas and social architect of transformative experience. We thrummed with the vibrancy

Figure 4.5: Three Amigos.

of the vision he conveyed in the interview, both of us eager to transcribe, analyze, and write before the spell was broken.

The photo instantly evokes the power of place for me: the brilliant sun and searing heat, majestic mountains changing color by the hour as they ring the desert floor, the alkali dust that works its way inexorably into every orifice and pore, the creative dwelling structures people devise to cope with a challenging climate. The image reminds me of the friendship and fictive kinship that arise from joyous immersion in dire straits, the forging of community in the company of strangers, and the deepening of bonds born of shared experience over time. The picture reinforces for me that ethnography is a contact sport, that such research (whether undertaken alone or with a partner) is always collaborative, and that we are blessed to experience what we do for a living as hedonic consumption. Doubly blessed if you have the right field partner. Finally, the shot recalls the performance-centered nature of life in Black Rock City, where participants adopt playa names and personae, wear costumes for the amusement of self and others, engage in a host of aesthetic interaction rituals, and generally embody art by becoming mobile micro-installations as they wander the playa.

cosmic pan man

2015, 48" × 30", mixed media on canvas, diptych (Figure 4.6)

The further away I was from Burning Man, the larger his reach. Especially as the spring season ended and summer began, my thoughts would turn to the Burning Man event. When to make a ritual return? How to make it happen? In 2015, I was in the midst of some major life changes. Flying back and forth to Australia to be with my new love. Planning my move to California to start working at USC. There was almost no way that I would be able to set foot in Black Rock City that summer. For the many years I was unable to visit the event, art would provide me with another type of event. Art about

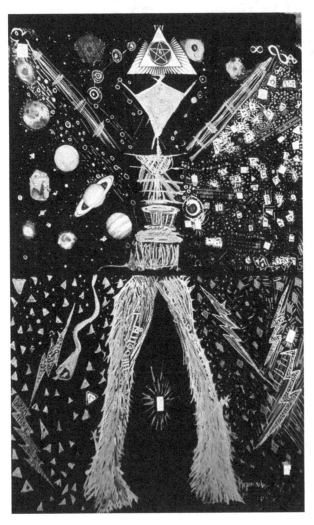

Figure 4.6: cosmic pan man.

Burning Man became an internal journey, a contemplation and visit to the dreamworld and spirit space of Burning Man. My own *Golgonooza*, although I suppose that Burning woman and man more literally manifests William Blake's actual cityscape.

cosmic pan man happened opportunistically, as much of my art does. After watching a movie, I walked by a bookstore that was selling stretched black canvases on sale. I bought several. I knew at once I wanted to use the black background to create something cosmic in scale and scope. I'm fairly sure the idea of a depiction of the man came quite soon after that.

The figure of *cosmic pan man* was drawn freehand and from memory. I didn't want to or need to consult any other visual guide. The man's image is already seared into the art centers of my being. He was drawn using a mix of metallic silver, gold, and bronze ink magic markers. He is portrayed with arms outstretched, ready to be burned, about to ascend.

Cosmic sacrifice.

Channeling his ancient mystical resonance, Larry Harvey has said that the man is like a ladder between the earth and the sky. We use ladders to climb upward, to reach heights inaccessible. Here, the ladder climbs higher than the skies to the cosmos itself.

The top of the diptych portrays the cosmic and spiritual reach of the man. Over the man's right arm lies an omega symbol with an open circle inside it to evoke an all-seeing eye. Both refer to God, especially in the Book of Revelation: the Ultimate Cosmic Creator Spirit. The omega symbol culminates a collage of photographs of the planets taken from NASA spacecraft images and galactic shots from the Hubble satellite camera, all printed using a color laser printer on glossy photographic paper. For God created the Heavens and the Earth, and in this work the man is celebrating that he is a part of this work. Over the man's left arm lies an infinity symbol, which echoes throughout the artwork. This infinity symbol is at the zenith of a pandemonium of symbols. There is a rushing tide of mainly Hebrew and some Greek letters. All of these symbols and letters were chosen by me and laser printed on glossy photographic paper, then custom cut to size and pasted to the canvas.

The Hebrew letters seem to be related to Burning Man participant Daniel Pinchbeck's description of a psychedelic realization. Recounted in his 2002 book *Breaking Open the Head*, he saw Hebrew letters in everything he perceived and had that experience that these Hebrew symbols were the ground of reality. These apparently abstract symbols were actually the ontological root basis of all that is. This recognition related not only the Kabbalah, with its symbolic basis and numerological significance rooted in the Hebrew *Aleph Bet*, but also a type of symbolic synesthesia and onomatopoeia that I found enchanting. The first letter, *Aleph*, reminds us of eternal oneness, our essential unity. *Vav*, the sixth letter, is the power to unite everything in creation that seems separate. It is the ladder of Jacob, rooted deep in the earth with its head in the heavens, and it relates to the man as the ladder to heavenly worlds. *Zayin*, the lucky seventh letter, is the sword that Jacob and the angel struggled over. It extends into the essential dot, *Yod*, the star matter which fills the

background of this canvas, both top and bottom. *Yod* is ether, starstuff, dark matter – the God-essence from which all of creation comes forth. Ourobouros, the snake eternally devouring its own tail, appears in several forms, uniting alpha and omega, yod and Jupiter, the horseshoe nebula and the concept of infinity.

Pinchbeck's phantasm rockets my own imagination into a fulsome psychedelic dreamspace. What was it like to see the world in symbols? Was it analogous to being able to taste sounds or see smells? Isn't this what we academics do? We take the brute reality of the world and try to see it as abstraction. The synesthesia of the overwrought academic imagination. Or is there in truth no brute reality there to perceive, unlike Huxley's promise no actual world beyond the doors of our perception? Only the symbols of it? Only abstraction?

The man is constructed of wood and rungs, like a ladder. The man becomes Jacob's ladder, linking heavens to the earth. Heaven also climbs down to us using these ladders, as the angels descending in Jacob's impactful Biblical dream did. The bottom half of the diptych depicts this more grounded reality. There are distinct left and right sides to the artwork. They split the diptych into distinct quadrants.

The figure of *cosmic pan man* was drawn in one session, a sketch that I filled in and whose background images and surrounding details I worked on for several weeks afterward. Holding the two canvas boards together, I sketched the man from his head downward. Arms outstretched. And then, as I got to the bottom canvas, everything changed. From the waist down, this man was a Minotaur, like the Greek god Pan. The god of the wild, and wildness, or mountains, flute music, and nymphs. And it's whispered that soon, if we all read the rune, then Pan the Piper will call us to join him.

The man has thick, muscly, hairy legs, and hooves. You can see that he has a spur on his right foot, as if he is also wearing a cowboy boot. For he is also a creature of the American West. He stands amid the pulsating energies of earth spirits and bodies. Silver lightning bolts and bronze diamonds and crazy weather accompany him on his left side. To his right, his electric tail hangs down. At the end of it is a three-prong plug. For the man is a creature of electricity. For his cosmic charge, he taps into the wealth of silver triangles that float all around him. Symbols of power and energy race down his right leg. In between his legs, in this most powerful of interstitial spaces, is the Greek letter *psi*. *Psi*, the 23rd letter in the Greek alphabet, is arguably the most scientifically mystical letter of all. It stands for psychology, for a quantum wave function, the mind, Neptune and his trident, parapsychology and the supernatural, for the psychic arts.

As Mind, *psi* is both the root and the consequence of man's presence in the cosmos. *Psi* is depicted as a sort of silicon chip with radiating spokes around it. Man, representation, mind, art. *Psi* is the cause of the self-reflection and the self, reflecting upon its own causes.

Finally, the man is crowned with a cosmic pyramid in which is nestled an ever-radiating pentagram. From the time of the Babylonians and Ancient Greeks to the Wiccans today, many of whom consider the man to be related to their craft and

their Earth deities, such as the Wicker Man, the pentagram has sacred appeal. In this depiction, the pentagram leads to an interconnected network, a lattice of eyes and stars that surround, unite, and bind the *cosmic pan man*.

My longing to be with the man guided this image to me to draw. Further away and closer than ever. Abstraction concretized. Present on my wall and in my thoughts. Nearer than near and full of the rich symbolic surroundings he deserves as tribute and psychic fuel.

<p style="text-align:center">***</p>

Desert Magic

subversive of extended servicescapes
 provided river rafters to consume
in frenzied bursts of splashy fresh air flow
 and flickering lulls of languid campfire meals,
a sheltered taste of raw bewilderment
 subsidized by guides, sherpaed by pros,
the playa is a bedlam set aflame,
 a DIY and –to-yourself conclave
of mad becomings dancing in the dust,
 of synesthetic in-to-body trips,
an artscape of smart tesserae incarnate,
 reweaving time and space to suit new sense.
festivity and ferity suffuse
 this handmade golgotha cum golgonooza.

Conclusion

How can we answer Eliot's (1934) Stranger when he asks "What is the meaning of this city?" As strangers in this strange land, our reply is still emerging, and feels reductive each time we revoice it. The place is more than an evanescent atelier or gallery. Black Rock City is an experiment, catalyzed by art, in the forging of regenerative culture (Wahl 2016), in participation with the environment, in collaboration with tens of thousands of unindicted co-conspirators. It resonates with two of the volume's main themes – sustainability and artification – in provocative ways.

Being ecologically considerate is a priority for every burner, from the capture and disposal of grey water, the policing of moop ("matter out of place"), or the prevention of burn scars on the playa's surface, pursuant to the principle of Leave no Trace. The previously described "Crude Awakening" installation was itself powered in part by 900 gallons of laterally cycled jet fuel donated by NASA. Sustainability has been a looming organizational challenge, culminating in a 10-Year Roadmap for progress

(https://burningman.medium.com/burning-man-project-2030-environmental-sustainability-roadmap-c79657e18146) that envisions three accomplishments by 2030: ecological waste management, regenerative environmental impact, and carbon negativity. Reconciling the massive amount of consumption undergirding the event with the principle of Decommodification poses the greatest ideological provocation to participants, but sacrifice of Bataille's "accursed share" may well be essential to this postmodern potlatch.

Artification occurs at Burning Man insofar as the ritual re-enchantment of civic engagement happens in an aesthetic key. Imagination transforms most encounters into aesthetic moments of mutual presence. Any experience is susceptible to artful inflection, and any object may be incorporated into bricolage. Perhaps a more accurate description of what goes on in BRC is artifexion, that is, a focus on the transitory making and ephemeral appreciation of art, with an emphasis on crafting instead of curation and on oblation instead of ownership. Further, "art" is reconceived as "public art," with virtuoso and amateur sharing a common stage, and profession and avocation having equal standing. Artifexion is the liberation of art from the orbit of the commodity, whether product or purchase, and from the total institution all together.

Burning Man is a revitalization moment-becoming-a-movement, the exaltation of immediacy, kairos remaking chronos. It is the apotheosis of aesthetic experience, the transformation of *art*work into art*work*, the restoration of gift from exchange. It is an eternal homecoming, an abiding presence in the hearts of its citizens, an aestheticization of being and becoming. To invoke the title of our chapter, BRC is Arts Я Us. It invites a ludic rendition.

References

Bruder, Jessica (2007). *Burning Book: A Visual History of Burning Man*. New York: Simon and Schuster.
Causey, Andrew (2017). *Drawn to See*. Toronto: University of Toronto Press.
Chen, Katherine (2009). *Enabling Creative Chaos: The Organization Behind the Burning Man Event*. Chicago: University of Chicago Press.
Doherty, Brian (2004). *This Is Burning Man: The Rise of a New American Underground*. New York: Little Brown.
Eliot, T.S. (1934). *The Rock*. New York: Harcourt, Brace and Co.
Elliott, Denielle, and Dara Culhane, eds. (2017). *A Different Kind of Ethnography*. Toronto: University of Toronto Press.
Gilmore, Lee (2010). *Theater in a Crowded Fire: Ritual and Spirituality at Burning Man*. Oakland: University of California Press.
Gilmore, Lee, and Mark Van Proyen, eds. (2005). *AfterBurn: Reflections on Burning Man*. Albuquerque, NM: University of New Mexico Press.
Harvey, Stewart (2017). *Playa Fire*. New York: Harper Collins.
Howes, David (2019). "Multisensory Anthropology." *Annual Review of Anthropology* 48: 17–28.
Ingold, Tim (2015). *The Life of Lines*. New York: Routledge.

Jones, Steven (2011). *The Tribes of Burning Man: How an Experimental City in the Desert is Shaping the New American Counterculture*. San Francisco: Consortium of Creative Consciousness.

Kozinets, Robert V. (2002a). "Can Consumers Escape the Market? Emancipatory Illuminations from Burning Man." *Journal of Consumer Research*, 29 (1): 20–38.

Kozinets, Robert (2002b). "Desert Pilgrim." *Consumption Markets & Culture* 5 (2): 171–186.

Kozinets, Robert V. (2003). "Moment of Infinite Fire," in *Time, Space, and the Market: Retroscapes Rising*, eds. Stephen Brown and John F. Sherry, Jr. New York: M.E. Sharpe, 199–216.

Magister, Caveat [Benjamin Wachs] (2019). *The Scene That Became Cities*. Berkeley: North Atlantic Books.

McLean, Stuart (2017). *Fictionalizing Anthropology: Encounters and Fabulations at the Edges of the Human*. Minneapolis: University of Minnesota Press.

Nash, Leo (2007). *Burning Man: Art in the Desert*. New York: Abrams.

Neilsen, Morten, and Nigel Rapport, eds. (2018). *The Composition of Anthropology*. New York: Routledge.

McGranahan, Carole, ed. (2020). *Writing Anthropology*. Durham, NC: Duke University Press.

Pandian, Anand (2019). *A Possible Anthropology*. Durham, NC: Duke University Press.

Pinchbeck, Daniel (2002). *Breaking Open the Head: A Psychedelic Journey into the Heart of Contemporary Shamanism*. New York: Broadway Books.

Post, George (2012). *Dancing with the Playa Messiah: A 21-Year Burning Man Photo Album*. Richmond, CA: Dragon Fotografix.

Sherry, John F., Jr. (2009). "Leaving Black Rock City." *Studies in Symbolic Interaction* 33: 459–464.

Sherry, John F., Jr. (2003). "Bespectacled and Bespoken: The View from Throne Zone and Five O'Clock and Head," in *Time, Space, and the Market: Retroscapes Rising*, eds. Stephen Brown and John F. Sherry, Jr. New York: M.E. Sharpe, 19–34.

Sherry, John F., Jr., and Robert Kozinets (2007). "Comedy of the Commons: Nomadic Spirituality at Burning Man," in *Consumer Culture Theory*, Vol. 11 of *Research in Consumer Behavior*, ed. Russell Belk and John F. Sherry, Jr. Oxford: Elsevier, 119–47.

Shister, Neil (2019). *Radical Ritual: How Burning Man Changed the World*. Berkeley: Counterpoint Press.

Taussig, Michael (2011). *I Swear I Saw This*. Chicago: University of Chicago Press.

Traub, Barbara (2006). *Desert to Dream: A Decade of Burning Man Photography*. San Francisco: Immedium.

Wahl, Daniel (2016). *Designing Regenerative Cultures*. Axminster, UK: Triarchy Press.

Amanda Sorensen, Susan Rowley

Chapter 5
Valued Belongings: Museums and the Luxury Art Market

Introduction

This chapter engages with Western constructs of value and luxury as applied to non-Western cultural heritage.[1] In it, we pose several questions: (1) How has Indigenous cultural heritage been commodified? (2) What roles have museums and collectors played in this transformation? (3) How are contemporary museums working with Indigenous communities to redress this history through exhibitions? (4) How is this read by Indigenous museumgoers? (4) How are Indigenous nations and communities reclaiming their heritage from museums and collectors?

We use cultural heritage from the Pacific Northwest as a case study and begin by tracing the history of the dissociation of Indigenous material culture from the cultural value system of its creators beginning in the 19th century. Next, we discuss the exhibition *In A Different Light: Reflecting on Northwest Coast Art*. This exhibition opened at the Museum of Anthropology at the University of British Columbia (MOA) in the summer of 2017. We present findings from an audience research project undertaken with Indigenous university students examining this exhibition. With this foundation, we explore these students' responses in conjunction with how *In a Different Light* provides opportunities for the self-representations of Indigenous value systems. We conclude with a discussion of work by museums and collectors to reconnect heritage with communities of origin and restore Indigenous value systems.

The coastal region of the Pacific Northwest coast of North America are home to numerous Indigenous nations. Multiple languages, ontologies, and governance systems exist along this coast. Extensive trade networks, economies, and elaborate social and kinship systems created ties across the nations within and beyond this region before the disruptions created by European colonization. This region is often referred to by scholars as the Northwest Coast culture area. The material culture heritage these peoples created, prior to and just post-European contact, are the luxury goods referred to in this chapter as *belongings* and *treasures*.

1 We thank the curators and exhibit reviewers who generously shared their thoughts and perspectives on *In a Different Light*: Karen Thomas, Heather Burge, Kay Collins, Autumn Schnell, Karen Duffek, Jordan Wilson, and Bill McLennan. We extend another thanks to Karen Duffek and Christopher W. Smith for their supportive conversations, which shaped the direction and content of this paper. A special thank you also to Sarah Holland who helped us fully understand one of the stories we included.

https://doi.org/10.1515/9783110732757-005

The terms *belongings* and *treasures* frame Northwest Coast historical pieces through a different lens. Common museum terms include objects, artworks, artifacts, and, sometimes, specimens. These terms create a sense of distance, framing these belongings and treasures as specimens for academic study. They also act as forms of colonial cultural erasure and are part of the dissociation we are examining. Belongings, as used here, was proposed by several Musqueam community members, including Larry Grant, Morgan Guerin, and Debra Sparrow, prior to and during the development of the exhibition *c̓əsnaʔəm: the city before the city*. They employed this term to reclaim their heritage and assert their rights as creators and descendants of creators to speak about these belongings. Referring to tools recovered from ancient villages, elder Larry Grant noted, "Those things belonged to somebody, they didn't just appear in some pile of dirt. They belonged to someone, and that's how it was always explained to us." Morgan Guerin added, "There is a little bit of our soul that goes into everything we make. There's a prayer in every stroke, because if you don't believe in it, if you don't put it in there, it won't work" (Wilson and Rowley 2016). MOA and other museums are increasingly using this term (Kramer 2015; Collison and Levell 2018).

Conceptions of Luxury and 20th Century Western Interpretations of Northwest Coast Art

Luxury goods existed prior to European contact and included systems of patronage whereby the wealthy hired the most skilled artists to bring into being treasures for their families and clans (Jensen in Duffek 2013: p. 621; Hoover 2004: p. 93). These treasures, symbols of family wealth, were danced and displayed during ceremonies, now collectively known as *potlatches*. At these events, still a vibrant part of Northwest Coast Nations, governance takes place, rights, privileges and titles are acknowledged and inherited, names are given, and rites of passage occur. After the ceremony, these movable treasures were carefully stored away. These concepts of luxury differ from Western systems whereby luxury includes prestige through display in homes and in non-ceremonial settings.

European diseases, against which Northwest Coast Indigenous peoples had no immunity, followed ancient trade routes and decimated populations before Europeans physically arrived on the coast in the late 18th century. Wave upon wave of disease followed, in some areas wiping out over 90% of the population. British settlers declared the lands *terra nullius* (uninhabited) and settled wherever they wished. These settlers created a reserve system curtailing Indigenous access to their lands, imposed fishing and hunting regulations, and developed a residential schooling system to forcibly assimilate Indigenous children. In 1876, the Canadian government passed the Indian Act. This legislation defines who are and are not status First Nations in

Canada. Over the years, numerous clauses have been added to further circumscribe First Nations. The potlatch, seen as antithetical to the goals of the state and the church, was banned in 1884.[2] At the second reading of the bill, Prime Minister John A. Macdonald stated, "This Indian festival is debauchery of the worst kind, and the departmental officers and all clergymen unite in affirming that it is absolutely necessary to put this practice down" (Canada 1884: p. 1063). This cultural genocide practiced by the Canadian state caused a rupture in the creation of treasures, ceremonial regalia, and other belongings. It is deeply ironic that these deliberate acts led directly to the salvage paradigm whereby agents of the state sought to collect and encase the material heritage of Indigenous peoples, preserving it in museums as the vestiges of dying primitive cultures.

Museums in 19th- and early 20th-century Europe and North America, through their exhibitions of the heritage of Indigenous peoples, played into and reinforced ideas of the primitive and the exotic. They also elevated certain items by setting them aside as rare, unique, or worthy. Museums thus assisted in creating the market in Northwest Coast heritage collections (Hawker 2013: p. 379) and helped to set the stage for their transition from belongings with cultural context and use into Western luxury goods.

The transition from Western curiosity to luxury goods took place gradually. In the 19th and early 20th centuries, collectors of Northwest Coast heritage created shopping lists of items to acquire. Masks, bowls, goat horn spoons, and totem poles were highly prized. The status of totem poles as monumental and scarce works increased their appeal to such an extent that the Indian Act was amended in 1926 making it illegal to remove any "grave-house, carved grave-pole, totem-pole, carved house-post of large rock embellished with paintings or carvings . . ." from an Indian reserve without written consent of the Superintendent General of Indian Affairs (Hinge ca. 1985: p. 212; Cole 1995: p. 285; Hawker 2002: pp. 54–55).

> A London Government official to whom I happened to mention the American "collecting" craze, told me that he had a personal grievance in the matter. He is unable to get a totem pole for which his heart craved. So active have the American visitors to Canada been in their acquisition of totem poles – sometimes they carried off poles 30 feet long! – that the British Columbia authorities have put their foot down and refused to allow the export of a single specimen.
> (*The Derby Daily Telegraph*, Saturday January 4, 1930)

Canada as a country was founded in 1867. Within the emerging Canadian society, there was a search for a Canadian identity to distinguish Canada from the United States and Britain. In 1913, painter Emily Carr observed, "I glory in our wonderful west and I hope to leave behind me some of the relics of its first primitive greatness. These things should be to us Canadians what the ancient Briton's relics are to the English" (Carr 1913 in Shadbolt 1990: p. 104; Crosby 1991). The sentiment that

2 The Indian Act still exists, however, the amendment outlawing the potlatch was removed in 1951.

Northwest Coast belongings represented a truly Canadian art form was also champ-ioned by anthropologists Harlan I. Smith and Marius Barbeau in the late 1920s (Dawn 2006; Dawn 2013: pp. 313–317). In 1927, the Canadian government mounted two major Canadian Art exhibitions: one in Paris and one in Canada. In both, the works of the Group of Seven, contemporary Canadian landscape painters, were shown alongside Northwest Coast belongings (Dawn 2013: p. 306).

A number of French surrealists collected Northwest Coast treasures in New York galleries and some traveled to the region in the 1930s (Ades 2011; Browne 2011; Mauzé 2011, 2013; Townsend-Gault 2013). Their interest demonstrates a nascent tran-sition from art as identity into high art. By 1939, treasures from the Northwest Coast were beginning to be recognized as ". . . an art of high aesthetic worth" (McInnes 1939 in Dawn 2013: p. 337). As Marjorie Halpin (1978: p. 51) noted, famous French anthropologist "Claude Levi-Strauss was ahead of his time when he wrote: 'Certainly the time is not far distant when the collections of the Northwest Coast will move from anthropology museum to take their place in art museums among the arts of Egypt, Persia, and the Middle Ages.' (Levi-Strauss 1943: p. 175)."

Throughout the 1960s and 70s the transition from curios into high art, and thus luxury goods, continued. Two events in Vancouver highlighted this transition: *Arts of the Raven* in 1967 and the opening of MOA (Museum of Anthropology at UBC) in 1976. The exhibition *Arts of the Raven* argued that Northwest Coast belongings can be appreciated aesthetically by erasing their cultural contexts and significance. Cu-rator Doris Shadbolt wrote, "this is an exhibition of art, high art, not ethnology" (Shadbolt in VAG 1967: p. i). *Arts of the Raven* was seen as marking the "threshold over which Northwest Coast art had come into recognition as 'fine art' as well as 'primitive art'" (Duff et. al. 1975: p. 13).

Arts of the Raven was followed by other statements of Northwest Coast works as art within a Western European framework, the most impressive of these being the main galleries of the new MOA building, which opened in 1976. The seminal Great Hall displayed massive carvings from many nations while the adjacent Masterworks Gallery highlighted smaller works including masks, spoons, bowls, and silver and gold bracelets (MOA 1975a; MOA 1975b). Curator Marjorie Halpin noted that the gal-lery was designed to "enhance the visitor's enjoyment of Northwest Coast Indian objects as 'art'" (MOA 1975a: p. 41). These treasures had labels identifying the cul-ture and time period of the works but were devoid of information on their role within their cultures of origin or their histories of dislocation and acquisition.

The term "masterworks," as it has been applied to Indigenous art, carries bag-gage. When a belonging is considered a masterwork, the formal, aesthetic aspects of that belonging are privileged with limited consideration given to associated in-tangible meanings. They are frequently displayed in glass cases or on plinths con-taining small labels written by museum professionals, reminiscent of the windows of exclusive jewelry boutiques. This transition led to a rapid increase in monetary value in the market of these increasingly sought after and rare masterworks.

This trend follows what curator Karen Duffek has termed "value added" whereby outsiders applied "modernist values of isolating an object from its cultural context in order to enhance its value as art" (Duffek 2013: p. 594). These exhibitions fed a growing connoisseurship as well as an awareness of the increasing scarcity of these works in the market. Within this framework, the owners of these works are viewed by others as wealthy individuals possessing refined taste. This led to further increases in value increasing the status of these belongings and treasures as luxury goods attainable only by the very wealthy.

An analysis of the dollar values achieved for Chilkat robes in the auction market demonstrates this trend. Chilkat robes are family treasures woven from mountain goat hair and strengthened with cedar bark. The fibers are hand spun and naturally dyed before being woven into blankets with intricate designs. These robes convey histories, rights, and privileges as well as demonstrating family wealth and power. Within their original cultural contexts they were and continue to be luxury treasures. In the market, they became iconic symbols of the Northwest Coast. Sale prices were located by examining auction catalogs and online resources. Eighty-four records from 1970 to 2020 were reviewed. In the decades between 1970 to 2010 the average cost of a historic Chilkat robe increased tenfold from about USD $4,000 from 1970–1979 to about USD $40,000 from 2000–2009. The past 10 years have witnessed a very slight decline to an average of about USD $33,500.

Similar and even more dramatic trends are seen in historic masks. A scan of auction records of masks created by Kwakwa̱ka'wakw peoples shows the achieved prices almost quadrupling in the period from 1970 to 1980. These markets are driven to dazzling heights when a particularly rare piece reaches the market. Such was the case in 2006 when a Tsimshian mask sold for USD $1.8 million at Sotheby's and in 2012 when a Nuu-chah-nulth club provenanced to Captain Cook's 1778 voyage was sold by a dealer for about USD $1 million. The timing of these increases highlights the complicity of museums in the creation of a luxury market in Northwest Coast historic treasures. By identifying them as masterpieces and 'high art' and displaying them in specially lit boutique cases, these works are read by museum visitors as luxury goods to be consumed.

Until recently, North American museums have privileged European, Euro-American, and Euro-Canadian worldviews and knowledge systems, employing them to structure, design, and curate exhibits. These museum processes reinterpret and value Northwest Coast belongings while these institutions occupy land from which Indigenous peoples are dispossessed (Phillips 2011; Greene 2016; Turner 2017, 2021). ḵi-ḵe-in describes the effects of these museum processes: "They have helped to create a new setting, where much of the richness and many of the complex meanings faded away, the superficial details are stressed, and decoration seems to be the focus" (2013: p. 686).

Increasingly, museums are recognizing their collective histories and uplifting the priorities of communities of origin, specifically through collaborative museology.

Collaborative museology responds to calls from Indigenous peoples to speak for themselves and their heritage. This practice has resulted in repatriations (Krmpotich and Peers 2013), databases more intuitive for those unfamiliar with museum cataloging (Rowley 2013; Leischner 2018), exhibits that validate the worldviews of those who see their ancestors' belongings within the exhibits (Kramer 2015; Wilson 2016, 2015; Shannon 2014), conservation standards that prioritize community use of belongings (Clavir 2002), and more welcoming museum spaces (Phillips 2011). *In a Different Light* is one example of how MOA is responding to colonial histories.

In a Different Light and the Museum of Anthropology

The curators of MOA intended *In a Different Light* to upend the messaging of *Arts of the Raven* by reconnecting communities with belongings and treasures, and presenting their intangible meanings to the public. In 2017, this exhibition inaugurated the new Elspeth McConnell Gallery of Northwest Coast Masterworks at MOA.

The location of *In a Different Light* is significant. MOA and UBC are situated on the ancestral, unceded territories of the *hən̓q̓əmin̓əm̓* speaking Musqueam peoples. Acknowledging MOA's location, MOA staff have a history of developing relationships with Musqueam and other Northwest Coast peoples and nations. This has resulted in a robust focus on collaborative museology, which is documented within publications by MOA staff and students (Phillips 2011; Ames 1992; Kramer 2015; Leischner 2018; Schultz 2011; Balcombe 2018; Duffek 2013; Wilson 2015; Fortney 2009). MOA director from 1974–1997 Michael Ames set a tone by documenting how collaboratively developed exhibits create more positive experiences for the descendants of belonging makers (Ames 1992; 1999). Ruth Phillips, director from 1997–2003, and Anthony Shelton, director since 2003, have continued this focus on critical museology. Additionally, MOA is a significant location for *In a Different Light* because the curatorial goal of presenting displayed belongings' intangible meanings stands in contrast to MOA's early exhibits in the Great Hall, which framed works as art and "masterworks," much like *Arts of the Raven*.

The MOA curators who developed *In a Different Light* include Jordan Wilson, Karen Duffek, and the late Bill McLennan. Jordan Wilson is a member of the Musqueam Indian Band. During the exhibit development he was a Canada Council for the Arts Aboriginal Curator-in-Residence at MOA. Karen Duffek is a settler and the Curator of Contemporary Visual Arts and Pacific Northwest. Her research explores cultural belongings and she works with contemporary art and artists across disciplines. William McLennan was a settler and a Curator Emeritus of the Pacific Northwest.

Preparations for this exhibit began when Elspeth McConnell decided to bequeath MOA her collection of 400 plus Northwest Coast contemporary and historical works

and cultural belongings. The Doggone Foundation, created by Elspeth McConnell, granted MOA funds to create a gallery to exhibit these works and other Northwest Coast treasures. Subsequently, MOA began building the Elspeth McConnell Gallery of Northwest Coast Masterworks. McLennan, Wilson, and Duffek worked in conjunction with 30 First Nations artists, curators, and knowledge-keepers to develop this gallery's first exhibit, *In a Different Light: Reflecting on Northwest Coast Art* (see Figure 5.1) (Duffek, McLennan, and Wilson 2021).

The curators aimed to contextualize displayed belongings with specific cultural meanings: "these works of art are more than art" (Duffek, in Wilson and Duffek 2018). They intended to bring "in this intangible aspect," the cultural contexts and significance, by "putting [belongings] back in connection with people" (Wilson and Duffek 2018; Duffek 2021). Wison and Duffek had some hesitations concerning the gallery's title, specifically the term "masterworks" (Wilson and Duffek 2018). McLennan, on the other hand, expressed no problem with the term "masterwork," as it encourages close looking, demonstrating the importance of Northwest Coast cultures (McLennan 2018). McLennan's thoughts reference how the belongings chosen for this exhibit can be associated with luxury, as close looking highlights the fine detailing, the connoisseurship, associated with them. Wilson, Duffek, and McLennan's thoughts on *In a Different Light* illustrate the overlapping, but distinct conceptions each curator has for this gallery.

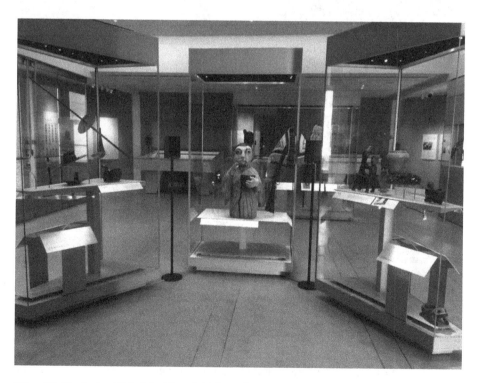

Figure 5.1: The first exhibit of the Elspeth McConnell Gallery of Northwest Coast Masterworks.

In a Different Light frames Northwest Coast 19th- and 20th-century belongings as belongings and treasures, luxury goods, within their original cultural contexts by re-framing these works through the thoughts of contemporary Northwest Coast community members. Like many art museums, labels list the artist names, dates, and the materials used. The gallery aesthetic is minimal. Described as the "grey box" by Erica Balcombe in her analysis on the design of this gallery (2018), the walls, floors, and wall texts draw on a grey color palette, except for two "idea chairs," which are bright red. The display cases are made with non-reflective glass and are positioned away from walls to encourage close looking (McLennan 2018; Wilson and Duffek 2018). Belongings are mounted to maximize as many viewing angles as possible (see Figures 5.2 and 5.3). Everything is done to minimize the impact of the space and maximize viewers' focus on the belongings. The text, video, and audio content, presented in first person voice, connects the belongings with their cultural contexts.

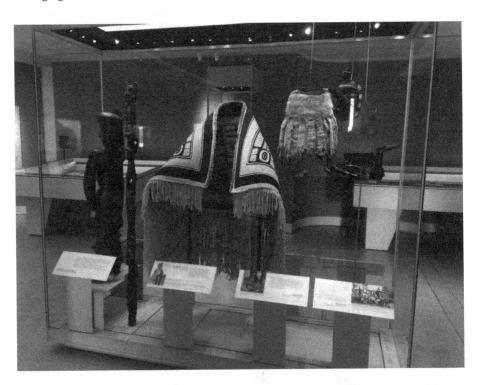

Figure 5.2: Belongings are mounted to maximize as many viewing angles as possible.

Throughout *In a Different Light*, museumgoers read and hear quotes from the First Nations contributors who participated in exhibit development. These artists, cura-tors, and knowledge-keepers interacted with belongings while being interviewed. Portions of these interviews are included within text panels and gallery wide audio (McLennan 2018; Wilson and Duffek 2018). Their thoughts emphasize how the

belongings displayed have meanings linked to many aspects of life including law, governance, food culture, and history.

Figure 5.3: The walls, floors, and wall texts of the exhibit draw on a grey color palette, except for two "idea chairs," which are bright red.

Museumgoers also encounter photographs, both contemporary and historical, and film footage. These visuals place belongings within community contexts where they are created, danced, worn, and used, demonstrating continuity and reclaiming this heritage. Film footage also includes scenes of Northwest Coast forests and bodies of water, and MOA collections facilities.

Wilson, Duffek, and McLennan chose aspects of the exhibit, specifically the media of presentation, strategically. For example, the display cases group belongings thematically with a gerund verb to describe a given theme, such as "feasting," "traveling," or "Indigenizing." These titles, along with the film footage, are intended to convey a sense of motion, to interrupt the static nature of museum exhibits (McLennan 2018; Wilson and Duffek 2018). Additionally, the photographs and film scenes of collection contexts aim to prompt consideration of the social lives of the belongings displayed. Overall, *In a Different Light* aims to challenge uncritical perspectives of Northwest Coast art as "high art," which ignores the multiple meanings imbued by makers to focus solely on form and aesthetic value.

Responses to *In a Different Light*

An audience research project explored Indigenous museumgoers' reactions to this exhibition and its messaging, eliciting the perspectives of four Indigenous women who were students or recent graduates of UBC. These interviews, both those conducted with the curators and exhibit reviewers,[3] were focused on continual evaluation of museum exhibitions and aimed to bring curators and museum audiences into conversation with one another, as discussions about exhibit spaces often stop after installation. The interviews, and initial framings of this project, were grounded within museum anthropology and First Nations and Indigenous studies literatures. The interview questions focused on exhibit content, media of presentation, curatorial intentions, and gallery experiences. The perspectives of the exhibit reviewers included within this chapter discuss concepts of value within Indigenous knowledge systems. The words of these women allude to Indigenous concepts of luxury based on ways of sharing and knowing.

Museums can elicit myriad feelings within audiences, such as alienation based on language use, financial barriers, (mis)representation, and/or a lack of representation (Tolia-Kelly 2017; Dawson 2014; Dodd et al. 2012; Frank 2000). Museum experiences can also surface affects, memories of personal and collective experiences, and associations with some potentially violent histories (Crang and Tolia-Kelly 2010; Tolia-Kelly, Wateron, and Watson 2017; Million 2008).

Given that museums can and often have excluded Indigenous peoples, it is also important to note that museums "serve as formal sanctioned spaces of memory," constructing knowledge about both the past and the present (Tolia-Kelly 2017: p. 1). This means that the memories, personal and intergenerational, that people carry to museums, can overlap with the historical narratives museums present, finding either affirmation, invalidation, or something in between. The Indigenous women, whose perspectives are included here, interpreted *In a Different Light* with "heart knowledge," or emotion, and also "thought or intellect" (Simpson 2017: p. 28; Million 2008).

These women all live and work in the Vancouver metropolitan area and are current or former students at the University of British Columbia (UBC). Karen Rose Thomas is səlilwətaɬ (Tsleil-Waututh) and, at the time, a graduate student in archaeology. Kay Collins is an Indigenous woman and a graduate of the Information School. Autumn Schnell is Gwich'in, Inuvialuit, and Dene. At the time of the interviews, they were second-year undergraduates in the First Nations and Indigenous Studies program. Heather Burge is Mohawk and adopted Tlingit.

When thinking about *In a Different Light,* Thomas discussed the ways that Western thought has reinterpreted cultural belongings: "I think everything is contact,

3 The Indigenous women who contributed their thoughts to this chapter are referred to as exhibit reviewers.

proto-historic period and I think that just speaks to the way the settler art world transforms objects, I guess, from utilitarian objects to art to be appreciated" (Thomas 2019). Thomas' comment highlights how *In a Different Light* frames the displayed belongings as art in addition to belongings and treasures. The curators pondered how best to communicate to audiences the complexity of meanings tied to the displayed belongings:

> Despite the fact that we weren't grappling directly with this idea of masterworks, I think we had that idea that we'd try to unsettle the viewer or to challenge the viewer to look at things differently. It was our hope that the community voices would intervene in a way in terms of how people, like how museum visitors, look at and relate to the object.
>
> (Wilson, in Wilson and Duffek 2018)

Thomas' and Wilson's thoughts underscore how within Indigenous knowledge systems the belongings displayed have intangible meanings.

Kay Collins elaborates on these thoughts: "Something that is ceremonial is also a part of governance, is also a part of artwork, also a part of family and history. It's all bound up in one another, but generally it seemed like each piece was something that was removed from the community through colonization" (Collins 2018). For Collins, the perspectives of the First Nations contributors made a difference by illustrating belonging connections with cultural practices rather than rupture. She describes how the exhibit communicated a message of continuity:

> These things are still happening and being cared for, and it's part of a history when these things were being erased or trying to be taken away or snuffed out and so being in the exhibit was great, because it highlighted how these things are still taking place – feasts are still happening – instead of seeing all of these old photographs. (Collins 2019)

The displayed belongings and similar items continue to be used within Indigenous communities. This focus on longevity of cultural practice within *In a Different Light* was important. Duffek speaks to this exhibit messaging: "You don't want this idea that it's all in the past" (Wilson and Duffek 2018). The curators intended *In a Different Light* to upend the arguments made by *Arts of the Raven* from 1967. This intention further distanced *In a Different Light* from MOA's earliest exhibits as well, demonstrating how belongings are connected with land and people.

Autumn Schnell's thoughts echo those of Thomas and Collins. Schnell describes the multiple, interrelated meanings belongings have and their uses within originating contexts:

> I saw Marianne Nicolson's quote and it said that they want the public to know that these are legal documents and I think that hit really hard. It's really cool to see traditional governance and the ways art was the pinnacle of that. It made me think of back home how we always have traditional pieces of regalia that will let other people know which nation you're from or just easy identifiers or how there are specific bead patterns that you use and how that was a way of governance. And it let people know which Nation you belong in and specifically within

your Nation who had governing power and who didn't. It also said, "we need to reconstitute these objects and their meanings back to our political actions," and I guess that really hit that it was resurgent. (Schnell 2019)

Schnell connects governance and material culture, elucidating the ways *In a Different Light* communicates this link and why it is important.

For Heather Burge, some of the curatorial efforts were successful. For example, Burge liked the idea chair with the recording from Tallio:

It was a story about that object, but not just any: it was a story about what that mask was representing and the story behind that mask. I personally felt more connected to that particular object knowing that story. It's more than just "oh, that must have taken a lot of work," but this is what it is, this is what it was supposed to be, and this was the cultural context it came from. I liked it. (Burge 2019)

Burge felt connected to this mask because she learned information about its "cultural context." However, Burge did not encounter this same feeling at every display within *In a Different Light*. She expressed some concerns about the design of the gallery: "what I struggled with was, in attempting to make it just about the pieces, it seemed very sterile and I think of a fancy art gallery, modern" (Burge 2019). In contrast to aspects of the exhibit that elicited feelings of connection, Burge found the design of the gallery distracting, which made her feel unconnected from the works. Her interviews highlight how museum exhibits do not always use a belonging the way makers intended them to be used, alluding to the ways museums participate within the art market's processes of ascribing monetary value to belongings (Burge 2018; Burge 2019).

In addition to discussing this closeness and distance, Burge spoke generally about her experiences visiting museums and the associated affects these spaces surface: "I'm sure not every object was stolen from a grave and put on display, but some really were and so all of them could be that thing. There's a certain sadness to having them here and not having them where they would have been one hundred years ago" (Burge 2018). Museums can elicit personal and intergenerational memories tied to violent histories. Burge's words speak to how museum and collecting processes have harmed Indigenous peoples by erasing their cultures, all while the modern and contemporary art market has reinterpreted these belongings within Western luxury paradigms.

The exhibit reviewers' words allude to issues of authority, specifically who can and should speak about Northwest Coast belongings within museum collections. Historically, museums did acquire certain belongings under duress or coercion and often interpreted these works without any input from descendant communities. All of these women express how the displayed belongings are imbued with meanings and purposes not relegated to art, as explored by the perspectives of the First Nations contributors included within *In a Different Light*. The contributors' thoughts elicited relational experiences for the exhibit reviewers in part because of who got

to speak about the displayed belongings: "Having this narration and these people who are themselves artists and creators and are from this culture talking about their own personal relationships to just art in general and to creation in general just made the exhibit that much more meaningful, in a way that just reading a plaque that may not evoke that amount of emotion" (Burge interview, January 18, 2019). In contrast, "Museums have typically preferred the *Wizard of Oz* technique: Exhibits present the anonymous voice of authority, while in reality texts are constructed by one or more curators hiding behind the screens of the institution" (Ames, 2005: p. 48). This method of interpreting belongings reinforces the construction of a luxury goods market, within which museums participate by valuing belongings and framing them, sometimes solely, as art.

Repatriating Belongings

In this chapter, we have examined how Northwest Coast historic treasures were separated from their cultures by colonial ventures and transformed into Western luxury goods where value has been ascribed through aesthetics and scarcity. Indigenous communities worldwide are seeking to restore the value and intention of cultural belongings housed in museums.

Museums are clearly complicit in the creation of the market and establishment of Northwest Coast art as luxury goods and thus must redress this history as part of their work in implementing the United Nations Declaration on the Rights of Indigenous Peoples. The *In a Different Light* exhibition brings to the public an understanding of the ways that these treasures were separated from community. The voices of the artists and knowledge-keepers who participated illustrates that these treasures are alive. They have inherent values and have active roles to play within communities today. *In a Different Light* performs critical work in informing the public and changing perceptions of the values of these works as more than art.

Exhibitions such as *In A Different Light* are one way museums are responding to their colonial history through collaborative museological work. Repatriation of belongings to Indigenous nations and peoples is another way. It acknowledges that many of these treasures were removed through theft or coercion. Increasingly, museum professionals are returning belongings in creative ways that use existing museum structures to support the goals of Indigenous peoples (Chavez Lamar 2019; Duke 2019; Poeh Cultural Center n.d.) as well as providing access in other innovative ways (Cooper and Swierenga 2020). Some countries, such as the United States, have legislation requiring institutions to engage in repatriation. Increasingly, there are global calls for the repatriation of these treasures.

Concepts of luxury within a Western paradigm often prevent Indigenous families from reclaiming their heritage. As we have demonstrated, entry into the market

is possible only for the very wealthy. How does this impact just society ideals, reconciliation, and decolonization movements? This is a complicated issue raising many additional questions. Repatriations from private collectors to communities of origin have been an uncommon occurrence but are becoming more frequent. Collectors and dealers have recognized the diaspora of Indigenous collections and have responded in different ways. Walter Koerner, a lumber baron in British Columbia, collected Northwest Coast works from Europe and the United States beginning in the mid-1900s. "Koerner likes to say most of his pieces were repatriated from other countries – returned to their place of birth" (Grescoe 1976: p. 15). He donated his collection to MOA. Likewise, the Nuu-chah-nulth club mentioned earlier was purchased by the Audain Foundation, and also donated to MOA. Foundation Chairman Michael Audain noted:

> While certain Nuu-chah-nulth objects collected by Cook exist in museums abroad – for example, in London, Berlin, and Vienna – this is the first and only in Canada. With our Foundation's donation, I hope to encourage the repatriation of other Northwest Coast art works to public museums and cultural centres in British Columbia. (UBC News March 20, 2012)

An example that illustrates not only value differences in luxury items but also the complexity of the market and its entangled history with museums is the case of a Kwakwaka'wakw sun mask loaned as a promised gift to the U'mista Cultural Centre[4] in 2019 by Donald Ellis, a well-known dealer in historic Northwest Coast pieces (Johnson 2020). In 1921, this mask was present at Namgis Chief Dan Cranmer's potlatch on Village Island. The potlatch was held in secret because of the Indian Act ban on potlatches. However, the Indian agent and police discovered the plans and raided the event, arresting participants and seizing regalia. The owners of the regalia were presented with an illegal choice: give up their regalia or go to jail. Many of the seized treasures ended up in museums in eastern Canada. However, the Indian agent undertook another illegal action by selling several of the masks including the sun mask to George Heye, director of a private museum in New York.[5] Claude Levi-Strauss purchased the mask in New York after World War II and took it home to France. He later sold it and in 2017 it was about to be auctioned at Christie's. French anthropologist Marie Mauzé was asked to write for the auction catalog. A scholar who has written extensively on the Cranmer potlatch (Mauzé 2003), she recognized the mask and informed Donald Ellis, who began looking for a way to bring the mask back to U'mista. Journalist Marsha Lederman wrote: "Mr. Ellis decided to

4 The U'mista Cultural Centre in Alert Bay, British Columbia, was established to house the treasures seized during the raid on the Cranmer potlatch of 1921 and repatriated from museums to the Kwakwaka'wakw peoples.

5 Heye founded the Museum of the American Indian in 1916. In 1989 the museum was transferred to the Smithsonian Institution and its collections became the foundation of the National Museum of the American Indian (National Museum of the American Indian nd.).

purchase it himself for U'mista. "I have a pretty strong sense of right and wrong," Mr. Ellis said of his motivation "I want this to show that . . . dealers are not all bad guys." Also, he says, he has done very well and wanted to do something to give back" (Lederman 2019). This example demonstrates not only the entangled nature of museums and anthropologists with collectors and dealers but also raises questions about value and return.

Conclusion

Within this chapter, we have explored interrelated aspects of the luxury art market and museums: (1) the role of museums and collectors in removing cultural property from their communities of origin and transforming them into a commodity within Western markets, (2) the role museums are increasingly playing in making reconnections and providing forums for self-representation, and (3) how Indigenous nations and communities are regaining ownership of their belongings and treasures through various means. We examined the market through records of Northwest Coast belongings and analyzed their relationship with historical shifts, which influenced market values. *In a Different Light: Reflecting on Northwest Coast Art* is one example of how Indigenous audiences, scholars, curators, and knowledge keepers are thinking about belongings and treasures within Indigenous systems of value, and how the University of British Columbia's Museum of Anthropology is centering their voices and sharing their words with museumgoers. Lastly, this chapter discussed challenges Indigenous peoples may face when working to regain access and ownership of belongings and treasures within private collections.

Western and Indigenous conceptions of luxury are both systems of value. However, one is extractive, often private, and representative of past and ongoing colonial processes. In closing we ask: Can there be a luxury goods market based on the stolen or questionably removed heritage of others? Ethically and socially, how can this be justified?

References

Ades, Dawn (ed.) (2011). *The Colour of My Dreams: The Surrealist Revolution in Art*. Vancouver: Vancouver Art Gallery.

Ames, Michael M. (2005). "Museology Interrupted." *Museum International* 57 (3): 44–51.

Ames, Michael M. (1999). "How to Decorate a House: The Renegotiation of Cultural Representations at the University of British Columbia Museum of Anthropology." *Museum Anthropology* 22 (3): 41–51.

Ames, Michael M. (1992). *Cannibal Tours and Glass Boxes: The Anthropology of Museums*. Vancouver: UBC Press.

Balcombe, Erika (2018). "Making Space: New Aesthetics in the Masterworks Gallery at the UBC Museum of Anthropology." MA Thesis, University of British Columbia.

Browne, Colin (2011). "Scavengers of Paradise." In Ades, Dawn (ed.), *The Colour of My Dreams: The Surrealist Revolution in Art*. Vancouver: Vancouver Art Gallery, 245–264.

Burge, Heather (2019). Interview by Amanda Sorensen. MA Thesis Interview. Vancouver, January 18, 2019.

Burge, Heather (2018). Interview by Amanda Sorensen. MA Thesis Interview. Vancouver, December 18, 2018.

Canada, House of Commons, Debates [Hansard], 24 March 1884, 1063.

Chavez Lamar, Cynthia (2019). "A Pathway Home: Connecting Museum Collections with Native Communities." *Arts* 8 (4): 154. https://doi.org/10.3390/arts8040154

Clavir, Miriam (2002). *Preserving What is Valued: Museums, Conservation, and First Nations*. Vancouver: UBC Press.

Cole, Douglas (1995). *Captured Heritage: The Scramble for Northwest Coast Artifacts*. Norman: University of Oklahoma Press.

Collison, Jisgang Nika, and Nicola Levell (2018). "Curators Talk: A Conversation." *BC Studies* 199: 53–79.

Collins, Kay (2019). Interview by Amanda Sorensen. MA Thesis Interview. Vancouver, January 17, 2019.

Collins, Kay (2018). Interview by Amanda Sorensen. MA Thesis Interview. Vancouver, December, 2018.

Cooper, Catherine, and Swierenga, Heidi (2020). "Preservation Technology: A Conversation With Heidi Swierenga." *MOA Magazine*, Fall 2020: 18–21. Accessed June 5, 2021. https://online.fliphtml5.com/xkla/zxko/#p=1

Crang, Mike, and Tolia-Kelly, Divya P. (2010). "Nation, Race, and Affect: Senses and Sensibilities at National Heritage Sites." *Environment and Planning A* 42 (10): 2315–31.

Crosby, M. (1991). "Construction of the Imaginary Indian." In Douglas, Stan (eds.), *Vancouver Anthology: The Institutional Politics of Art*. Vancouver: Talonbooks, 267–291.

Dawn, Leslie (2006). *National Visions, National Blindness: Canadian Art and Identities in the 1920s*. Vancouver: UBC Press, 456.

Dawn, Leslie (2013). Northwest Coast Art and Canadian Identity, 1900–1950. In Townsend-Gault, Charlotte, Jennifer Kramer, and ḳi-ḳe-in (eds), *Native Art of the Northwest Coast: A History of Changing Ideas*. Vancouver: UBC Press, 304–347.

Dawson, Emily (2014). "'not designed for us': How Science Museums and Science Centers Socially Exclude Low-income, Minority Ethnic Groups." *Science Education* 98 (6): 981–1008.

Dodd, Jocelyn, Jones, Ceri, Sawyer, Andy and Tseliou, Maris-Anna (2012). *Voices from the Museum: Qualitative Research Conducted in Europe's National Museums (EuNaMus Report No 6)*. Linkoping: Linkoping University Electronic Press.

Duff, Wilson, Hilary Stewart, Art Gallery of Greater Victoria. 1975. *Images Stone B.C.: Thirty Centuries of Northwest Coast Indian Sculpture: An Exhibition Originating at the Art Gallery of Greater Victoria*. Saanichton, BC: Hancock House.

Duffek, Karen (2013). "Value Added: The Northwest Coast Art Market since 1965." In Townsend-Gault, Charlotte, Jennifer Kramer, and Ḳi-ḳe-in (eds), *Native Art of the Northwest Coast: A History of Changing Ideas*. Vancouver: UBC Press, 590–632.

Duffek, Karen (2021). "In a Different Light: Reflecting on Northwest Coast Art." Panel, The Work We Do from the Museum of Anthropology at UBC, online, May 27, 2021.

Duffek, Karen, McLennan, Bill, and Wilson, Jordan (2021). *Where the Power Is: Indigenous Perspectives on Northwest Coast Art*. Vancouver: Figure 1.

Duke, Ellie (2019). "100 Pieces of Tewa Pottery Returned to Their Ancestral Home in the Rio Grande Valley." *Hyperallergic*, october 30, 2019. https://hyperallergic.com/525469/100-pieces-of-tewa-pottery-returned-to-their-ancestral-home-in-the-rio-grande-valley/

Fortney, Sharon (2009). "Forging New Partnerships: Coast Salish Communities and Museums." PhD Dissertation, University of British Columbia. Accessed July 18, 2021. https://open.library.ubc.ca/cIRcle/collections/ubctheses/24/items/1.0067741

Frank, Gloria Jean (2000). "'That's My Dinner on Display': A First Nations Reflection on Museum Culture." *BC Studies* 125: 163–178.

Greene, Candace S. (2016). "Material Connections: 'The Smithsonian Effect' in Anthropological Cataloguing." *Museum Anthropology* 39 (2): 147.

Grescoe, Paul (1976). "Native Treasure: Walter Koerner Reclaims West Coast Art." *The Provincial Magazine*. June 19, 1976: 14–16.

Halpin, Marjorie (1978). "Some Implications of Connoisseurship for Northwest Coast Art: A Review Article." *BC Studies: The British Columbian Quarterly* 37 (Spring): 48–59.

Hawker, Ronald William (2002). *Tales of Ghosts: First Nations Art in British Columbia, 1922–61.* Vancouver: UBC Press.

Hawker, Ronald William (2013). "Welfare Politics, Late Salvage, and Indigenous (In)Visibility, 1930–60." In Townsend-Gault, Charlotte, Jennifer Kramer, and Ḵi-ḵe-in (eds), *Native Art of the Northwest Coast: A History of Changing Ideas*. Vancouver: UBC Press, 379–403.

Hinge, Gail (ca. 1985). *Consolidation of Indian Legislation. Volume II: Indian Acts and Amendments, 1868–1975.* Unpublished documents prepared for the Department of Indian and Northern Affairs, Canada.

Hoover, Alan (2004). "Bill Reid: Master of Patronage." In Duffek, Karen, Charlotte Townsend-Gault (eds.), *Bill Reid and Beyond: Expanding on Modern Native Art*. Vancouver: Douglas & McIntyre, 93–117.

Johnson, Juanita (2020). "Sun Mask Returns." *T̓sit̓sikala̱m*, April 2020. https://www.umista.ca/blogs/news/t-sit-sikala-m-april-2020. Accessed June 5, 2021.

Ḵi-ḵe-in (2013). "Art for Whose Sake?" In Townsend-Gault, Charlotte, Jennifer Kramer, and Ḵi-ḵe-in (eds.), *Native Art of the Northwest Coast: A History of Changing Ideas*. Vancouver: UBC Press, 677–719.

Kovach, Margaret (2010). "Conversational Method in Indigenous Research." *First Nations Child and Family Review* 5 (1): 40–48.

Kovach, Margaret (2009). *Indigenous Methodologies: Characteristics, Conversations and Contexts*. Toronto: University of Toronto Press.

Kramer, Jennifer (2015). "Möbius Museology: Curating and Critiquing the Multiversity Galleries at the Museum of Anthropology at the University of British Columbia." In Coombes, Annie and Ruth Phillips (eds.), *The International Handbook of Museum Studies: Museum Transformations*. Hoboken: John Wiley & Sons, Ltd., 489–510.

Krmpotich, Cara, and Laura Peers with the Haida Repatriation Committee and the staff of the Pitt Rivers Museum and the British Museum (2013). *This is Our Life: Haida Material Culture and Changing Museum Practice*. Vancouver: UBC Press.

Leischner, Emily Jean (2018). "Kulhulmcilh and iixsalh: our land and medicine: creating a Nuxalk database of museum collections." MA Thesis, University of British Columbia. https://open.library.ubc.ca/cIRcle/collections/ubctheses/24/items/1.0365710 Accessed June 1, 2021.

Lederman, Marsha (2019). "Almost 100 years after being seized and sold, a Kwakwaka'wakw sun mask returns to B.C." *The Globe and Mail*, July 20, 2019. https://www.theglobeandmail.com/arts/art-and-architecture/article-a-long-journey-back-home-the-kwakwakawakw-sun-mask-witnessed-worlds/. Accessed June 5, 2021.

Levi-Strauss, Claude (1943). "The Art of the Northwest Coast at the American Museum of Natural History." *Gazette des Beaux-Arts* XXIV: 175–82.

Mauzé, Marie (2003). "Two Kwakwaka'Wakw Museums: Heritage and Politics." *Ethnohistory* 50 (3): 503–522.

Mauzé, Marie (2011). "A Kwakwaka'wakw headdress in Andre Breton's collection." In Ades, Dawn (ed.), *The Colour of My Dreams: The Surrealist Revolution in Art*. Vancouver: Vancouver Art Gallery, 265–270.

Mauzé, Marie (2013). "Surrealists and the New York Avant-Garde, 1920–1960." In Townsend-Gault, Charlotte, Jennifer Kramer, and ḳi-ḳe-in (eds.), *Native Art of the Northwest Coast: A History of Changing Ideas*. Vancouver: UBC Press, 270–303.

McLennan, Bill (2018). Interview by Amanda Sorensen. MA Thesis Interview. Vancouver, August 24, 2018.

Million, Dian (2008). "Felt Theory." *American Quarterly* 60 (2): 267–272.

MOA (Museum of Anthropology) (1975a). *Northwest coast Indian artifacts from the H. R. MacMillan Collections in the Museum of Anthropology, the University of British Columbia*. Vancouver: University of British Columbia Press.

MOA (Museum of Anthropology) (1975b). *Indian masterpieces from the Walter and Marianne Koerner collection: in the Museum of Anthropology, the University of British Columbia*. Vancouver: University of British Columbia Press.

National Museum of the American Indian. nd. "History of the Collections." https://americanindian. si.edu/explore/collections/history#:~:text=The%20Museum%20of%20the%20American% 20Indian's%201989%20transfer%20to%20the,all%20aspects%20of%20the%20museum. Accessed June 5, 2021.

Neufert, Alfred (2011). "Ten rolls of 8 mm film documenting Wolfgang Paalen's Journey through British Columbia in Summer 1939." In Ades, Dawn (ed.), *The Colour of My Dreams: The Surrealist Revolution in Art*. Vancouver: Vancouver Art Gallery, 229–236.

Phillips, Ruth B. (2011). *Museum Pieces: Toward the Indigenization of Canadian Museums*. Montreal: McGill-Queen's University Press.

Poeh Cultural Center. n.d. "Di Wae Powa: They Came Back." https://poehcenter.org/diwaepowa/. Accessed May 31, 2021.

Rowley, Susan (2013). "The Reciprocal Research Network: The Development Process." *Museum Anthropology Review* 7 (1–2): 22.

Schnell, Autumn (2019). Interview by Amanda Sorensen. MA Thesis Interview. Vancouver, January 22, 2019.

Schultz, L. (2011). "Collaborative Museology and the Visitor." *Museum Anthropology* 34 (1): 1–12.

Shadbolt, Doris (1990). *Emily Carr*. Vancouver: Douglas & McIntyre.

Shannon, Jennifer (2014). *Our Lives: Collaboration, Native Voice, and the Making of the National Museum of the American Indian*. Santa Fe: SAR Press.

Simpson, Leanne Betasamosake (2017). *As We Have Always Done: Indigenous Freedom Through Radical Resistance*. Minneapolis: University of Minnesota Press.

Thomas, Karen Rose (2019). Interview by Amanda Sorensen. MA Thesis Interview. Vancouver, January 17, 2019.

Tolia-Kelly, Divya P. (2017). "Race and Affect at the Museum: the Museum as a *Theatre of Pain*." In Tolia-Kelly, D.P., E. Waterton, and S. Watson, *Heritage, Affect and Emotion: Politics, Practices, and Infrastructures*. New York: Routledge, 33–46.

Tolia-Kelly, Divya P., Emma Waterton, and Steve Watson (2017). "Introduction: Heritage, Affect and Emotion." In Tolia-Kelly, D.P., E. Waterton, and S. Watson, *Heritage, Affect and Emotion: Politics, Practices, and Infrastructures*. New York: Routledge, 1–11.

Townsend-Gault, Charlotte (2013). "'My World is Surreal' or 'The Northwest Coast is Surreal.'" *Journal of Surrealism and the America* 7 (1): 96–107.

Townsend-Gault, Charlotte, Jennifer Kramer, and Ḳi-ḳe-in (2013) *Native Art of the Northwest Coast: A History of Changing Ideas*. Vancouver: UBC Press.

Turner, H. (2021). *Cataloging Culture: Legacies of Colonialism in Museum Documentation*. Vancouver: UBC Press.

Turner, H. (2017). "Organizing Knowledge in Museums: A Review of Concepts and Concerns." *Knowledge Organization* 35 (3): 472–485.

UBC News. March 20, 2012. "Last privately held object from Captain Cook's collection donated to UBC Museum of Anthropology." https://news.ubc.ca/2012/03/20/last-privately-held-object-from-captain-cooks-collection-donated-to-ubc-museum-of-anthropology/. Accessed May 25, 2021.

VAG (Vancouver Art Gallery) (1967). *Arts of the Raven: masterworks by the northwest coast Indian: an exhibition in honour of the one hundredth anniversary of Canadian Confederation / catalogue text by Wilson Duff, with contributory articles by Bill Holm and Bill Reid*. Vancouver: Vancouver Art Gallery.

Wilson, Jordan (2016). "Gathered Together: Listening to Musqueam Lived Experiences." *Biography: An Interdisciplinary Quarterly* 39 (3): 469–495.

Wilson, Jordan (2015). "sq̓əq̓ip – Gathered Together." MA Thesis, University of British Columbia. https://open.library.ubc.ca/cIRcle/collections/ubctheses/24/items/1.0223194. Accessed May 31, 2021.

Wilson, Jordan, and Karen Duffek (2018). Interview by Amanda Sorensen. MA Thesis Interview. Vancouver, July 25, 2018.

Wilson, Jordan, and Susan Rowley (2016). *c̓əsnaʔəm, the city before the city* exhibition text. On file in the Audrey and Harry Hawthorn Archives, Museum of Anthropology, Vancouver, BC.

Henrik Hagtvedt
Chapter 6
Art and Aesthetics in the Future of Luxury

Popular and scholarly conceptions of luxury afford a noteworthy role to art and aesthetics (Hagtvedt and Patrick 2008a; Kapferer 2014). The aim of this chapter is to discuss the nature of these latter constructs and their relationships with luxury.

As an introductory example, Nueno and Quelch (1998: p. 61) describe luxury products as those "whose ratio of functionality to price is low, while the ratio of intangible and situational utility to price is high." Both of these ratios exemplify some of the intertwined relationships between art, aesthetics, and luxury. The first ratio does not suggest that functionality should be low in absolute terms – consumers expect high functionality from luxury products (Berthon et al. 2009) – but that luxury products tend to provide weaker performance per dollar, as compared to non-luxury alternatives. Notably, aesthetically pleasing design typically contributes to increased prices, but not necessarily to increased functionality, unless the product category is in arts or entertainment; in these latter categories, aesthetic pleasure can be the main function. As for the second ratio, intangible and situational utility might include consumption pleasure (Hagtvedt and Patrick 2009; Kapferer 1997; Vigneron and Johnson 2004), status signaling (Han et al. 2010; Kim et al. 2018), or other symbolic benefits. Precisely these kinds of benefits are also highly characteristic of aesthetics in general and art in specific.

In the following sections, I will present conceptualizations of art and aesthetics, discuss luxury-related research in these domains, and highlight potential research directions to illuminate the roles of art and aesthetics in the future of luxury.

Conceptualizations of Art and Aesthetics

The Art Construct

The definition of art is probably one of the few areas in which people have a harder time coming to agreement than they do in politics. This diversity of opinion has been especially evident during the past century, after the rise of *conceptual art* (Carroll 2000; Gaut and Lopes 2007). For the current purposes, however, we need not restrict ourselves to one specific definition, although it perhaps makes sense to focus primarily on aesthetics-based conceptualizations that fit with the majority of art from the broad sweep of history (Tansey and Kleiner 1996). I also believe that the broader history of art contributes to the luxury-related signals provided by artworks, regardless of specific definitions or art movements favored by present-day

https://doi.org/10.1515/9783110732757-006

observers. This tendency to draw on a colorful past will likely continue in the future of luxury. For example, a work of contemporary art may benefit from the aura of galleries and museums, which in turn echoes the wealth and opulence associated with some of the most salient art displays through the ages as well as the traditions of craftsmanship that have characterized much of the art valued by prior generations. Notably, the modern distinction between art and craft is a relatively recent notion (Hagtvedt et al. 2008; Hauser 1999).

In a stimulus-based conceptualization that fits with a broad range of times and geographic regions, art results from applying creativity and skill to the structuring of formal qualities (e.g., shapes, colors, movements, sounds) to achieve an aesthetic impact (Hagtvedt 2020a). In this conceptualization, one difference between art and craft is that the latter involves art applied to functional products, whereas aesthetic impact, regardless of other functions, is the primary characteristic of pure artworks. Of course, artworks often have other functions too, whether the purpose is decorative, religious, political, financial, or to serve some other task, but such functions are of secondary importance in terms of classifying an object as an artwork. For example, although an altarpiece may have been created as a functional object, that function is not necessarily central to the object's status as an artwork. Arguably, intended functions can even detract from the extent to which a given object qualifies as an artwork. For instance, a consumer could perceive fashion to be wearable art (Venkatesh et al. 2010), but to the extent a clothing item's creator is constrained by practical considerations (e.g., the ease with which a consumer can disrobe), a purist could argue that these considerations hamper artistic freedom and therefore disqualify the work as pure art. According to this view, art is a continuum, such that something is art to varying degrees, depending on how central aesthetic concerns are as opposed to other functional concerns.

These notions reflect one of many possible definitions of art (and even in this view, intended functions can effectively inspire artistic work), but I believe the perspective fits with a vast cornucopia of works across the globe and throughout the ages. In particular, given our current topic of luxury, I believe it fits well with some of the Western traditions that have reinforced the capacity of art to serve as a luxury signal (Drummond 2006; Hagtvedt and Patrick 2008a, 2011a). According to this perspective, one might in fact describe art as one of the purest forms of luxury imaginable.

To reiterate, a variety of conceptualizations are possible, and researchers can choose the one that fits with their own focus, as long as it identifies a unique construct with distinct characteristics. In the context of consumer research, however, consumers' perspectives may be more important than a given scholar's preferences, and that perspective may shift over time. Given the nebulous nature of the art market and the apparent low likelihood that it will become clearer in the future, it may be necessary to pretest a sample population's perceptions of focal constructs in this area of research.

The Aesthetics Construct

Researchers also vary somewhat in their conceptualization of aesthetics. The term initially stems from the Greek word *aisthetikos*, referring to sensory perception. Whereas Alexander Baumgarten (1735/1954) appropriated the term to refer to taste or sense of beauty, Immanuel Kant's *Critique of Judgement* (1790/2007) brought aesthetics into mainstream philosophy. Kant conceptualized the construct more broadly, closer to the original Greek.

In my view, Baumgarten's conceptualization is a bit narrow for the current context; aesthetics is more than beauty, although a sense of beauty is often central to aesthetic experience. For example, the *Oxford Dictionary of Philosophy* defines aesthetics as the "study of the feelings, concepts, and judgments arising from our appreciation of the arts or of the wider class of objects considered moving, or beautiful, or sublime" (Blackburn 2016: p. 10). The term *moving* might here be understood as emotionally stirring in a broad sense. Furthermore, the manner in which something is presented to the senses forms the basis for this emotional response (Hagtvedt and Patrick 2011b). Like an artwork, any object presented to the senses may be visually interesting or appealing because of an interplay between formal qualities (Berlyne 1974). Further, this type of appeal can represent intangible and situational utility that tends to mesh well with luxury products and brands.

To avoid going too far beyond Kant's conceptualization, thereby making aesthetics overly inclusive, I believe it is useful to distinguish between aesthetics and general sensory perception. In my view, sensory perception covers a broader area – consumers do not experience all sensory perception as particularly interesting, appealing, or emotionally stirring, even if it influences their behavior (e.g., as a result of sensory marketing; Krishna 2012). Finally, although vision tends to be the dominant sense – not just in terms of subjective experience, but also in terms of the percentage of cerebral cortex dedicated to visual processing – I believe it is reasonable to conceptualize aesthetics as pertaining to all sensory modalities. Sounds, tastes, scents, and haptic input may all give rise to aesthetic experience. As with art, however, different conceptualizations may be equally valid, and some researchers might restrict aesthetics to the visual realm. The most important point is that individual scholars are clear about their own definitions when conducting research on art or aesthetics.

Luxury-Related Research on Art

Art as a Luxury Product

Luxury products may not be top of mind for those who associate art with the projects their children bring home from school or the drawings that someone might

make in their free time. For much of the art market, however, it seems reasonable to classify artworks as luxury products. In many of those works, experiential and symbolic properties are central, whereas the ratio of functionality to price approaches zero, at least unless one considers the perception or experience of the work as its function. This classification also meshes well with the galleries opening in affluent, densely populated areas, consistent with the patterns seen in luxury retailing (Schuetz and Green 2014).

As noted, however, researchers may differ in which products they include in the art construct as well as how they characterize these product categories. For example, scholars have long distinguished between high and low art (Colbert and St-James 2014; Fisher 2007). According to this perspective, some products may appeal broadly, whereas others appeal exclusively to the refined tastes of an elite (see also Bourdieu 1986 for the social implications of different forms of capital). In typical inter-category segmentation, a set of educated and affluent consumers might appreciate offerings such as opera, ballet, and art galleries, while a broader segment prefers pop music and blockbuster movies. In this example, the former offerings are more likely than the latter ones to have luxury connotations. Notably, some researchers only focus on products typically considered part of the fine-art market and exchanged via sales channels such as galleries, agents, and auction houses. But segmentation can also be implemented on an intra-category level. Within the category of sculpture, for instance, consumers may consider specific artists to be higher brow than others. Notably, to the extent that these classifications depend on subjective assessments, it behooves scholars to rely on data rather than stereotypes.

These types of assessments can depend on the degree of perceived commercialization; there are often tensions between commerce and cultural authenticity in markets for cultural goods (Newman and Bloom 2012; see also Morhart and Malär 2020; see Alexander and Bowler 2021 for related discussions on legitimacy). Some scholars distinguish artists from manufacturers of other marketable products, arguing that the former dedicate their creativity to expressing their subjective visions, independent of consumer demands (Hirschman 1983). The art market, however, does not necessarily reflect such idealism (Joy and Sherry 2003a), and many of the most successful, visible, and critically acclaimed contemporary artists appear to be motivated primarily by commercial aspirations (Velthuis 2012). Further, luxury connotations seem likely to follow from high prices, brand awareness, and strategic product placement in galleries and museums, regardless of idealism or subjective visions.

The central role of branding, which is common in luxury markets, is particularly evident in the realm of art (Baumgarth and O'Reilly 2014; Preece and Kerrigan 2015; Rodner and Kerrigan 2014; Schroeder 2005). It would be difficult to exaggerate the role of conspicuous consumption of brands in high-end art markets, and some collectors even purchase extremely costly work unseen, based only on the brand of the artist or dealer (Thompson 2008). Similar branding effects apply to museums, auction houses, art fairs, critics, and other players in the art market. One of the main benefits

of luxury brands, whether in the realm of art or elsewhere, is their role in signaling status to others (although the relationship between consumption and authentic signaling may be complicated; Goor et al. 2020; McFerran et al. 2014). Taking this type of thinking to an extreme, Dion and Borraz (2017) even argue that social relationships define luxury, whereas objects and brands do not. In my view, that argument is a bit one-sided. First, luxury consumption is not just about social signaling but also about individual enjoyment (Hagtvedt and Patrick 2009). Second, social signaling depends on visible markers inherent in products and brands (Han et al. 2010). Having said that, I believe the suggested role of social relationships is particularly evident in parts of the high-end contemporary art market, in which features of the specific product can appear virtually irrelevant, whereas social signaling can seem like the main or only benefit sought from brands (see also Joy and Sherry 2003a).

Art as a Luxury Cue

In much of the art market, however, branding effects also tend to draw on historical traditions of artisanship in which the art construct is steeped. This latter notion is central to the phenomenon of *art infusion*, which arises when consumer products or brands are associated with art (Hagtvedt and Patrick 2008a, 2008b). For example, companies may link their products and brands to the concept of art by incorporating artworks into packaging, advertising, or the design of products and retail outlets. Such practices lead luxury connotations to spill over from art to consumer products, thereby encouraging favorable consumer evaluations (Hagtvedt and Patrick 2008a). Similarly, art infusion can increase a brand's extendibility to diverse product categories through a combination of enhanced brand image (via a spillover of luxury connotations) and improved perceived fit between the brand and the extension category (via increased cognitive flexibility; Hagtvedt and Patrick 2008b).

Art infusion theory does not equate art with luxury or construe luxury as the main characteristic of art, but the two domains have overlapping connotations. Art and luxury both are centered around experiential and symbolic qualities (Hagtvedt and Patrick 2009, 2011a; Patrick and Hagtvedt 2009; Vigneron and Johnson 2004), are often used for status signaling (Han et al. 2010; Schnugg and Lehner 2016; Wang and Griskevicius 2014; Wilcox et al. 2009), comprise ultra-premium categories and democratized categories (Kapferer and Bastien 2009; Silverstein and Fiske 2003; Velthuis 2005), and involve tensions between social elitism and a broader social appeal (Dissanayake 1995; Hagtvedt and Patrick 2016; Thompson 2008; Torelli et al. 2012). When marketers describe luxury products as works of art, their aim is typically to draw on the exalted status of artworks, along with connotations of fine craft, culture, and connoisseurship (Hoffman 2002). Artistic activity involves going beyond the strictly functional or mundane, and in the context of consumer products or brands, such aspirations can translate to luxury. Additionally, artworks have

historically been central to displays of opulence, adding to the luxury connotations of the art world – despite most artists earning little money on their art.

In more recent research that draws on the notion of art infusion, Kapferer (2014) uses the term *artification* to explain the transformation of nonart into art in the context of luxury brands. This is the same term that Dissanayake (1995, 2007) has used in a broader sense, describing a universal artistic behavior that evolved through prehistory, also referred to as *making special*. As Kapferer explains, brands can use artification to overcome challenges such as the need to balance increasing production volume with perceptions of scarcity. Luxury stores may also emulate aspects of art galleries and museums, thereby bringing a form of artification to the point of sale (Joy et al. 2014).

Some observers criticize the blurred boundaries between art and consumer products, especially when public institutions are involved. For example, art museums have sometimes ceded creative control to sponsoring firms, at times even allowing the firms to showcase their own private collections (Harrell and Perraudin 2010). The boundaries are even more blurred when firms are allowed to use art museums as showrooms for their branded merchandise, as with the Armani show at the Guggenheim in New York in 2000 (Stallabrass 2004). There may be fewer concerns, however, when firms have their own corporate museums, such as the Salvatore Ferragamo Museum in Florence, Italy (Carù et al. 2017). Further, despite any criticisms of blurred boundaries, there is little evidence that such criticisms have adversely affected consumers' desire for luxury brands.

Luxury-Related Research on Aesthetics

Aesthetic Appeal

Although the field of aesthetics largely evolved as theories of art appreciation (Gaut and Lopes 2007), it has long been considered applicable to virtually any category of objects (Hoegg and Alba 2008; Postrel 2003). Most aesthetics research in marketing has focused on commonplace consumer topics ranging from beauty work (Samper et al. 2018) to charity solicitations (Grinstein et al. 2019; Townsend 2017) to product design (Bloch 1995; Homburg et al. 2015; Townsend and Sood 2012). For example, when aesthetic design elements are salient in new product acquisitions, consumers are motivated to achieve congruence between these products and their existing possessions (Patrick and Hagtvedt 2011). Indeed, the aesthetic dimension of design tends to delight, whereas the functional and ergonomic dimensions merely satisfy (Chitturi et al. 2008; Jindal et al. 2016).

Aesthetic design, however, can have drawbacks, too. For example, it can impede product usage when consumption entails destroying nondurable product aesthetics

(Wu et al. 2017). Unfavorable evaluations may also result from design that obstructs the easy categorization of a new product (Goode et al. 2013). Further, if product functionality sinks beneath a certain threshold, aesthetically pleasing design can cease to have a positive influence on consumer responses (Hagtvedt and Patrick 2014). In fact, a mismatch between aesthetics and functional performance can even lead consumers to be biased in favor of less attractive products (Hoegg et al. 2010; see also Hoegg 2015). Conversely, aesthetically pleasing designs appear particularly efficacious when combined with a strong brand (Landwehr et al. 2012; see also Page and Herr 2002; see Sevilla and Townsend (2016) for a related argument on product spacing and perceived store prestige). In other words, there is a natural fit between high aesthetic appeal and a brand with a strong luxury profile.

Principles of Aesthetics

This special relationship between aesthetics and high-equity luxury brands may extend to specific design principles. For instance, high-equity brands appear to benefit more from brand typicality (i.e., similarity within the brand's range) but less from segment typicality, as compared to low-equity brands (Heitmann et al. 2020). Further, brand consistency tends to muffle price sensitivity, whereas economy-segment products can benefit from cross-segment mimicry of luxury products (Liu et al. 2017). Together, these observations suggest that companies may benefit from exploring and establishing unique visual identities for luxury brands. In conjunction, luxury firms may benefit from restricting consumers' customization opportunities because customers tend to appreciate the status conveyed by the brand's unique design, presumably brought about via brand designers' expertise and vision (Moreau et al. 2020; see also Fuchs et al. 2013).

A brand's overall design and promotion can incorporate a variety of specific elements that give rise to aesthetic appreciation. For example, ambiguity (e.g., textural or visual patterns with two or more interpretations or expected continuations) can enrich aesthetic experiences via a process of recreation (Berlyne 1971, 1974; see also Dewey 1934/1989). Ambiguous design invites reflection and leaves something for a perceiver to mentally complete (Hagtvedt 2011; Peracchio and Meyers-Levy 1994; Zeki 2001). The effect may be similar to one arising from partial concealment in advertising; the communications spark curiosity and can encourage favorable consumer response, especially for brands congruent with curiosity-related positive affect (Sevilla and Meyer 2020), which one might expect to be the case for luxury brands.

In work related to curiosity, Berlyne (1971, 1974) argues that stimuli with an optimum level of novelty or complexity induce an optimum level of arousal. When design elements such as asymmetry induce arousal, the effect may also be associated with brand excitement (Bajaj and Bond 2018), which aligns well with the concept of luxury. Consumers, however, tend to underestimate their long-term appreciation for

arousing stimuli, because they – often mistakenly – expect such stimuli to satiate them over time (Buechel and Townsend 2018). This effect echoes the finding that consumers' preference for visually complex designs increases with repeated exposure, whereas it decreases for simple designs (Cox and Cox 2002).

Reber and colleagues (2004) similarly argue that aesthetic pleasure is grounded in the perceiver's processing experience, but they propose fluency (i.e., ease of processing) as the determining factor. In this view, stimulus features such as symmetry and contrast between figure and ground facilitate processing to different degrees, whereas consumers experience high fluency as subjectively positive. Some scholars (e.g., Silvia 2005) deem the fluency perspective informative but too simple to explain the diverse emotional responses arising from aesthetically interesting stimuli (see also Kumar and Garg (2010) for connections between aesthetic principles and emotion-related cognitive appraisals). For instance, aesthetic experience in domains such as art or luxury can stimulate awe (Dion and Arnould 2011; Williams et al. 2018); but it seems unlikely that emotions of this kind are based purely on fluency. Further, concepts such as unity or prototypicality (Veryzer and Hutchinson 1998) can stimulate processing fluency without therefore explaining the entirety of aesthetic pleasure or experience (Silvia 2005; see also Landwehr et al. 2013). Related neuroaesthetics research has focused on identifying aesthetic laws, with the view that hardwired mental predispositions inform responses to features that suggest or exaggerate evolutionarily relevant signals (Ramachandran and Hirstein 1999).

In my opinion, research has not convincingly shown that fluency, arousal, or any other singular mechanism fully explains aesthetic experience. Literature in psychology and marketing has provided valuable insights into aspects of this phenomenon, but future research will likely lead to an increasingly nuanced and comprehensive understanding.

Design Elements and Sensory Marketing

Some of the extant literature highlights overlaps between research on art, aesthetics, and sensory marketing (Joy and Sherry 2003b; Krishna 2012). Notably, a growing cross-disciplinary area of research focuses on attributes that might be termed *perceptual components*, *design elements*, or *formal qualities*, depending on the literature consulted (Sample et al. 2020). These are basic building blocks of aesthetics, such as shape (Ordabayeva and Chandon 2013; Sevilla and Kahn 2014) or color (Labrecque et al. 2013). For example, research on color has focused on such diverse areas as task performance (Mehta and Zhu 2009), construal level (Lee et al. 2014), emotions (Labrecque and Milne 2012), eating behavior (Van Ittersum and Wansink 2012), willingness to pay (Bagchi and Cheema 2012), moral judgments (De Bock et al. 2013), preferences involving color combinations (Deng et al. 2010), products, and advertising (Kareklas et al. 2014; Meyers-Levy and Peracchio 1995); and

consumer perceptions of various kinds, including time (Gorn et al. 2004), price (Puccinelli et al. 2013), weight (Walker et al. 2010), size (Hagtvedt and Brasel 2017), durability, user-friendliness (Hagtvedt 2020b), and gender (Semin and Palma 2014).

Along with the research on individual senses, recent research on cross-modal correspondences has identified perceptual matches between stimuli attributes in different sensory modalities (Spence 2011). For example, a semantic correspondence between smell and touch can enhance product evaluation (Krishna et al. 2010). A synesthetic correspondence between sound frequency and color lightness can guide visual attention, thereby favorably influencing product choice (Hagtvedt and Brasel 2016). Preferences can also shift when visual attention is directed toward the location of a corresponding sound (Shen and Sengupta 2014).

According to the conceptualizations at the outset of this chapter, the extent to which these types of sensory effects pertain to aesthetics depends on the degree to which consumers find them interesting, stirring, or perceptually pleasing. People have evolved to enjoy numerous kinds of useful input, ranging from food to visual information, for the simple reason that those of our ancestors who enjoyed useful input tended to survive, thrive, and ultimately propagate their genes. Additionally, different cultures provide frameworks that can hinder or enhance such aesthetic appreciation. Future research may increase our knowledge about when and why perceptual communication gains an aesthetic impact. In turn, future work may identify practical uses for this aesthetic impact in the management of luxury products and brands.

Future Research on Art and Aesthetics

Future Research on Art

At least three main areas of research on art are relevant to the current context of luxury: the psychological experience of art, arts marketing, and the use of art in the marketing of other products.

All known societies around the world engage in the creation and appreciation of art in some form, and based on historical and prehistorical evidence, it appears that these behaviors stretch back to the dawn of humanity (Dissanayake 1995; Dutton 2002). Cognitive and emotional responses to artworks may depend on their aesthetic properties, the interaction of such properties with the conceptual content of the work, the physical environment in which the artworks are perceived, individual traits of the perceiver, the broader cultural setting, or other factors (e.g., whether the context involves purchasing the work or merely perceiving it; Chen 2009). Much remains to be investigated in these and related areas. Given an evolutionary background for art appreciation, some aspects are likely to be universal and enduring, but other aspects may depend on future changes in the cultural and technological

landscapes. Along with behavioral and/or qualitative approaches, future research might apply neuroscience to tease apart biological and cultural influences (Chatterjee 2014; Lacey et al. 2011). Further, future work may map out consumer responses that vary depending on the consumption motivation, such as art consumption for enjoyment versus social signaling, which in turn may map onto private versus public consumption. Such distinctions are pertinent not just for art and aesthetics, but for luxury consumption in general, and they depend not only on individual or relatively static cultural differences, but on a given zeitgeist. As popular consumption goals change along with demographic and social shifts, future research will need to update insights relevant to the times. Such considerations may also include evolving conceptualizations of art, as well as the manner in which art is created. For example, consumers may respond differently to art as an individual versus collaborative endeavor (Bublitz et al. 2019; Hagtvedt 2019). In turn, these differences have implications for luxury. For instance, if collaborative endeavors seem inclusive rather than exclusive, they may be incompatible with an exclusive brand image.

The second area, namely, arts marketing, is a relatively recent but growing subdiscipline of marketing (Colbert and St-James 2014). It covers topics such as the various roles of consumers, critics, and art professionals in the relevant marketplace. For example, research may focus on differences between the supply-side marketing represented by artists with subjective visions and the commercialization that seems to dominate much of the high-end contemporary art market (Hirschman 1983; Joy and Sherry 2003a). The unique and often extravagant aspects of the art market may also provide new insights within traditional topics such as branding and pricing. In other words, arts marketing can be a specific focus area for unique topics, but it can also be an interesting context for general marketing questions.

As for the third area, that is, the use of art in other marketing contexts, future work could extend research findings on the art infusion effect (Hagtvedt and Patrick 2008a, 2008b). For example, Lee et al. (2015) find that the favorable impact of art is stronger for higher-priced, as compared to lower-priced, products. Conversely, Huettl and Gierl (2012) find that using art in advertising works for hedonic products but not utilitarian ones, and that such usage can even negatively influence purchase intentions because of increased perceived expensiveness. Clearly, there may be numerous contextual factors at play, and future work may provide increasingly nuanced insights into the role of art in consumer marketing. Particularly relevant for the current context, future work may explore the opportunities and limitations for the use of art in connection with luxury brands (Kapferer 2014).

Future Research on Aesthetics

Experimental aesthetics is one of the longest-standing areas of research in psychology, second only to *psychophysics* (Fechner 1871); and the area is currently growing in

marketing and related fields (Hagtvedt 2020a; Hoegg and Alba 2008). Whereas art is arguably a substantive domain, depending on how one defines it, aesthetics is clearly a theoretical one (despite *Journal of Consumer Research* currently listing it as a substantive domain). As noted, this area began as art theories, but it has broadened substantially since then to comprise both human-made non-art objects and objects not made by humans. Some of these topics may be intuitively associated with aesthetics (e.g., fashion; Phillips and McQuarrie 2010; Venkatesh et al. 2010), whereas others may seem less obviously relevant (e.g., the impact of financial documents' aesthetic appeal; Townsend and Shu 2010). Future research is also likely to include marketplace developments such as the digital technologies that are increasingly central in consumers' lives.

Among other potential avenues for research, the psychological mechanisms at work need further attention. Notable examples include the relationship between processing fluency and novelty or complexity (Reber et al. 2004), and the relationship between cognitive and affective responses to aesthetics (Lee et al. 2013; Silvia 2005). Focuses and findings will depend, at least to some extent, on the research methods used, whether ethnographies, behavioral experiments, or neuroscience (or mixed methods; Reimann et al. 2010). As with other areas of inquiry, the application of diverse lenses to the same topic can enrich aesthetics scholarship. To varying degrees, aesthetics-related phenomena may be universal or differ between cultures (Ulver-Sneistrup 2011), genders (Meyers-Levy and Zhu 2010), or other individual traits (Bloch et al. 2003; Holbrook and Schindler 1994). Reality often includes a hodgepodge of influences, and although many universal phenomena reflect the evolutionary pressures that gave rise to them, general tendencies do not imply complete uniformity (Gupta and Hagtvedt 2021). Aesthetic taste is presumably based on evolved attitudinal and behavioral tendencies, but that in no way precludes the individual development that occurs within a given cultural framework (Hoyer and Stokburger-Sauer 2012; Maciel and Wallendorf 2017).

Within the context of luxury, the notion of individuality is pertinent to both the consumer and the brand. On the one hand, luxury brands need to balance the desire for scarcity perceptions with revenue goals tied to production volume (Kapferer 2014). The former consideration may encourage limited editions, and in the extreme case, it could entail one-of-a-kind designs. Furthermore, limiting the supply of specific luxury products increases the buyers' ability to signal their own uniqueness and nonconformity to other consumers (Bellezza et al. 2014). On the other hand, luxury firms need to be careful about customization and consumer co-creation, lest they dilute the brand image (Fuchs et al. 2013; Moreau et al. 2020; Tynan et al. 2010). Future research may extend investigations into the benefits and drawbacks of such marketing practices, taking into account the evolving marketplace, including aspects such as consumers' increasing design and customization choices in general, especially in digital and online contexts. The need to balance opposing considerations of this kind also extends to consumers' attempts to maintain aesthetic congruity

among their possessions, given the difficulty of incorporating unique designs (Patrick and Hagtvedt 2011). Further, firms must balance goals of aesthetic unity or multiplicity in contexts such as service uniforms (Pounders et al. 2015) or retail interiors (Sevilla and Townsend 2016). For instance, identical interiors and/or exteriors can make retail outlets instantly recognizable, but unique designs can provide a fresh experience at each individual location. Similar to advertisements or pop music, perhaps the ideal combination is a familiar theme with a novel twist. If so, future research should illuminate the effects of changing or maintaining specific design elements.

It is well known that aesthetics is important for luxury products and brands, but there is less certainty about the individual and interactive influences of specific design elements (Sample et al. 2020). Further, new technological developments enable novel twists to familiar aesthetics, as with animated brand logos (Brasel and Hagtvedt 2016). Such marketplace developments should spur new research, which could also incorporate the notion that certain aspects of aesthetics may be timeless, whereas others are ephemeral (Joy et al. 2012).

On a final note, aesthetics may have implications for the sustainability of luxury brands. For example, it can be challenging for luxury firms to engage in corporate social responsibility without diluting their brand image and/or decreasing their profits (Hagtvedt and Patrick 2016; Torelli et al. 2012). However, recent work suggests that one way forward might be to *emphasize* sustainability rather than exclusivity in branding efforts (Sipilä et al. 2021). Further, it has been proposed that associating luxury brands with art can make products seem more durable, thereby increasing perceived sustainability (De Angelis et al. 2020). Similarly, it seems reasonable that people would tend to take better care of aesthetically appealing products than ordinary ones. Future work could also investigate whether, when, and why aesthetically appealing products and environments facilitate health and wellbeing. Given consumers' increasing focus on such factors, efforts to play a positive role in human well-being may benefit certain luxury brands in the future.

References

Alexander, Victoria D., and Anne E. Bowler (2021). "Contestation in Aesthetic Fields: Legitimation and Legitimacy Struggles in Outsider Art." *Poetics* 84. https://doi.org/10.1016/j.poetic.2020.101485.

Bagchi, Rajesh, and Amar Cheema (2012). "The Effect of Red Background Color on Willingness-to-Pay: The Moderating Role of Selling Mechanism." *Journal of Consumer Research* 39 (5): 947–60.

Bajaj, Aditi, and Samuel D. Bond (2018). "Beyond Beauty: Design Symmetry and Brand Personality." *Journal of Consumer Psychology* 28 (1): 77–98.

Baumgarten, Alexander (1735/1954). *Reflections on Poetry*. Berkeley, CA: University of California Press.

Baumgarth, Carsten, and Daragh O'Reilly (2014). "Brands in the Arts and Culture Sector." *Arts Marketing: An International Journal* 4 (1/2): 2–9.

Bellezza, Silvia, Francesca Gino, and Anat Keinan (2014). "The Red Sneakers Effect: Inferring Status and Competence from Signals of Nonconformity." *Journal of Consumer Research* 41 (1): 35–54.

Berlyne, Daniel E. (1971). *Aesthetics and Psychobiology*. New York: Appleton-Century-Crofts.

Berlyne, Daniel E. (1974). *Studies in the New Experimental Aesthetics: Steps toward an Objective Psychology of Aesthetic Appreciation*. Washington, DC: Hemisphere.

Berthon, Pierre, Leyland Pitt, Michael Parent, and Jean-Paul Berthon (2009). "Aesthetics and Ephemerality: Observing and Preserving the Luxury Brand." *California Management Review* 52 (1): 45–66.

Blackburn, Simon (2016). *The Oxford Dictionary of Philosophy*. Oxford, UK: Oxford University Press.

Bloch, Peter H. (1995). "Seeking the Ideal Form: Product Design and Consumer Response." *Journal of Marketing* 59 (3): 16–29.

Bloch, Peter H., Frédéric F. Brunel, and Todd J. Arnold (2003). "Individual Differences in the Centrality of Visual Product Aesthetics: Concept and Measurement." *Journal of Consumer Research* 29 (4): 551–65.

Bourdieu, Pierre (1986). "The Forms of Capital," in *Handbook of Theory and Research for the Sociology of Education*, J. G. Richardson, ed., 241–58. New York: Greenwood.

Brasel, S. Adam, and Henrik Hagtvedt (2016). "Living Brands: Consumer Responses to Animated Brand Logos." *Journal of the Academy of Marketing Science* 44 (5): 639–53.

Bublitz, Melissa G., Tracy Rank-Christman, Luca Cian, Xavier Cortada, Adriana Madzharov, Vanessa M. Patrick, Laura A. Peracchio, et al. (2019). "Collaborative Art: A Transformational Force within Communities." *Journal of the Association for Consumer Research* 4 (4): 313–331.

Buechel, Eva C., and Claudia Townsend (2018). "Buying Beauty for the Long Run: (Mis)predicting Liking of Product Aesthetics." *Journal of Consumer Research* 45 (2): 275–97.

Carroll, Noël (2000). *Theories of Art Today*. Madison, WI: The University of Wisconsin Press.

Carù, Antonella, Maria Carmela Ostillio, and Giuseppe Leone (2017). "Corporate Museums to Enhance Brand Authenticity in Luxury Goods Companies: The Case of Salvatore Ferragamo." *International Journal of Arts Management* 19 (2): 32–45.

Chatterjee, Anjan (2014). *The Aesthetic Brain: How We Evolved to Desire Beauty and Enjoy Art*. New York: Oxford University Press.

Chen, Yu (2009). "Possession and Access: Consumer Desires and Value Perceptions Regarding Contemporary Art Collection and Exhibit Visits." *Journal of Consumer Research* 35 (6): 925–40.

Chitturi, Ravindra, Rajagopal Raghunathan, and Vijay Mahajan (2008). "Delight by Design: The Role of Hedonic Versus Utilitarian Benefits." *Journal of Marketing* 72 (3): 48–63.

Colbert, François, and Yannik St-James (2014). "Research in Arts Marketing: Evolution and Future Directions." *Psychology & Marketing* 31 (8): 566–75.

Cox, Dena, and Anthony D. Cox (2002). "Beyond First Impressions: The Effects of Repeated Exposure on Consumer Liking of Visually Complex and Simple Product Designs." *Journal of the Academy of Marketing Science* 30 (2): 119–30.

De Angelis, Matteo, Cesare Amatulli, and Margherita Zaretti (2020). "The Artification of Luxury: How Art Can Affect Perceived Durability and Purchase Intention of Luxury Products," in Gardetti M. and Coste-Manière I. (eds), *Sustainable Luxury and Craftsmanship. Environmental Footprints and Eco-design of Products and Processes.*, 61–84 Springer: Singapore.

De Bock, Tine, Mario Pandelaere, and Patrick Van Kenhove (2013). "When Colors Backfire: The Impact of Color Cues on Moral Judgment." *Journal of Consumer Psychology* 23 (3): 341–8.

Deng, Xiaoyan, Sam K. Hui, and J. Wesley Hutchinson (2010). "Consumer Preferences for Color Combinations: An Empirical Analysis of Similarity-Based Color Relationships." *Journal of Consumer Psychology* 20 (4): 476–84.

Dewey, John (1934/1989). "Having an Experience," in *John Dewey: The Later Works, 1925–1953: Art as Experience*, Jo Ann Boydston, ed., 43–63 Carbondale: Southern Illinois University Press.

Dion, Delphine, and Eric Arnould (2011). "Retail Luxury Strategy: Assembling Charisma through Art and Magic." *Journal of Retailing* 87 (4): 502–20.

Dion, Delphine, and Stéphane Borraz (2017). "Managing Status: How Luxury Brands Shape Class Subjectivities in the Service Encounter." *Journal of Marketing* 81 (5): 67–85.

Dissanayake, Ellen (1995). *Homo Aestheticus: Where Art Comes From and Why*. Seattle, WA: University of Washington Press.

Dissanayake, Ellen (2007). "What Art Is and What Art Does: An Overview of Contemporary Evolutionary Hypotheses," in *Evolutionary and Neurocognitive Approaches to Aesthetics, Creativity, and the Arts* (1–14), Colin Martindale, Paul Locher, and Vladimir M. Petrov, eds. Amityville, NY: Baywood Publishing Company, Inc.

Drummond, Kent (2006). "The Migration of Art from Museum to Market: Consuming Caravaggio." *Marketing Theory* 6 (1): 85–105.

Dutton, Denis (2002). "Aesthetic Universals," in *The Routledge Companion to Aesthetics*, Berys Gaut and Dominic McIver Lopes, eds., 279–291 London, UK: Routledge.

Fechner, Gustav Theodor (1871). *Zur Experimentalen Aesthetik*. Leipzig, Germany: Hirzel.

Fisher, John A. (2007). "High Art versus Low Art" in *The Routledge Companion to Aesthetics*, Berys Gaut and Dominic McIver Lopes, eds. New York: Routledge, 527–40.

Fuchs, Christoph, Emanuela Prandelli, Martin Schreier, and Darren W. Dahl (2013). "All That Is Users Might Not Be Gold: How Labeling Products as User Designed Backfires in the Context of Luxury Fashion Brands." *Journal of Marketing* 77 (5): 75–91.

Gaut, Berys, and Dominic McIver Lopes, eds. (2007). *The Routledge Companion to Aesthetics*. New York: Routledge.

Goode, Miranda R., Darren W. Dahl, and C. Page Moreau (2013). "Innovation Aesthetics: The Relationship between Category Cues, Categorization Certainty, and Newness Perceptions." *Journal of Product Innovation Management* 30 (2): 192–208.

Goor, Dafna, Nailya Ordabayeva, Anat Keinan, and Sandrine Crener (2020). "The Impostor Syndrome from Luxury Consumption." *Journal of Consumer Research* 46 (6): 1031–51.

Gorn, Gerald J., Amitava Chattopadhyay, Jaideep Sengupta, and Shashank Tripathi (2004). "Waiting for the Web: How Screen Color Affects Time Perception." *Journal of Marketing Research* 41 (2): 215–25.

Grinstein, Amir, Henrik Hagtvedt, and Ann Kronrod (2019). "Aesthetically (Dis)Pleasing Visuals: A Dual Pathway to Empathy and Prosocial Behavior." *International Journal of Research in Marketing* 36 (1): 83–99.

Gupta, Tanvi, and Henrik Hagtvedt (2021). "Safe Together, Vulnerable Apart: How Interstitial Space in Text Logos Impacts Brand Attitudes in Tight versus Loose Cultures." *Journal of Consumer Research*, forthcoming, https://doi.org/10.1093/jcr/ucab006.

Hagtvedt, Henrik (2011). "The Impact of Incomplete Typeface Logos on Perceptions of the Firm." *Journal of Marketing* 75 (4): 86–93.

Hagtvedt, Henrik (2019). "Shared Aesthetics: A Commentary on Collaborative Art." *Journal of the Association for Consumer Research* 4 (4): 336.

Hagtvedt, Henrik (2020a). "Art and Aesthetics," in *Research Handbook on Luxury Branding*, ed. Felicitas Morhart, Sandor Czellar, and Keith Wilcox. Cheltenham, UK: Edward Elgar Publishing, 171–89.

Hagtvedt, Henrik (2020b). "Dark Is Durable, Light Is User-Friendly: The Impact of Color Lightness on Two Product Attribute Judgments." *Psychology & Marketing* 37 (7): 864–75.

Hagtvedt, Henrik, and S. Adam Brasel (2016). "Cross-Modal Communication: Sound Frequency Influences Consumer Responses to Color Lightness." *Journal of Marketing Research* 53 (4): 551–62.

Hagtvedt, Henrik, and S. Adam Brasel (2017). "Color Saturation Increases Perceived Product Size." *Journal of Consumer Research* 44 (2): 396–413.

Hagtvedt, Henrik, Reidar Hagtvedt, and Vanessa M. Patrick (2008). "The Perception and Evaluation of Visual Art." *Empirical Studies of the Arts* 26 (2): 197–218.

Hagtvedt, Henrik, and Vanessa M. Patrick (2008a). "Art Infusion: The Influence of Visual Art on the Perception and Evaluation of Consumer Products." *Journal of Marketing Research* 45 (3): 379–89.

Hagtvedt, Henrik, and Vanessa M. Patrick (2008b). "Art and the Brand: The Role of Visual Art in Enhancing Brand Extendibility." *Journal of Consumer Psychology* 18 (3): 212–22.

Hagtvedt, Henrik, and Vanessa M. Patrick (2009). "The Broad Embrace of Luxury: Hedonic Potential as a Driver of Brand Extendibility." *Journal of Consumer Psychology* 19 (4): 608–18.

Hagtvedt, Henrik, and Vanessa M. Patrick (2011a). "Fine Arts," in *Encyclopedia of Consumer Culture*, ed., 604–606. Dale Southerton. Sage Publications.

Hagtvedt, Henrik, and Vanessa M. Patrick (2011b). "Turning Art into Mere Illustration: Concretizing Art Renders Its Influence Context Dependent." *Personality and Social Psychology Bulletin* 37 (12): 1624–32.

Hagtvedt, Henrik, and Vanessa M. Patrick (2014). "Consumer Response to Overstyling: Balancing Aesthetics and Functionality in Product Design." *Psychology & Marketing* 31 (7): 518–25.

Hagtvedt, Henrik, and Vanessa M. Patrick (2016). "Gilt and Guilt: Should Luxury and Charity Partner at the Point of Sale?" *Journal of Retailing* 92 (1): 56–64.

Han, Young Jee, Joseph C. Nunes, and Xavier Drèze (2010). "Signaling Status with Luxury Goods: The Role of Brand Prominence." *Journal of Marketing* 74 (4): 15–30.

Harrell, Eben, and Frances Perraudin (2010). "Cultural Assets: Banks Stock Up on Art." *Time*, October 24, 2010, http://content.time.com/time/magazine/article/0,9171,2024218-2,00.html

Hauser, Arnold (1999). *The social history of art*. London: Routledge.

Heitmann, Mark, Jan R. Landwehr, Thomas F. Schreiner, and Harald J. van Heerde (2020). "Leveraging Brand Equity for Effective Visual Product Design." *Journal of Marketing Research* 57 (2): 257–77.

Hirschman, Elizabeth C. (1983). "Aesthetics, Ideologies and the Limits of the Marketing Concept." *Journal of Marketing* 47 (summer): 45–55.

Hoegg, JoAndrea (2015). "Beyond Aesthetics: Seeing Form and Believing in Function." *Gfk-Marketing Intelligence Review* 7 (2): 40–45.

Hoegg, JoAndrea, and Joseph W. Alba (2008). "A Role for Aesthetics in Consumer Psychology," in *Handbook of Consumer Psychology*, Curtis P. Haugtvedt, Paul M. Herr, and Frank R. Kardes, eds. New York: Taylor & Francis Group, 733–54.

Hoegg, JoAndrea, Joseph W. Alba, and Darren W. Dahl (2010). "The Good, the Bad, and the Ugly: Influence of Aesthetics on Product Feature Judgments." *Journal of Consumer Psychology* 20 (4): 419–30.

Hoffman, Barry (2002). *The Fine Art of Advertising*. New York: Stewart, Tabori, and Chang.

Holbrook, Morris B., and Robert M. Schindler (1994). "Age, Sex, and Attitude Toward the Past as Predictors of Consumers' Aesthetic Tastes for Cultural Products." *Journal of Marketing Research* 31 (3): 412–22.

Homburg, Christian, Martin Schwemmle, and Christina Kuehnl (2015). "New Product Design: Concept, Measurement, and Consequences." *Journal of Marketing* 79 (3): 41–56.

Hoyer, Wayne, and Nicola Stokburger-Sauer (2012). "The Role of Aesthetic Taste in Consumer Behavior." *Journal of the Academy of Marketing Science* 40 (1): 167–80.

Huettl, Verena, and Heribert Gierl (2012). "Visual Art in Advertising: The Effects of Utilitarian vs. Hedonic Product Positioning and Price Information." *Marketing Letters* 23 (3): 893–904.

Jindal, Rupinder P., Kumar R. Sarangee, Raj Echambadi, and Sangwon Lee (2016). "Designed to Succeed: Dimensions of Product Design and Their Impact on Market Share." *Journal of Marketing* 80 (4): 72–89.

Joy, Annamma, and John F. Sherry (2003a). "Disentangling the Paradoxical Alliances between Art Market and Art World." *Consumption, Markets and Culture* 6 (3): 155–81.

Joy, Annamma, and John F. Sherry (2003b). "Speaking of Art as Embodied Imagination: A Multisensory Approach to Understanding Aesthetic Experience." *Journal of Consumer Research* 30 (September): 259–82.

Joy, Annamma, John F. Sherry Jr, Alladi Venkatesh, Jeff Wang, and Ricky Chan (2012). "Fast Fashion, Sustainability, and the Ethical Appeal of Luxury Brands." *Fashion Theory* 16 (3): 273–95.

Joy, Annamma, Jeff Jianfeng Wang, Tsang-Sing Chan, John F. Sherry, and Geng Cui (2014). "M(Art) Worlds: Consumer Perceptions of How Luxury Brand Stores Become Art Institutions." *Journal of Retailing* 90 (3): 347–64.

Kant, Immanuel (1790/2007). *Critique of Judgement* New York: Oxford University Press.

Kapferer, Jean-Noël (1997). "Managing Luxury Brands." *Journal of Brand Management* 4 (4): 251–60.

Kapferer, Jean-Noël (2014). "The Artification of Luxury: From Artisans to Artists." *Business Horizons* 57 (3): 371–80.

Kapferer, Jean-Noël, and Vincent Bastien (2009). "The Specificity of Luxury Management: Turning Marketing Upside Down." *Journal of Brand Management* 16 (5): 311–22.

Kareklas, Ioannis, Frédéric F. Brunel, and Robin A. Coulter (2014). "Judgment Is Not Color Blind: The Impact of Automatic Color Preference on Product and Advertising Preferences." *Journal of Consumer Psychology* 24 (1): 87–95.

Kim, Jeehye Christine, Brian Park, and David Dubois (2018). "How Consumers' Political Ideology and Status-Maintenance Goals Interact to Shape Their Desire for Luxury Goods." *Journal of Marketing* 82 (6): 132–49.

Krishna, Aradhna (2012). "An Integrative Review of Sensory Marketing: Engaging the Senses to Affect Perception, Judgment, and Behavior." *Journal of Consumer Psychology* 22 (3): 332–51.

Krishna, Aradhna, Ryan S. Elder, and Cindy Caldara (2010). "Feminine to Smell but Masculine to Touch? Multisensory Congruence and Its Effect on the Aesthetic Experience." *Journal of Consumer Psychology* 20 (4): 410–8.

Kumar, Minu, and Nitika Garg (2010). "Aesthetic Principles and Cognitive Emotion Appraisals: How Much of the Beauty Lies in the Eye of the Beholder?" *Journal of Consumer Psychology* 20 (4): 485–94.

Labrecque, Lauren I., and George R. Milne (2012). "Exciting Red and Competent Blue: The Importance of Color in Marketing." *Journal of the Academy of Marketing Science* 40 (5): 711–27.

Labrecque, Lauren I., Vanessa M. Patrick, and George R. Milne (2013). "The Marketer's Prismatic Palette: A Review of Color Research and Future Directions." *Psychology and Marketing* 30 (2): 187–202.

Lacey, Simon, Henrik Hagtvedt, Vanessa Patrick, Amy Anderson, Randall Stilla, Gopikrishna Deshpande, Xiaoping Hu, João R. Sato, Srinivas Reddy, and Krish Sathian (2011). "Art for Reward's Sake: Visual Art Recruits the Ventral Striatum." *NeuroImage* 55 (1): 420–433.

Landwehr, Jan R., Daniel Wentzel, and Andreas Herrmann (2012). "The Tipping Point of Design: How Product Design and Brands Interact to Affect Consumers' Preferences." *Psychology & Marketing* 29 (6): 422–33.

Landwehr, Jan R., Daniel Wentzel, and Andreas Herrmann (2013). "Product Design for the Long Run: Consumer Responses to Typical and Atypical Designs at Different Stages of Exposure." *Journal of Marketing* 77 (5): 92–107.

Lee, Chan Jean, Eduardo B. Andrade, and Stephen E. Palmer (2013). "Interpersonal Relationships and Preferences for Mood-Congruency in Aesthetic Experiences." *Journal of Consumer Research* 40 (2): 382–91.

Lee, Hsiao-Ching, Wei-Wei Chen, and Chih-Wei Wang (2015). "The Role of Visual Art in Enhancing Perceived Prestige of Luxury Brands." *Marketing Letters* 26 (4): 593–606.

Lee, Hyojin, Xiaoyan Deng, H. Rao Unnava, and Kentaro Fujita (2014). "Monochrome Forests and Colorful Trees: The Effect of Black-and-White versus Color Imagery on Construal Level." *Journal of Consumer Research* 41 (4): 1015–32.

Liu, Yan, Krista J. Li, Haipeng Chen, and Subramanian Balachander (2017). "The Effects of Products' Aesthetic Design on Demand and Marketing-Mix Effectiveness: The Role of Segment Prototypicality and Brand Consistency." *Journal of Marketing* 81 (1): 83–102.

Maciel, Andre F., and Melanie Wallendorf (2017). "Taste Engineering: An Extended Consumer Model of Cultural Competence Constitution." *Journal of Consumer Research* 43 (5): 726–46.

McFerran, Brent, Karl Aquino, and Jessica L. Tracy (2014). "Evidence for Two Facets of Pride in Consumption: Findings from Luxury Brands." *Journal of Consumer Psychology* 24 (4): 455–71.

Mehta, Ravi, and Rui (Juliet) Zhu (2009). "Blue or Red? Exploring the Effect of Color on Cognitive Task Performances." *Science* 323 (5918): 1226–9.

Meyers-Levy, Joan, and Laura A. Peracchio (1995). "Understanding the Effects of Color: How the Correspondence between Available and Required Resources Affects Attitudes." *Journal of Consumer Research* 22 (2): 121–38.

Meyers-Levy, Joan, and Rui (Juliet) Zhu (2010). "Gender Differences in the Meanings Consumers Infer from Music and Other Aesthetic Stimuli." *Journal of Consumer Psychology* 20 (4): 495–507.

Moreau, C. Page, Emanuela Prandelli, Martin Schreier, and Silke Hieke (2020). "Customization in Luxury Brands: Can Valentino Get Personal?" *Journal of Marketing Research* 57 (5): 937–47.

Morhart, Felicitas, and Lucia Malär (2020). "Authenticity in luxury branding," in *Research Handbook on Luxury Branding*, ed. Felicitas Morhart, Sandor Czellar, and Keith Wilcox. Cheltenham, UK: Edward Elgar Publishing, 190–207.

Newman, George E., and Paul Bloom (2012). "Art and Authenticity: The Importance of Originals in Judgments of Value." *Journal of Experimental Psychology: General* 141 (3): 558–69.

Nueno, Jose Luis, and John A. Quelch (1998). "The Mass Marketing of Luxury." *Business Horizons* 41 (November/December): 61–68.

Ordabayeva, Nailya, and Pierre Chandon (2013). "Predicting and Managing Consumers' Package Size Impressions." *Journal of Marketing* 77 (5): 123–37.

Page, Christine, and Paul M. Herr (2002). "An Investigation of the Processes by Which Product Design and Brand Strength Interact to Determine Initial Affect and Quality Judgments." *Journal of Consumer Psychology* 12 (2): 133–47.

Patrick, Vanessa M., and Henrik Hagtvedt (2009). "Luxury Branding," in *Handbook of Brand Relationships*, ed. Joseph Priester, Deborah J. MacInnis, and C. Whan Park, 267–279. New York: Society for Consumer Psychology and M.E. Sharpe.

Patrick, Vanessa M., and Henrik Hagtvedt (2011). "Aesthetic Incongruity Resolution." *Journal of Marketing Research* 48 (2): 393–402.

Peracchio, Laura A., and Joan Meyers-Levy (1994). "How Ambiguous Cropped Objects in Ad Photos can Affect Product Evaluations." *Journal of Consumer Research* 21 (June): 190–204.

Phillips, Barbara J., and Edward F. McQuarrie (2010). "Narrative and Persuasion in Fashion Advertising." *Journal of Consumer Research* 37 (3): 368–92.

Postrel, Virginia (2003). *The Substance of Style: How the Rise of Aesthetic Value Is Remaking Commerce, Culture, and Consciousness*. New York: HarperCollins.

Pounders, Kathrynn, Barry Babin, and Angeline Close (2015). "All the Same to Me: Outcomes of Aesthetic Labor Performed by Frontline Service Providers." *Journal of The Academy of Marketing Science* 43 (6): 670–93.

Preece, Chloe, and Finola Kerrigan (2015). "Multi-Stakeholder Brand Narratives: An Analysis of the Construction of Artistic Brands." *Journal of Marketing Management* 31 (11/12): 1207–30.

Puccinelli, Nancy M., Rajesh Chandrashekaran, Dhruv Grewal, and Rajneesh Suri (2013). "Are Men Seduced by Red? The Effect of Red Versus Black Prices on Price Perceptions." *Journal of Retailing* 89 (2): 115–25.

Ramachandran, V.S., and William Hirstein (1999). "The Science of Art: A Neurological Theory of Aesthetic Experience." *Journal of Consciousness Studies* 6 (6–7): 15–51.

Reber, Rolf, Norbert Schwarz, and Piotr Winkielman (2004). "Processing Fluency and Aesthetic Pleasure: Is Beauty in the Perceiver's Processing Experience?" *Personality and Social Psychology Review* 8 (4): 364–82.

Reimann, Martin, Judith Zaichkowsky, Carolin Neuhaus, Thomas Bender, and Bernd Weber (2010). "Aesthetic Package Design: A Behavioral, Neural, and Psychological Investigation." *Journal of Consumer Psychology* 20 (4): 431–41.

Rodner, Victoria L., and Finola Kerrigan (2014). "The Art of Branding – Lessons from Visual Artists." *Arts Marketing: An International Journal* 4 (1/2): 101–18.

Samper, Adriana, Linyun W. Yang, and Michelle E. Daniels (2018). "Beauty, Effort, and Misrepresentation: How Beauty Work Affects Judgments of Moral Character and Consumer Preferences." *Journal of Consumer Research* 45 (1): 126–47.

Sample, Kevin L., Henrik Hagtvedt, and S. Adam Brasel (2020). "Components of Visual Perception in Marketing Contexts: A Conceptual Framework and Review." *Journal of the Academy of Marketing Science* 48 (3): 405–421.

Schnugg, Claudia, and Johannes Lehner (2016). "Communicating Identity or Status? A Media Analysis of Art Works Visible in Photographic Portraits of Business Executives." *International Journal of Arts Management* 18 (2): 63–74.

Schroeder, Jonathan E. (2005). "The Artist and the Brand." *European Journal of Marketing* 39 (11/12): 1291–1305.

Schuetz, Jenny, and Richard K. Green (2014). "Is the Art Market More Bourgeois than Bohemian?" *Journal of Regional Science* 54 (2): 273–303.

Semin, Gun R., and Thomas A. Palma (2014). "Why The Bride Wears White: Grounding Gender With Whiteness." *Journal of Consumer Psychology* 24 (2): 217–25.

Sevilla, Julio, and Barbara E. Kahn (2014). "The Completeness Heuristic: Product Shape Completeness Influences Size Perceptions, Preference, and Consumption." *Journal of Marketing Research* 51 (1): 57–68.

Sevilla, Julio, and Robert J. Meyer (2020). "Leaving Something for the Imagination: The Effect of Visual Concealment on Preferences." *Journal of Marketing* 84 (4): 109–26.

Sevilla, Julio, and Claudia Townsend (2016). "The Space-to-Product Ratio Effect: How Interstitial Space Influences Product **Aesthetic** Appeal, Store Perceptions, and Product Preference." *Journal of Marketing Research* 53 (5): 665–81.

Shen, Hao, and Jaideep Sengupta (2014). "The Crossmodal Effect of Attention on Preferences: Facilitation versus Impairment." *Journal of Consumer Research* 40 (5): 885–903.

Silverstein, Michael J., and Neil Fiske (2003). *Trading Up: The New American Luxury*. New York: Portfolio Penguin Group.

Silvia, Paul J. (2005). "Emotional Responses to Art: From Collation and Arousal to Cognition and Emotion." *Review of General Psychology* 9 (4): 342–57.

Sipilä, Jenni, Sascha Alavi, Laura Marie Edinger-Schons, Sabrina Dörfer, and Christian Schmitz (2021). "Corporate Social Responsibility in Luxury Contexts: Potential Pitfalls and How to Overcome Them." *Journal of the Academy of Marketing Science*, forthcoming, https://doi.org/10.1007/s11747-020-00755-x.

Spence, Charles (2011). "Crossmodal Correspondences: A Tutorial Review." *Attention, Perception, & Psychophysics* 73 (4): 971–95.

Stallabrass, Julian (2004). *Contemporary Art: A Very Short Introduction*. Oxford, UK: Oxford University Press.

Tansey, Richard G., and Fred S. Kleiner (1996). *Gardner's Art through the Ages*. Orlando, FL: Harcourt Brace.

Thompson, Don (2008). *The $12 Million Stuffed Shark: The Curious Economics of Contemporary Art*. New York: Palgrave Macmillan.

Torelli, Carlos J., Alokparna Basu Monga, and Andrew M. Kaikati (2012). "Doing Poorly by Doing Good: Corporate Social Responsibility and Brand Concepts." *Journal of Consumer Research* 38 (5): 948–63.

Townsend, Claudia (2017). "The Price of Beauty: Differential Effects of Design Elements with and without Cost Implications in Nonprofit Donor Solicitations." *Journal of Consumer Research* 44 (4): 794–815.

Townsend, Claudia, and Suzanne B. Shu (2010). "When and How Aesthetics Influences Financial Decisions." *Journal of Consumer Psychology* 20 (4): 452–58.

Townsend, Claudia, and Sanjay Sood (2012). "Self-Affirmation through the Choice of Highly Aesthetic Products." *Journal of Consumer Research* 39 (2): 415–28.

Tynan, Caroline, Sally McKechnie, and Celine Chhuon (2010). "Co-Creating Value for Luxury Brands." *Journal of Business Research* 63 (11): 1156–63.

Ulver-Sneistrup, Sofia (2011). "Cosmopolitans Talking the Global but Walking the Local: A Multisited Exploration into Middle-Class Consumers' Tastes in Home Aesthetics." *Advances in Consumer Research – European Conference Proceedings* 9: 101–7.

Van Ittersum, Koert, and Brian Wansink (2012). "Plate Size and Color Suggestibility: The Delboeuf Illusion's Bias on Serving and Eating Behavior." *Journal of Consumer Research* 39 (2): 215–28.

Velthuis, Olav (2005). *Talking Prices: Symbolic Meaning of Prices on the Market for Contemporary Art*. Princeton, NJ: Princeton University Press.

Velthuis, Olav (2012). "The Contemporary Art Market Between Stasis and Flux," in *Contemporary Art and its Commercial Markets: A Report on Current Conditions and Future Scenarios*, Maria Lind and Olav Velthuis, eds., 17–50. Berlin: Sternberg Press.

Venkatesh, Alladi, Annamma Joy, John F. Sherry Jr., and Jonathan Deschenes (2010). "The Aesthetics of Luxury Fashion, Body, and Identity Formation." *Journal of Consumer Psychology* 20 (4): 459–70.

Veryzer, Robert W., and J. Wesley Hutchinson (1998). "The Influence of Unity and Prototypicality on Aesthetic Responses to New Product Designs." *Journal of Consumer Research* 24 (4): 374–94.

Vigneron, Franck, and Lester W. Johnson (2004). "Measuring Perceptions of Brand Luxury." *Brand Management* 11 (July): 484–506.

Walker, Peter, Brian J. Francis, and Leanne Walker (2010). "The Brightness-Weight Illusion: Darker Objects Look Heavier but Feel Lighter." *Experimental Psychology* 57 (6): 462–9.

Wang, Yajin, and Vladas Griskevicius (2014). "Conspicuous Consumption, Relationships, and Rivals: Women's Luxury Products as Signals to Other Women." *Journal of Consumer Research* 40 (5): 834–54.

Wilcox, Keith, Hyeong Min Kim, and Sankar Sen (2009). "Why Do Consumers Buy Counterfeit Luxury Brands?" *Journal of Marketing Research* 46 (2): 247–59.

Williams, Patti, Nicole Verrochi Coleman, Andrea C. Morales, and Ludovica Cesareo (2018). "Connections to Brands that Help Others versus Help the Self: The Impact of Incidental Awe and Pride on Consumer Relationships with Social-Benefit and Luxury Brands." *Journal of the Association for Consumer Research* 3 (2): 201–15.

Wu, Freeman, Adriana Samper, Andrea C. Morales, and Gavan J. Fitzsimons (2017). "It's Too Pretty to Use! When and How Enhanced Product Aesthetics Discourage Usage and Lower Consumption Enjoyment." *Journal of Consumer Research* 44 (3): 651–72.

Zeki, Semir (2001). "Artistic Creativity and the Brain." *Science* 293 (5527): 51–52.

Part 3: **The World of Fashion**

Laurie A. Meamber, Annamma Joy

Chapter 7
Wearing the Writing on the Wall: Streetwear and Street Art

Introduction

> Mood transcends time. Culture shapes my imagination.
>
> (Sen2 | Sandro Figueroa 2021)

At the time of this writing, *streetartnews.net* has announced the limited street art fashion offering by the basketball lifestyle brand POINT3! in collaboration with New York street artist Sen2 Figueroa. The collection consists of fashion clothing items such as shorts and a compression sleeve. A quote in the article reads, "For him [Sen2], fashion and art are the perfect blend of creativity, ingenuity, and risk. Each garment has a unique quality to it. Inspired by Sen2 abstract graffiti and pop art style, the collection conveys an intricate balance of lines, color, writing, and strong gestural movements combined into one single composition" ("Summer Buckets" Limited drop by Sen2 Figueroa x POINT3, https://streetartnews.net/2021/05/sum mer-buckets-limited-drop-by-sen2-figueroa-x-point3.html, May 31, 2021).

Several decades ago, if a reader encountered a description like the above: ". . . the collection conveys an intricate balance of lines, color, writing, and strong gestural movements combined into one single composition" without a context, what would likely come to mind? Artworks by any number of artists, such as Vincent Van Gogh? Focusing on the "lines, writing, and color" aspect, perhaps individuals would envision the work of pop artists such as Roy Lichtenstein or Andy Warhol? Further afield, maybe this phrasing would raise thoughts of a high fashion collection by many designers such as Gianni Versace, Betsey Johnson, or Vivienne Westwood? Today, perhaps readers of this passage would think of streetwear fashion, particularly streetwear involving street artists, which we term "street art wear" in this chapter.

While the collaboration of artists and fashion is not new, in recent years we have witnessed a wave of street art wear – fashion created (or co-created with fashion designers/clothing brands) by street artists. Street art wear fashion is one type of streetwear and is now part of the luxury brand fashion sector. This chapter focuses on the artification process that formally began with graffiti emerging as an art movement, which now spans both the art world and luxury fashion. As a recent development in fashion history, we argue that street art wear is an example of *ongoing* artification. Artification is the process by which non-art becomes art, and one definition of *ongoing* artification is when the object or practice has lately become art. We will begin our discussion by defining fashion and luxury brands. Second,

https://doi.org/10.1515/9783110732757-007

we will look at the intersection of art and brands. Third, we will examine the ascent of street art. Fourth, we will consider the birth and progression of streetwear fashion. Next, we will describe examples of street art wear collaborations between artists and luxury fashion brands. We will then identify the different types of artification and locate street art wear in the category of ongoing artification related to its cultural production process. Finally, we explain the artification characteristics of luxury street art wear and conclude with ideas for future research.

Fashion and Luxury Brands

Fashion, in dictionary terminology, is the prevailing or popular style of dress at a particular point in time. Scholars have discussed and examined fashion as, among other ideas, the cultural construction of embodied identity and as an aesthetic mode of expression of ideas, desires, and beliefs that circulate in society (Joy et al. 2010; Venkatesh et al. 2010; Wilson 1985). Fashion can be considered an aesthetic system or aesthetic representation in which objects (such as clothing) become fashionable when imbued with meaning and become aesthetically significant (Meamber, Joy, and Venkatesh 2017). Significant aesthetic properties are particularly emblematic of luxury fashion.

The concept of luxury evolves in meaning over time (Joy, Belk, and Bhardwaj 2017). Luxury dates back thousands of years to when prominent individuals were buried with jewels, precious metals, and other rare objects (Kapferer and Bastien 2009). Romans first used the term "luxury" to describe the wealthy who did not use their money for the public good, contrary to Roman values (Kovesi 2015). By the late 19th century, the era of the Gilded Age in the West, luxury was associated with extravagance, abundance, or great ease and comfort. In the current era, luxury can be defined as hedonic-oriented objects and rare experiences and classified as beyond life necessities (Kapferer 2015). Iconic French fashion designer Coco Chanel famously articulated that, "Luxury is a necessity that begins where necessity ends."

Correspondingly, a "luxury brand" refers to consumers' perceptions of aesthetics, symbolism, high quality, high price, extraordinariness, rarity, and a high level of non-functionality associated with a brand, among other properties (Heine 2012). Joy, Belk, and Bhardwaj (2017) highlight common themes associated with luxury brands, including aesthetics, beauty, form, magic, and creativity that encourage dreams, pleasure, and transcendence. Luxury brands, particularly luxury fashion brands, have received increased attention from researchers in different academic fields over the last several decades. Broad topics of study include luxury status/values, luxury consumer behavior, luxury brand management, and brand counterfeiting (Ko and Megehee 2012). In recent years, scholars have also examined the intersection of art and (luxury) brands.

Art and Brand Collaborations

The integration of art and brands can be traced back to late-19th-century brand communications, such as Henri Toulouse-Lautrec's posters for dance, entertainment, and other clubs in France (Baumgarth 2018). The interplay of artists, art, and brands takes many forms, including (1) brands commissioning art; (2) artists creating advertising and other brand communications; (3) branding elements by artists – artists creating brand logos; (4) artists as endorsers of brands; (5) artistic interventions within organizations; (6) artists using corporate resources, such as specialized materials; and (7) corporate collections of art or alliances of luxury art brands with well-known artists ("luxeart foundations") of art (Baumgarth 2018; Joy et al. 2014).

Artists can also connect with brands by housing their artworks inside retail stores or galleries (such as Fondazione Prada in Milan and Fondation Louis Vuitton in Paris) associated with luxury brands (Grassi 2019). The "M(Art) Worlds" of Louis Vuitton flagship stores embody elements of art galleries, including artisanal offerings for sale with artworks side by side (Joy et al. 2014). It has been reported that eight luxury fashion brands are among the most prominent patrons of art and artists – Louis Vuitton, Dior, Gucci, Prada, Hermès, Uniqlo, and Cos (Harold 2020). By the 1980s and 1990s, fashion also entered the mainstream art world through museum exhibitions, such as the 1996 Biennale di Firenze "Looking at Fashion" (Jelenik 2018; Steele 2012a).

One additional critical intersection of art and brand is "brand art" – where artists reference brands in their artwork. Subtypes of brand art include (1) brand play, such as pop artists using brands in their work (e.g., Andy Warhol's Campbell's soup can); (2) expressions of social, political, or ecological topics through collaborations of art and brand, such as in fashion; and (3) brand critiques or brand attacks in art.

Academic research on the collaborations between brands and art is wide-ranging and multi-disciplinary. Baumgarth (2018) structures topics of extant research on the relationship between brand and art in business and marketing into four categories.

1. Inspiration: art inspiring brands, and brands inspiring art
2. Insights: arts and artists as a seismograph of trends, and arts-based brand research
3. Identity: general approaches and case studies of organizations and consumers
4. Image: the art infusion effect – integrating classical visual art images onto a product (Hagtvedt and Patrick 2008), luxury brands, and brand communication

Topics in this domain encompass studies on parallels between art (or artists) and luxury brands. For example, findings suggest that both art and luxury brands strive to be considered timeless and impressive, and both value creativity, craftsmanship, rare materials, and scarcity or exclusivity (Kapferer 2015). Associations with artists allow luxury brands to be perceived as more luxurious and gain artistic caché

(Radford 1998). In turn, artists are rewarded financially and find inspiration and new ways of expressing themselves and new audiences for their work (Harold 2020). Jelinek (2018) explores the role of art in creating value and as a strategic tool in positioning (European) luxury fashion brands. The collective work by Venkatesh et al. (2010), Joy et al. (2014), and Joy, Belk, and Bhardwaj (2017) showcase the past, present, and future connections between the worlds of luxury brands, including fashion, consumption, and art. Among other themes, Venkatesh et al. (2010) find that consumers view high fashion as wearable art.

Early examples of artist and luxury brand pairings in fashion have included the collaboration between Elsa Schiaparelli and Salvador Dalí in the 1930s on luxury fashion items such as the Lobster dress worn by Wallis Simpson (Legras 2020). In the 1980s, Keith Haring signed watches for Swatch (Legras 2020). More recent examples include the co-creation between Cindy Sherman and COMME des Garcons, Richard Prince and Louis Vuitton, and Daniel Buren and Hermès. In these instances, the stated goal for the relationship was to enhance the brand's image through artistic participation. Louis Vuitton is among the most well-known brands for its ongoing work with artists. In 2019, the flagship store in Florence highlighted the art pieces by Osvaldo, Medici del Vascello, and Massimo Listri inside the store (Grassi 2019). Louis Vuitton also partnered with Takashi Murakami and Yayoi Kusama. In 2017, Louis Vuitton worked with Jeff Koons on a line of bags titled "Masters" that included hand-painted reproductions of Grand Master painters (Legras 2020). Over the last decade, luxury fashion brands have increasingly worked with street artists to create street art wear inspired by their art.

Street Art

"An artwork is street art if, and only if, its material use of the street is internal to its meaning" (Riggle 2010). Street art, sometimes equated with the term "public art," can be traced back to cave paintings thought to date from prehistoric times (The Art Story 2021; Visconti et al. 2010). The purpose of these early artistic expressions is thought to mark hunting successes, or to have been part of rituals enacted before hunting. While public art has been pervasive in Western cities throughout the centuries (for example, signage found in the excavations of Roman cities, colors found in structures from the Middle Ages such as churches, and neoclassical urban architecture famous in the Renaissance (Visconti et al. 2010)), street art is often equated with the rise of contemporary graffiti in the late 1960s. While historians can theorize the origins of the prehistoric cave paintings, and be certain without a doubt that World War II "Kilroy was here" drawings left by soldiers in public places across Europe were used to mark their presence, contemporary graffiti (sometimes referred to

as "hip-hop" graffiti) is thought to have originated in New York City with the advent of aerosol spray can technology (The Art Story 2021).

The word graffiti stems from the Greek "graphein," which means to scratch, draw, or write. There is some dispute about the first graffiti artist, or "tagger" – so-called because these individuals spray-painted tags or signatures in public places. Nevertheless, names such as Julio 204 and Taki 183 of Washington Heights have been identified as early examples of taggers (The Art Story 2021). In addition to tagging stationary places, such as roadway underpasses, graffiti artists also began writing in New York City subway cars, making it a dynamic art form meant to be in motion (Lachmann 1988; The Art Story 2021).

Key features of street art are ephemerality and innovation. Street art usually is short-lived as it is replaced by other art or removed. As technology has advanced with the invention of different spray can nozzles and other aerosol-based products, such as oven cleaner, tags began to grow into large, colorful, stylized aesthetic pieces. Graffiti soon spread worldwide and, by the late 1970s and early 1980s, moved beyond text to include imagery (The Art Story 2021). Innovation allowed street artists more flexibility to express themselves, including using their voices through art during periods of social and economic unrest (Alabi 2013).

At the same time as these developments were happening, the art world began to notice these artists and consider graffiti as a new form of contemporary art. Street art became known for using aesthetic standards separate from institutionalized art and for being accessible to audiences that traditional art forms may not have reached (Ritchie 2019). New York-based artists such as Jean-Michel Basquiat (using the tag SAMO) and Keith Haring (drawing simple, colorful figures, drawing attention to AIDS) were recognized by key figures in the art world like Andy Warhol and became well known (The Art Story 2021).

In the late-20th and early 21st centuries, other street artists have risen to fame, such as Lady Pink (NYC), Banksy (Bristol, UK), Zevs (Paris), and Shepard Fairey (LA), among others (The Art Story 2021). Along with the rise in fame of street artists, street art has become legitimized by art museums and art collectors (Visconti et al. 2010). For example, The Museum of Contemporary Art in Los Angeles held a show on the history of graffiti in 2011 (Alabi 2013; Firestone 2016). Banksy's work has fetched record prices in art auctions and can be found in many art collectors' homes. Commenting on the commercialization of his street art, Banksy famously created a print drawing mocking the auction of three of his works at Sotheby's London with the title: "I Can't Believe You Morons Actually Buy This Shit" (Firestone 2016).

As mentioned previously, street art is often created to promote an artist's point of view on social and other concerns. Zevs (pronounced "Zeus," as in the Greek god) is known for creating street art using logos of companies that he spray paints on public walls and shows in art galleries (Greenberger 2013). He often creates "liquidated" images – compositions that look like melted logos – with their colors

dripping down a wall. One example of his work was his spray-painting of the Chanel logo onto one side of a Giorgio Armani store, for which he was arrested. Zevs indicates he is interested in the dialogue between art and luxury (Greenberger 2013). For example, Leonardo da Vinci's monogram is similar to Louis Vuitton's monogram. Zevs created a handbag with a golden LDV logo on it – calling it an "original copy." Realizing Baudrillard's (1988) idea of the hyperreal, Zevs' original copy is a copy more original than the original itself (Greenberger 2013). The stated purpose of his artwork overall is to attack the interrelationships between signs of identification, social codes, significations, and emotions. He wants to suggest ideas such as overconsumption, advertising tyranny, and the slang of appearance, but acknowledges that his art retains some ambiguity (Greenberger 2013).

Other street artists' messages also have an anti-marketing and status focus. For example, Banksy has been quoted as saying, "To some people breaking into property and painting it might seem a little inconsiderate, but in reality the 30 square centimeters of your brain are trespassed upon every day by teams of marketing experts. Graffiti is a perfectly proportionate response to being sold unattainable goals by a society obsessed with status and infamy. Graffiti is the sight of an unregulated free market getting the kind of art it deserves" (The Art Story 2021).

In recent decades, there has been further innovation in the materials used by street artists, such as wheat (or flour) paste to install posters, and the use of stencils that minimize installation time and make it easier to use repeatable images (Borgini et al. 2010). Taking space wherever it may be, there have also been sculptural street art installations, such as the 2006 Third Man Series by Dan Witz that utilized gloves installed on sewer grates to resemble a person trying to come out from the sewer (Firestone 2016). Additional types of street art innovations include reverse graffiti – which removes dirt or other surface materials to create images – or ceramic tiles, like those used by the artist Space Invader, or the use of clay, chalk, charcoal, projections, and other media (The Art Story 2021; Visconti et al. 2010). The making of public art includes several dichotomies: action being individual versus collective, goals being self-affirmative versus altruistic, audiences being self/peer versus the public, and language being protest-oriented versus aesthetic-oriented (Visconti et al. 2010). Street art wear tends to fall in the collective, self-affirmative, public, and aesthetic-oriented sides of these dualities.

The participation of street artists and the use of "street art" aesthetics in fashion is a further recent development in the history of street art and is not without controversy. When prominent street artists, such as Banksy, tell people not to buy anything with street art to keep the art where it belongs, this suggests a specific context for street art. At the same time, exhibitions of Banksy's work bought by private collectors now appear in new places, such as in the "Immersion Vegas" Fashion Show Mall in Las Vegas in late 2019–2020, suggesting there is no one place where street art belongs (Firestone 2016; Lupiani 2019). When street artists intentionally collaborate in the realm of fashion, they can be criticized for "selling out"

or told that the meaning of their artwork is being compromised since it is no longer materially connected to the street (Riggle 2010). To counter this disapproval, street artists themselves defend the value of honest work no matter the setting (The Art Story 2021). These artists also cite the creative opportunities that working in another arena provide, such as fashion, including adding permanency to their work. In addition to deliberate co-creative efforts, there are also unintentional collaborations between street artists and fashion brands. For example, the street artist Kidult is known for illegally spray painting high fashion storefronts, such as that of Marc Jacobs. Marc Jacobs responded by co-opting the street art using images of this illegal art on branded hats and T-shirts (Kamer 2012). T-shirts are strongly connected to the origin story of streetwear and continue to be part of luxury street art wear fashion.

Streetwear Fashion

The term "streetwear" can invoke several different ideas and research streams. One connotation of streetwear is fashion born on the streets by everyday consumers. For several decades, companies studying youth culture have purported to understand what is considered "cool" ("cool hunting") by studying "street style" clothing that is supposed to be characterized by consumers assembling individual outfits distinct from what has been presented to them by brands, stylists, and other fashion influencers. In this vein, research examines how fashion worn by consumers on the street can be mapped worldwide using visual analytics – deep neural networks to determine the world's fashion landscape (Chang et al. 2017).

Many scholars have written on the rise of Japanese street fashion styles created by youth subcultures in Japan, such as in the districts of Harajuku and Shibuya in Tokyo (Kawamura 2006; Schiele and Venkatesh 2016). Other researchers discuss the diffusion and sharing of street fashion across different countries, such as between Tokyo and the Dongdaemun district in Seoul, South Korea (Azuma 2002). Researchers studying street styles have found that the correspondence between what is shown in fashion magazines and the unique, "individualized" outfits is strong, indicating that perhaps consumer street style is more myth than reality (Woodward 2009).

As fashionable, casual clothing associated with urban youth cultures, a second notion of streetwear was born in the last decades of the 20th century (Streetwear Impact Report 2019). The definition of casual clothing includes T-shirts and sweatshirts (hoodies), shorts and casual pants, and footwear. This sense of streetwear centered on street art wear is the focus for our discussion of artification. The beginnings of this type of streetwear are diverse, but all are associated with self-expression and subversion of the conventional fashion process. A prominent origin story is that streetwear in the United States began when surfer and surfboard creator Shawn Stussy started creating logo T-shirts in the early 1980s as a form of promotion for his

handmade boards. He never intended to start a clothing line or even sell the T-shirts, but his clothing items quickly became iconic and fashionable, inspiring other makers of surfboards and skateboards to offer clothing associated with their brands (Block 2017). Another notable figure in early streetwear development is James Jebbia, creator of the skateboard brand Supreme.

This clothing became popular within the surf and skateboarding subcultures and beyond, becoming "lifestyle" brands more generally adopted by youth culture. This shift in the fashion market can be viewed in light of the shift in popular culture (Streetwear Impact Report 2019). Streetwear is the fashion element of a more significant widespread culture shift encompassing art, music, and fashion. The fashionable, comfortable streetwear clothing became popular within the hip-hop music and hip-hop dance subcultures after adoption by hip-hop celebrity musicians such as Run DMC and Puff Daddy. Dapper Dan is a legendary designer who created street-style clothing for hip-hop artists ignored by luxury brands in the 1980s. Internationally, Hiroshi Fujiwara and Nigo, well-known DJs and designers, are credited with introducing street style and hip-hop in Japan in the 1980s. Streetwear quickly became sought after in major urban areas worldwide, including China and Korea (Streetwear Impact Report 2019). Today, streetwear is also becoming popular with musicians and other entertainment celebrities in India. Indian streetwear designers have started their clothing labels, such as Jay Jajal, who founded the brand Jaywalking in 2019. In 2018, a multi-brand streetwear retail store called Capsul launched in Bangalore (Mehta 2021).

In 2019, it was estimated that streetwear comprises 10 percent of the fashion market. Around the world, other new streetwear brands have also popped up in the last decade or two. Two examples of famous streetwear brands today include Vetements (founded in 2014 in Switzerland) and Off-White (founded in 2012 in Italy) (Streetwear Impact Report 2019). Today, streetwear is still closely connected with consumers and linked to subcultures, such as sports and music – but it has also made its way into the mainstream of luxury fashion. Unable to ignore the popularity and exclusivity that now characterizes streetwear, well-known luxury fashion brands now offer streetwear lines. According to Streetwear Impact Report (2019), it has become a multi-billion-dollar retail sector and has incorporated young men into the fashion market more than ever before.

Streetwear established its credibility and authenticity with consumers as it became associated with music (and musicians), art, counterculture, and created community among wearers who rejected or felt excluded by the mainstream fashion system. While the traditional fashion process assumes a hierarchical cultural production process starting with ideas generated by a fashion designer (often representing a brand), streetwear has disrupted this approach by often starting with ideas from those immersed in consumer subcultures or, more recently, artists. For example, in the autumn/winter 2017/2018 season, Louis Vuitton partnered with the streetwear brand Supreme to launch the Supreme X Louis Vuitton collaboration.

Street Art Wear

Street art wear in fashion started when street artists put their designs on everyday clothing. By 2001, street art had entered the world of luxury fashion when street artist Stephen Sprouse began working with Marc Jacobs for Louis Vuitton. While additional collaborations between street artists and luxury brands have taken place since those early years, today we are witnessing the growth of luxury brands collaborating with street artists (Legras 2020). One well-publicized example is when Swiss luxury watch brand, Richard Mille, worked with Cyril Kongo to create his art using micro-spray painting tools to create a set of 30 individual limited edition RM 68–01 Tourbillon Cyril Kongo watches (Lake 2017). Likewise, Hale Harden (LA cashmere fashion brand) and LA graffiti artist RETNA collaborated on a cashmere blanket line that used glyphic marks by RETNA. The blanket line was marketed as "tagged and touchable artworks" (Firestone 2016).

Pairings of street artists with iconic luxury fashion brands are also increasing. As mentioned previously, there was the early collection co-created by Stephen Sprouse and Louis Vuitton. The work included monograms and the Louis Vuitton brand name "tagged" on handbags and pieces of luggage. Another well-known pairing is when street artist Kongo provided the design inspired by urban tags on the "Carré Graff" silk square sold by Hermès (Firestone 2016; Legras 2020). In 2016, Gucci created GucciGhost with the New York street artist Trevor Andrew who had previously coined and created Gucci Ghost images in his artwork. One of the most famous creations for this brand was the leather tote bag with the Gucci logo tagged with the word REAL written in dripping painted letters. This item, still available in the resale market for several thousand US dollars, plays with the notions of aura and authenticity. Its creation also expanded street art into new territory, the mocking high culture fashion (Firestone 2016). Continuing this trend, in 2017, Gucci's creative director, Alessandro Michele, hired street artist Coco Capitàn to "deface" some of the fashion pieces with her graffiti-style text art (Lake 2017).

Dior Homme has also offered collections with street art graphics – including splattered paint, collaborating with street artist Witz in 2017, and cartoon-like characters depicting the Chinese zodiac with Kenny Scharf in 2021. Another recent noteworthy collaboration between the Dior Homme (menswear division of luxury fashion house Christian Dior SA) occurred in 2019 when Kim Jones, the Dior Homme artistic director (formerly artistic director of menswear at Louis Vuitton), worked with Brian Donnelly, known professionally as KAWS or Kaws, to invent the fashion house bee motif. They also created a fresh Dior logo for a line titled Dior Homme X Kaws that featured hooded jackets, T-shirts, trousers, and accessories (Legras 2020).

These fashion creations live well beyond the initial retail releases. The resale market for luxury streetwear has entered the prestigious auction markets traditionally reserved for art and collectible luxury items. For example, Christie's Handbags X HYPE auction included Supreme skateboard decks that included prints by Damien

Hirst, KAWS, Jeff Koons, and items from the Supreme X Louis Vuitton collection. Street art wear is part of the resale trend in fashion. Predictions indicate that by 2023, ten percent of sales in the fashion industry will come from the resale market (Loeb 2019). Streetwear clothing found in the resale markets in Japan command higher prices than anywhere else globally, reflecting the highest consumer spend on streetwear in the world (Shah 2019; Streetwear Report 2019). Beyond this trend, we argue that luxury street art wear has also transformed the traditional cultural production process for fashion as it has become artified. A brief discussion of artification of luxury (fashion) brands can found in Jelenik (2018) and a discussion of haute couture fashion by Crane (2019), but this process has not been addressed in light of changes to the luxury fashion industry with the introduction of luxury streetwear.

Artification and the Cultural Production Process for Street Art Wear

Artification is the process by which non-art is transformed into art. Artification reflects long-term, dynamic social change. Not only are objects and practices altered, but relationships and institutions also transform (Shapiro 2019; Shapiro and Heinich 2012). Artification also encompasses legitimization as a part and consequence of the process. In recent decades, a more extensive range of activities and objects are becoming artified, and the process is accelerating faster, so it may only take several years to decades rather than centuries to happen (Shapiro 2019).

Joy et al. (2021) discuss Bordeaux wine to illustrate artification and how artists work in creative contexts outside of art. We now extend the discussion of artification to streetwear, precisely *street art fashion*. Street art wear, as luxury fashion, provides an example of artists creating work outside of the traditional institutional context of art. According to Shapiro and Heinich (2012), artificatory objects and practices originate from many sources, and those that undergo the artification process are often reflective of several categories. These sources include craftsmanship; industry; leisure (encompassing fun, free time, travel, and tourism); entertainment; new forms of visual art (such as graphic novels and graffiti); sports (such as breakdancing); technique that becomes invisible (such as the use of soft focus that releases photography from an emphasis on technique); and science, religion, and artifacts designed for political purposes and as criminal acts (such as graffiti). Street art wear begins with or overlaps with several of these classifications, as discussed earlier in this chapter.

Artification can be durable, partial, unattainable, or ongoing. *Durable* artification would include established art forms such as painting, music, and dance universally recognized as art. *Partial* artification includes objects and practices where artification is incomplete, such as architecture. Shapiro and Heinich (2012) conclude that architecture has never become fully artified because its focus is technique

over art or aesthetics. Lack of recognition by peers, critics, merchants/collectors, and the public, or intra-group differences (such as bullfighting audiences: aesthete aficionados versus militant opponents) can also hinder the artification process. *Unattainable* artification describes the situation when there are obstacles to the artification process rendering artification unattainable at present. Shapiro and Heinich (2012) include gardening and perfumery, among other examples, featuring one or more obstacles to artification. Gardening and perfumery are not practiced by producers considered "artists" in an enduring, institutional, and universal sense, and are not commonly acknowledged as art in society.

Ongoing artification is when artification is in progress or recent, or just barely artified. For example, Shapiro and Heinich (2012) note that breakdancing and graffiti are recent artified practices and objects, respectively. Street art wear fits into the *ongoing* artification category. Artification of streetwear through the introduction of artists into the cultural production process has transformed the practice and the produced objects. Several conditions are necessary for the successful artification process to occur. These include luxury activities that produce easily transportable objects, enhance individuality, and obtain creative autonomy. Also essential conditions for artification are networks of cooperation, collective organization, and a body of critical discourse (Shapiro and Heinich 2012). Street art wear includes all of these as part of the cultural production process with its origins in consumption subcultures and collaborations with street artists.

Cultural production is creating, transforming, and diffusing offerings and meaning with cultural content, including fashion. The traditional conceptualization of cultural production is grounded in the framework set forth by Michael Solomon (1988). Corresponding to Simmel's (1971/1904) sociological views on fashion, in Solomon's model of cultural production (1988), the set of individuals and organizations that create and market a cultural product is a cultural product system. The cultural system has three subsystems: a *creative* subsystem that creates new symbols and products; a *managerial* subsystem that selects, produces, and distributes the new symbols and products; and a *communication* subsystem that gives meaning and provides the product with a symbolic set of attributes. The managerial subsystem works in concert with the communication subsystem in providing suggested meanings. These meanings are then transferred to consumers via cultural gatekeepers, both formal and informal.

Since the rise of the well-known luxury fashion houses or brands in the 19th century, we can identify producers in the creative subsystem, including elite designers and creative directors. Throughout history, these fashion designers have taken inspiration for their creations from various sources and subjects, including people (such as "celebrities" or other muses) or activities (such as evening wear and work wear). The continuity of luxury fashion brands, in part, depends on a variety of actors, such as the families that own them, founders, top management, and well-known designers. The creative director (often a designer) provides the aesthetic

ideology for the brand (Dion and Arnould 2011). Cultural intermediaries, such as marketers of fashion labels, and fashion writers and critics, have been those that intercede in the transfer of meaning for the cultural products from producers to consumers. These cultural intermediaries indicate meanings for these cultural products and communicate them to consumers. Luxury fashion consumers take cultural products such as fashion objects and collect their intended meaning(s) in the act of consumption. Culture is reconstituted when these meanings are connected back to the culture or symbolic pool that was the birth of the inspiration.

In contrast, streetwear fashion often begins within a particular consumption or artistic domain and diffuses into popular culture, challenging the top-down approach to cultural production. Streetwear offers a concrete example of a cultural production process that functions from the bottom up (i.e., originating with consumers) or, in the case of street art wear, begins outside of the established fashion hierarchy (i.e., with street artists). The relationships between the cultural actors, including cultural producers, cultural intermediaries, and consumers, operate collaboratively and dynamically (Venkatesh and Meamber 2006). The codes of streetwear are community, authenticity, and rejection of the traditional cultural production process – including cultural authorities such as traditional designers and cultural gatekeepers (e.g., fashion critics) (Streetwear Report 2019). The altered cultural production process for streetwear fashion allows for artification to occur.

The Artification Characteristics of Luxury Street Art Wear

Artification includes several micro-processes that we have condensed to a list of nine. Each of these micro-processes of artification is discussed below, with examples drawn from Shapiro and Heinich (2012) or Shapiro (2019) and then extended to street art wear fashion.

1. *Displacement/Reshuffling rankings/making breaks and the conflation of art with non-art.* This process involves the movement of objects or practices into the arts sphere. The objects or practices are displaced from their initial context and status hierarchies. Graffiti was extracted from the streets to be photographed for books or art installations (Shapiro 2019). Breakdancing was first viewed as disorderly street conduct and is now considered professional dance (Shapiro 2019). Streetwear entered into the arts sphere when designed by artists and considered luxury fashion. It began as part of specific consumption subcultures and was elevated to become and be called luxury fashion as part of the collaborations between artists and luxury brands, and turn to exclusivity with a large resale market. Streetwear has subverted the traditional fashion process by redefining the idea of exclusivity. Instead of exclusivity being associated with a price point, in streetwear, exclusivity is defined by authenticity and community. In the early days of streetwear, few mainstream consumers knew what

or where to purchase the clothing; only consumers within consumption subcultures had this knowledge. As the Streetwear Impact Report (2019) indicates, this type of exclusivity allowed streetwear to become part of luxury fashion that, in addition to being expensive, was accessible by those with knowledge of fashion – designers and trends. Because streetwear was associated with individuals and brands associated within particular communities of consumption subcultures, it was valued for its authenticity.

2. *Renaming.* Renaming codifies a new status by using a different name, such as when fashion designers were first considered artists, and street dance became known as hip-hop (Shapiro 2019). Renaming in the context of streetwear occurred when T-shirts associated with consumption subculture brands were given the title of streetwear, eventually growing into other types of clothing and into street art fashion that encompasses clothing and fashion accessories.

3. *Institutionalization/organizational change.* This change includes an acknowledgment or imprimatur from sources that offer legitimacy to an object or event. In France, the government has recognized and offered monetary support for breakdancing (Shapiro 2019). Through collaborations with famous brands, artists, designers, musicians, and celebrities, streetwear is granted status and legitimacy. Street art wear has been acknowledged in the art museum and art gallery worlds, and with a pop-up Museum of Streetwear in Chicago in 2019 and the Van Gogh Museum partnership with a Dutch streetwear fashion brand, Daily Paper (Charr 2020; Harvey 2019).

4. *Differentiation of functions/individualization of labor/formal roles.* This type of formalization fosters the role of individuals in the cultural production process. For example, when breakdancing was first performed on stage in France, it consisted of a collective of choreography, but as it has undergone artification, individual choreographers create and are recognized for their work (Shapiro 2019). In street art wear, different functions include artists and designers, and creative directors for streetwear that are well-known and have established authority and autonomy over their creations.

5. *Normative/Legal consolidation* confirms the new status of the art form in society, such as when censorship restrictions on filmmaking were ended in the 1960s in the United States that furthered the artification of film as an art form (Shapiro 2019). In the United States, there have been legal challenges concerning intellectual property (design, trademarks) in streetwear. For example, the streetwear brand Supreme has engaged in legal disputes regarding a camouflage design and logo used by another company in markets outside of the United States (Garcia and Gestal 2019).

6. *Redefining time/duration of events or objects that prove longevity and legitimacy.* Redefining time, breakdancing as art is performed as part of a whole "performance"

narrative (Shapiro 2019). Streetwear is often available for only a limited time and limited number through a "drops" distribution model. Customers can purchase streetwear through a brand's brick-and-mortar or online store when the pieces are released at a specified date and time (Streetwear Impact Report 2019). Because the items are scarce, the secondhand or reseller market is strong for streetwear and serves as an indicator of the brand's strength. It is the secondhand market that marks the success of street art wear fashion.

7. *Aesthetic formalization.* The formalization occurs when the object or event draws upon an established art form to innovate aesthetically. An example is Schiaparelli's 1930s fashion design that utilized the aesthetic principles of surrealism (Shapiro 2019). Street art wear uses a newer but now recognized visual art form – graffiti – and expanded into other media and forms.

8. *Patronage.* Related to institutionalization is the support offered by patrons, often by the government or public, in subsidies and endowments (Shapiro and Heinich 2012). Street art wear has patrons and champions, such as well-known luxury fashion creative directors, fashion designers, or celebrities.

9. *Intellectualization (along with evaluation)* occurs when the discourse on an object or event becomes more concrete and formalized. Breakdance in France underwent an aesthetic turn when journalists and critics began referencing art and art history in their reviews (Shapiro 2019; Shapiro and Heinich 2012). For streetwear, this is demonstrated by terms such as "drops" as found in streetwear terminology guides and descriptions of streetwear – as the quote in the introduction illustrates. Streetwear, as fashion, is constantly reviewed and critiqued by experts.

De-artification can occur when art forms are transformed (back) into non-art (Shapiro and Heinich 2012). French haute couture is thought to have undergone a de-artification process because ownership of these brands is now controlled by international financial conglomerates, which means that fashion designers have lost artistic autonomy (Crane 2019). Crane (2019) suggests that in major categories of fashion: haute couture, ready-to-wear, and fashion collectibles, only partial artification can now be identified. In contrast, we argue that street art wear fashion – while being part of the fashion system and often under the brands controlled or financed by large corporations or conglomerates – allows for artification to take place because of the introduction of street artists into the system. Before the development of street art wear, differences thought to define art and fashion include art as an arena of (high) cultural production, while fashion was characterized as an industry with a creative element (Steele 2012a, 2012b). Without street artists and street art, streetwear would likely fit the partial or unattainable category of artification.

Conclusion

Street art wear fashion, whereby artists, art, and luxury fashion intersect, can be classified as *ongoing* artification. While the collaborations between art and brands have a long history, the co-productions between street artists and luxury fashion brands in the realm of streetwear began only twenty years ago. These co-productions are accelerating. Already streetwear comprises 10 percent of the retail fashion market and is predicted to make up ten percent of the resale market in a few years. The street art wear co-creations between street artists and luxury fashion houses (creative directors and designers) have become popular worldwide. As the fashion industry continues to evolve, we can identify many directions for research on street art wear fashion. For example, how does street art wear fashion intersect and contend with issues of sustainability? After the rise of fast fashion in recent decades, movements such as *slow fashion*, limited consumption of high-quality fashion items are gaining interest (Joy and Peña 2017). As a result, standard business models in fashion are being called to question, and ethical consumption is of interest in the fashion industry and with consumers alike (Joy and Peña 2017).

Future investigations of the perceived fit between street artists and brands in luxury fashion co-creation, and explorations of brand meaning, are also unexplored and deserving of further attention. The process of cultural production itself is worth further conceptual and empirical approaches. In-depth studies of street art wear consumers (and collectors of street art wear) are also important. As consumers continue to wear the "writing on the wall," street art wear as both fashion and art will provide many avenues for further research.

References

Alabi, Mo (2013). "When street art meets runway style." https://www.cnn.com/2013/09/07/living/high-fashion-street-art/index.html.

Azuma, Nobukaza (2002). *"Pronto Moda* Tokyo-style – Emergence of Collection-Free Street Fashion in Tokyo and the Seoul-Tokyo Fashion Connection." *International Journal of Retail & Distribution Management* 30 (3): 137–144.

Baudrillard, Jean (1988). "Simulacra and Simulations," in *Jean Baudrillard, Selected Writings*, ed. Mark Poster, Stanford, CA: Stanford University Press, 166–184.

Baumgarth, Carsten (2018). "Brand Management and the World of the Arts: Collaboration, Co-operation, Co-creation, and Inspiration." *Journal of Product and Brand Management* 27 (3): 237–248.

Block, Elinor (2017). "The History of Streetwear: From Stüssy to Vetements." https://www.whowhatwear.com/streetwear.

Borgini, Stefania, Luca M. Visconti, Laurel Anderson, and John F. Sherry, Jr. (2010). "Symbiotic Postures of Commercial Advertising and Street Art." *Journal of Advertising* 39 (3): 113–126.

Chang, Yu-Ting, Wen-Haung Cheng, Bo Wu, and Kai-Lung Hua (2017). "Fashion World Map: Understanding Cities Through Streetwear Fashion," in *MM'17: Proceedings of the 25th ACM International Conference on Multimedia ACM International Conference on Multimedia*, 91–99.

Charr, Manuel (2020). "Van Gogh Museum Partners with Streetwear Brand." https://www.museum next.com/article/van-gogh-museum-partners-with-streetwear-brand/.

Crane, Diane (2019). "Fashion and Artification in the French Luxury Fashion Industry." *Cultural Sociology* 13 (3): 293–304.

Dion, Delphine, and Eric Arnould (2011). "Retail Luxury Strategy: Assembling Charisma through Art and Magic." *Journal of Retailing* 87 (4): 502–520.

Firestone, Anya (2016). "Damaged Goods: The Draw of the High Brand X Street-Art Collaboration." https://www.maisonfirestone.com/damaged-goods.

Garcia, Daniela, and Iria P. Gestal (2019). "Supreme vs. Supreme: The Story of the Streetwear King's (Legal?) Fake." https://www.themds.com/companies/supreme-vs-supreme-the-story-of -the-legal-fake-of-the-streetwear-cult-brand.html.

Grassi, Alessia (2019). "Consumer Engagement Through Contemporary Art - Fondazione Prada," in *Vol. 2019 Global Fashion Management Conference*, 228–233.

Greenberger, Alex (2013). "Street Artist Zevs on Attacking Luxury Brands with Their Own Logos." https://www.artspace.com/magazine/interviews_features/meet_the_artist/zevs-51556#:~: text=Street%20Artist%20Zevs%20on%20Attacking%20Luxury%20Brands%20With%20Their %20Own%20Logos,-By%20Alex%20Greenberger&text=French%20street%20artistZevs%20 (pronounced,lately%20also%20shows%20in%20galleries.

Hagtvedt, Henrik, and Vanessa M. Patrick (2008). "Art Infusion: The Influence of Visual Art on the Perception and Evaluation of Consumer Products." *Journal of Marketing Research* XLV (June): 379–389.

Harold, Theresa (2020). "8 Fashion Brands Leading the Pack in Art Patronage." https://www.thai landtatler.com/style/fashion-brands-art-patronage.

Harvey, Matt (2019). "The Museum of Streetwear Enshrines Young Chicago Designers (For a Weekend)." https://www.chicagoreader.com/chicago/museum-of-streetwear-runwayaddicts /Content?oid=71911322#:~:text=The%20Museum%20of%20Streetwear%2C%20a,with% 20creative%20designs%20and%20ideas.

Heine, Klaus (2012). *The Concept of Luxury Brands.* https://upmarkit.com/sites/default/files/con tent/20130403_Heine_The_Concept_of_Luxury_Brands.pdf.

Jelinek, Julia-Sophie (2018). "Art as Strategic Branding Tool for Luxury Fashion Brands." *Journal of Product & Brand Management* 27 (3): 294–307.

Joy, Annamma, Russell Belk, and Rishi Bhardwaj (2017). "Luxury Consumption and Luxury Brands: Past, Present, and Future," in *Routledge Handbook on Consumption*, ed. Margit Keller, Bente Halkier, Terhi-Anna Wilska, and Monica Truninger. New York: Routledge, 442–452.

Joy, Annamma, Kathryn La Tour, Steven Charters, Bianca Grohmann, and Camilo Peña-Romero (2021). "The Artification of Wine: Lessons from the Fine Wines of Bordeaux and Burgundy." *Arts and the Market* 11 (1): 24–39.

Joy, Annamma, and Camilo Peña (2017). "Sustainability and the Fashion Industry: Conceptualizing Nature and Traceability," in *Sustainability in Fashion: A Cradle to Upcycle Approach*, ed. Claudia E Henninger, Panayiota J. Alevizou, Helen Goworek, and Daniella Ryding. Cham, Switzerland: Palgrave Macmillan, 31–54.

Joy, Annamma, John F. Sherry, Jr., Gabriele Troilo, and Jonathan Deschenes (2010). "Re-thinking the Relationship Between Self and Other: Levinas and Narratives of Beautifying the Body." *Journal of Consumer Culture* 10 (3): 333–361.

Joy, Annamma, Jeff Jianfeng Wang, Tsang-Sing Chan, John F. Sherry, Jr. and Geng Cui (2014). "M(Art) Worlds: Consumer Perceptions of How Luxury Brand Stores Become Art Institutions." *Journal of Retailing* 90 (3): 347–364.

Kamer, Foster (2012). "Marc Jacobs vs. The Graffiti Artist Round 4: Revenge by $10 T-Shirt." https://observer.com/2012/05/kidult-marc-jacobs-tshirt-05152012/.

Kapferer, Jean-Nöel (2015). *Kapferer on Luxury: How Luxury Brands Can Grow Yet Remain Rare.* London: Logan Page.

Kapferer, Jean-Noël, and Vincent Bastien (2009). *The Luxury Strategy.* London: Kogan Page.

Kawamura, Yuniya (2006). "Japanese Teens and Producers of Street Fashion." *Current Sociology* 54 (5): 784–801.

Ko, Eunju, and Carol M. Megehee (2012). "Fashion Marketing of Luxury Brands: Recent Research Issues and Contributions." *Journal of Business Research* 65 (10): 1395–98.

Kovesi, Catherine (2015). "What is Luxury? The Rebirth of a Concept in the Early Modern World." *Luxury* 2 (1): 25–40.

Lachmann, Richard (1988). "Graffiti as Career and Ideology." *The American Journal of Sociology* 94 (2): 229–250.

Lake, Camille (2017). "How Luxury Teams Up With Street Art." https://www.luxurysociety.com/en/articles/2017/10/how-luxury-collaborates-street-art.

Legras, Barbara (2020). "The Great Collaborations in the History of Fashion and Luxury Episode 20: When Luxury Brands Slum It with Street Artists . . ." https://magazine.luxus-plus.com/the-great-collaborations-in-the-history-of-fashion-and-luxury-episode-2-when-luxury-brands-slum-it-with-street-artists/?lang=en

Loeb, Walter (2019). "The Resale Fashion Industry Is Bigger and More Disruptive Than You Think." https://www.forbes.com/sites/walterloeb/2019/05/15/resale-fashion-industry-bigger-and-more-disruptive-than-you-think/?sh=16c2c38a609b.

Lupiani, Joyce (2019). "'Banksy: Genius or Vandal?' Is Now Open on Las Vegas Strip." https://www.ktnv.com/positivelylv/dining-and-entertainment/banksy-exhibit-coming-to-las-vegas-strip-for-limited-time.

Meamber, L.A., A. Joy, and A. Venkatesh (2017). "Fashion in consumer culture," in *Routledge Handbook on Consumption*, ed. Margit Keller, Bente Halkier, Terhi-Anna Wilska, and Monica Truninger. New York: Routledge, 431–441.

Mehta, Tanya (2021). "How Streetwear is Growing Into A Highly Covetable Sartorial Genre in India." https://www.grazia.co.in/fashion/how-streetwear-is-growing-into-a-highly-covetable-sartorial-genre-in-india-6785.html.

Radford, Robert (1998). "Dangerous Liaisons: Art, Fashion and Individualism." *Fashion Theory: The Journal of Dress, Body and Culture* 2 (2): 151–163.

Riggle, Nicholas Alden (2010). "Street Art: The Transfiguration of the Commonplaces." *The Journal of Aesthetics and Art Criticism* 68 (3): 243–257.

Ritchie, Greg (2019). "Luxury Brands are Taking Over the Street Art Scene." https://www.bloomberg.com/news/features/2019-07-23/luxury-brands-gucci-louboutin-graffiti-ads-take-over-street-art#:~:text=Luxury%20Brands%20Are%20Taking%20Over,score%20points%20on%20social%20media.&text=A%20Christian%20Louboutin%20mural%20on,the%20Global%20Street%20Art%20Agency.

Schiele, Kristen, and Alladi Venkatesh (2016). "Regaining Control Through Reclamation: How Consumption Subcultures Preserve Meaning and Group Identity after Commodification." *Consumption Markets & Culture* 19 (5): 427–450.

Shah, Shalini (2019). "How streetwear culture became mainstream over the course of this decade." https://www.vogue.in/fashion/content/streetwear-becomes-mainstream-decade-virgil-abloh-demna-gvasalia-kanye-west-supreme.

Shapiro, Roberta (2019). "Artification as Process." *Cultural Sociology* 13 (3): 265–275.

Shapiro, Roberta, and Nathalie Heinich (2012). "When Is Artification?" *Contemporary Aesthetics*, Special Issue 4. https://quod.lib.umich.edu/c/ca/7523862.spec.409/–when-is-artification?rgn=main;view=fulltext.

Simmel, Georg (1971/1904). "Fashion," in *On Individuality and Social Forms, Selected Writings"* ed. D.N. Levine. Chicago: The University of Chicago Press, 294–323.

Solomon, Michael R. (1988). "Building Up and Breaking Down: The Impact of Cultural Sorting on Symbolic Consumption," in *Research in Consumer Behavior*, ed. Jagdish Sheth and Elizabeth C. Hirschman. Greenwich, CT: JAI Press, 325–351.

Steele, Valerie (2012a). "Fashion," in *Fashion and Art*, ed. Adam Geczy and Vicki Karaminas. London: Berg, 13–28.

Steele, Valerie (2012b). "Is Fashion Art @ mumok." https://www.youtube.com/watch?v=weB-SQ-XP-c.

Steetartnews.net (2021). "'Summer Buckets' Limited drop by Sen2 Figueroa x POINT3!" https://streetartnews.net/2021/05/summer-buckets-limited-drop-by-sen2-figueroa-x-point3.html.

Streetwear Impact Report (2019). https://strategyand.hypebeast.com/streetwear-report.

The Art Story (2021). "Summary of Street and Graffiti Art." https://www.theartstory.org/movement/street-art/.

Venkatesh, A., A. Joy, J.F. Sherry, and J. Deschenes (2010). "The Aesthetics of Luxury Fashion, Body, and Identity Formation." *Journal of Consumer Psychology* 20: 459–470.

Venkatesh, Alladi, and Laurie A. Meamber (2006). Art and Aesthetics: Marketing and Cultural Production. *Marketing Theory* 6 (1): 11–39.

Visconti, Luca M., John F. Sherry, Jr., Stefania Borghini, and Laurel Anderson (2010). "Street Art, Sweet Art? Reclaiming the 'Public' in Public Space." *Journal of Consumer Research* 37 (3), 511–529.

Wilson, Elizabeth (1985). *Adorned in Dreams – Fashion and Modernity*, London: Virago.

Woodward, Sophie (2009). "The Myth of Street Style." *Fashion Theory* 13 (1), 83–101.

Linda Armano, Annamma Joy

Chapter 8
Seller and Consumer Activists in the World of Canadian Diamonds: A Case of Italian Political Consumerism

Introduction

In the late 1990s, natural resources were discussed by activists and the media for their alleged role in financing contemporary wars (Le Billon 2006). Among these commodities, diamonds were especially subjected to debates from the outset. In 1999, the *Fatal Transactions* campaign introduced the terms "African conflict diamonds" and "African terrorist diamonds" to convey the message that buying diamonds was tantamount to killing civilians from disadvantaged socio-economic groups (D'Angelo 2019). The information communicated was to blame capitalism, complicit in these illegal trades, and that it was the responsibility of consumers to be ahead of such events in order not to be labeled as "terrorist consumers" (Le Billon 2006). Diamonds thus assumed a role in influencing consumer orientation toward companies that claimed to take a long-term sustainable position on environmental impacts and ethical treatment of socio-economic groups considered to be disadvantaged (Baek 2010).

Faced with the threat of financial losses because of international boycotts, the diamond industry had to recognize the role of the diamond trade as a source of conflict funding. To avoid the further extension of boycotts, many multinational corporations adhered to forms of certification to limit the illicit diamond trade. Some authors have recognized *consumption politics* (CP) as a powerful tool for orienting consumption (Goodman 2005). Nevertheless, CP is mainly limited to trade in those luxury goods that are labeled as ethical and sustainable. In this context, it has also been observed that ethical and sustainable choices can also represent the moral adaptations (Bryant and Goodman 2004) of consumers toward purchasing decisions driven by marketing strategies capable of both linking certain products to an image of progressive politics (Banet-Weiser 2012) and of making consumers self-perceive as boycotters of global commercial systems that contribute to social injustices.

Concerning the diamond sector, due to the positive economic impact of the diamond industry in the Northwest Territories (NWT) of Canada since the early 2000s, the government of the Northwest Territories labels stones mined in the NWT as *ethical diamonds*. Thus, Canada has been internationally publicized as the exporter of diamonds mined in absolute legality since, as it is a nation free of civil wars, there are no links between the mining industry and conflict.

https://doi.org/10.1515/9783110732757-008

We can therefore say that the Canadian Ethical Diamond (CED) is representative of a branded politics (Banet-Weiser 2012) that uses the gemstone as a vehicle to discuss the possibility of connecting diamond mining not only to the financing of war but also to the protection of the rights of workers and indigenous communities living in the territories where the mines have been opened. Banet-Weiser (2012) observes that political and social actions are made understandable in economic terms and therefore speaks of political consumption and politicized consumers to explain the actions of consumers who endorse social responsibility campaigns shaped by corporate logic.

To provide an example of *political consumerism* (PC) (Banet-Weiser 2012), we set our analysis, based on ethnographic research, in an Italian context and in particular in two jewelry stores selling CEDs. Similarly, to Barnett, Cloke, Clarke, and Malpass (2005), although PCs partly follow universal communication styles to convey ethical choices, they are always recontextualized in local realities. Scholars, however, have focused on how PC is expressed in Italy (Lekakis and Forno 2019), how it is articulated in retail contexts (Jacques and Sandgren 2018), and how it is contextualized within jewelry stores.

Consequently, the choice of setting our survey in the Italian context is intended to help bridge this gap. Therefore, to fill this void, our objective is to understand how, within the two jewelry stores, the CED is explained by the jewelers and understood by the interviewed ethical consumers. To understand the relationship in the dialog between jewelers and customers, we used Thematic Analysis (TA) and Performance Analysis (PA) (Riessman 2008) through which we analyzed the ethical rhetoric during the buying and selling of CEDs in the stores. The subjects involved in our research were assumed by us to be "ethical seller activists" (ESA) and "ethical consumer activists" (ECA), respectively, as they declare their intention to engage in boycott behavior through their choices of selling and buying jewelry.

Furthermore, addressing the concept of 'authentic space' (Banet-Weiser 2012) as a context for ethical rhetoric about CEDs, we applied the theory of 'destorification of the negative' (De Martino 2008) to explain how diamonds mined in Canada enable the people involved in our research to think that their sales and purchases serve to reduce illicit socio-economic practices related to the diamond trade.

Political Consumerism: Definition, Analysis of the Concept, and General State of the Art

Concerning products labeled as ethical and sustainable, consumer activists are assumed to be citizens 'doing good' by 'buying good' (Banet-Weiser 2012: p. 127). If boycotting a product implies a decision to not buy goods produced under conditions that do not meet consumer ideals (Boström et al. 2019), many authors speak,

in contrast, of *buycotting* to define consumer behavior aimed at purchasing products or services from a company that instead reflects their social and political values (Baek 2010).

Scholars agree in defining CP as the set of commitments regarding purchasing choices which emerge from concerns associated with certain types of production (Boström et al. 2019; Baek 2010). Within this context, consumers have the ability to punish (boycotting) or reward (buycotting) companies through selective choices of products or brands based on social, political, or ethical considerations (Baek 2010). CP thus defines the market as a political arena in which institutional or commercial practices can be changed through ethical or environmental orientations through the participation of responsible individuals (Stolle and Micheletti, 2013). CP involves moral challenges concerning ethnicity, gender relations, animal welfare, and our common future (Baek 2010). Some authors also argue that in CP it is impossible to separate consumers and citizens and economics and politics (Boström et al. 2019). Banet-Weiser (2012) argues that CP emerges from the intertwining of practices, emotions, and the market, and it is from this relationship that political debates and conflicts are employed in everyday life to make sense to the actions of consumer citizens. Despite the recent increased interest in CP, this crossing of boundaries between different sociopolitical and economic spheres and the hybridization of social roles requires further investigation (Baek 2010).

Starting from the concerns of social movements and activists and expanding to political, social, and economic issues affecting public and private organizations (Boström et al. 2019), CP offers a significant tool to manage complex problems in productive sectors especially within a global context (Mol and Oosterveer 2015).

The analyses produced in relation to CP have focused mainly on four main themes: (1) boycott actions in which consumers refuse to buy products on the basis of the concerns (environmental, social) that the purchase of such a good raises; (2) the purchase, by contrast, of other goods that replace the boycotted products; (3) the actions and results that the boycott of certain goods determined in the sociopolitical reality of a country; and (4) the relationship between CP and lifestyle changes such as dietary changes through slow food or veganism (Stolle and Micheletti 2013). Other authors have also explored the relationship between CP and the rhetoric that accompanies the sale of certain products (Bromberg Bar Yam 1995), while others have focused on the question of how consumers' political identity orients people's purchasing choices toward products that support social issues (Mol and Oosterveer 2015).

Scholars have also recognized that CP is a phenomenon that affects the networks of social movements (trade unions, environmental groups, associations aimed at defending human rights, and specialized groups that emerge for specific causes), the reaction of institutions, international relations, and the roles of individual states (Pentina and Clinton 2011). Product labeling and certification are also significant components of contemporary CP (Boström et al. 2019). Therefore, concepts such as

ethics and sustainability are topics of increasing interest to both consumers, social movements, businesses, and government institutions which often help facilitate the diffusion of CP (Pentina and Clinton 2011).

Many authors also argue that in the existing literature few empirical studies confirm or disprove these theories (Baek 2010). Baek (2010), by highlighting various types of consumers involved in CP through their purchasing choices, conceptualized four different categories of consumer activists (i.e., nocotters, dualcotters, boycotters, and buycotters).

While there are studies related to macro-level processes that have highlighted, for instance, the reduction, in many cases, of state governmental authority and its capacities to act in the face of various forms of CP (Stolle and Micheletti 2013), there are also micro-level analyses that explore the historical paths that have inspired the local practices of political consumers (Boström et al. 2019). Sarah Banet-Weiser (2012), dealing with the case, among others, of a green branding campaign concerning bottled water in the United States in the early 2000s, identifies that many citizens who adhered to this campaign shared on the one hand values of social ethics and an interest in improving their physical well-being, and on the other hand affiliated themselves with a goal promoted by the government.

Other authors, focused on local contexts, analyze the relationship between CP and ethical shopping as a form of boycott. Philip Balsiger (2014), by mapping clothing stores that support an ethical philosophy (supported by the non-governmental organization Swiss Third World) in the sale of their products, examines the motivations that drive Swiss activists toward these alternative forms of clothing purchase. In the Italian context, although not numerous, some interesting studies show how some regions (e.g., Lombardy) compared to others have developed, since the mid-1990s, forms of CP through, for example, Solidarity Purchasing Groups (Graziano and Forno 2012). Nevertheless, analyses on CP in the Italian context have mainly focused on the subjective practices and personal motivations that push people to become political consumers, neglecting the collective responses of consumer activists (Balsiger 2014). Zamponi and Bosi (2018), investigating instead the relationship between CP and the current economic crisis in Italy, highlighted how the participation of political consumers during the economic crisis in Italy increased. The authors relate this increase not so much to further differentiation between socioeconomic classes in which many people lost their jobs, but well-off people increased purchases labeled as ethical and sustainable. Scholars would rather relate this increase to the significant salience that political debate historically assumes in Italy. Lekakis and Forno (2019) noted how, when investigating PC in Southern Europe (Italy, Spain, Portugal, and Greece), the political consumers, although less numerous than in Northern Europe, increased during the current economic crisis. These studies, by arguing that the most widespread forms of CP in Southern Europe are local networks that aim to promote a solidarity economy, also challenge the conclusions of many analyses that political consumers, as well as ethical consumers,

are commonly found in rich countries (Burke, Eckert, and Davis 2014) and in periods of economic prosperity (Smith and Johns 2020).

From the general analysis of the state of the art, it is evident that there is a gap in studies of how CP materializes within stores (Mol and Oosterveer 2015) and especially within luxury stores and jewelry stores (Moraes, Carrigan, Bosangit, Ferreira, and McGrath 2017). Nevertheless, in some research, jewelry stores have been assumed as places of consumption where the ambiguous relationship between luxury and responsible consumption can be implemented (Smith and Johns 2020) and where consumers can enact forms of boycott by choosing products that conform to their values (Moraes et al. 2017). Therefore, jewelry stores can be considered as a site ontology (Everts, Lahr-Kurten, and Watson 2011) which explicates not just PC-related purchasing practices but also the values of sellers and customers through the buying and selling of jewelry that allows ethical performances to be actualized. Thus, in the context of jewelry, ESAs and ECAs can create a shared knowledge and a sharing of values that enable them to co-build a structured community based on the boycott of untraced diamonds and the purchase of ethically certified diamonds.

Methodology and Findings

The first Italian ethical jewelry shop was the Gioielleria Belloni in Milan. The shop has a long history dating back to 1926 when Francesco Belloni, the grandfather of the current owner who bears the same name, decided to open a small workshop in the city center to repair watches and jewelry. The current Belloni jewelry shop was opened in 1958. After three generations, the shop is now in the hands of Francesco Belloni who, in 2002, began to promote charitable campaigns in his shop in collaboration with associations that helped cancer patients through the sale of jewelry (Armano and Joy 2021).

In 2003, Francesco wanted to make a donation to Londoner Survival International (https://www.survivalinternational.org, a human rights organization formed in 1969 whose campaigns support human rights in developing countries) but the organization refused his offer as the donation came from the sale of diamonds. The group had been boycotting Diamond Trading Company and De Beers in Botswana for years because the mining companies had taken land from the Bushmen to open diamond mines. In the early 2000s, the jeweler only sold African diamonds, but Survival International offered him the alternative of Canadian diamonds mined in the Ekati and Diavik mines in the NWT. Belloni Jewelers began selling CEDs in Italy in 2005.

Francesco created the Ethical Diamonds brand with a logo depicting a stylized diamond and a maple leaf. In less than a year, the jewelry website became one of the largest e-commerce sources in Italy and Europe, and its activity is promoted by Radio Popolare in Milan, a local station with a politically liberal viewpoint that

addresses a target audience that embrace ideals related to environmental sustainability and ethical behavior that support human rights. Before introducing CEDs to the jewelry world, Francesco sold around 60 diamonds a year. Recently, thanks to CEDs, his sales have reached around 300. This increase is explained above all by the start of his activity as a wholesaler. Indeed, since 2010, Francesco has also been supplying CEDs to other Italian jewelry stores and a jewelry store in Switzerland. His first customer as a wholesaler was the jewelry store of Simone Righi in Bologna, who is a retailer and a jewelry designer. Simone kept the brand name Ethical Diamonds created by Francesco. The motivation of the owner of Righi's jewelry shop to propose CEDs came from his personal values and habits. Like Francesco Belloni, he is a conscientious objector to the use of weapons and a volunteer in associations that help poor people in his city. This is why he decided to boycott the sale of blood diamonds and turn to alternative products. It should be highlighted that not only ethical jewelry is sold by Belloni and Righi jewelers, but also other types of jewelry that have no certification. However, thanks to the CEDs, a sort of sub-community of sellers and consumers activists is being built up in the two jewelry stores, created by the common ideals represented by ethical jewelry.

Our ethnographic survey (Table 8.1), conducted between July 2020 and January 2021, within the Belloni and Righi jewelry stores was based on an interpretive approach (Armano and Joy 2021). In the stores, we carried out 14 semi-structured interviews, subsequently transcribed, with both the two jewelers (Francesco and Simone) and 12 of their customers who had purchased jewelry on which CEDs were embedded. Picking up on Baek's (2010) categorizations, the interviewed consumers can be made to fall into the category of *dualcotters* in that they boycott non-certified diamonds by purchasing CEDs.

In all the interviews we kept some key questions including: What does the concept of ethics relating to diamonds mean to you? What does it mean to be an ethical jeweler and an ethical consumer? When and why did you decide to buy ethical jewelry rather than other types of jewelry? How do you imagine Canadian mines where CEDs are mined? How do you imagine mines where uncertified diamonds are mined? How do you perceive the mining profession?

Table 8.1: Informants interviewed in Belloni Jewelers in Milan and Righi Jewelers in Bologna.

Italian informants	Age, profession, and provenance
Simone	48, Jeweler and artisan, Bologna
Francesco	59, Jeweler, Milan
Francesca	42, Office worker, Milan
Manuela	42, Manager, Torre del Greco
Mauro	51, Doctor, Milan
Carlo	42, Office worker, Piacenza

Table 8.1 (continued)

Italian informants	Age, profession, and provenance
Letizia	40, Office worker, Bollate-Milan
Umberto	50, Architect, Milan
Luigi	45, Doctor, Rome
Francesco	45, Entrepreneur, Rome
Gustavo	39, Engineer, Monza
Luca	30, Milan, Entrepreneur
Luca	58, Lower, Bologna
Mattia	43, Entrepreneur, Reggio Emilia

The importance of setting the analysis in the Italian context allowed us to assess not only how PC can take shape in luxury stores in Italy, but also how it is shaped within the ethical rhetoric in relation to diamonds.

Using Grounded Theory (GT) (Glaser, Strauss 1967) as a basic methodological approach, data analysis started early in the field research intending to remain as faithful as possible to the emic viewpoint of the informants. In order to understand how CED is explained by the jewelers and understood by the consumers, we started from the question of how the concepts of CED and blood diamonds are culturally interpreted by our interlocutors, categories which were always counterposed by informants during interviews. From the interpretation of these two cultural categories, we could extrapolate the meaning, for the people involved in our research, of the value of ethics and what is unethical. According to all the informants interviewed, "ethics" means behaving respectfully toward others and the environment in everyday life. Behavior that does not coincide with this viewpoint must therefore be modified in order to achieve an ideal form of ethics. On the basis of this categorization, ethics for our interlocutors is characterized by certain essential and very clear traits, so much so that we can say that ethics is, for them, synonymous with respect. We can therefore say that the CED is the "spokesperson" for a cultural critique capable of showing the values and norms, valid for ESAs and ECAs, which inform certain social actions linked to the CP.

Analyzing both the information that emerged during the interviews and the ethical rhetoric during the buying and selling of CEDs in jewelry stores, the GT was supplemented with the TA and PA (Riessman 2008). By using this method, specific information was isolated in interviews and conversations between salesmen and customers in the shop. While analyzing this isolated data through TA, we elicited some particular themes that the interviewees had used to explain why they both sell and buy CEDs. By categorizing these themes, we were also able to understand how the ethical rhetoric about CEDs used by jewelers and understood by consumers during the buying and selling process emphasizes certain topics rather than others, thus determining a precise communicative performance. Through the PA, we have

therefore understood the buying and selling of ethical jewelry as a context in which the knowledge of the concept of ethics related to diamonds is co-constructed and in which the PC in the choice of buying a piece of jewelry becomes concrete.

During the ethnographic research, some important results emerged which were further confirmed and supplemented in the subsequent phases of the investigation. We noted that the choice of selling and buying diamonds very often depends on whether certain mining technologies are approved or not. We find this information extremely interesting as very few studies have examined consumers' perceptions of mining methods when purchasing jewelry (Lacey, Malakar, McCrea, Moffat 2019). Our survey found that jewelers and consumers do not approve of non-industrialized mining techniques as they are perceived by them as abusive forms of excavation. Nevertheless, this perception of them is not based on a detailed technical knowledge of mining methods but rather on their stereotypical representation of mine work. It was interesting to note that perceptions of mining methods are related to both the environmental impacts that these methods cause and how the work in the mine is organized. The approval of particular mining techniques depends, for informants, on three components: (1) the health and safety of miners and communities living near mines; (2) the impacts that mines have on the soil; and (3) the impacts that mines have on the water. Within these categorizations, the first emerges more redundantly than the others during the conversations. Indeed, when asked how they imagined Canadian mines, informants mostly envisioned the application of careful regulations to protect workers in the workplace, a characteristic that, according to the answers given, would differentiate Canadian mines from African mines.

Discussion: The Themes and Their Performance Emerged in the Purchase and Sale of In-Store CEDs Evaluated Through Thematic Analysis and Performance Analysis

CEDs represent a niche product in Italy. Thus, the ethical rhetoric used by jewelers (albeit with subjective variations on the part of the two sellers) is based on several fundamental themes that allow CEDs to be clearly distinguished from diamonds mined elsewhere in the world. During informal conversations between jewelers and customers, the storytelling by the former counterpose CEDs to diamonds mined in African mines, as if to constitute two opposing sides in the narrative with regard to the global geopolitical landscape in relation to diamond mining and trade. Consequently, clients imagine Canadian mines as production sites that guarantee, to consumers, compliance with labor regulations and thus a focus on workers' health due to the presence of industrialized extraction systems. The ethical rhetoric on CEDs

simultaneously creates an attempt to establish a direct link between African mines and places that are economically poor but rich in natural resources, as well as stereotypical images of Africa as synonymous with violence and primitivism (D'Angelo 2019). Moreover, if in the discourses of our interlocutors there are industrialized mines in Canada, in countries categorized as economically poor (such as some African and South American countries) there is the presence of artisanal and small-scale mines where mined diamonds directly finance armed conflicts (Lacey et al. 2019). Clients' interest in listening to storytelling about CEDs connects to their mediocre prior knowledge about diamonds, as well as Canadian and African mines, summarily constructed mainly through reading online reports and viewing films narrating working conditions in various mines. Ultimately, even the existing literature tends to create a classification that is not thoroughly researched by merely distinguishing between industrialized mines on the one hand and artisanal and small-scale mines on the other. In particular, the latter are very often used as synonyms. Indeed, some scholars (D'Angelo 2019) speak directly of artisanal and small-scale mining by which they mean an informal sector about which there is limited information on production, revenues, mining operations, and even the location of activities (Armano and Joy 2021). However, an analysis of the published studies reveals some differences. While artisanal mining is typically informal, often family-run, lacks sophisticated machinery and attracts poor and non-professional workers (D'Angelo 2019), small-scale mining is more organized in terms of labor management and, although miners often do not own sophisticated machinery, they have a turnover and possess legal licenses (Armano and Joy 2021).

During the interviews, despite attempts to construct stereotypical representations, customers admitted a knowledge gap about the world of diamonds, as well as about the Canadian mines where CEDs are mined. During our ethnographic survey in the jewelry stores, we found that the consumers' choice of purchase is based on the notions transmitted to them by the jewelers. Customers, therefore, have unconditional confidence in what they are told in the stores. The customers who purchased CEDs in the two jewelry stores almost all stated their initial fear of making a wrong purchase choice and the subsequent reassurance provided to them by the jewelers thanks to the explanation of some fundamental themes related to CEDs. Thus, it is useful to realize that TA and PA, used in this part of the analysis, are closely related to each other. Indeed, in our study, we considered the narrative about CEDs to be imbued with an agency (Duranti 2004). This means that the storytelling about CEDs told by the sellers has the potential to drive any consumer to buy ethical jewelry.

From the analysis of conversations between jewelers and customers in the stores, we have extrapolated, through the TA, two main themes that sellers often highlight: stone certification and charitable acts through the sale of diamonds.

The subject of CED certification is the main topic in sellers' explanations to their customers before selling a piece of jewelry. Certification makes it possible to identify the Canadian diamond by distinguishing it from other diamonds that are

not certified and therefore have no identity. Thanks to certification, the CED results in clarity since by employing an alphanumeric code, it is possible to know the mine of origin (MoO) and the characteristics not only of the diamond but also the peculiarities of when it was a rough stone. Furthermore, by having a maple leaf laser engraved on each diamond, consumers are assured of the stone's Canadian origin. Thanks to the application of PA, we have seen that this aspect increases the confidence of the customers in the jewelers' words. Therefore, the storytelling on the CEDs, combined with the display of the alphanumeric code, guarantees that the diamond they are buying is extracted through an industrialized process which automatically implies the application of standards to protect workers as well as environmental monitoring to control the impact of the mining industry in the NWT. This guarantee is not, however, built on surveys conducted by the consumers themselves, but is imagined by them as a result of the narrative carried out by the jewelers, which augments the fragments of information that customers have gathered personally before entering the stores.

Despite the lack of knowledge about MoO, consumers are clear about the values that guide them toward boycotting uncertified diamonds and choosing to buy CEDs. Francesco Belloni has often said during interviews: "We want to be different thanks to ethical options." In this sentence, diversity is implicitly linked both to the certification of CEDs and to the charitable acts that both jewelers perform for associations supporting disadvantaged socio-economic groups, which are also greatly appreciated by their customers.

In addition to the explanation of CED certification and the highlighting of charitable acts, there is a sales performance, highly appreciated by customers, which is reminiscent of a wider fair trade. As one customer interviewed testifies:

> When my wife and I went to pick up the ring I'd given her for our first wedding anniversary at Belloni Jewellers, Francesco handed it over on a cushion and told us that it was made in Africa by women from some aboriginal communities who also do other crafts that help them earn a living. This focus is not just on the ethical diamond but also encompasses a whole range of attention to handmade products that are part of fair trade. I really liked this aspect. My wife liked it too. (Gustavo, 39, Engineer, Monza)

In this way, the sales performance corresponds to a purchase performance in which the distinction of ethical customers from other clients who are neither interested in diamond certification nor specific charitable actions through the sale of CEDs performed by jewelers is reaffirmed. The application of PA has thus enabled us to consider ethical consumers as belonging to an imagined community (Anderson 1983) in which, while all ethical customers cannot know each other, they know that they ideally belong to a group of people who share the same values linked to specific ethical ideals.

ESA and ECA in the Jewelry Stores: Destorification of the Negative Through CED

All informants compare selling and buying to a personal attempt to help mitigate the many harms caused by unscrupulous capitalist and financial exploitation that affect both the environment and socio-economic groups perceived as disadvantaged. Echoing Ernesto De Martino, we can therefore classify these damages within what he calls the "negative of existence" (De Martino 2008). Indeed, the scholar stated how any society manages to overcome crises only when it manages to go beyond the harmful situation. In our analysis, however, it is not the jewelers and ethical consumers who are directly affected by the crisis caused by capitalist exploitation. Nevertheless, the CED shows them how the crisis can be omnipresent and embedded in every aspect of life and relationships. In this way, the CED becomes the critical means of exposing harmful forms of capitalist practices. In this 'alarming universe' (Banet-Weiser 2012: p. 3) the relationship between ESA, ECA, and product/brand thus seems to be reinforced. Banet-Weiser argues that this kind of relationship is only possible within a culture of consumerism. She notes that the 21st century is characterized by a hunger for anything that allows people to perceive themselves as authentic, in opposition to the actions of capitalism which is judged as exploitative and therefore inauthentic. Being authentic also implies attitudes contrary to *superficial* attitudes. Therefore, following ethical behavior also means, in this case, being authentic insofar as caring for disadvantaged humanity. It thus triggers implicit anthropology, that is, an attempt to understand socio-cultural diversity (in this case, workers in the NWTs) by ESAs and ECAs through consumer and brand culture (Banet-Weiser 2012).

Picking up on Banet-Weiser's (2012) concept of "authentic space," we can therefore state that within the Belloni and Righi jewelry stores, symbolic devices for interpreting the differences in human groups are created through the ethical rhetoric about CEDs and buying and selling them. In other words, in the "authentic space," socio-cultural categories are co-constructed that classify and determine the roles of all subjects related to the diamond trade, which ideally include jewelers and consumers, but also Canadian and African miners. In the "authentic space," questions arise about how consumers should behave and how miners should work, as well as how the exploitation of human groups in poor countries can be remedied through purchasing decisions. In this panorama, there is a clear distinction between the West and "the other" (often assumed to be exotic) where the former, besides being the author of the damage, is also the one who can determine a change to the situation caused by it. In this way, the encounter with "the other" takes place through the CED, which creates a possibility for ESA and ECA to express the authentic ideal of ethics, although Banet-Weiser (2012) warns that authenticity is still a branded value as it is expressed, in the West, within the brand culture. In fact, she states, with the concept of "brand culture," that marketing, products, and citizens are

nowadays so closely related that brand culture forms the backdrop to everyday life and structures individual identity as well as emotional relationships.

The storytelling of the CEDs during the purchase of the jewel is therefore imbued with emotionality thanks to the explanation of charitable actions, as well as the narration of attentive behavior toward others (both jewelers explain to their customers, for example, how they are conscientious objectors and engage in voluntary operations in associations in their cities), as well as attention to the use, within the Belloni and Righi jewelers, of renewable sources. All these aspects, combined with the emotional-narrative transport of the jewelers, relate to each other within the "authentic space," which in turn is incorporated into the "brand culture," allowing customers to familiarize themselves with the product and to be guided toward their ethical purchasing choice.

Thanks to the buying and selling of the CED, a sort of collective exorcism takes place in the minds of the ESAs and ECAs in which both the entire group and each of its individual participating members attempt to find a resolution to the crisis caused by the violation of human rights determined by the West. This mythical representation of the struggle between good and evil, which is evident when buying and selling a piece of jewelry, can also be analyzed through a whole series of evaluations that, from time to time, each customer elaborates upon before choosing a product to buy. Within the common value horizon that allows dealing with the negative, there are those who, for example, consider the contextualization of the CED within a fair trade market, those who are more focused on the fear of making the wrong purchase choices where the ethical jewel is the exorcism of this fear, and those who want to underline, through the variant of ethics applied to the jewel, the affection, and attachment to a loved one. Notwithstanding these variants, the common objective is the "destorification of the negative" (De Martino 2008) through which the existential datum that caused the crisis (e.g., the violation of human rights) is mentally abstracted, by ESAs and ECAs, from the historical-cultural context within which such damage was experienced. In the "authentic space," harm is resolved by means of the ideals of ethics that provide a clear direction to ethical sellers and consumers during buying and selling, as if the latter were a mythical-ritual context in which the value of ethics manages to find the maximum satisfactory solution to harm. In this context, storytelling about CED thus enables the ritual entry into this mythical space.

References

Anderson, Benedict (1983). *Imagined Communities Reflections on the Origins of Nationalism.* London: Verso.

Armano, Linda and Annamma Joy (2021). "Encoding Values and Practices in Ethical Jewellery Purchasing: A Case History of Italian Ethical Luxury Consumption." In *Sustainable Luxury and Jewellery*, Miguel Ángel Gardetti and Ivan Coste-Manière (eds.). Singapore: Springer, pp. 1–20.

Baek, Young Min (2010). "To Buy or Not to Buy: Who are Political Consumers? What do they Think and How Do they Participate?" *Political Studies* 58: pp. 1065–1086.

Balsiger, Philip (2014). "Between shaming corporations and promoting alternatives: The politics of an "ethical shopping map."" *Journal of Consumer Culture* Vol. 14(2): pp. 218–235.

Banet-Weiser, Sarah (2012). *Authentic™ the Politics of Ambivalence in a Brand Culture.* New York: University Press.

Barnett, Clive, Paul Cloke, Nick Clarke, Alice Malpass (2005). "Consuming ethics: Articulating subjects and spaces of ethical consumption." *Antipode* 37(1): pp. 23–45.

Boström, Magnus, Michele Micheletti and Peter Oosterveer (2019). "Studying Political Consumerism." *The Oxford Handbook of Political Consumerism.* Oxford: Oxford University Press.

Bryant, Raymond L. and Michael K. Goodman (2004). "Consuming narratives: The political ecology of "alternative" consumption." *Transactions of the Institute of British Geographers* 29: pp. 344–366.

Bromberg, Bar Yam (1995). "The Nestlé boycott: The story of the WHO/UNICEF Code for marketing breastmilk substitutes." *Mothering* 25(2): pp. 56–63.

Burke, Paul, Christine Eckert, Stacey Davis (2014). "Segmenting consumers' reasons for and against ethical consumption." *European Journal of Marketing* 48(11): pp. 2237–2261.

D'Angelo, Lorenzo (2019). *Diamonds. Mining practices and stereotypes in Sierra Leone.* Milan: Meltemi.

De Martino, Ernesto (2008). *The end of the world.* Turin: Einaudi.

Duranti, Alessandro (2004). "Agency in Language." In A Companion to Linguistic Anthropology. Alessandro Duranti (ed.). Malden, MA: Blackwell, pp. 451–473.

Everts, Jonathan, Matthias Lahr-Kurten, and Matt Watson (2011). "Practice Matters! Geographical inquiry and theories of practice." *Erdkunde* 65(4): pp. 323–334.

Glaser, Barney G. and Anselm L. Strauss (1967). The discovery of Grounded Theory. New York: Aldine.

Goodman, Michael K. (2005). "Reading fair trade: Political ecological imaginary and the moral economy of fair-trade foods." *Political Geography* 23: pp. 891–915.

Graziano, Paolo, and Francesca Forno (2012). "Political Consumerism and New Forms of Political Participation: The Gruppi di Acquisto Solidale in Italy." *The Annals of the American Academy of Political and Social Science* 644(1): pp. 121–133.

Jacques, Tristan, and Frerik Sandgren (2018). "Retail Trade, Consumption, and the Construction of Markets." *Scandinavian Economic History Review* 66(2): pp. 127–131.

Lacey, Justine, Yuwan Malakar, Rod McCrea, Kieren Moffat (2019). "Public perceptions of established and emerging mining technologies in Australia." *Resources Policy* 62: pp. 125–135.

Le Billon, Philippe (2006). "Fatal Transactions: Conflict Diamonds and the (Anti)Terrorist Consumer." *Antipode* 38(4): pp. 778–801.

Lekakis, Eleftheria, and Francesca Forno (2019). "Political Consumerism in Southern Europe." In Boström, Magnus, Michele Micheletti and Peter Oosterveer (2019). "Studying Political Consumerism." *The Oxford Handbook of Political Consumerism.* Oxford: Oxford University Press., pp. 46–67.

Mol, P.J. Arthur, and Peter Oosterveer (2015). "Certification of markets, markets of certificates: Tracing sustainability in global agro-food value chains." *Sustainability* 7: pp. 12258–12278.

Moraes, Caroline, Marylyn Carrigan, Carmela Bosangit, Carlos Ferreira, Michelle McGrath (2017). "Understanding Ethical Luxury Consumption Through Practice Theories: A Study of Fine Jewellery Purchases." *Journal of Business Ethics* 145(3): pp. 525–543.

Pentina, Iryna and Amos Clinton (2011). "The Freegan phenomenon: Anti-consumption or consumer resistance?" *European Journal of Marketing* 45(11/12): pp. 1768–1778.

Riessman, Catherine K. (2008). Narrative Methods for the Human Sciences. Thousand Oaks, CA: Sage Publications, Inc.

Smith, Andrew, and Jennifer Johns (2020). "Historicizing Modern Slavery: Free-Grown Sugar as an Ethics-Driven Market Category in Nineteenth-Century Britain." *Journal of Business Ethics* 166: 271–292.

Stolle, Dietland, and Michele Micheletti (2013). *Political consumerism: Global responsibility in action*. Cambridge: Cambridge University Press.

Zamponi, Lorenzo, and Lorenzo Bosi (2018). "Political Consumerism and Participation in Times of Crisis in Italy." In Marco Giugni and Maria T. Grasso, "Citizens and the Crisis. Experiences, Perceptions, and Responses to the Great Recession in Europe." *European Political Sociology*: pp. 141–163. Palgrave Macmillan.

Claudia E. Henninger, Taylor Brydges, Celina Jones,
Aurelie Le Normand

Chapter 9
That's So Trashy – Artification of Waste in the Luxury Fashion Industry

Introduction

Fashion is no longer simply something that we wear or that allows us as individuals to express ourselves, but rather it can also be seen as an art form, which changes the original intended purpose of items. This is often referred to as *artification*. Thus, "an ordinary object [could be] elevated to the dignity of a work of art by the mere choice of an artist" (MoMa 2021). For example, we can look at a range of iconic creations that have made headlines, with Agatha Ruiz de la Prada, who made her debut in 1981 by taking on a surrealist style, inspired by artists such as Dalí, Ernst, and Magritte and designing outfits that depict "cage-dresses, melting fried eggs, lips, piano keys," and many more designs, thereby transforming garments into walking canvasses (Awwwards n.d.).

Agatha Ruiz de la Prada's collection not only made it onto a variety of catwalks, but was also transformed into an exhibition, which further showcases the transition for garments to becoming a canvas that can be visited in a museum, yet is no longer worn by an individual. Thus, artification may not necessarily be through a physical transformation of, here, the actual dress, but through using these fashion items in a different way than they were originally intended for (Hwang and Yim 2020). Crane (2019: p. 293) highlights that "fashion design is created in systems of collaborative relationships comparable to art worlds but fashion systems differ from art worlds in the relative emphasis on economic considerations and in the utility of what is produced."

In line with Crane's (2019) assessment, we see changes happening in the 20th century in that fashion emerged as an art form, which was further enhanced through the emergence of museums that specialized in exhibiting fashion items. Examples of these museums and exhibitions include the Victoria and Albert Museum's (V&A) *Fashioned from Nature*, which featured not only historic costumes, but also modern garments, such as Emma Watson's Calvin Klein Met Gala outfit from 2016 (VAM 2021a).

More recently, we have also seen virtual museums that showcase sustainable fashion innovations, such as the *Fashion for Good Museum*, which in the time of Covid-19 has adapted their museum experience to take place virtually in order to enable individuals to still enjoy these fashion items without having to travel to Amsterdam (FFG 2021). In 2021, we also see the opening of *The art of the sneaker* exhibition, which not only showcases "the rise of global sneaker culture, from performance shoe to cult collector item(s)" (*Business Times* 2021), but also the newest trends of no longer creating physical products, but rather virtual fashion pieces that can be used on

https://doi.org/10.1515/9783110732757-009

social media accounts, such as Instagram. Although out of scope for this chapter, an area that should be explored further is what the impact of digital fashion is on becoming more sustainable and what the impacts adorning selfies as an art form can have on the self (e.g., Bernat and Domoszlai-Lantner 2021).

Within this chapter, we not only seek to explore the artification of luxury fashion, but also focus on how this can impact sustainable practices and thinking. This includes works by designers such as Dame Vivienne Westwood and Stella McCartney, who have taken a stance to promote sustainable luxury fashion, with the former having had an exhibition in the V&A entitled "Vivienne Westwood: punk, new romantic and beyond" (VAM 2021b) and the latter using script on T-shirts to make a stance (Glamour 2017).

Here, luxury fashion refers to any type of garment and/or accessory that has been produced by luxury fashion brands, which include, but are not limited to Prada, Gucci, Calvin Klein, Jean-Paul Gaultier, Alexander McQueen, Coco Chanel, or Diane von Furstenberg (McDowell 2020; Statista 2021). Within the artification process, we explore the role of celebrities in further enhancing the drive to enjoy more sustainable fashion and engage in sustainable fashion practices, especially through the artification process of their garments designed by key luxury brands in the industry.

The chapter will provide insights into the artification of fashion items. We seek to address the following research questions:

1. What does sustainability of fashion and/or garments mean within this chapter and more broadly the field of luxury fashion?
2. How are sustainable fashion and artification linked?
3. What are the implications of artification of sustainable fashion?

Sustainability and Luxury Fashion

In addressing the first research question, we feel it is necessary to highlight what sustainable fashion is, and more specifically, what it means within the luxury context and artification. Indeed, exploring whether (or not) sustainability in the fashion industry can be achieved is a philosophical question, as sustainability is a fuzzy concept that is understood by many, yet hard to define (Henninger et al. 2016; Mukendi et al. 2020). We have also noticed that various terms are used (often interchangeably) when it comes to sustainability and fashion.

For example, ethical, green, eco, sustainable, and slow fashion are often seen as being the same, whilst Blazquez et al. (2020) have indicated that clear distinctions can be made, drawing on research by Niinimäki (2010), who highlights that eco-fashion is linked to the materials used and an overall focus being placed on reducing chemical usage and CO_2 emissions throughout the production process.

Ethical fashion on the other hand also takes the human factor into account, thereby centering attention on labor law and general health and safety aspects (Joergens 2006). While slow fashion not only has a time aspect of reducing fashion production, it also emphasizes local craftsmanship, artisanry, traditional production, and the reduction of waste per year (Fletcher 2008).

A commonality between all definitions provided is the fact that "sustainable fashion" seeks to reduce impacts that are deemed harmful during the production as well as consumption processes on the natural and social environment. We follow this line of thinking by further highlighting that sustainability in the fashion industry is reflected either in the production process or business model innovations (Niinimäki 2010; Henninger et al. 2019, 2020).

As indicated, fashion has a dirty secret, since it is one of the key polluting industries globally, as well as being resource and labor intensive (EAC 2019; WRAP 2020a, b). To highlight this further, textile production processes require substantial resources. In reducing the environmental impact, fashion companies, including luxury brands have started to reduce the use of virgin materials, and invested more in recycled raw materials (e.g., polyester, Econyl) and closed loop fiber spinning processes (lyocell), or using alternative feedstocks such as food (orange fiber) or textile waste (refibra).

Luxury fashion brand Salvatore Ferragamo is one of the advocates of orange fiber, who has produced a fashion collection "with our sustainable fabrics from citrus juice by-products" (Orange Fibre 2018), which was exhibited under the "fruity fabrics" section in the Victoria and Albert Museum (VAM 2021a). A question that emerges here is whether visitors of the exhibition were aware that the dress was made from more sustainable materials? Of course, the sign right next to the dress had all the key information provided, with the snappy heading of "Fruity Fiber," but do we, in our capacity as a visitor of a museum, take in and process this information? Do we make the connection that the dress that was so decoratively displayed in the museum is made from food waste? We will return to these questions later.

What may be more obvious is that various fashion brands have started to replace their often ethically questionable animal-based raw materials (which could also be a result of increasing pressure from non-governmental organizations and consumers). The year 2020 marks a key milestone, with headlines stating "Claiming victory, PETA ends 30-year campaign against fur" (Adegeest, 2020). The *"I'd rather go naked than wear fur!"* campaign was supported by various celebrities. It can also be seen as one of the reasons why brands, such as Stella McCartney and Vivienne Westwood, have taken a strong stance to promote luxury fashion that is not only more 'sustainable' than perhaps some of their counterparts, but also, in some instances, vegan friendly. Moreover, Stella McCartney has designed various slogan shirts, including the "women power love" design that not only sends a strong message and supports The Girl Project, but also transforms into an art piece that not only adorns people, but also decorates walls and postcards (Glamour 2017).

From these discussions, it becomes apparent that luxury brands face various challenges: on the one hand, their collections are used as artifacts that often portray a political stance (e.g., tackling the climate crisis, supporting anti-fur campaigns, promoting living wage payments) (e.g., Adegeest 2020; Nguyen 2020; Buttler 2021). But on the other hand, the same fashions are also 'cool' and 'trendy' and are therefore worn by many consumers, whether they agree with the original messaging or not, and whether they actually know the meaning behind it – a different question and one that goes beyond this chapter. Thus, we have a 'behind the scenes' scenario, whereby fashion companies, including those in the luxury sector, have made every effort to reduce their environmental impact across the textile supply chain, and further have the drive to tackle the associated challenges they face.

One key issue the luxury fashion industry is tackling is waste across production processes, laundering, and end-of-life, with most of the textile waste ending up in a landfill or being incinerated (Ütebay et al. 2019). For example, Suave, a Kenyan fashion brand, made it their mission to create unique backpacks and accessories made from fabric scraps (Fashion Revolution 2018). Here we can see the artification process by re-imagining waste and creating colorful products that are meaningful and have sustainability at the core of the production process.

However, although companies such as Suave exist, overall only a small percentage of textile waste is recycled (either mechanically or chemically), with a majority of it being landfilled, which not only has environmental implications, but also implies a loss in terms of economic value (WRAP 2020a, b). One of the reasons why more fibers are not recycled is the changed performance properties. For example, recycled cotton has shorter fiber length and may no longer be as strong as virgin material (Ütebay et al. 2019). This can have further impacts on how items can be dyed and thus, which dyeing processes can be utilized. Depending on the dyeing processes utilized, water usage can increase, as some dyeing processes are more water intensive than others (Khatri et al. 2015).

From a social sustainability angle, we have also seen increased monitoring processes, calls for action, and more research undertaken to foster and ensure safe and sweatshop-free working conditions to avoid tragedies such as Rana Plaza (Bangladesh) in 2013, which saw thousands of people lose their lives (EPRS 2014; Brydges and Hanlon 2020). Various companies, such as People Tree, are also continuously investing in stakeholders by providing, for example, schools or other vital institutions in the communities (e.g., People Tree 2021).

Focusing on business model innovations, we have seen the emergence of the circular economy, in which materials are continuously re-looped back into the production process, thereby capitalizing on the value of waste materials (Niinimäki 2017; Henninger et al. 2020). New business models, such as renting, swapping, and secondhand r-commerce have emerged, as well as designing garments for circularity (Niinimäki 2018). The latter focuses more on the creation process as well as what

can be done with the material once the actual garment has fulfilled its useful life. The design aspect is what we will focus on here and link it more closely to the artification process.

Sustainable Luxury Fashion, Artification, and Celebrities

In this section, we further allude to the link between artification and luxury fashion, while addressing the implications artification has on sustainable thinking. We first provide some background information, then discuss different 'scenarios' of luxury fashion, sustainability, and artification, thereby focusing on the 4Rs (reuse, reduce, resew, resell) and discuss them in light of concrete examples.

Although Covid-19 has, unsurprisingly, dominated much of our media outlets, it is not the only key event that happened. The year 2020 also marked the 10th anniversary of the Green Carpet Challenge, which was initiated by Livia Firth, the co-founder and creative director of Eco-Age, and Lucy Siegel, a columnist and book author, to raise awareness of issues in the fashion industry and to promote wearing more sustainable fashion at key events (Pithers 2020). Amid the flashing lights of red-carpet events, we see the emergence of a quiet, but powerful revolution that promotes wearing garments "fashioned within the remit of environmental and social justice" (Pithers 2020). We see celebrities joining in this silent revolution, and taking a variety of different stances, which are analyzed in the following scenarios.

Reuse: Emma Watson's Met Gala 2016 Dress

In 2020, Emma Watson was described as "Hollywood's Queen of Ethical Dressing" (Okwodu 2020), which all started in 2016. Along with the opportunity to raise awareness during the Hollywood award season, the Metropolitan Museum of Art (Met) Gala has historically invited guests said to be pushing the boundaries in fashion, entertainment, and politics (Vogue 2020). In 2016, Emma Watson wore a Calvin Klein dress that was heavily discussed in the media. Her dress was designed in three parts – to allow for it to be worn multiple times, yet still looking different. In an interview, the actress and sustainable fashion spokesperson indicated that sustainability is important to her, and as such, she was happy to work together with her stylist and "tak(e) something that is such a massive pollutant on our planet such as plastic bottles and actually finding a way to repurpose that" (YouTube 2016).

Reuse here links to the fact that the dress was created from 'trash,' namely PET bottles which we consume often on a daily basis (Okwodu 2020). Interestingly, we could not see a difference in terms of the material, whether made from virgin

polyester or made from plastic bottles – there is quite literally no difference, as the feel and the look of the material stays the same, yet it provides a more sustainable option through reusing 'trash.'

What is fascinating about the dress is the thought process that went behind its creation. In an interview with Style host Derek Blasberg, Emma Watson (YouTube 2016) stated that she wanted to have a piece that could be worn on multiple occasions (*reused*), which is why the 'dress' was designed in three pieces. There are multiple implications involved.

First, it is commendable that celebrities like Emma Watson, who has a huge fan base, are taking a stand and wanting to promote change in the fashion industry by wearing something that has a reduced environmental impact and/or is made from 'trash.' Emma Watson is seen as a key influencer here as she is advocating sustainability and is a spokesperson for Good On You, an app that ranks fashion brands in accordance with their sustainability performance (Fashion Revolution 2019). She further actively seeks to "wear labels that work with zero-waste factories, ethically sourced materials, and that maintain a commitment to being cruelty-free" (Okwodu 2020).

Second, it also uncovers issues in our society that need to change, namely the fact that it is seen as unacceptable to be photographed twice in the same outfit. "When you're a celebrity, there's a lot of pressure to look a certain way and, of course, dress a certain way. To make things even more complicated, there's also an unwritten rule that celebrities should rarely – if ever – repeat an outfit" (Ledbetter 2018). How this unspoken rule came into play and why it has dominated the luxury fashion celebrity world is beyond this discussion. However, what needs to be mentioned here is that this trend is no longer a luxury fashion phenomenon, but rather has been enhanced through our Instagram society (Bowman 2017; Satenstein 2019) and, thus, has become a mainstream phenomenon.

Third, Emma Watson's Met Gala Dress has found itself as one of the key pieces showcased at the *Fashioned from Nature* exhibit in London (VAM 2021a), where visitors were able to not only admire the design, but also read more about the actual material and the creation process. The artification process has begun – an item, or here three pieces, has been taken out of its intended context and has been artified to represent sustainable luxury fashion that is not only aesthetically pleasing to look at, but also is associated with having been worn by Emma Watson.

Here, we come back to our previous questions: Do consumers understand the connection between the material used, sustainability, and the luxury fashion industry? Perhaps they do, as arguably one of the reasons people went to see this specific exhibition was to see garments that are *Fashioned from Nature* (VAM 2021a). However, do we always understand the message? The dress was positioned in front of scenery depicting white flowers and grass, as well as surrounded by bottles with succulent plants, a setting that may have promoted the "marrying ethics with aesthetics" angle, rather than the fact it is made from plastics.

Yet, it could be argued that this exact depiction is also a metaphor for the material being more environmentally friendly and less damaging than, for example, other raw materials. To debate this philosophically – as beauty is often said to be in the eye of the beholder – if these items of clothing are not arranged in an aesthetically pleasing manner and paired with easy to read, short, and catchy headlines, would anyone go and see them?

On the other hand, you can make the argument that people only went to see the dress because it was worn by Emma Watson, and seeing the dress may make fans feel closer and more connected. As such, we could question whether the celebrity factor of the dress outweighs the underlying message of being made from 'trash.'

Another challenge associated with this artification process is the fact that Emma Watson, who wanted to wear the individual parts on different occasions, is unable to do so as long as the dress is being exhibited. Although the dress was placed behind a barrier, and may have been safe from anyone touching it, artificial lighting and the warmth of the room could perhaps have an impact on the fabric, not to mention that the plastic material in itself is also aging – all of which can have an impact on it being worn again in the future. Thus, could it be argued that although the artification process may educate more people about the fabrics used, at the same time it may hinder other intentions, such as wearing the item in the future, thereby neglecting the *reuse* part?

Rewear: Joaquin Phoenix's Stella McCartney Suit

Four years on from Emma Watson's fashion statement, we saw the message of reducing waste being reinforced through a different approach. In 2020 Joaquin Phoenix vowed to wear the same Stella McCartney suit to each award ceremony, in order to do his bit to reduce waste (The Independent 2020). He is thus going against the norm, by not only breaking free from expectations of wearing different outfits to avoid being photographed twice in the same one, but also by highlighting that wearing the same outfit multiple times reduces waste.

It has been argued that male celebrity fashion is different from that of their female counterparts (in that it is not always obvious whether (or not) a black suit or tux is different from the one worn previously), and thus the statement may not be as powerful (Nguyen 2020). As such, a key question that emerges here is how powerful was this statement? If the press had not reported about Joaquin Phoenix making a stance in his Stella McCartney outfit, would we have known about it?

This line of argument is also followed by Nguyen (2020), who indicated that these questions were indeed raised before by others. Nguyen (2020) further highlights that the message of reducing waste may have gotten lost and/or been interpreted differently. The suit most certainly found itself to be part of a Twitter debate that had two opposing views: on the one hand, the actor was commended for taking

a stand and was described as a 'winner,' while on the other hand, it was seen as 'Hollywood hypocrisy' that received various sarcastic comments with fans not buying into the 'reducing waste' message (Hainey 2020).

Nevertheless, celebrities' fame provides a vehicle to raise public awareness about environmental causes and, in Joaquin Phoenix's case, the climate crisis in general terms (Raphael 2019). For activism to be impactful, it needs to be not only convincing and believable, but also an authentic message of the luxury brand DNA and the celebrity DNA. Further, Joaquin Phoenix has in the past voiced his concerns about climate change, thus, people will expect action from him to further his cause as seen in wearing the same suit throughout the awards season. Teaming up with Stella McCartney has been a strong statement and provides additional authenticity, since Stella McCartney is known for her stance on producing vegan friendly fashion and does not shy away from making her opinion known about sustainability in the fashion industry. They are both outspoken and advocates for sustainability, make activism part of their DNA, or, in other words, part of who they are and what they stand for. Some argue that brands uphold societal values as instrumental ways to show to their target consumers that they support social causes in a mere function of attracting more customers (Vredenburg et al. 2020). This latter point can only emphasize the importance of the object and its meaning in the artification process.

Jackson and Shaw (2006) argued that there are two fashion schools, the one that considers fashion as an art form worthy of an exhibition, and the one that focuses on purely commercial activities. Artification is part of the first school, the one that will inform and question authentic social and environmental issues from design ideas all the way to how the collection is produced (Singer 2020). Stella McCartney's suit designed for Joaquin Phoenix could fall into both categories, as it was designed with social and environmental sustainability aspects in mind, while at the same time could be seen as fostering commercial value.

Taking a stand, whether political, environmental, or anything else, is reflected within the art scene. Throughout history we see changes not only in the way pictures are painted (e.g., Realism versus Pop Art), but also in the way they uncover hidden meanings over time (e.g., still life). Not everything we see may be as obvious to us in the first instance, it takes time to decode the messages and understand the meanings, and even then, it may not be interpreted in the same manner. The street art artist Banksy is loved and hated at the same time, the often simple images are not only iconic and powerful, but also sometimes seen as a nuisance, as they are sprayed onto buildings and/or walls.

If we reflect on this, could we argue that individuals like Joaquin Phoenix are starting a similar revolution that is either liked or disliked by people who follow celebrities? Breaking rules and standing against norms that may be seen as constraining is certainly part of the art world, which would imply that the Stella McCartney suit is no longer simply a garment, but a sign for a revolution that seeks to empower individuals and raise awareness of current consumption practices that

are unsustainable in addition to the climate crisis. Straying from what is commonly perceived as acceptable can be a powerful move. These individuals are highlighting that they do not agree with what is going on in the world of celebrities and luxury fashion. Historically speaking, people may only have had one 'Sunday suit' that was seen to be more elegant and to be worn on special occasions. This has changed, with people owning more than they can often wear. Thus, moving back to only wearing one suit throughout awards season is, in a way, a revolution, as we see a re-evaluation of our lifestyle. On the other hand, the critiques have indicated that this may not go far enough since it may not always be obvious that it was indeed the same suit that was worn to multiple events and, thus, the message, no matter how important, may be lost in translation (Nguyen 2020).

Resewn: Saoirse Ronan's Gucci Dress

To quote Kaliviotis (2020), Saoirse Ronan acted in accordance with "something old, something new, something borrowed, something blue," when she attended the 2020 Academy Awards. Parts of the actual dress, namely the black satin, were upcycled material from a dress she had previously worn at the BAFTA awards (Kaliviotis 2020).

There are two very interesting themes emerging. First, the original black Gucci dress was described as "a strikingly simple, sustainable work of art" (Le Caer 2020). This comment is fascinating due to the fact that the *'work of art'* here refers to the simplicity of the black dress, which still managed to catch the media's attention. This is opposed to being a piece of art in the sense of being a canvas that could be looked at in a museum. What becomes apparent is that sustainability is not just a complex issue that is hard to capture, but so is the artification process of garments. Could we say that the design process in itself makes it part of the art world? Or the fact that it was so simplistic that it could be worn again? Do we need to widen the concept of artification? These are all questions that may need to be addressed in the future.

A second interesting snippet about the 2020 Academy Awards dress is not only that it featured parts of the "strikingly simple, sustainable work of art" (Le Caer 2020), but that hardly anyone reported on it (Kaliviotis 2020). We saw media outlets discussing the dress and the fact that the actress has managed to reinvent herself, but not many have highlighted the fact that the dress was re-sewn or upcycled.

This aligns with an argument Nguyen (2020) has brought forward that the outfit itself often becomes more important than the actual message that is being broadcast. Whether this is intentional or not is a different question. What we know, however, is that the dress may not have had its full voice heard. What needs to be highlighted here is the fact that the 'new' BAFTA dress featured only a small part of the 'old' dress – the top part of the dress.

We come to the proverbial crossroads in the argument and can see a twofold opinion. Was it really necessary to cut up a dress that may still have been perfectly usable? Would it have been more sustainable to simply give the black dress away and resell it rather than making it into a garment, and creating waste, as it is not clear what happened to the rest of the satin fabric and whether it was used in another piece. We could highlight that it may be better to cut up parts of a dress in order to create a new one if the old dress would have otherwise never been worn, then at least parts of it gain a new life. Yet the question that remains as the elephant in the room is what happens with the *rest* of the dress? Could this have been one of the reasons why there was not more of a buzz around the dress? Or is it simply because, similarly to Joaquin Phoenix's suit, if the actor/actress is not shouting out about the fact that it is upcycled, no one would know about it and the message gets lost? There are more questions raised than can be answered, so there is a need to do further research in this area.

Resell: Kylie Jenner, The RealReal and the ReCollection Program

The RealReal (2021a) is a resale platform that describes itself as "empowering consignors and buyers to extend the lifecycle of luxury goods. The future of fashion is circular." It provides individuals with an opportunity to resell authentic luxury fashion pieces. In the past, celebrities have also taken this opportunity, with Kylie Jenner being one of them. Kratofil (2017) highlights "the only thing better than high-priced items at a discount, is when they come straight from the closet of the world's most famous family."

Although the various activities of the Kardashian-Jenner family may be heavily debated, it was also suggested that they can have a significant impact, seeing as their Instagram following is in the millions (Lodhi 2017). Kylie Jenner has been described as "the frontrunner in terms of ethical Kardashians" (Lodhi 2017), – her cosmetic line is not only vegan friendly, but she also puts a lot of emphasis on it being cruelty free; though her dress style makes the ethical stance more questionable, as she wears a lot of fur and leather products. Yet, because she is selling things on The RealReal, one could argue that she is making a step in the right direction in terms of promoting the reuse of garments and allowing for an extended wear-time of the items.

However, it is questionable if consumers buy into the implicit altruism of these celebrity secondhand products: is it because they are secondhand or because they have been worn by someone famous? We also question whether these items will actually be worn, or could they become decorative trophies that may be showcased in a manner similar to the Hardrock Café?

A quite fascinating recent development is the fact that The RealReal has changed direction slightly. While their main business remains resale, the company has created

one of its first collections made from upcycled materials, using old garments donated from Balenciaga, Dries Van Noten, and Stella McCartney as raw materials and transforming them in their new ReCollection program (Kent 2021). This not only addresses an issue that we discussed in the beginning of the chapter – that waste is a key issue, yet old garments continue to have value (Kent 2021) – but also how we can transform items into something new.

In their first ReCollection collection, consumers are not only able to buy garments, but also art pieces, such as wall tapestries, made from scrap materials (TheRealReal 2021b). Similarly, to Saoirse Ronan's dress, we see the emergence of re-sewn garments making a statement, yet this time the message is clear with media outlets commending the company by highlighting that the "resale leader The RealReal takes on upcycling" (Cernansky 2021).

Although this is an interesting turn of events, it is questionable how financially viable this may be and whether new collections can be created. Upcycling depends on raw materials, which implies that without having access to donated materials and/or clothing items, it is impossible to manufacture a new collection. Similarly, in the Pre-Loved Podcast on April 19, 2021, Emily Stochi had a conversation with co-founder of Fashion Revolution Orsola De Castro, who indicated that there needs to be more work done in terms of acceptance of secondhand and pre-loved garments, since there may be a stigma attached to it that prevents consumers from fully engaging with this type of sustainable fashion (e.g., Henninger et al. 2019).

Consumers may not always be aware that some of the upcycled material comes from pre-consumer waste, which implies that it has not been worn, or are garments that have been donated because they could not be sold in the store. As such, the fear of contamination and wearing something that someone else may have had close to their skin would become obsolete.

Conclusion

This chapter addresses three broad questions to gain a better understanding of what sustainability means within the context of sustainable practices and artification, as well as the implications of artification. What became apparent is that we have more questions than answers, which highlights the necessity to conduct more research in this area.

We provided a variety of examples where fashion brands have utilized celebrities and their influence to make their key message known. This not only helps the brand in terms of awareness, but also shows that sustainability is increasingly important. We can see examples where artification can be an easy way in for consumers, by learning more about materials and/or following the stances celebrities make with their luxury garments. Going to exhibitions, such as *Fashioned From Nature,*

provides an opportunity to not only look at aesthetically pleasing garments, but to also consciously or unconsciously take in the impact of materials and how materials have changed over time.

The luxury fashion industry is linked to celebrities wearing these outfits. Celebrities have become a part of our lives and can have a huge influence on what we do, how we feel, and what we think, and incorporating them into the sustainable messaging can be highly influential. Yet what happens once the buzz is over? While the spotlight is on the red carpet, it presents an opportunity for celebrities and designers to highlight the social, environmental, and political issues surrounding the fashion industry. But what happens when the cameras have disappeared and the event comes to a close; how are these sustainable luxury garments then presented *inside* (for example, the Met Costume Institute collection)?

We discussed the fact that fashion items are designed to be worn and have a set life span. Thus, displaying garments, whether historic or new, can present a variety of challenges, such as limiting the amount of light to prevent the degradation of the dyes in the fabrics, or halting the natural degradation of natural fibers such as cotton by mold and wool from being eaten by moths.

As current and future fashion items become deliberately designed to biodegrade or to be recycled, moving away from linear production processes, further difficulties will be presented for the curators of exhibitions such as *Fashioned From Nature*. Once fashion items are taken out of context and *need* to be preserved, is the message and context of these items also being altered? The answer to this question may be: perhaps. As illustrated through the case studies, different actions have different consequences. Giving people an opportunity to look at a dress in a museum might be educational and provide them with the possibility to learn more about materials, and the history and thought process of the garment. On the other hand, with garments not being worn, they could be seen as an idle capacity that is not fulfilling its intended purpose – being worn. In this specific instance, the message of promoting sustainability may remain, but is broadcast through a different medium, namely an exhibition.

If we think back to the resewing and reusing examples, we may have a different answer, as the message may have gotten lost in the first instance (i.e., Joaquin Phoenix's suit). Conversely, the intention of reusing fabric from a previously owned garment might be an interesting concept, yet if this garment had had more of a useful life, it may be seen as contradictory to what sustainability means. Since more waste may have been created by cutting up the initial dress, it is not clearly outlined what will happen to the rest of the material that was not reworked. Yet this may be an opportunity for companies such as The RealReal to come in and enhance collaborations by making use of 'waste' materials and ensuring that all parts are reworked.

A key conclusion is the fact that it is vital to communicate about sustainability and the luxury fashion industry. It has become a global priority and various stakeholders have outlined that actions need to be taken. Luxury fashion forms a vital

segment of the fashion industry, with controversies that have been highlighted surrounding sustainability (e.g., use of precious materials, animal skins, etc.). Any action taken to promote sustainability and educate consumers is vital. Artification can be one of these ways to not only 'speak' to the luxury consumer, but also to consumers who may be interested in art and/or fashion in more general term.

References

Adegeest, D.A. (2020). "Claiming victory, PETA ends 30-year campaign against fur," *FashionUnited* (online): https://fashionunited.uk/news/fashion/claiming-victory-peta-ends-30-year-campaign-against-fur/2020020647402, 22/05/2021.

Awwwards (n.d.) "20 spectacular and surreal dresses." *Awwwards* (online): https://www.awwwards.com/20-spectacular-and-surreal-dresses.html, 22/05/2021.

Bernat, E., and D. Domoszlai-Lantner (2021). "Everyone from Gucci to Louis Vuitton is betting on digital fashion." *Fast Company* (online): https://www.fastcompany.com/90639443/everyone-from-gucci-to-louis-vuitton-is-betting-big-on-digital-fashion-heres-why-they-should-proceed-with-caution (accessed 5/27/2021).

Blazquez Cano, M., C.E. Henninger, B. Alexander, and C. Franquesa (2020). "Consumers' knowledge and intentions towards sustainability: A Spanish fashion perspective," *Fashion Practice* 12(1): 34–54.

Bowman, L. (2017). "One in six young people won't wear an outfit again if it's been seen on social media." *Metro* (online): https://metro.co.uk/2017/11/15/one-in-six-young-people-wont-wear-an-outfit-again-if-its-been-seen-on-social-media-7078444/ (accessed 5/24/2021).

Brydges, T., and M. Hanlon (2020). "Garment worker rights and the fashion industry's response to COVID-19." *Dialogue in Human Geography* 10(2): 195–198.

Business Times (2021). "The art of the sneaker." *Business Times* (online): https://www.businestimes.com.sg/consumer/the-art-of-the-sneaker (accessed 5/27/2021).

Buttler, S. (2021). "Livia Firth: 'How do fast fashion bosses sleep at night?'" *Standard* (online): https://www.standard.co.uk/insider/livia-firth-ecoage-sustainability-fast-fashion-b933165.html (accessed 5/24/2021).

Cernansky, R. (2021). "Resale leader The RealReal takes on upcycling." *Vogue* (online): https://www.voguebusiness.com/sustainability/resale-leader-the-realreal-takes-on-upcycling (accessed 5/05/2021).

Crane, D. (2019). "Fashion and artification in the French luxury fashion industry." *Culture Sociology* 13(3): 293–304.

EAC (2019). "Fixing fashion: clothing consumption and sustainability." *Parliament* (online): https://publications.parliament.uk/pa/cm201719/cmselect/cmenvaud/1952/report-files/195207.htm (accessed 5/31/2021).

EPRS (2014). "Workers' conditions in the textile and clothing sector: just an Asian affair?" *European Parliament* (online): https://www.europarl.europa.eu/EPRS/140841REV1-Workers-conditions-in-the-textile-and-clothing-sector-just-an-Asian-affair-FINAL.pdf (accessed 5/20/2021).

Fashion Revolution (2018). "7 fashion brands that are designing out waste." *Fashion Revolution* (online): https://www.fashionrevolution.org/usa-blog/7-fashion-brands-that-are-designing-out-waste/ (accessed 5/22/2021).

Fashion Revolution (2019). "Good On You, Emma Watson!" *Fashion Revolution* (online): https://www.fashionrevolution.org/good-on-you-emma-watson/ (accessed 6/8/2021).

FFG (2021). "Fashion for Good Museum," *FFG* (online): https://fashionforgood.com/museum/ (accessed 5/19/2021).

Fish, I. (2020). "How Covid turned the spotlight on sustainability," *Drapers* (online): https://www.drapersonline.com/insight/analysis/how-sustainability-became-a-covid-survival-strategy (accessed 5/22/2021).

Fletcher, K. (2008). *Sustainable Fashion and Textiles Design Journeys*. London: Earthscan.

Fuller, G. (2020). "Covid-19 lockdowns have improved global air quality, data shows." *Guardian* (online): https://www.theguardian.com/environment/2020/oct/08/covid-19-lockdowns-global-air-quality-india-london-uk (accessed 5/20/2021).

Glamour (2017). "Stella McCartney talks her exclusive t-shirt collaboration with Glamour and her empowering worldview." *Glamour* (online): https://www.glamour.com/story/stella-mccartney-t-shirt-collaboration-with-glamour (accessed 5/22/2021).

Hainey, F. (2020). "Hollywood star 'reducing waste' by wearing same tuxedo to award bashes – but fans don't buy in." *Manchester Evening News* (online): https://www.manchestereveningnews.co.uk/news/uk-news/stella-mccartney-joaquin-phoenix-tuxedo-17527828 (accessed 5/27/2021).

He, G., Y. Pan, and T. Tanaka (2020). "The short-term impacts of COVID-19 lockdown on urban air pollution in China." *Nature Sustainability* 3: 1005–1011.

Henninger, C.E., P.J. Alevizou, and C.J. Oates (2016). "What is sustainable fashion?" *Journal of Fashion Marketing & Management* 20(4): 400–416.

Henninger, C.E., N. Bürklin, and K. Niinimäki (2019). "The clothes swapping phenomenon – when consumers become suppliers." *Journal of Fashion Marketing & Management* 23(3): 327–344.

Henninger, C.E., M. Blazquez Cano, R. Boardman, C. Jones, H. McCormick, and S. Sahab (2020). "Cradle-to-cradle vs. consumer preferences," in Choudhury, I. and Hashmi, S. (eds.) *Encyclopedia of Renewable and Sustainable Materials*, Volume 5: 353–357. Oxford: Elsevier.

Hwang, J.J., and E.H. Yim (2020). "Artification in flagship stores of luxury fashion brands." *Fashion & Textile Research Journal* 22(4): 413–431.

Jackson, T., and D. Shaw (2006). *The fashion handbook*. Abingdon, UK: Routledge.

Joergens, C. (2006). "Ethical Fashion: Myth or Future Trend?" *Journal of Fashion Marketing and Management* 10(3): 360–371.

Kaliviotis, C. (2020). "BAFTAs pink ladies, Grazia Magazine." (online): https://graziamagazine.com/us/articles/pink-biggest-trend-on-the-baftas-red-carpet-2020/ (accessed 11/19/2021).

Kent, S. (2021). "How old clothes became big business." *BoF* (online): https://www.businessoffashion.com/articles/sustainability/how-old-clothes-became-big-business (accessed 5/24/2021).

Khatri, A., M.H. Peerzada, M. Mohsin, and M. White (2015). "A review on developments in dyeing cotton fabrics with reactive dyes for reducing effluent pollution." *Journal of Cleaner Production 87*: 50–57.

Kratofil, C. (2017). "Kylie Jenner's Prom Dress is for sale on the RealReal right now." *People* (online): https://people.com/style/kardashian-jenner-sell-clothes-on-the-real-real/ (accessed 5/27/2021).

Le Caer (2020). "Saoirse Ronan's BAFTAs Gown Is a Strikingly Simple, Sustainable Work of Art," *PopSugar* (online): https://www.popsugar.co.uk/fashion/saoirse-ronan-2020-baftas-black-gucci-gown-47172549 (accessed 5/24/2021).

Ledbetter, C. (2018). "Tiffany Haddish Explains Why, Unlike Most Celebs, She Rewears Her Clothes," *Huffington Post* (online): https://www.huffingtonpost.co.uk/entry/tiffany-haddish-rewears-white-dress_n_5abcfc17e4b04a59a31552ea (accessed 5/30/2021).

Lodhi, A. (2017). "K Power! Can the Kardashians Help Ethical Fashion," *eLux Magazine* (online): https://eluxemagazine.com/culture/articles/ethical-fashion/ (accessed 5/27/2021).

McDowell, E. (2020). "The most iconic fashion designers of the last 100 years." *Insider* (online): https://www.insider.com/most-iconic-fashion-designers-of-the-last-century (accessed 5/30/2021).

MoMa (2021). "Dada," *MoMaLearning* (online): https://www.moma.org/learn/moma_learning/themes/dada/marcel-duchamp-and-the-readymade/ (accessed 5/27/2021).

Mukendi, A., I. Davies, S. Glozer, and P. McDonagh (2020). "Sustainable fashion: current and future research directions." *European Journal of Marketing* 54(11): 2873–2909.

Niinimäki, K. (2010). "Eco-Clothing, Consumer Identity and Ideology." *Sustainable Development* 18(3): 150–162.

Niinimäki, K. (2017). "Fashion in a circular economy," in Henninger, C.E., Alevizou, P.J., Goworek, H., and Ryding, D. (eds). *Sustainable Fashion a cradle to upcycle approach, Chapter 8*, 151–169. Heidelberg: Springer.

Niinimäki, K. (2018). *Sustainable fashion in a circular economy*. Helsinki: Aalto ARTS Books.

Nguyen, T. (2020). "Joaquin Phoenix wore the same tux all awards season." *Vox* (online): https://www.vox.com/the-goods/2020/2/9/21128544/joaquin-phoenix-same-tux-2020-awards-season (accessed 11/19/2021).

Okwodu, J. (2020). "At 30, Emma Watson is Hollywood's Queen of Ethical Dressing." *Vogue* (online): https://www.vogue.com/slideshow/emma-watson-30th-birthday-best-red-carpet (accessed 5/27/2021).

Orange Fibre (2018). "At the V&A Museum Fashion From Nature exhibition." *Orange Fibre* (online): http://orangefiber.it/en/orange-fiber-at-the-fashioned-from-nature-exhibition/ (accessed 5/22/2021).

Pithers, E. (2020). "10 Years On, Livia Firth Reflects On Walking The Green Carpet." *Vogue* (online): https://www.vogue.co.uk/fashion/article/livia-firth-10-years-green-carpet-challenge (accessed 5/3/2021).

People Tree (2021). "Our Story." *People Tree* (online): https://www.peopletree.co.uk/about-us (accessed 5/20/2021).

Raphael, J. (2019). "Authentic activism: challenges of an environmental celebrity," in Farrell, N. (ed.) *The political economy of celebrity activism*, Chapter 9, 134–150. London: Routledge.

Satenstein, L. (2019). "Confessions of a Serial Outfit Repeater." *Vogue* (online): https://www.vogue.com/article/confessions-of-an-outfit-repeater-rules-tiffany-haddish-kate-middleton (accessed 5/24/2021).

Sherman, L. (2021). "Bird, the Retailer that Helped Establish the Brooklyn Look, Is Closing." *BoF* (online): https://www.businessoffashion.com/news/retail/bird-the-retailer-that-helped-establish-the-brooklyn-look-is-closing (accessed 5/22/2021).

Singer, M. (2020). "Power Dressing: Charting the Influence of Politics on Fashion." *Vogue* (online): https://www.vogue.com/article/charting-the-influence-of-politics-on-fashion (accessed 5/27/2021).

Statista (2021). "Brand value of leading 10 most valuable luxury brands worldwide in 2020." *Statista* (online): https://www.statista.com/statistics/267948/brand-value-of-the-leading-10-most-valuable-luxury-brands-worldwide/ (accessed 5/30/2021).

The Independent (2020). "Joaquin Phoenix vows to wear the same Stella McCartney suit." *The Independent* (online): https://www.independent.co.uk/life-style/fashion/joaquin-phoenix-suit-tux-stella-mccartney-fashion-waste-awards-a9273241.html (accessed 11/19/2021).

The RealReal (2021a). "About The RealReal." *The RealReal* (online): https://www.therealreal.com/about (accessed 5/24/2021).

The RealReal (2021b). "ReCollection 1." *The RealReal* (online): https://www.therealreal.com/flash_sales/recollection-01-6989 (accessed 5/24/2021).

Young, S. (2020). "Joaquin Phoenix vows to wear the same Stella McCartney suit throughout award season to help 'reduce waste.'" *The Independent* (Online) https://www.independent.co.uk/life-style/fashion/joaquin-phoenix-suit-tux-stella-mccartney-fashion-waste-awards-a9273241.html (accessed 5/19/2021).

YouTube (2016). "Emma Watson dons dress made of this (Met Gala 2016)." *YouTube* (online): https://www.youtube.com/watch?v=t2j4hsQdMs0 (accessed 5/20/2021).

Ütebay, B., P. Çelik, and A. Çay (2019). "Effects of cotton textile waste properties on recycled fibre quality." *Journal of Cleaner Production* 222: 29–35.

VAM (2021a). "Fashioned from Nature." *VAM* (online) https://www.vam.ac.uk/exhibitions/fashioned-from-nature (accessed 5/19/2021).

VAM (2021b). "Vivienne Westwood: punk, new romantic and beyond." *VAM* (online): https://www.vam.ac.uk/articles/vivienne-westwood-punk-new-romantic-and-beyond (accessed 5/22/2021).

Vogue (2020). "Everything you need to know about the history of the Met Gala." *Vogue* (online): https://www.vogue.com/article/everything-you-need-to-know-about-the-met-gala-video (accessed 11/19/2021).

Vredenburg, J., S. Kapitan, A. Spry, and J.A. Kemper (2020). "Brands Taking a Stand: Authentic Brand Activism or Woke Washing?" *Journal of Public Policy & Marketing* 39(4): 444–460.

WRAP (2020a). "Changing our clothes: Why the clothing sector should adopt new business models." *WRAP*: https://www.wrap.org.uk/content/changing-our-clothes-why-clothing-sector-should-adopt-new-business-models?_ga=2.182743332.30533189.1593259255-1614214988.1593259255 (accessed 6/27/2020).

WRAP (2020b). "67 million clothes could be discarded by UK homes post lockdown." *WRAP*: https://wrap.org.uk/content/67-million-clothes-could-be-discarded-uk-homes-post-lockdown (accessed 6/27/2020).

Linda Lisa Maria Turunen

Chapter 10
Luxury Resale Shaping the Future of Fashion

Introduction

The rapid growth of the resale market, as well as the luxury market, has brought the secondhand phenomenon to the center of attention. Brands are exploring various ways to capture resale opportunities, taking control of their product's lifecycles to enhance the value for their customers without sabotaging the primary market. According to Boston Consulting Group (2020), the luxury resale market was estimated to be worth between USD $30 billion and $40 billion in 2020, with expected growth of 15% to 20% annually over the next five years. The key audience for growth comes especially from environmentally aware millennials and Gen Z consumers (BCG 2019). Targeting future generations, luxury brands cannot ignore the resale market, which is expected to grow four times faster than the primary luxury market – 12% per year as compared to 3% (BCG 2019) – but they need to find their own way of being involved in it.

A global luxury group, Kering, invested in Vestiaire Collective, a platform for pre-owned luxury goods (Kering 2021) and acquired about a 5% stake from the resale titan while becoming a Vestiaire Collective Board member (Vogue 2021b). Luxury brands – such as Stella McCartney, Gucci, and Burberry, among others – are collaborating with The RealReal, a consignment-seller for pre-owned luxury goods (BoF 2020b). Simultaneously, Chanel has had a legal battle with The RealReal concerning trademark infringement and counterfeiting. Chanel is accusing The RealReal of selling counterfeit Chanel handbags (The Fashion Law 2018, 2021).

By investing in Vestiaire Collective, Kering obviously believes in the future of the resale market. François-Henri Pinault, Chairman and CEO of Kering, stated the reasoning for the acquisition: "Pre-owned luxury is now a real and deeply rooted trend, especially among younger customers. Rather than ignoring it, our wish is to seize this opportunity to enhance the value we offer our customers and influence the future of our industry towards more innovative and more sustainable practices. This fits naturally with our entrepreneurial spirit, our pioneering sustainability strategy, and our modern vision of luxury" (Kering 2021).

Timeless and recognizable aesthetics, premium quality, high prices, and exclusivity obtained through scarcity (see, for example, Dubois et al. 2001; Kapferer and Michaut-Denizeau 2015) are all cherished characteristics of luxury-branded products that also give a solid ground for luxury resale. However, luxury is not inherent in an object (Berthon et al. 2009; Turunen 2015; Joy forthcoming), which problematizes the existence of luxury in the resale context. Can the previously used luxury

https://doi.org/10.1515/9783110732757-010

artifact be regarded as such even though it lacks the exclusive service, high price, or flawless quality? **François-Henri** Pinault refers in his statement to a "modern vision of luxury" (Kering 2021), but does not specify what it is and how it is constructed. What is the role of a brand in constituting luxury, and what is the role of the (resale) platform, an individual consumer, and society at large?

This chapter sheds light on the value of the resale market for luxury brands and what luxury brands can learn from the secondary market. The chapter aims to clarify the dynamics of the second-hand market; build an understanding about the actors–consumer-sellers, buyers, platforms, and brands–enabling the transactions; and explore the resale market's opportunities and challenges from the viewpoint of a luxury brand. In addition to previous luxury and secondhand literature, netnographical observations will be integrated to offer a time-bound narrative. The booming resale market has multiplied the secondhand-related media hits, reports, and newspaper and magazine articles in the past few years. The media presence guided the exploration to webpages of luxury brands, retailers, and platforms. Our guiding questions for data exploration were: (1) What is going on in the market? Who is involved? How are they involved? (2) What kinds of discussions relate to the secondhand market? How is the resale market validated? How is it argued for and against? (3) How are luxury brands involved, and what are the key platforms involved?

We will first discuss the construction of luxury, especially in the context of the secondhand market. Then the role of consumers in the luxury secondhand market will be reviewed in light of the current academic literature. Besides consumers' actions, the intersecting trends will also be discussed when examining the reasons for the resale market's boom. Finally, the chapter focuses on the practical level by making sense of how luxury brands are integrating the resale market in their businesses. At the end, key conclusions will be drawn about the value and benefit of the resale market for luxury brands.

How Is Luxury Constructed in the Secondhand Market?

In the primary market, luxury brands have control over their products, distribution, and marketing efforts, and thus they are actively orchestrating the luxury experience. This is more than the concrete product: not all items that are rare, handcrafted pieces of excellence with sky-high price tags and available in exclusive distribution channels are regarded as luxury (Berthon et al. 2009). Thus, product attributes are seldom sufficient to convey the meaning of luxury. Instead, experiential and symbolic dimensions also play a key role when defining "luxury" (Tynan et al. 2010; Vickers and Renand 2003). Luxury can be seen as a socially constructed concept that calls for a branded artifact with all crucial product characteristics. It

also conveys the notion of what is valued in society at any given point in time as well as reflects the values of the consumer (Turunen 2015).

Approaching the concept through this lens, we may acknowledge that despite the fact that luxury is not a collection of product characteristics of an object, some brands or branded products may be perceived as luxurious in a specific sociocultural context (Turunen 2015). For example, some branded artifacts may signal status and luxuriousness in a specific time and space, for the wearer as well as for observers. Kapferer and Bastien (2012) differentiate "luxury for oneself" and "luxury for others."

While he luxury for oneself might require an exclusive service experience (Kapferer and Bastien 2012), it might also be constructed through a personal consumption experience (Turunen 2015). The core for "luxury for oneself" is prestigious experience, and instances where social context is less relevant.

In terms of "luxury for others," the social context of a usage situation may gain greater emphasis (Kapferer and Bastien 2012), while the channel or exact purchase situation is secondary and often even unknown by the observer. On many occasions, the purchase situation is experienced only by the customer. In this light, previously used luxury goods might be regarded as luxurious as brand-new items. The only question is whether and how much the owner or user of the product placed value on the purchase situation.

The Resale Market Is Dependent on Consumer-Sellers and Buyers

The resale market offers an additional channel for consumers to access luxury-branded products. The resale market has its own characteristics, such as a set of product attributes associated with the history of an individual product (Gabbott 1991), the unique condition of the previously used item (Turunen and Leipämaa-Leskinen 2015), and accessible price (Cervellon et al. 2012). Different from the traditional market, a transaction situation may happen between consumers or with the help of an intermediary platform that orchestrates the transactions. Thus, luxury resale often lacks the experiential facets, which are offered through conventional luxury channels (Cervellon and Vigreux 2018).

Compared to the controllable company-consumer interactions that the primary market represents, the market dynamics are different in the secondary market (Sweeting 2019). For the resale market to exist, two kinds of consumers are needed: those who are disposing of and/or selling their pre-owned products, and those who are interested in buying items in used condition. While the transactions can occur among consumers, the rapid growth of the resale market is a result of an increasing number of intermediary platforms, which ease the transactions between consumers

(Turunen et al. 2020). Thus, resale platforms need to operate in two directions. To have a functional and desirable resale platform, one must attract both consumer-sellers who want to dispose of their treasures and potential consumers willing to acquire used goods.

From a luxury brand's perspective, the resale market seems to be highly uncontrollable (BoF 2021a). Luxury brands cannot influence what products are available (for example, decades' old licensed pieces or rare limited editions) and their quality (such as nearly brand new or worn and patinated); whether the products are authentic (to prevent counterfeiting, the platforms offer authentication services); how the products are represented on the platform (whether users are photographing the product themselves or whether the company platform is doing it); or what kind of service experience the resale platform offers. Brands are exploring different forms of collaboration with the leading resale platforms (BoF 2021a).

In addition to the uncontrollability of their brand presence in the market or diluting the exclusivity of their brand, hesitance may rise from a fear of cannibalizing sales of new products (Luxe Digital 2019). Before drawing conclusions, it is valuable to explore the target audience for luxury items and whether the secondhand buyers are the same as firsthand consumers.

Consumer-sellers possess luxury items that they have bought from either primary or secondary markets (Turunen et al. 2020). Without brand-new items, there is no secondary market. Turunen, Cervellon, and Carey (2020) identified various reasons why some luxury consumers end up selling their treasures. First, consumer-sellers might be driven from the product for personal reasons, such as emotional detachment from a past symbolic meaning associated with the product or aiming to achieve the financial empowerment that the sales process may provide. Second is the social value associated with the act of selling: for some, the act of selling was driven by the enactment of their social role, such as pursuing a higher social status in comparison to the purchaser or aiming toward a higher status as an eco-conscious consumer. Interestingly, the process around selling stripped luxury items down to the object of a financial transaction, which was used as a token for personal development or in social interaction.

Consumer-sellers are a key resource for resale platforms. Platforms are seducing the consumer-sellers with various services and offering different commission rates. Could the resale service be seen as a luxury service for their most devoted clients?

In addition to consumer-sellers, the market is also dependent on the secondhand buyers. Prior literature points out a variety of reasons why consumers purchase secondhand luxury. Secondhand luxury goods have often been regarded as a stepping stone for those who do not have access to the primary market. Besides financial reasons (see, for example, Amatulli et al. 2018; Sihvonen and Turunen 2016), the fascination might also relate to the uniqueness of a product that is not necessarily available on the market anymore (see, for example, Cervellon et al. 2012; Turunen and Leipämaa-Leskinen 2015), or sustainability and eco-conscious

concerns (see, for example, Kessous and Vallette-Florence 2019; Carrigan et al. 2013). The motivations to buy luxury items secondhand seem to be different when compared to those of firsthand luxury buyers. Kessous and Vallette-Florence (2019) found out that while secondhand buyers are motivated by social climbing, eco-conscious concerns, brand heritage, and windfall, the firsthand luxury consumers may crave power, social ranking, and quality when purchasing brand-new luxury items.

In 2019, Boston Consulting Group conducted a survey together with Vestiaire Collective in order to grasp why luxury brands should embrace the resale boom. The survey concluded that despite the fact that secondhand purchasers are typically not the buyers of brand-new luxury items, they might become the primary buyers someday. Consumer-sellers – in the BCG (2019) report – are regarded as firsthand luxury buyers who use resale to reinvest in the new. Separating the buyers and sellers is not necessarily straightforward, as consumers might have multiple roles in the resale market (Turunen et al. 2018, 2020). It is valuable to acknowledge that the resale market is not just a one-directional space for secondhand buyers, but also an agora where both buyers and customer-sellers intersect.

Role of Possessions and Changing Ownership

The entire resale market is dependent on (1) the consumer's active involvement in the market, and (2) the primary market and brand-new goods. Without the consumer who has bought a product firsthand and decides to dispose of it after use, there is nothing to be sold in the secondary market (Turunen et al. 2018). Consumers' emerging roles as consumer-sellers are driving the secondhand market (Turunen et al. 2020), and online platforms as well as secondhand shops have entered to ease the transactions in an organically growing market.

Flea markets, vintage shops, and secondhand shops are nothing new. Some form of secondhand commerce has existed since the Middle Ages and the Renaissance, but its current form links to the increased clothing production during the mid-19th century (Shell 2021). Fashions changed faster, thus the increased amount of clothing became common and items were discarded more quickly. Newness and excess signaled social status (Shell 2021). However, the social acceptance of the secondhand has changed enormously over the years (see, for example, Amatulli et al. 2018). For example, the stigma associated with purchasing pre-owned goods has diminished, even becoming trendy (Gorra 2017). The shifting attitudes of consumers and the renewed acceptability (see, for example, Ferraro, Sands, and Brace-Govan 2016; Beard 2008) has great influence on the growth of the market.

Consumers are taking an active role in the resale market. Machado et al. (2019) have suggested that secondhand fashion drives consumption toward circularity. Resale enables consumers to lengthen the products' lifespans past that of the current

owner. Boston Consulting Group (2020) even argued that the existence of the secondhand luxury market shapes consumer behaviors in a more profound manner: the accessible prices enable consumers to trade up, to buy higher-quality products to which they would not otherwise have access. While BCG (2020) approaches the behavioral change with sustainability lenses, Kessous and Valette-Florence (2019) explain this through social climbing, which they suggest as being characteristic especially to the luxury secondhand market. In addition, the possibility to resell an item also influences how consumers are engaging with the product; for example, they take care of the product in order to keep the resale value high (BCG 2020; Turunen and Pöyry 2019).

These behavioral changes emerging from secondhand consumption are closely related to the sustainability trend, but they also signal the slowly changing role of ownership. Iran, Geiger, and Schrader (2019) approached secondhand consumption as one form of "Collaborative Fashion Consumption" (CFC). Although the artifact changes ownership in the secondhand transaction similarly to the traditional market behavior, it turns into collaborative fashion consumption, as there are collaborative practices and multiple owners involved during the product's lifecycle. Thus, it is valuable to ask whether secondhand is the first step toward non-possessive collaborative fashion consumption practices such as lending, renting, and leasing.

The rise and acceptance of recommerce reflects the shifting cultural values and consumption habits, especially among millennials and younger generations (BCG 2019). It is not a surprise that the tech-savvy Gen Y generation advocates for a sharing and collaborative economy – they were born with the Internet. They are also less materialistic and more experientialist (Kapferer and Michaut-Denizeau 2020). When the role of possession decreases, luxury goods and artifacts that were previously passed from generation to generation have been harnessed in an unconventional way. Today, consumers are not necessarily seeing themselves as the end-users of luxury artifacts (Turunen et al. 2020) but, instead, as part of the product's life span. Instead of passing the treasure from mother to daughter, for instance, the speed of transmission of the luxury object from one person to another has accelerated: the resale market's global online presence has boosted the accessibility and has enabled the transfer of the product from customer to customer. Whether this multiplies the usage time of the product or increases the speed of consumption remains unanswered.

Sustainability Driving the Resale Market

The dominant zeitgeist right now is overflowing with sustainability, and the resale market is one form of embracing this trend (Carrigan, Moraes, & McEachern 2013; Iran et al. 2019). BCG (2019) even suggests that a thriving resale market could make the luxury industry more sustainable.

Regarding the resale market as an arena for extending the lifespan of a product has connected the secondhand market with the sustainability discussion. Klepp, Laitala, and Wiedemann (2020) analyzed clothing life spans and argued that if a secondhand product is replacing the acquisition of a new item, it could be considered as having a smaller environmental impact. However, the change of ownership is rarely an environmentally neutral situation when compared with products used multiple times by the same owner, as transportation, additional laundering, sorting, and storing may be involved (Fisher et al. 2011; Farrant et al. 2010; Botticello 2012). If the change of ownership enables an increasing number of usages for the garment, the relative environmental impact of the garment will be smaller the longer the life span of the garment (Sandin and Peters 2018; Fisher et al. 2011).

Instead of viewing the product as the unit of analysis, the market dynamic that the growing resale phenomenon promotes should be critically examined before embracing sustainability goals through resale. As its best, the luxury resale market celebrates high-quality and timeless products that may have an extensive life span with the first owner (Sun et al. 2021). Simultaneously, the accessible prices to rare, unique, and previously used luxury items may attract conspicuous consumption. In the skyrocketing resale market, it is valuable to ask whether the market may feed guilt-free binge shopping – consumers are making rapid purchase decisions due to the prevalence of one-of-the-kind products with low price points. The speed of consumption has also been acknowledged in BCG's (2019) report, where surveyors found that 62% of the products sold on secondhand luxury platforms are unworn or scarcely worn.

Prior research literature also supports the accelerating speed of consumption that the resale platforms may support. For example, Turunen and Pöyry (2019) suggest that consumers may purchase a pre-used luxury good with resale value in mind or with the option of reselling it right away if the product is unfit. This is aligned with Laitala and Klepp's (2021) research that discovered a secondhand item may have even fewer usage numbers than a brand-new item. While examining consumer-sellers in luxury resale, Turunen, Cervellon, and Carey (2020) also noted that there is an emerging entrepreneurial mindset that prefers ongoing transactioning over long-term usage.

Thus, the resale market seems to have turned into a battlefield of two opposite endeavors: a circular mindset of extended product life spans (Iran et al. 2019; Machado et al. 2019) versus a linear mindset with ease and speed of disposition. Although the secondhand and resale markets are often perceived as one solution toward circularity and sustainability, since they celebrate durability and extend the life span of articles of clothing, such markets are a double-edged sword. Besides the sustainability dilemma smoldering in the resale market, luxury brands should also carefully consider their actions in order to avoid becoming too accessible or losing the perceived luxuriousness of the brand.

Different Ways Luxury Brands Are Embracing the Resale Market

The resale phenomenon is reshaping the luxury market. Luxury items are now available in marketplaces that brands cannot control; and new, emerging target audiences are interacting with these products. There are various ways that brands can collaborate with the pre-owned market to capture their value, stay relevant, and connect with their customers. First and foremost, the growing resale market should be seen not as a competitor for the primary market, but as an extension. While the resale market may serve the potential customers who use a secondhand purchase as a stepping-stone, it is especially a channel for existing luxury consumers to engage and possibly monetize their possessions (see, for example, Turunen et al. 2020). Further, the resale market is an arena for older treasures that are perhaps no longer available in the primary market.

Digitalization has brought the traditional small-scale vintage and secondhand market to the next level: global secondhand platforms have made the resale market impossible to ignore. Currently, there are many different kinds of resale platforms operating in the fashion and luxury sector, and there are various ways that luxury brands are collaborating with these resale platforms. Whether or not a luxury brand decides to become actively involved in the resale market, that market does exist.

All kinds of operating models in resale platforms aim toward one goal: to ease the buying and selling process of pre-owned artifacts. The resale platforms differ mainly in terms of the consumer-sellers' role in the selling process. While some platforms boost peer-to-peer transactions, others concentrate on creating a uniform customer experience for secondhand shoppers through consignment services. Table 10.1 summarizes the main operating models and key characteristics of various platforms.

As noted in the table, an increasing number of resale platforms have entered the market since 2010. While the largest luxury resale platforms are US-based The RealReal, with 17 million users in 60 countries, and European-origin Vestiaire Collective, with 9 million members in 90 countries (Techcrunch 2020; Vogue 2020), the growing number of platforms challenges the digital treasure hunt. Additional services have entered the market to ease searchability – for example, Gem application (gem.app), which serves secondhand purchasers by collecting all online vintage and luxury treasures under the same search engine.

While peer-to-peer platforms are busy transacting everything from fast-fashion garments to luxury goods, luxury brands are not actively engaging with them. Instead, platforms with greater control, such as luxury consignment online stores, like The RealReal and Vestiaire Collective, have raised the interest of luxury companies. For example, Stella McCartney was the first luxury brand to partner with The RealReal. The collaboration has been ongoing since 2017, and consigning customers receive a $100 credit to shop the brand (The RealReal 2017). Since 2019, Burberry has also been partnering with The RealReal. The RealReal encourages their customers to

Table 10.1: Main operating models in secondhand fashion.

	Platforms that enable consumer-to-consumer transactions (C2C)	Platforms that are consignment sites (C2B2C)	Platforms mixing peer-to-peer and consignment services
Aim	Platforms aim to ease the process of buying and selling		
Characteristics	– Products available in the platform are priced, photographed, and shipped by consumer-sellers themselves – Platform is not responsible for authenticity questions – Platform takes 0–20% commission from sold items – Consumer-seller receives the payment once the product is sold (and received)	– Consumer-seller sends the item to the platform (middleman), who authenticates the product – Consumer-seller owns the product until it is sold to the platform, or sold to a new end-customer – Company/platform takes care of the authentication, pricing, visual merchandising, and sales – Tiered commission rates, ranging from 15–50% what company takes from sold item – Consumer-seller receives the payment after product has sold or the platform has purchased the product (buy-out)	– Consumer-seller photographs and prices the product – Once sold, consumer-seller ships the product to the platform's authentication service – After authentication and product check, platform ships the artifact to the new end-customer – Platform takes 17–25% commission from sold item – Consumer-seller receives the payment after product is sold and authenticated
Product categories	All kinds of fashion items	Luxury items and all kinds of fashion items	Luxury and vintage items

Table 10.1 (continued)

	Platforms that enable consumer-to-consumer transactions (C2C)	Platforms that are consignment sites (C2B2C)	Platforms mixing peer-to-peer and consignment services
Examples	Platforms for general fashion resale: eBay (1995, US), Tradesy (2009, US), Poshmark (2011, US), Depop (2011, UK), Vinted (2012, Lithuania), Grailed (2014, US) Peer-to-peer transactions booming also in social media platforms that are not designed for sales, such as Facebook and Instagram.	Platforms for luxury and high-end resale: The RealReal (2011, US), Fashionphile (1999, US), Re-SEE (2013, France) Platforms for general fashion resale: ThredUP (2009, US) Physical vintage and secondhand stores	Platforms for luxury and high-end resale: Vestiaire Collective (2009, France), Rebelle (2013, Germany), Hardly ever worn it/Hewi (2012, UK) eBay is also developing an authentication service for expensive artifacts

consign Burberry goods on the resale platform and offers to Burberry-consigning customers a personal shopping experience that includes the English high tea ceremony in 18 US stores (Vogue Business 2019). The RealReal also started a partnership with Gucci in 2020 and launched an e-shop stocked with consignors' Gucci items (Vogue 2020). In addition, The RealReal has promised to plant a tree through *One Tree Planted* for every Gucci item purchased or sold through the consignment site (Vogue 2020).

European player Vestiaire Collective has launched a "Brand-Approved" program, which takes the idea of partnerships to the next level. For example, Vestiaire Collective is partnering with Alexander McQueen, who is involved in the authentication process of its own pre-used artifacts. McQueen boutiques contact their best clients and offer store credit in return for accepted items from previous collections (Vogue 2021a; Forbes 2021). Involving luxury brands in the authentication process may require resources, but it also allows them to have more control over their brand in the resale market. Deepening the collaboration, Kering, a global luxury group, acquired a 5% stake of Vestiaire Collective in spring 2021 (Vogue 2021b). This investment brought Kering to Vestiaire Collective's board and provided them with a front-row seat to observe where the resale market is heading.

In addition to luxury brands collaborating with luxury resale sites, various multi-brand online stores have launched their own resale marketplaces. For instance, Farfetch offers a "Second Life" service for pre-loved luxury handbags (Farfetch 2019), and Mytheresa partners with Vestiaire Collective by offering a designer resale program for Mytheresa high-end luxury customers (Businesswire 2021). In addition, Zalando has

extended their offering by launching Zalando Zircle, through which consumer-sellers can gain store credit (Zalando 2021).

Department stores are also following the trend: UK-based Selfridges opened its doors for Vestiaire Collective, who launched its first in-store destination with Selfridges (Selfridges 2019) containing Vestiaire Collective's expertly curated and authenticated pre-loved and resold pieces. Further, in a partnership with Vestiaire and Depop, Selfridges launched a resale service called RESELLFRIDGES (Retrail Gazette 2021; RESELLFRIDGES 2019). Neiman Marcus, a high-end department store in the United States, is collaborating with Fashionphile, where it has also acquired a minority stake in 2019 (Bizwomen 2021).

The self-standing luxury brands that have concerns about their brand perception seem to seek control through collaborating with resale platforms and building brand loyalty among their long-term customers. For luxury brands, the resale market is also an information fountain that first and foremost shows how their collectable investment pieces stand the test of time, but also reflects price development. For example, changes in pricing in the primary market peaks the demand in the secondary market, whereas relaunches may lead to collapsing resale prices.

The retailer's resale services aim to turn the customer-sellers into primary consumers of the retail platform by offering short-term monetary benefits for future purchases. All multi-brand retailers who have included resale opportunities in their stores offer credit to purchase new items. Thus, the expectation is that a consumer who disposes of and sells will become a firsthand customer in the primary market. Retailers' resale services try to keep the customer in the loop and possibly boost the customer loyalty. This logic is aligned with Boston Consulting Group's (2019) findings, which suggest that around 30% of respondents' primary reason for selling was to purchase new goods.

Besides the luxury brand partnerships, The RealReal took a next step by bridging the collaboration from recommerce to remanufacture. Part of the Earth Month project, The RealReal launched a ReCollection, which consisted of fifty sellable pieces made from defective garments donated by eight luxury brands, such as A-COLD-WALL*, Balenciaga, Dries Van Noten, Jacquemus, Simone Rocha, Stella McCartney, Ulla Johnson, and Zero +Maria Cornejo (HighSnobiety 2021).

Hidden Value of the Resale Market

Lengthening a product's life span with multiple users might be a step toward a more sustainable fashion future, but it is not a solution for the industry's sustainability problems. If the resale market is only used to boost the sale of brand-new items, the fashion industry's shift toward sustainable practices will not become a reality until the primary market comes down (BoF 2020a).

Despite the sustainability aspects, the resale market offers valuable information and pathways forward for luxury brands. As pointed out earlier, there exist various ways for luxury brands to partner with resale platforms. Currently, most of the partnerships highlight the monetary value, but being involved in the resale market, luxury brands could also benefit in the following areas.

1 Customer Engagement and Brand Loyalty

The resale market serves and engages all kinds of luxury consumers. It combines both consumer-seller (current luxury clients) and secondhand buyers – this becomes a valuable target audience to expand and to include in the brand community. Through resale services, aside from gaining potential future customers, luxury brands could have access to and build on value for current luxury customers who may become consumer-sellers.

The resale market offers informational value for customers to support their decision making: previously used luxury goods demonstrate the test of time, durability, and high quality (Turunen and Pöyry 2019). The resale market also offers an arena for product information to support the decision-making process before a first-hand purchase – for example, how the product has aged and what the expected resale value is (BoF 2020c).

2 Reputational Value over Monetary Value

The resale market has its own dynamics and characteristics when compared to primary market operations (Sweeting 2019). Instead of integrating the resale service within the brand's own operations, the existing collaboration has turned out to be successful – luxury brands have gained reputational value through close partnerships with resale platforms; being involved in the last stages of a product's lifecycle signals sustainability. It shows that a luxury brand puts a high value on its own goods and that those are not just commodities. Authenticating one's own products is part of a larger battle against counterfeiting. Viewing secondhand clients as if they are primary customers may speed their decision to become primary customers. Besides the long-term reputational value that builds the brand, the collaboration with resale platforms may drive sales for new items, or at least deepen the relationship with consumer-sellers.

3 Brand Management and Product Development

Luxury brands that are involved in the secondary market may gain better control over how their products are presented, as well as their products' price and condition

when they are sold. The resale market contains and generates informational value with continuously increasing new data, information about customers who are engaging with the brand, product- and material-related data, data about pricing, and trends (VogueBusiness 2021). There are extensive data-points that luxury brands could learn from and use for brand management and product-development purposes.

Being involved in the resale market, luxury brands can have tighter control – for example, in terms of authentication of their own products or in influencing the brand experience. Heritage-owning luxury brands may have an extensive history with licensing agreements or global differences in sizing (BoF 2021b). By being actively involved in the resale market, luxury brands could gain some control in curating what products are available, as well as in determining their price and condition.

Besides focusing on gaining control and orchestrating the luxury experience, the idea of a consumer as being a co-creator of luxury could be embraced. Previous lives of products could enrich storytelling and upgrade one-way communication into becoming more interactive and inclusive.

Conclusion

Resale platforms are competing with one another for direct partnerships and strategic alliances with luxury brands, hoping to become the platform that sells vintage items on their behalf. Various levels of collaboration can be created; through this collaboration, luxury brands aim to win back control over how their products are presented in the resale market.

Luxury experience is more than the shopping experience or usage of the artifact. As the peaking resale market shows, customers are organically searching for relevance and finding alternative ways to engage with luxury goods. Luxury brands need to consider the lifecycle of their products beyond the sales situation. While the secondhand market seems like an opportunity for luxury brands to support long-term sustainable goals, the major studies in secondhand luxury have not yet found direct relationships between eco-consciousness and the desire to buy secondhand goods (Cervellon et al. 2012; McNeill and Moore 2015; Yan, Bae, and Xu 2015). Thus, a luxury brand's presence in the resale market should be regarded first and foremost as a path to building a long-term customer relationship.

The resale market is shaping the luxury and fashion industries by lengthening the lifecycle of branded products through multiplying ownership, questioning how luxury is constructed, and engaging a community of consumers. The power dynamics are shifting from an emphasis on the company to a focus on consumers. The secondary market does not exist without firsthand customers and their active roles of consuming and disposing of luxury artifacts (Turunen et al. 2020).

The luxury resale market is currently dominated by global resale platforms, such as TheRealReal and Vestiaire Collective, that have been building an extensive army with millions of pre-loved enthusiasts. Luxury brands are getting involved through collaboration and partnerships as well. Some non-luxury brands – such as Levi's, Patagonia, and Eileen Fisher, among others – have been launching take-back programs for their own goods. Whether this will become a route toward a new system remains to be seen.

References

Amatulli, C., G. Pino, M. De Angelis, and R. Cascio (2018). "Understanding Purchase Determinants of Luxury Vintage Products." *Psychology & Marketing* 35, no. 8: 616–624.

Beard, N.D. (2008). "The Branding of Ethical Fashion and the Consumer: A Luxury Niche or Mass-Market Reality?" *Fashion Theory* 12, no. 4: 447–467.

Beauloye, Florine Eppe (2021). "Luxury Resale: A Secondhand Strategy for Brands." *Luxe Digital*. https://luxe.digital/business/digital-luxury-reports/luxury-resale-transformation/.

Berthon, P., L. Pitt, M. Parent, and J. P. Berthon (2009). "Aesthetics and Ephemerality: Observing and Preserving the Luxury Brand. *California Management Review* 52, no. 1: 45–66.

Botticello, J. (2012). "Between Classification, Objectification, and Perception: Processing Secondhand Clothing for Recycling and Reuse." *Textile* 10, no. 2: 164–183.

Carrigan, M., C. Moraes, and M. McEachern (2013). "From Conspicuous to Considered Fashion: A Harm-Chain Approach to the Responsibilities of Luxury-Fashion Businesses. *Journal of Marketing Management* 29, no. 11–12: 1277–1307.

Cervellon, M.C., L. Carey, and T. Harms (2012). "Something Old, Something Used: Determinants of Women's Purchase of Vintage Fashion vs. Second-Hand Fashion." *International Journal of Retail & Distribution Management* 40, no. 12: 956–974.

Cervellon, M.C., and E. Vigreux (2018). "Narrative and Emotional Accounts of Secondhand Luxury Purchases along the Customer Journey," in *Vintage Luxury Fashion*, edited by D. Ryding, C. Henninger, and M. B. Cano, 79–95. Cham: Palgrave Macmillan.

Chen, Cathaleen (2021). "Business of Fashion: For Brands, Is Resale Actually Worth It?" *Business of Fashion*. https://www.businessoffashion.com/articles/retail/for-brands-is-resale-actually-worth-it.

Deely, Rachel (2020). "Why Gucci Is Getting Into Resale." *Business of Fashion*. https://www.businessoffashion.com/articles/luxury/gucci-resale-the-realreal-levis-luxury-gen-z.

Dillet, Romain (2020). "Vestiaire Collective Raises $64.2 Million for its Second-Hand Fashion Platform." *TechCrunch*. https://techcrunch.com/2020/04/20/vestiaire-collective-raises-64-2-million-for-its-second-hand-fashion-platform/.

Dubois, B., G. Laurent, and S. Czellar (2001). *Consumer Rapport to luxury: Analyzing Complex and Ambivalent Attitudes*, no. 736. Paris: HEC.

Edelson, Sharon (2021). "Partnerships like Vestiaire Collective and Alexander McQueen are Fueling the Circular Economy." *Forbes*. https://www.forbes.com/sites/sharonedelson/2021/02/18/partnerships-like-the-vestiaire-collective-and-alexander-mcqueen–are-fueling-the-circular-economy/?sh=dd8ed9d3ff68.

Farra, Emily (2020). "Gucci and The RealReal Announce a Game-Changing Partnership." *Vogue*. https://www.vogue.com/article/gucci-the-realreal-partnership-secondhand-consignment.

Farra, Emily (2021). "What Does Kering's Deal With Vestiaire Collective Mean for Secondhand Fashion – And the Entire Industry?" *Vogue*. https://www.vogue.com/article/kering-vestiaire-collective-resale-secondhand-fashion-industry-future.

Farrant, L., S.I. Olsen, and A. Wangel (2010). "Environmental Benefits from Reusing Clothes." *The International Journal of Life Cycle Assessment* 15, no. 7: 726–736.

Ferraro, C., S. Sands, and J. Brace-Govan (2016). "The Role of Fashionability in Second-Hand Shopping Motivations." *Journal of Retailing and Consumer Services* 32: 262–268.

Fisher, K., K. James, and P. Maddox (2011). "Benefits of Reuse Case Study: Clothing." *Banbury, UK: WRAP* 41.

Gabbott, M. (1991). "The Role of Product Cues in Assessing Risk in Second-Hand Markets." *European Journal of Marketing* 25, no. 9: 38–50.

Gorra, Charles (2017). "The New Normal: Luxury in the Secondary Market." *Harvard Business School Digital Initiative*. https://digital.hbs.edu/innovation-disruption/new-normal-luxury-secondary-market/.

Iran, S., S.M. Geiger, and U. Schrader (2019). "Collaborative Fashion Consumption–A Cross-cultural Study between Tehran and Berlin." *Journal of Cleaner Production* 212: 313–323.

Kansara, Vikram Alexei (2020). "Should Luxury Build Resale into its Business Model?" *Business of Fashion*. https://www.businessoffashion.com/briefings/luxury/should-luxury-build-resale-into-its-business-model.

Kapferer, J.N., and V. Bastien (2012). *The Luxury Strategy: Break the Rules of Marketing to Build Luxury Brands*. London: Kogan Page Publishers.

Kapferer, J.N., and Anne Michaut-Denizeau (2020). "Are Millennials Really More Sensitive to Sustainable Luxury? A Cross-generational International Comparison of Sustainability Consciousness when Buying Luxury." *Journal of Brand Management* 27, no. 1: 35–47.

Kapferer J.N., and Anne Michaut-Denizeau (2015). "Luxury and Sustainability: A Common Future? The Match Depends on How Consumers Define Luxury?" *Luxury Research* 1, no.1: 3–17.

Keller, K.L. (2009). "Managing the Growth Tradeoff: Challenges and Opportunities in Luxury Branding." *Journal of Brand Management* 16, no. 5: 290–301.

Kent, Sarah (2020). "Is Resale Actually Good for the Planet?" *Business of Fashion*. https://www.businessoffashion.com/articles/sustainability/is-resale-actually-good-for-the-planet.

Kessous, A., and P. Valette-Florence (2019). "'From Prada to Nada': Consumers and Their Luxury Products: A Contrast between Second-Hand and First-Hand Luxury Products." *Journal of Business Research* 102: 313–327.

Klepp, I.G., K. Laitala, and S. Wiedemann (2020). "Clothing Lifespans: What Should Be Measured and How." *Sustainability* 12, no. 15: 6219.

Laitala, K., and I.G. Klepp (2021). "Clothing Longevity: The Relationship between the Number of Users, How Long and How Many Times Garments are Used." *4th PLATE Virtual Conference*. Limerick, Ireland.

Machado, M.A.D., S.O. de Almeida, L.C. Bollick, and G. Bragagnolo (2019). "Second-Hand Fashion Market: Consumer Role in Circular Economy." *Journal of Fashion Marketing and Management: An International Journal* 23, no. 3: 382–395.

McDowell, Maghan (2019). "Burberry's Partnership with The RealReal Signifies a Real Shift." *Vogue Business*. https://www.voguebusiness.com/companies/burberrys-partnership-realreal-secondhand.

McNeill, L., and R. Moore (2015). "Sustainable Fashion Consumption and the Fast Fashion Conundrum: Fashionable Consumers and Attitudes to Sustainability in Clothing Choice." *International Journal of Consumer Studies* 39, no. 3: 212–222.

Nazir, Sahar (2021). "Fast Fashion Retail and Resale: A Way Forward?" *Retail Gazette*. https://www.retailgazette.co.uk/blog/2021/04/fast-fashion-retail-and-resale-a-way-forward/.

Sandin, G., and G.M. Peters (2018). "Environmental Impact of Textile Reuse and Recycling–A Review." *Journal of Cleaner Production* 184: 353–365.

Segran, Elizabeth (2021). "Luxury Brands once shunned resale sites. now, they're embracing secondhand." *Fast Company*. https://www.fastcompany.com/90609991/luxury-brands-once-shunned-resale-sites-now-theyre-embracing-secondhand.

Shell, Hannah Rose (2021). "A global history of second-hand clothing." *Spreadable Media*. https://spreadablemedia.org/essays/shell/index.html#.YMtxrCO6qRs.

Sherman, Lauren (2018). "Luxury Resale's Quiet Reckoning." *Business of Fashion*. https://www.businessoffashion.com/articles/news-analysis/luxury-resales-quiet-reckoning.

Sihvonen, J., and L.L.M. Turunen (2016). "As Good as New–Valuing Fashion Brands in the Online Second-Hand Markets." *Journal of Product & Brand Management* 25, no. 3: 285–295.

Snowden, Heather (2021). "Bringing defected A-COLD-WALL*, Jacquemus & Balencianga Pieces Back to Life." *HighSnobiety*. https://www.highsnobiety.com/p/the-real-real-recollection-drop-one/.

Solomon, Michael (2017). "How Millennials Will Reshape the Luxury Market." *Forbes*. https://www.forbes.com/sites/msolomon/2017/06/20/how-millennials-will-reshape-the-luxury-goods-market-bain-luxury-report-2017/?sh=1e1b10922f86.

Stych, Anne (2021). "Neiman Marcus Extends Partnership with Luxury Reseller Fashionphile." *Bizwomen*. https://www.bizjournals.com/bizwomen/news/latest-news/2021/04/neiman-marcus-extends-partnership-fashionphile.html?page=all.

Sun, J.J., S. Bellezza, and N. Paharia (2021). "Buy Less, Buy Luxury: Understanding and Overcoming Product Durability Neglect for Sustainable Consumption." *Journal of Marketing* 85, no. 3: 28–43.

Sweeting, A. (2019). "Secondary Markets," in *The New Palgrave Dictionary of Economics*. London: Palgrave Macmillan.

Turunen, L.L.M. (2015). "Consumers' Experiences of Luxury–Interpreting the Luxuriousness of a Brand." Doctoral Dissertation. University of Vaasa, Finland.

Turunen, L.L.M., M.C. Cervellon, and L.D. Carey (2020). "Selling Second-Hand Luxury: Empowerment and Enactment of Social Roles." *Journal of Business Research* 116: 474–481.

Turunen, L.L.M., and H. Leipämaa-Leskinen (2015). "Pre-loved Luxury: Identifying the Meanings of Second-Hand Luxury Possessions." *Journal of Product & Brand Management* 24, no. 1: 57–65.

Turunen, L.L.M., H. Leipämaa-Leskinen, and J. Sihvonen (2018). "Restructuring Secondhand Fashion from the Consumption Perspective," in *Vintage Luxury Fashion*, 11–27. Cham: Palgrave Macmillan.

Turunen, L.L.M., and E. Pöyry (2019). "Shopping with the Resale Value in Mind: A Study on Second-Hand Luxury Consumers." *International Journal of Consumer Studies* 43, no. 6: 549–556.

Tynan, C., S. McKechnie, and C. Chhuon (2010). "Co-creating Value for Luxury Brands." *Journal of Business Research* 63, no. 11: 1156–1163.

Vickers, J. S., and F. Renand (2003). "The Marketing of Luxury Goods: An Exploratory Study–Three Conceptual Dimensions." *The Marketing Review* 3, no. 4: 459–478.

Webb, Bella (2021). "How the Next Generation of Fashion Resale is Shaping Up." *Vogue Business*. https://www.voguebusiness.com/fashion/how-the-next-generation-of-fashion-resale-is-shaping-up.

Williams, Robert (2021). "Why Kering Invested in Vestiaire Collective." *Business of Fashion*. https://www.businessoffashion.com/articles/luxury/kering-acquires-5-stake-in-vestiaire-collective.

Winston, Andrew (2017). "An Inside View of How LVMH Makes Luxury More Sustainable." *Harvard Business Review*. https://hbr.org/2017/01/an-inside-view-of-how-lvmh-makes-luxury-more-sustainable.

Yan, R.N., S.Y. Bae, and H. Xu (2015). "Second-Hand Clothing Shopping among College Students: The Role of Psychographic Characteristics." *Young Consumers* 16, no. 1: 85–98.

Yotka, Steff (2021). "Alexander McQueen Launches a Buy-Back Program with Vestiaire Collective." *Vogue*. https://www.vogue.com/article/alexander-mcqueen-launches-a-buy-back-program-with-vestiaire-collective.

Websites Consulted

https://www.bcg.com/publications/2020/consumer-segments-behind-growing-secondhand-fashion-market (accessed 7/12/2021).

https://www.bcg.com/fr-fr/publications/2019/luxury-brands-should-celebrate-preowned-boom (accessed 7/12/2021).

https://www.businesswire.com/news/home/20210608005814/en/Mytheresa-Partners-With-Vestiaire-Collective-to-Introduce-a-Unique-Resale-Service-Dedicated-to-Mytheresa's-High-end-Luxury-Customers-to-Reinforce-the-Shift-to-Circularity-as-Part-of-the-Fashion-Ecosystem (accessed 7/12/2021).

https://www.farfetch.com/positively-farfetch/secondlife/fi (accessed 7/12/2021).

https://www.kering.com/en/news/vestiaire-collective-announces-a-new-eur178m-us-216m-financing-round-backed-by-kering-and-tiger-global-management-to-accelerate-its-growth-in-the-second-hand-market-and-drive-change-for-a-more-sustainable-fashion-industry (accessed 7/12/2021).

https://resellfridges.com (accessed 7/12/2021).

https://www.selfridges.com/GB/en/features/articles/selfridges-meets/vestiaire-collective/ (accessed 7/12/2021).

https://www.thefashionlaw.com/chanel-is-suing-the-realreal-for-allegedly-selling-counterfeit-bags/ (accessed 7/12/2021).

https://www.thefashionlaw.com/chanel-the-realreal-agree-to-mediation-amid-escalating-counterfeiting-antitrust-fight/ (accessed 7/12/2021).

https://promotion.therealreal.com/stellamccartney/ (accessed 6/17/2021).

https://corporate.zalando.com/en/magazine/zircle-wardrobe-of-the-the-future (accessed 7/12/2021).

Part 4: **Wine and Hospitality Services**

Bianca Grohmann
Chapter 11
Artification and Social Responsibility in the Context of Fine Wine: Opus One

Introduction

Both artification – an ongoing process of transformation of non-art into art (Shapiro and Heinich 2012; Shapiro 2019) – and corporate social responsibility – an organization's voluntary engagement to improve the well-being of society while minimizing negative impact (Wagner et al. 2009) – are increasingly important to producers of fine wines. This is due to growing consumer demand for exceptional consumption experiences and luxury, even among consumers of the middle class (Silverstein and Fiske 2003), and increasing consumer demand for socially responsible products and business practices (Sipilä et al. 2021) in light of changing social norms and growing sensitivity to social and environmental issues. As a result, producers of fine wines face mounting pressure to integrate sustainability and social responsibility into their products and processes (Anson 2019).

For this reason, it is important to consider that artification of fine wines has consequences for consumer responses to wineries' corporate social responsibility activities. Fine wines that have undergone artification share many characteristics with luxury brands (Passebois-Ducros et al. 2015). Luxury brands are frequently accused of not engaging in social responsibility initiatives to a sufficient degree (Kapferer and Michaut-Denizeau 2014), and when they do, consumers often ascribe insincere motives or respond negatively to their social responsibility efforts, due to the conflicting values represented by social responsibility and luxury (Kapferer and Michaut-Denizeau 2014; Torelli et al. 2012; Vilasanti da Luz et al. 2020).

Luxury brands' engagement in social responsibility activities therefore does not always result in favorable outcomes (Achabou and Dekhili 2013; Torelli et al. 2012). Hermès, for example, is a luxury brand with a long history of collaboration with artists, including the Hermès Éditeur series of works of art on silk designed by Joseph Albers, Daniel Buren, Hiroshi Sugimoto, and Julio Le Parc (Hermès 2021). To answer the call for more responsible luxury fashion (Achabou and Dekili 2013; Kim and Ko 2012), Hermès introduced recycled materials in its petit H project (Achabou and Dekhili 2013; LuxuryLaunches 2014). Although this introduction was aligned with increasing consumer demand for socially responsible and environmentally friendly products, significantly lower consumer preferences emerged for Hermès products that included recycled fabrics, with evidence pointing toward the perceived incongruence between luxury and recycling underlying these responses (Achabou and Dekhili 2013).

https://doi.org/10.1515/9783110732757-011

In the domain of fine wines, producers' focus on the communication of their products' and practices' sustainability is often viewed as a thinly disguised marketing ploy to meet consumer demand for sustainable products and increase market share (Anson 2019). For wineries engaged in artification of their fine wines – a transformation that strengthens associations of rarity, exclusivity, sophistication, and luxury in consumers' minds – a relevant question is whether artification is likely to result in negative perceptions of social responsibility activities, and negative consumer responses to the brand.

A review of the literature on artification and social responsibility sheds light on the debate regarding the incompatibility of luxury brands and social responsibility, and explores how positive synergies can be created. The example of Opus One – an iconic fine wine that has experienced artification, yet is at the center of successful social responsibility activities – illustrates that consumer responses to corporate social responsibilities depend on the perceived fit between the brand and the social responsibility activities. As long as complementary associations between fine wines and social responsibility initiatives are created, artification does not preclude successful social responsibility initiatives, and may even present unique possibilities for the reinforcement of brand associations.

These insights contribute to the literature in several ways:

First, they add to the literature on artification of fine wines. The notion of artification emerged in the branding literature relatively recently (Kapferer 2014) and emerges in few articles on product brands (Kapferer 2014; Masè et al. 2018, 2020) and retail spaces (Vukadin et al. 2019), despite artification's implications for luxury brands. Similarly, few articles focus on artification in the context of fine wines (Joy et al. 2021; Passebois-Ducros et al. 2015). This chapter distinguishes artification from art infusion (Hagdtvedt and Patrick 2008a), and extends the notion of artification to a new world fine wine.

Second, research on the joint effects of artification and social responsibility on consumer responses is scarce. Neither the branding literature, nor the literature on luxury brands or fine wines has considered the implications of artification for the successful use of complementary branding strategies, including social responsibility activities. Brand strategies rooted in artification and social responsibility cannot be considered separately, however, because they jointly contribute to consumers' perception of and responses to the brand. Artification therefore influences the effectiveness of other marketing strategies, including social responsibility initiatives. Despite the increasing importance of brands' social responsibility initiatives, many questions regarding their efficacy for luxury brands remain. Although luxury brands possess inherently sustainable characteristics, such as lasting value and durability, they are increasingly perceived as products of unsustainable mass-production rather than artisanal creation (Kapferer 2014) – an impression artification can counteract (Kapferer and Michaut-Denizeau 2014). It is therefore beneficial to consider the joint impact of artification and social responsibility, and to examine whether and under what

circumstances artification and social responsibility generate synergies for the brand. If artification and social responsibility are to serve as strategic pillars of luxury brand strategies, including those related to fine wines, a better understanding of their interaction is crucial.

Third, from a brand management perspective, it is beneficial to identify consequences of the artification of fine wines. While artification may be a resource-intensive, yet worthwhile long-term strategy (Kapferer 2014), research on its strategic and performance implications for brands is scarce. Previous research highlights positive outcomes of the artification of product brands, such as consumers' brand associations (Masè et al. 2018, 2020) and brand loyalty (Masè et al. 2020). Retails brands, too, benefit from artification in terms of perceived differentiation, perceived value of the offering, customer satisfaction, and store and product image (Vukadin et al. 2019). Possible negative outcomes of artification have not been considered, however. This chapter highlights that the joint use of artification and social responsibility initiatives requires careful management in order to preclude consumer perceptions of insincerity and subsequent negative consumer responses to the brand, and illustrates how congruence between artification and social responsibility initiatives can be achieved.

Artification

Constituent Processes and Domains of Artification

Artification is a long-term process in which non-art is reconceived as art (Shapiro and Heinich 2012; Shapiro 2019). In the process of artification, a formerly common object or practice is transformed into a work of art through a complex mechanism that induces changes in the definition and perception of people, objects, and activities that were formerly not associated with the arts (Passebois-Ducros et al. 2015; Shapiro and Heinich 2012). Artification involves multiple actors and institutions (Kapferer 2014), and is comprised of several constituent processes (i.e., displacement, renaming, shifting categories, organizational and institutional change, functional differentiation, redefining time, legal consolidation, patronage, aesthetic formalization, and intellectualization; Shapiro 2019).

Because artification is a long-term process, the component processes may only emerge gradually and are sometimes concomitant or dependent on each other (e.g., renaming and shifting categories often co-occur; Shapiro 2019). Despite the fluid nature of the artification process, the component processes generalize to a wide range of domains (Shapiro 2019). These include fashion (haute couture), the circus, cinema, breakdancing, gastronomy, or graffiti (Shapiro 2019), as well as business, healthcare, politics, education, and – by some accounts – even objects of everyday life (Saito 2012; von Bonsdorff 2012). Regardless of domain, artification requires a

gradual shift in social and cultural perspectives (Kapferer 2014; Shapiro 2019), and – if initiated on purpose – a significant investment in time and financial resources (Kapferer 2014).

Artification of Luxury Brands

The marketing literature on artification is relatively recent and focuses on luxury brands (Kapferer 2014; Masè et al. 2020; Passebois-Ducros et al. 2015). Artification plays an important role in establishing and upholding the legitimacy of luxury brands, given that artisanal production or charismatic leadership are no longer credible sources of legitimacy in the context of mass-production of luxury branded items (Kapferer 2014) or in luxury retailing (Dion and Arnould 2011). The literature points toward artification as an escalation of art infusion strategies adopted by brands (Passebois-Ducros et al. 2015). *Art infusion* consists of the deliberate association of brands with the arts (Hagdtvedt and Patrick 2008a) through the integration of art into products, brands, retail spaces, or advertisements (Hagdtvedt and Patrick 2008a, 2008b; Hüttl and Gierl 2015; Joy et al. 2014; Naletelich and Paswan 2018), collaboration with artists in product design or advertising campaigns, art patronage, and artistic mentoring (Chailan 2018). This association gives rise to an art infusion effect (Hagdtvedt and Patrick 2008a), such that art's connotations of exclusivity, sophistication, culture, innovation, taste, luxury, class, prestige, and rarity (Chailan 2018; Hagdtvedt and Patrick 2008a; Lee et al. 2015; Masè et al. 2020) are transferred to and result in more positive consumer evaluations of products (Baumgarth and Wieker 2020; Estes et al. 2018; Hüttl and Gierl 2015; Hüttl-Maack 2018; Kim et al. 2012; Kim et al. 2020; Logkizidou et al. 2019), brands (Jelinek 2018; Lee et al. 2015), or retail spaces (Joy et al. 2014; Naletelich and Paswan 2018; Vukadin et al. 2016, 2018, 2019).

Artification goes beyond art infusion in that the brand is not only associated with artworks or artists – the brand itself becomes a work of art (Masè et al. 2020). Although the literature on the artification of luxury brands is extremely scarce and the delineation of artification and art infusion is at times unclear, initial findings suggest that artification strengthens consumer-based brand equity by enhancing brand image associations, particularly in regard to the brand's sophistication (Masè et al. 2018, 2020). The process and consequences of artification in the domain of luxury brands remain nonetheless underexplored, despite their potential for theoretical insight and managerial practice.

Artification of Fine Wines

The literature on the artification of fine wines is recent and closely linked to the research literature on the artification of luxury brands. A fine wine is defined as "complex,

balanced, with a potential to age, though highly drinkable in every stage of its development. A wine that provokes emotions and wonders to the one drinking it, while reflecting a certain expression of truth intended by its maker" (Vicard 2019: p. 11). Fine wines express the three core dimensions of taste, emotion, and truth (Vicard 2019). Fine wines' ability to represent the producers' authentic intent to create the very best wine possible and to connect with consumers on an emotional level, distinguishes them from luxury wines, which are generally defined in terms of high quality and price point (i.e., luxury $50–$100, super luxury $100–$200, or iconic $200 or more), scarcity, heritage, prestige, and organic, sustainable, or biodynamic farming practices (Mowery 2019). Like other luxury products, luxury wines are characterized by exceptional hedonic experience, high price, limited availability, heritage, and social distinction, and are strongly associated with rarity, nobility, craftsmanship, and exclusivity (Diallo et al. 2021; Kapferer and Bastien 2012).

The distinction between luxury wine and fine wine is subtle, and the delineation is not consistently employed. Nonetheless, whereas a luxury wine is considered "unique and singular in their effort to provide quality and consistency over time, provide an authentic and crafted product that comes from a recognized source, and is often scarce" (Dan Petroski, as cited in Mowery 2019), a fine wine distinguishes itself by sublime taste, a strong commitment to truth rooted in values, and emotional resonance (Vicard 2019) – all subjective criteria with a strong emotional undercurrent. Whereas luxury wines are oriented toward meeting high consumer expectations and taste requirements, fine wines focus on emotional authenticity and serve as a means of subtle social distinction (Passebois-Ducros et al. 2015). Fine wines are strongly associated with the arts (Mowery 2019) and lend themselves to artification (Joy et al. 2021).

Going beyond mere association of fine wines with the arts, the literature offers two alternative perspectives on how fine wines can be conceptualized as art. The first conceives of fine wines as works of art accomplished by their creators (Tomasi 2012). This line of reasoning suggests that wines are artifacts – objects that are intentionally produced to include aesthetic and expressive properties, which are both properties of "typical" art works (Tomasi 2012). Wine is a work of art in that it embodies the winemaker's intention to create specific aesthetic and expressive properties, and the conscious decisions regarding the use and combination of factors (including non-aesthetic properties, such as the wine's smell and taste) that result in aesthetic and expressive properties of the final product (Tomasi 2012). Some wines are art because they are aesthetic objects that give rise to aesthetic experiences when they are consumed (e.g., during wine tastings; Tomasi 2012).

An alternate perspective builds on the principles of artification (Shapiro and Heinich 2012). It suggests that fine wines become art after undergoing a relatively slow and complex process of artification, which involves institutional and social changes with regard to how they are perceived (Joy et al. 2021; Passebois-Ducros et al. 2015). This perspective holds that fine wines develop into art through a socio-

cultural process that evolves over time, and is – at least initially – geographically and socio-culturally bound. For example, constituent processes of artification (Shapiro 2019) are apparent in the context of the fine wines of Bordeaux and Burgundy, and comprise displacement, renaming, shifting categories, institutionalization, functional differentiation, redefining time, legal consolidation, policies regarding cultural practices and heritage, aesthetic formalization, and intellectualization (Joy et al. 2021).

Artification of a New World Fine Wine: Opus One

Although the literature on the artification of fine wines has primarily focused on old world wines (i.e., grand cru classé wines by Bernard Magrez; Passebois-Ducros et al. 2015; fine wines of Bordeaux and Burgundy; Joy et al. 2021), the potential for artification of new world wines has been recognized as well. An example of artification of a new world fine wine is Opus One (Passebois-Ducros et al. 2015). The Opus One Winery is located in Oakville, California and began as a joint venture between Baron Philippe de Rothschild of Château Mouton Rothschild and Robert Mondavi of the Napa Valley Robert Mondavi winery in 1978. This unique collaboration combined the emerging Mondavi's grape growing and wine making skills with the world-class reputation of Château Mouton Rothschild (Brook 2011). The involvement of the latter set the stage for Opus One's artification: Château Mouton Rothschild is a fine wine that – as a Bordeaux Premier Cru – has undergone artification (Joy et al. 2021). Château Mouton Rothschild also has a long history of collaboration with artists, such as Salvador Dalí, Marc Chagall, Pablo Picasso, Joan Miró, and Andy Warhol, by commissioning original artworks for wine labels since 1945 (Hindle 2016). These works are now displayed at Château Mouton Rothschild's Paintings for the Labels Room (Château Mouton Rothschild 2021).

The objective of the joint venture between Robert Mondavi and Baron Philippe de Rothschild was to create a single Bordeaux style-blend based on Napa Valley Cabernet Sauvignon (Brook 2011). In the 1990s, Opus One became a California cult wine and the first California luxury wine to be sold in Asia and Europe (Gordon 2010). After the Robert Mondavi winery was acquired by Constellation in 2004, the estate of Baron Rothschild maintained control over Opus One's marketing and vineyard management (Gordon 2010). Opus One commands an average price of USD $413 across vintages, and an average price of USD $178 (before taxes) for the 2020 Opus One vintage (WineSearcher.com 2021). It is considered one of the top 100 fine wines of California and one of the ten finest California Bordeaux blends (Brook 2011). This categorization of Opus One as a fine wine is also consistent with the criteria proposed by Mowery (2019) and Vicard (2019). Recognizing that artification is an ongoing socio-cultural process, several of its constituent processes suggest that the transformation of this new world fine wine into art is well under way:

- *Renaming and displacement*: For Opus One, renaming and displacement jointly served as a strategic means to heighten the wine's cultural recognition. Originally named Napamedoc, the wine was renamed Opus One in 1982. Opus – the Latin word for "work" – is a label used in cataloging classical music compositions, with the opus number representing the temporal order of a composer's creations. Renaming of the estate and its first wine extracted Opus One from the context of new world wines, and moved it into the world of art. Consistent with this reference to musical works of art, the estate's second wine, introduced in 1993, was named Overture (Radley-McConnell 2014).
- *Shifting categories*: A categorical shift and a rise in rankings arose from the involvement of Baron Philippe de Rothschild of Château Mouton Rothschild – for which he had achieved a reclassification to Premier Cru in modification of the Bordeaux Wine Official Classification (1855) within the Médoc region in 1973 – in order to create a Bordeaux-style Napa Valley red wine. Despite the good reputation Robert Mondavi wineries enjoyed at the time of Opus One's creation, this involvement catapulted the newly created wine out of the populated category of Napa Valley Cabernet Sauvignon-based wines to that of a fine wine built on the knowledge, tradition, and prestige associated with the fine wines of Bordeaux. As fine wines of Bordeaux are themselves considered art (Joy et al. 2021), this shift enhanced the acceptability of this new world product as a fine wine and, ultimately, as a work of art in its own right.
- *Aesthetic formalization*: Related to the shift in categories is the adoption of the aesthetic norms of the established fine wines of Bordeaux. Although its composition varies by vintage, Opus One – as a Bordeaux-style wine – reflects the proprietary blend of grape varieties characteristic of renowned Bordeaux red wines – a dominant base of Cabernet Sauvignon complemented by Petit Verdot, Cabernet Franc, Merlot, and Malbec (Opus One Winery 2021). The adapted aesthetic norms extend to the Opus One estate, which features paintings by Miró (Brook 2011) and allude to the collection of contemporary artworks (i.e., the Paintings for the Labels) at the Château Mouton-Rothschild. The Opus One label – designed in 1982 by Robert Mondavi and Baron Philippe de Rothschild – shows the portraits of the two winery founders in a blended image that captures the nature of Opus One as a Bordeaux blend connecting the old and new world (Slater 2013). The label also links the wine to the long history of portraiture in the fine arts.
- *Redefining time*: The recognition that a long-term perspective is necessary to develop a work of art, and – conversely – that art implies longevity, applies to Opus One. California as a wine growing region is renowned for the lack of rules and regulations, which gives rise to innovative techniques and blends, as well as diversification (Brook 2011). The industry tends to focus on meeting shifting consumer preferences rather than tradition, which results in a high level of instability with regard to wine ratings as well as to the existence of wineries (Brook 2011). In this context of instability, longevity and a proven track record

of consistent quality and highly favorable evaluations by experts is difficult to achieve (Brook 2011) yet critical to the perception of a fine wine as work of art, irrespective of a particular vintage.

- *Functional differentiation*: Given that Opus One was conceived as a partnership, different actors assumed specialized roles pertaining to vineyard ownership, grape production, and the conception, production, and commercialization of wine – a division of labor that was reinforced after Constellation acquired Mondavi. Responsibility is now shared between Constellation and Baron Philippe de Rothschild SA (Baron Philippe de Rothschild's estate) (Brook 2011). Functional differentiation involves estate ownership by investors, rather than owner-growers, and the employment of college-educated winemakers (Brook 2011). Importantly, winemaking – the creation of the work of art – is in the hands of highly experienced and oenology-trained wine makers, and is separated from vineyard management as well as commercialization of the brand, which benefits from the recognition and involvement of Camille Sereys de Rothschild, Baron Philippe de Rothschild's granddaughter (Brook 2011). As in the established domain of the arts, creation is separated from commercialization.
- *Organizational and institutional change*: The establishment of the Napa Valley Vintners' Association in 1944 represented a shift from individualistic activities to the creation of a collective to represent regional wine growers. The Napa Valley Vintners' Association is increasingly concerned with governance and regulations involving the labeling of its appellation of origin wines (Vickers 2020). While it is in the interest of producers of luxury and premium wines that regulations be stringent and labeling as transparent as possible, this concern is not shared by producers of lower and mid-priced wines, who stand to benefit from leeway with regard to labeling regarding grape provenance or wine composition (Vickers 2020). Although these issues are not resolved, institutionalization implies that the legitimacy and authenticity of wines are increasingly scrutinized, and that greater regulation is forthcoming and likely to positively impact the reputation of fine wines.
- *Normative and legal consolidation*: An important legal development supporting the increased recognition of Opus One was the delineation of American Viticultural Areas (AVAs) under the leadership of the U.S. Alcohol and Tobacco Tax and Trade Bureau. AVAs are legally protected appellations of origin used on wine labels, and delimit grape-growing regions based on distinct geographic (i.e., elevation, soil) and climatic (i.e., climate, rainfall) features, as well as grape varietals. Napa Valley was first designated as an AVA in 1981, and now comprises 16 nested AVAs, including Oakville (designated in 1993), the home of Opus One (Napa Vintners 2021). AVAs facilitate the competitive positioning of wines, as well as wine identification by consumers – both important in the development of a unique and outstanding reputation.

– *Intellectualization*: Expert analysis and media commentary on the status of California wines, particularly in comparison to the fine wines of Bordeaux and Burgundy, has its roots in a wine tasting organized by wine merchants Steven Spurrier and Patricia Gallagher in Paris in 1976. Known as the "Judgment of Paris" (Brook 2011; Robinson 2016; Steinmetz 2016), this blind tasting by a panel of renowned wine experts pitched then unknown California Pinot Chardonnays and Cabernet Sauvignons against fine wines of Burgundy and Bordeaux (Steinmetz 2016). In both categories, California wines outperformed French wine, precipitating media commentary, a book (Taber 2005), the movie *Bottle Shock* (2008), and a rematch in 2006, which resulted in similarly high rankings of California wines (Brook 2011). This expert evaluation and subsequent media commentary led to the emergence of California wines on the international stage and the recognition of California vintners; it was likely an important contributing factor in the creation of the Californian-French partnership that marked the beginnings of Opus One in 1979 (Steinmetz 2016).

In summary, several constituent processes of artification (i.e., renaming and displacement, shifting categories, aesthetic formalization, redefining time, functional differentiation, organizational and institutional change, legal consolidation, and intellectualization; Shapiro 2019) can be observed with regard to Opus One, and have resulted in its gradual and ongoing transformation from a new world wine to art. Of note is that patronage in terms of public policy initiatives or public funding has not emerged in this case, possibly because of the specifics of the economic, social, and political environment in the US. The absence of a constituent process does not preclude artification, however, as it may emerge at a later point in time (Shapiro 2019).

Like artification, social responsibility is gaining momentum in the domains of luxury brands and fine wines, and is therefore discussed next.

Social Responsibility

Sustainability describes an organization's integration of social, environmental, and economic activities in order to balance economic profits with environmental protection and social equity (Lindgreen et al. 2008). The marketing literature refers to this notion as corporate social responsibility (CSR).

Social Responsibility: Scope and Consequences

CSR comprises organizations' voluntary contribution of resources and activities in order to enhance societal well-being (Korschun et al. 2014; Wagner et al. 2009). It

consists of firm investments in product-related social responsibility, socially responsible business practices, and philanthropy, undertaken in isolation or combination, and directed toward different stakeholders, including consumers, employees, the community, or the environment (Peloza and Shang 2011). Product-related CSR activities pertain to organic product ingredients, product biodegradability, product quality (e.g., to reduce obsolescence and waste), or the product's energy efficiency (Peloza and Shang 2011). Socially responsible business practices include environmental protection (e.g., recycling, sustainable energy generation and use, emissions control), diversity in top management (i.e., equity, diversity, and inclusion), employee relations (e.g., health care, fair wages), packaging (e.g., minimal packaging, biodegradable materials), and supply chain responsibility (e.g., domestic sourcing, fair trade, stance against sweatshop and child labor; Peloza and Shang 2011). Philanthropy includes cause-related marketing (i.e., donations linked to product sales), cash or product donations, employee volunteerism, promotion or support of social causes, or event sponsorship (Peloza and Shang 2011).

Firms engage in CSR initiatives in order to build a positive reputation (Kotler and Lee 2005), which in turn increases consumer perceptions of a firm's trustworthiness (Singh et al. 2012), ethicality (Brunk and Blümelhuber 2011), compassion (Lichtenstein et al. 2004), and altruism (Kwak and Kwon 2016). CSR activities enhance consumer evaluations of the firm (Brown and Dacin, 1997; Sen and Bhattacharya 2001) and of product performance (Chernev and Blair 2015), consumers' self-identification with the firm (Bhattacharya and Sen 2003, 2004), customer satisfaction (Luo and Bhattacharya 2006), repurchase intent (Sen et al. 2006), and brand loyalty (Marín Rives et al. 2009), while decreasing consumers' price sensitivity (Green and Peloza 2011). Finally, CSR activities can mitigate negative consumer responses to subsequent firm transgressions (Klein and Dawar 2014; Vanhamme and Grobben 2009). Overall, CSR strengthens firms' competitive positioning (Kotler and Lee 2005) and can positively contribute to firm performance (Mishra and Modi 2016; Saeidi et al. 2015).

Due to the many positive consequences of CSR activities, their adoption in the wine industry has gained momentum. Wine Growers Canada, for example, actively promotes social responsibility practices among its members, including equity, diversity, and inclusion in the workplace, promotion of safe alcohol consumption, and environmental sustainability practices, such as LEED-certified cellars and tasting rooms, biodynamic viticulture and protection of indigenous plants and animals, or eco-glass bottles (Wine Growers Canada 2021). Similarly, the California Sustainable Winegrowing Alliance (CSWA) supports responsible use of water, energy, and nitrogen in vineyards and wineries, as well as reduction of emissions (California Sustainable Wine Growing Alliance 2021). Its growing membership (171 wineries and 2,247 vineyards in 2021; California Sustainable Wine Growing Alliance 2021) is a testament to the increased importance and acceptance of social responsibility in the winery industry.

Social Responsibility and Luxury Brands

Research on the effect of social responsibility activities on consumer responses and brand performance suggests that the fit between a social responsibility activity and the brand plays an important role. CSR fit is defined as consumers' perception of the congruence between a social responsibility activity and a firm (i.e., the CSR activity relates to core business activities, such as the donation of building materials to disaster areas by home improvement centers; Fan et al. 2020; Lee et al. 2012; Menon and Kahn 2003; Simmons and Becker-Olsen 2006) or brand (i.e., CSR activities relate to brand associations or positioning, such as cause-related marketing in support of a performing arts center by a luxury hotel chain; Koschate-Fischer et al. 2012; Pracejus and Olsen 2004; Vilasanti da Luz et al. 2020). When CSR fit is high, positive associations arising from social responsibility activities are more easily transferred to the brand (Yoo and Lee 2018). In addition, high-fit CSR activities signal sincere motives for the brand's CSR engagement (Ellen et al. 2006) and lead to more extensive and more positive elaboration on CSR information (Simmons and Becker-Olsen 2006). As a result, high levels of CSR fit are associated with positive outcomes, such as increased choice likelihood (Lichtenstein et al. 2004; Pracejus and Olsen 2004), brand attitudes (Becker-Olsen et al. 2006; Kim and Lee 2020), brand loyalty (Lee et al. 2012), and brand equity (Simmons and Becker-Olsen 2006).

The role of CSR fit may explain mixed effects of luxury brands' CSR activities on consumer responses to the brand (Sipilä et al. 2021). Because the notions of luxury and social responsibility are fundamentally incongruent (Janssen et al. 2014, 2017; Kapferer and Michaut-Denizeau 2014), the relation between luxury brands, social responsibility activities, and consumer responses generates ongoing inquiry into how luxury brands should engage in social responsibility activities (Achabou and Dekhili 2013; Davies et al. 2012; Joy et al. 2012; Sipilä et al. 2021; Torelli et al. 2012).

Luxury brands are characterized by elitism, distinction and status, rarity, reputation, creativity, power, hedonism, and refinement (De Barnier et al. 2012; Kapferer and Michaut-Denizeau 2014), and represent wealth, ambition, and dominance over people and resources (Torelli et al. 2012). Social responsibility, on the other hand, is associated with the conservation of resources and the environment for future generations (Kapferer and Michaut-Denizeau 2014), and reflects self-transcendent values such as caring for the well-being of society, environmental protection, social justice, and equality (Torelli et al. 2012). This apparent contradiction between values associated with luxury brand concepts (i.e., how brands are positioned in consumers' minds; Park et al., 1986, 1991) and social responsibility activities emerges in several studies measuring implicit (Voyeur and Backham 2014; Torelli et al. 2012) and explicit (Achabou and Dekhili 2013; Voyeur and Beckham 2014) associations between social responsibility and luxury brands. CSR activities undertaken by luxury brands evoke increased consumer experience of disfluency (i.e., difficulty processing the

brand-related CSR information in conjunction with information about a luxury brand) – particularly for luxury brands emphasizing the value of self-enhancement – and result in more negative brand evaluations (Torelli et al. 2012). CSR activities undertaken by luxury brands also elicit stronger perceptions of profit-driven, insincere motives for the brand's CSR engagement and are associated with decreased sales performance (Sipilä et al. 2021), and negatively affect consumers' brand preference (Achabou and Dekhili 2013; Davies et al. 2012). Table 11.1 summarizes research on consumer responses to luxury brands' CSR activities.

Table 11.1: Effects of luxury brands corporate social responsibility (CSR) activities.

Reference	Context	CSR activity	Psychological mechanism	Findings
Achabou and Dekhili 2013	Luxury clothing brand	Use of recycled materials; use of organic cotton	Consumer perceptions of incompatibility between luxury and recycling	Incorporation of recycled (versus organic) materials reduces consumer preferences
Diallo et al. 2021	Luxury fragrance and watch brands	Combination of activities: health care benefits for employees and their children; donation to construction of a children's hospital; certification attesting traceability and origin of raw materials	Luxury brands' functional and symbolic value mediate the effect of luxury brands' CSR on willingness to pay price premium	Luxury brand's CSR activities negatively influence willingness to pay price premium; CSR has a more positive effect in cultures with high (vs. low) long-term orientation
Hagtvedt and Patrick 2016	Luxury versus value retail store	Cause-related marketing: association with charity at the point of sale	Reduction of perceived guilt	Cause-related marketing increases consumers' choice of and purchase intention at luxury (vs. value) retail stores

Table 11.1 (continued)

Reference	Context	CSR activity	Psychological mechanism	Findings
Janssen et al. 2014	Enduring (jewelry) versus ephemeral (fashion) luxury products; scarcity: scarce vs. available		Perceived fit between luxury and CSR	Enduring luxury products are perceived as more socially responsible and elicit more positive attitudes when they are scarce (vs. available); this effect does not hold for ephemeral luxury products; perceived luxury – CSR fit mediates the joint effect of scarcity and ephemerality
Janssen et al. 2017	Conspicuousness of socially responsible luxury leather bag brand: low, high		CSR beliefs; self-congruity	Inconspicuous (vs. conspicuous) responsible luxury brand evokes more favorable CSR beliefs, greater self-congruity among consumers with a modest self-identity, and more positive brand attitudes
Kong et al. 2020	Luxury versus non-luxury apparel brands	Sustainability claim: cultural, economic, environmental, social, or none	Brand attitude mediates the effect of sustainability on purchase intentions; higher levels of brand trust reduce the effect of sustainability claims	Sustainability perception has negative impact on purchase intentions and eWOM for luxury (vs. non-luxury) brands

Table 11.1 (continued)

Reference	Context	CSR activity	Psychological mechanism	Findings
Park et al. 2019	Luxury sunglasses	Philanthropy: CSR, no CSR, CSR with value instantiation (i.e., concrete example of philanthropy in the presence of self-enhancement)	Integration of disparate self-enhancement and self-transcendence values associated with sustainable luxury consumption	Exposure to philanthropy of self-enhancement-driven celebrities or visualizing philanthropic activities while pursuing self-enhancement, mitigates unfavorable responses to luxury products promoted with CSR appeals
Septianto et al. 2021	Luxury, sustainable, sustainable luxury brand; advertising appeals: pride, gratitude	Environmental action: Trash removal from oceans	Status attainment (in response to pride appeal); affiliation seeking (in response to gratitude appeal)	eWOM for sustainable luxury brands mirrors luxury (sustainable) brands for pride (gratitude) appeal; pride (gratitude) appeal increases intentions to broadcast (narrowcast) eWOM via status attainment (affiliation seeking) motives
Sipilä et al. 2020	Luxury brands (multiple product categories)	Internal / employee focused or external / philanthropic CSR	Perceptions of extrinsic (i.e., self-interested) motivations for CSR engagement; negative effects are stronger when consumers deliberate on CSR engagement	CSR engagement lowers financial performance and brand loyalty; negative effects are mitigated by employee-oriented CSR and framing brands as sustainable rather than exclusive

Table 11.1 (continued)

Reference	Context	CSR activity	Psychological mechanism	Findings
Torelli et al. 2012	Luxury brands with a self-enhancement, openness, or conservation brand concept (multiple product categories)	Presence (or absence) of CSR information	Disfluency in processing self-enhancement value associated with the luxury brand and CSR information; more negative effects for consumers with abstract (vs. concrete) mindset	Less favorable evaluations of luxury brands associated with self-enhancement values that communicate CSR information
Vilasanti da Luz et al. 2020	Luxury versus mass-market brands (apparel, home appliances)	Green advertising message: demarketing, environmental	Advertising believability due to a match of luxury – demarketing (or mass-market – environmental)	Demarketing (vs. environmental) messages enhances brand attitudes and willingness to buy for luxury brands; environmental message is more beneficial for mass-market brands
Voyeur and Beckham 2014	Words representing luxury; luxury versus high-street handbags	Words representing sustainability	Context-dependent dissociation of luxury and sustainability notions; explicit positive attitude toward sustainable luxury	Luxury shows stronger implicit associations with unsustainability (vs. sustainability); when luxury brands are compared to high-street brands, this effect dissipates; consumers explicitly state that luxury items less desirable and luxurious when sustainable, and express difficulty in associating sustainability and luxury

Source: Author.

Increasing Perceived Fit Between Luxury Brands and CSR Activities

Negative consequences of the dissociation between luxury brand concepts and social responsibility raises the question of how luxury brands can enhance consumers' perceptions of fit in order to mitigate negative or encourage positive consumer responses. Research findings point to several possibilities.

The first approach to increasing CSR fit in the context of luxury brands consists of increasing consumers' ease of processing of luxury brand and CSR information in order to enhance subsequent brand responses. Low CSR fit is more likely and more harmful for luxury brands that emphasize self-enhancement values (i.e., power, achievement, hedonism in terms of pursuing one's own interests; Janssen et al. 2014; Torelli et al. 2012). Luxury brands emphasizing values of conservation (i.e., tradition, security, conformity; Janssen et al. 2014; Torelli et al. 2012) and openness (i.e., stimulation, self-direction, hedonism in terms of pursuit of new ideas and experiences; Janssen et al. 2014; Torelli et al. 2012), on the other hand, do not evoke unfavorable brand evaluations when communicating CSR engagement, which conveys self-transcendence values (i.e., benevolence, universalism; Torelli et al. 2012). Luxury brands undertaking CSR initiatives could therefore benefit from de-emphasizing self-enhancement values, while highlighting conservation and openness values (Torelli et al. 2012). Relatedly, any intervention alleviating consumers' processing disfluency of luxury brand and CSR information can enhance subsequent evaluations of luxury brands engaging in CSR activities (e.g., concrete mindset; Torelli et al. 2012; value instantiation; Park et al. 2019), although the implementation of such interventions in practice may pose challenges.

The second avenue to increasing CSR fit in the context of luxury brands relates to establishing a stronger link between luxury brands and CSR activities through brand communication. This can involve the communication of CSR activities that represent a better match with luxury brand concepts, or brand repositioning away from luxury and toward sustainability. With regard to CSR communication, most research does not find a positive impact of specific CSR domains on consumer responses to luxury brands (Diallo et al. 2021; Kong et al. 2020), although recent evidence points toward benefits of including carefully chosen CSR in the advertising of luxury brands, so that luxury brands elicit more positive brand attitudes in response to demarketing (i.e., encouraging consumers to consume less by buying better to reduce unnecessary consumption) compared to environmental sustainability messages (Vilasanti da Luz et al. 2020). Brand conspicuousness also influences consumers' CSR beliefs related to luxury brands: Conspicuous brands using prominent logos, monograms, or brand colors, elicit more negative CSR beliefs and brand attitudes, whereas inconspicuous luxury brands evoke more positive CSR beliefs and, as a result, more positive brand attitudes (Janssen et al. 2017). The reduction in luxury brand conspicuousness may contribute to an increase in consumer perceptions

of luxury brands' fit with the more altruistic values associated with CSR. Considering the impact of brand positioning in brand communication to consumers, several studies also document a positive effect of a change in luxury brand positioning away from exclusivity and toward sustainability (Sipilä et al. 2021; Vilasanti da Luz et al. 2020), although this may have negative effects on luxury brands' core target market pursuing self-enhancement motives (Park et al. 2019).

A third avenue relates to contextual effects that impact consumers' perceptions of the luxury brand's social responsibility values. Evidence suggests that the lack of perceived fit between luxury brands and CSR is mitigated when consumers consider the durability of luxury branded products (Janssen et al. 2014): Enduring and scarce luxury brand items (e.g., diamond jewelry) elicit greater CSR fit and more positive product evaluations, compared to ephemeral and scarce luxury branded items (e.g., haute couture clothing; Janssen et al. 2014). An additional factor influencing consumers' sustainability perceptions of luxury brands is whether the context involves a comparison to mass-market brands (Davies et al. 2012; Voyeur and Beckham 2014). When consumers consider both luxury and mass-market brands, the extent of dissociation between luxury brands and CSR activities decreases (Voyeur and Beckham 2014), because a context of mass-market brands increases consumers' perceptions of comparatively higher levels of sustainability of luxury brands (Davies et al. 2012), due to their association with high quality, lasting worth, and durability (Kapferer and Michaut-Denizeau 2014; Voyeur and Beckham 2014). This aligns with recent findings that heightened salience of durability increases consumers' choice of fewer high-end products over a greater number of mid-range products (Sun et al. 2021). Taken together, this evidence suggests that luxury brand–CSR fit can be increased by directing consumers' awareness toward the durability of luxury compared to mass-market brands, a sustainability-related attribute that consumers tend to neglect (Sun et al. 2021), especially because luxury brands are increasingly perceived as mass-produced rather than artisanal (Kapferer 2014; Kapferer and Michaut-Denizeau 2014).

The role of durability and scarcity in increasing CSR fit in the context of luxury brands suggests that artification is a promising avenue to closing the perceived gap between luxury brands and CSR. Artification elevates a brand in terms of its value, rarity, and durability. As an emphasis on durability and scarcity evokes high levels of CSR fit and enhances attitudes toward luxury brands (Janssen et al. 2014), artification could strengthen a luxury brand's links to sustainability and social responsibility.

Artification and Social Responsibility: Creation of Complementary Associations

In the context of vineyards and wineries, social responsibility initiatives frequently focus on environmental sustainability, due to the high level of fit between wines

that are the product of the *terroir* (i.e., the interactive ecosystem consisting of soil, climate, and the vine; van Leeuwen et al. 2004) and environmental protection. Opus One, for example, is certified within the framework of Napa Green (Oenogroup 2021) – a program established by the Napa Valley Vintners in 2004. Napa Green is only one of four sustainable winegrowing programs in the US (NapaGreen 2021), and comprises an independent accreditation based on a review of sustainability activities implemented by vineyards and wineries within a three-year evaluation cycle (Gane 2021). The sustainability plans are customized to the reality of specific vineyards and wineries, and aim at continuous improvement (Gane 2021). Opus One has been certified as a Napa Green vineyard and winery since 2018 (NapaGreen 2021). These certifications reflect commitment to sustainability principles supported by the implementation of numerous practices focused on saving energy, conserving scarce water supplies, and improving the overall business sustainability (Oenogroup 2021):

- The Napa Green vineyard certification focuses on the improvement of soil health and carbon neutrality within six to nine years (NapaGreen 2021). Accreditation requires the adoption of measures to prevent soil erosion, preserve and enhance natural habitat, reduce pesticide use, and reduce water consumption (NapaGreen 2021; Phillips 2021), such as through the dry-farming practices adopted by Opus One (Brook 2011). Accreditation also requires conservation burning and compliance with social equity, justice, and inclusion standards for farmworkers (NapaGreen 2021; Phillips 2021).
- The Napa Green winery certification focuses on winery facilities, including production, administration, and hospitality, and calls for the reduction of waste through recycling, composting, environmentally responsible purchasing, reduction of greenhouse gas emissions and carbon footprint, commitment to social equity, and energy and water conservation (NapaGreen 2021; Phillips 2021). As part of its continuous improvement in the area of energy efficiency, Opus One sources 100% renewable, locally produced solar and wind energy through the Marin Clean Energy (MCE) program (NapaGreen 2021).

Although environmental sustainability certifications are important from an environmental and social contribution standpoint, as well as in terms of meeting growing consumer demand for sustainable wines (Anson 2019), they are not likely to reinforce brand positioning of fine wines, due to the lack of associations with luxury (Kapferer and Michaut-Denizeau 2014), and the widespread adoption by competing wineries, which reduces their impact on unique competitive positioning (Kotler and Lee 2005).

Against this backdrop, artification provides unique possibilities for the creation of complementary associations between fine wines and social responsibility initiatives. Compared to product-related or business process-related CSR activities (Peloza and Shang 2011), philanthropy holds great potential in the generation of shared associations between CSR activities and fine wines. The important role of

philanthropy becomes particularly evident in the example of charity auctions undertaken by producers of fine wines. In this context, the convergence of associations arises from a long history of fine art auctions, with renowned fine art auction houses, such as Christie's, going back to the 18th century. A sign that fine wines have taken their place within the world of art is the fact that two of the world's largest auction houses (Christie's and Sotheby's New York) host auctions of fine wines, which – like other art forms – are now frequently considered an investment (Robillard 2020). Such secondhand auctions of fine wines by internationally recognized auction houses play an important role in reinforcing the status of fine wines as art.

Many of the firsthand auctions of fine wines hosted by wineries are charity auctions (Robillard 2020) in support of community or non-profit organizations. For this reason, these auctions can assume an important role in increasing consumer awareness and recognition of wineries' social responsibility activities in terms of community involvement and concern for societal well-being. Opus One is a good example of establishing confluence between a fine wine undergoing artification and CSR engagement in the form of charity-auction based philanthropy. Opus One's co-founder Robert Mondavi and his wife Margrit were instrumental in establishing the yearly Napa Valley Wine Auction, today known as Auction Napa Valley (Cook 2018; Laube 2005). This auction benefits local charities, supporting non-profit programs in integrated community health, early learning initiatives, child education, and adult day services for people suffering from Alzheimer's disease (Phillips 2018). Since its inception in 1981, the auction has raised more than USD $180 million, and about 100,000 people benefited in 2017 alone (Phillips 2018). In 2018, for example, the Opus One lots of four six-liter Imperials raised USD $1.4 million (Cook 2018; Phillips 2018). Although Auction Napa Valley was postponed due to the Covid-19 pandemic in 2020, Opus One contributed a lot of five bottles (one bottle of the 1979, 1987, 1991, 2001, 2010 vintage, each) to the Napa Valley Library Wine Auction organized by the Napa Valley Vintner's Association in support of community investments and the protection of Napa Valley (Mercer 2021).

Opus One's contribution to charity auctions reinforces the notion of a fine wine that – as a work of art – is highly prized and sought after by a discerning and upscale clientele, and complements Opus One's continuous association with and support for the arts. This includes the artistic influence, direction and vision of Baroness Philippine de Rothschild, who – after the death of Baron Philippe de Rothschild in 1988 – left her career in French theatre to play an important role in the development (Smith 2015) and – after the acquisition of Mondavi by Constellation – the marketing of Opus One (Brook 2011). In addition, the arts are integrated into Opus One's estate in the form of a Joan Miró painting and a prominent 18th century Bodhisattva statue displayed in the private visitors' lounge (Slater 2013), and live musical performances in the context of Festival Napa Valley (Festival Napa Valley 2021). Whereas charity auctions strengthen the notion of artification, the amounts Opus One lots garner at charity auctions not only constitute significant monetary contributions to community

initiatives that make the brand stand out among its peers (Cook 2018; Phillips 2018), but also attract bidders to these events, and thereby support the effectiveness of charity auctions centered on fine wines. This results in a positive feedback loop in which connotations of art, value, and social responsibility coalesce. When shared associations are successfully established, social responsibility activities undertaken by makers of fine wine can have favorable effects – not only for societal well-being, but the brand as well.

Conclusion

The artification of fine wines raises challenges in the identification and implementation of social responsibility activities because in consumers' minds the sophistication, exclusivity, and rarity of art may be incompatible with the compassion, inclusion, and universalism associated with social responsibility. Social responsibility is nonetheless not only desirable in terms of fulfilling ethical obligations to stakeholders including consumers, employees, the community, and the environment, but also valuable in creating unique brand associations and favorable consumer responses to the brand.

Opus One is an example of a new world fine wine that evolved into a work of art and has been successful in complementing its environmental sustainability activities – similar to those adopted by other wineries and vineyards either in isolation or under the auspices of vintners' or winegrowers' associations – with charity auctions in support of community initiatives. The careful choice of this uniquely fitting social responsibility initiative reinforces the brand's status as a work of art. This example demonstrates that artification does not preclude social responsibility. It highlights, however, that a careful selection of social responsibility activities is necessary to elicit positive consumer responses and build a strong brand reputation. Social responsibility activities that are highly congruent with the brand not only benefit stakeholders, but also reinforce the brand, thereby encouraging future CSR investments and sustaining the brand's contribution to societal well-being over time.

References

Achabou, Mohamed Akli, and Sinem Dekhili (2013). "Luxury and Sustainable Development: Is there a Match?" *Journal of Business Research* 66: 1893–1903.

Anson, Jane (2019). "Why We Need Ethical Fine Wine." *Decanter*. https://www.decanter.com/wine-news/opinion/news-blogs-anson/ethical-wine-sustainability-420945/

Baumgarth, Carsten, and Jennifer Bahati Wieker (2020). "From the Classical Art to the Urban Art Infusion Effect: The Effect of Street Art and Graffiti on the Consumer Evaluation of Products." *Creativity and Innovation Management* 27, no. S1: 116–127.

Becker-Olsen, Karen L., B. Andrew Cudmore, and Ronald Paul Hill (2006). "The Impact of Perceived Corporate Social Responsibility on Consumer Behavior." *Journal of Business Research* 59, no. 1: 46–53.

Bhattacharya, C.B., and Sankar Sen (2003). "Consumer–Company Identification: A Framework for Understanding Consumers' Relationship with Companies." *Journal of Marketing* 67, no. 2: 76–88.

Bhattacharya, C.B., and Sankar Sen (2004). "Doing Better at Doing Good." *California Management Review* 47, no. 1: 9–24.

Brook, Stephen (2011). *The Finest Wines of California – A Regional Guide to the Best Producers and Their Wines*. Berkeley, CA: University of California Press.

Brown, Tom J., and Peter A. Dacin (1997). "The Company and the Product: Corporate Associations and Consumer Product Responses." *Journal of Marketing* 61, no. 1: 68–84.

Brunk, Katja H., and Christian Blümelhuber (2011). "One Strike and You're Out: Qualitative Insights into the Formation of Consumers' Ethical Company or Brand Perceptions." *Journal of Business Research* 64, no. 2: 134–141.

Chailan, Claude (2018). "Art as a Means to Recreate Luxury Brands' Rarity and Value." *Journal of Business Research* 85: 414–423. doi: 10.1016/j.jbusres.2017.10.019.

Chernev, Alex, and Sean Blair (2015). "Doing Well by Doing Good: The Benevolent Halo of Corporate Social Responsibility." *Journal of Consumer Research* 41, no. 6: 1412–1425.

Cook, Whit (2018). "Auction Napa Valley Raises 13.6 Million for Charity – Four Imperials of Opus One and Masked Ball at Versailles Lead Way." *The GoodLife Report*. https://www.goodlifereport.com/dining/auction-napa-valley-raises-13-6-million-four-imperials-of-opus-one-and-masked-ball-at-versaille-lead-way/.

Davies, Iain A., Zoe Lee, and Ine Ahonkhai (2012). "Do Consumers Care about Ethical Luxury?" *Journal of Business Ethics* 106, no. 1: 37–51.

De Barnier, V., S. Falcy, and P. Valette-Florence (2012). "Do Consumers Perceive Three Levels of Luxury? A Comparison of Accessible, Intermediate and Inaccessible Luxury Brands." *Journal of Brand Management* 19, no. 7: 623–636.

Diallo, Mbaye Fall, Norchène Ben Dahmane Mouelhi, Mahesh Gadekar, and Marie Schill (2021). "CSR Actions, Brand Value, and Willingness to Pay a Premium Price for Luxury Brands: Does Long-Term Orientation Matter?" *Journal of Business Ethics* 169: 241–260. doi: 10.1007/s10551-020-04486-5.

Dion, Delphine, and Eric Arnould (2011). "Retail Luxury Strategy: Assembling Charisma through Art and Magic." *Journal of Retailing* 87, no. 4: 502–520.

Ellen, Pam Scholder, Deborah J. Webb, and Lois A. Mohr (2006). "Building Corporate Associations: Consumer Attributions for Corporate Socially Responsible Programs." *Journal of the Academy of Marketing Science* 34, no. 2: 147–157.

Estes, Zachary, Luisa Brotto, and Bruno Busacca (2018). "The Value of Art in Marketing: An Emotion-Based Model of How Artworks in Ads Improve Product Evaluations." *Journal of Business Research* 85: 396–405.

Fan, Xiaojun, Nianqi Deng, Yi Qian, and Xuebing Dong (2020). "Factors Affecting the Effectiveness of Cause-Related Marketing: A Meta-Analysis." *Journal of Business Ethics*, online first: 1–22. doi: 10.1007/s10551-020-04639-6.

Gane, Tamara (2021). "Napa Green: How One Sustainabilty Program is Working to Save Napa Valley." *Vinepair*. https://vinepair.com/articles/napa-green-sustainability/.

Gordon, Jim (2010). *Opus Vino*. London: DK Publishing.

Green, T., and John Peloza (2011). "How Does Corporate Social Responsibility Create Value for Consumers?" *Journal of Consumer Marketing* 28, no. 1: 48–56.

Hagdtvedt, Henrik, and Vanessa Patrick (2008a). "Art Infusion: The Influence of Visual Art on the Perception and Evaluation of Consumer Products." *Journal of Marketing Research* 45, no. 3: 379–389.

Hagdtvedt, Henrik, and Vanessa Patrick (2008b). "Art and the Brand: The Role of Visual Art in Enhancing Brand Extendibility." *Journal of Consumer Psychology* 18, no. 3: 212–222. doi:10.1016/j.jcps.2008.04.010.

Hagtvedt, Henrik, and Vanessa M. Patrick (2016). "Gilt and Guilt: Should Luxury and Charity Partner at the Point of Sale?" *Journal of Retailing* 92, no. 1: 56–64.

Hindle, Georgina (2016). "Château Mouton Rotschild Labels." *Decanter.* https://www.decanter.com/wine/producer-profiles/bordeaux-producers/chateau-mouton-rothschild-labels-4887/

Hüttl, Verena, and Heribert Gierl (2012). "Visual Art in Advertising: The Effects of Utilitarian vs. Hedonic Product Positioning and Price Information." *Marketing Letters* 23: 893–904.

Hüttl-Maack, Verena (2018). "Visual Art in Advertising: New Insights on the Role of Consumers' Art Interest and Its Interplay with the Hedonic Value of the Advertised Product." *Journal of Product & Brand Management* 27, no. 3: 262–276.

Janssen, Catherine, Joëlle Vanhamme, Adam Lindgreen, and Cécile Lefebvre (2014). "The Catch-22 of Responsible Luxury: Characteristics of Consumers' Perception of Fit with Corporate Social Responsibility." *Journal of Business Ethics* 119: 45–57. doi: 10.1007/s10551-013-1621-6.

Janssen, Catherine, Joëlle Vanhamme, and Sina Leblanc (2017). "Should Luxury Brands Say it out Loud? Brand Conspicuousness and Consumer Perceptions of Responsible Luxury." *Journal of Business Research* 77: 167–174. doi: 10.1016/j.jbusres.2016.12.009.

Jelinek, Julia-Sophie (2018). "Art as Strategic Branding Tool for Luxury Fashion Brands." *Journal of Product & Brand Management* 27, no. 3: 294–307.

Joy, Annamma, Kathryn La Tour, Steven Charters, Bianca Grohmann, and Camilo Peña (2021). "The Artification of Wine: Lessons from the Fines Wines of Bordeaux and Burgundy." *Arts and the Market* 11, no. 1: 24–39. doi: 10.1108/AAM-11-2020-0048.

Joy, Annamma, John F. Sherry, Jr., Alladi Venkatesh, Jeff Wang, and Ricky Chan (2012). "Fast Fashion, Sustainability, and the Ethical Appeal of Luxury Brands." *Fashion Theory* 16, no. 3: 273–295.

Joy, Annamma, Jeff Jianfeng Wang, Tsang-Sing Chan, John F Sherry Jr, and Geng Cui (2014). "M(Art) Worlds: Consumer Perceptions of How Luxury Brand Stores Become Art Institutions." *Journal of Retailing* 90, no. 3: 347–364.

Kapferer, Jean-Noël (2014). "The Artification of Luxury: From Artisans to Artists." *Business Horizons* 57: 371–380. doi:10.1016/j.bushor.2013.12.007.

Kapferer, Jean-Noël and Vincent Bastien (2012). *The Luxury Strategy: Break the Rules of Marketing to Build Luxury Brands*. London: Kogan Page Publishers.

Kapferer, Jean-Noël and Anne Michaut-Denizeau (2014). "Is Luxury Compatible with Sustainability? Luxury Consumers' Viewpoint." *Journal of Brand Management* 21, no. 1: 1–22. doi: 10.1057/bm.2013.19.

Kim, Angella J., and Eunju Ko (2012). "Do Social Media Marketing Activities Enhance Customer Equity? An Empirical Study of Luxury Fashion Brands." *Journal of Business Research* 65, no. 10: 1480–1486.

Kim, Kyulim, Eunju Ko, and Yang-Im Lee (2012). "Art Infusion in Fashion Products: The Influence of Visual Art on Product Evaluation and Purchase Intention of Consumers." *Journal of Global Fashion Marketing* 3, no. 4:180–186.

Kim, Pielah, Xiaoyang Deng, and Rao Unnava (2020). "In the Eye of the Beholder: Cross-Pollination Between Art-Infused Products and Retail Spaces." *Journal of Business Research* 117: 302–311.

Kim, Songmi, and Heejung Lee (2020). "The Effect of CSR Fit and CSR Authenticity on Brand Attitude." *Sustainability* 12, no. 275: 1–20. doi: 10.3390/su12010275.

Klein, Jill, and Niraj Dawar (2004). "Corporate Social Responsibility and Consumers' Attributions and Brand Evaluations in a Product-Harm Crisis." *International Journal of Research in Marketing* 21, no. 3: 203–217.

Kong, Hyun Min, Alexander Witmeier, and Eunju Ko (2020). "Sustainability and Social Media Communication: How Consumers Respond to Marketing Efforts of Luxury and Non-Luxury Fashion Brands." *Journal of Business Research*: online first. doi: 10.1016/j.jbusres.2020.08.021.

Korschun, Daniel, C.B. Bhattacharya, and Scott D. Swain (2014). "Corporate Social Responsibility, Customer Orientation, and the Job Performance of Frontline Employees." *Journal of Marketing* 78, no. 3: 20–37. doi: 10.1509/jm.11.0245.

Koschate-Fischer, Nicole, Isabel V. Stefan, and Wayne D. Hoyer (2012). "Willingness to Pay for Cause-related Marketing: The Impact of Donation Amount and Moderating Effects." *Journal of Marketing Research* 49, no. 4: 910–927.

Kotler, Philip, and Nancy Lee (2005). *Corporate Social Responsibility: Doing the Most Good for Your Company and Your Cause.* Hoboken, NJ: John Wiley & Sons.

Kwak, Dae Hee, and Youngbum Kwon (2016). "Can an Organization's Philanthropic Donations Encourage Consumers to Give? The Roles of Gratitude and Boundary Conditions." *Journal of Consumer Behaviour* 15, no. 4: 348–358.

Laube, James (2005). "Two Days That Changed Napa Valley." *Wine Spectator.* https://www.wine spectator.com/articles/two-days-that-changed-napa-valley-2562.

Lee, Eun Mi, Seong-Yeon Park, Molly I. Rapert, and Christopher L. Newman (2012). "Does Perceived Consumer Fit Matter in Corporate Social Responsibility Issues?" *Journal of Business Research* 65, no. 11: 1558–1564.

Lee, Hsiao-Ching, Wei-Wei Chen, and Chih-Wei Wang (2015). "The Role of Visual Art in Enhancing Perceived Prestige of Luxury Brands." *Marketing Letters* 26: 593–606.

Lichtenstein, Donald R., Minette E. Drumwright, and Bridgette M. Braig (2004). "The Effect of Corporate Social Responsibility on Customer Donations to Corporate-Supported Nonprofits." *Journal of Marketing* 68 no. 4: 16–32.

Lindgreen, Adam, Michael Antioco, David Harness, and Remi van der Sloot (2008). "Purchasing and Marketing of Environmental and Social Sustainability for High Tech Medical Equipment. *Journal of Business Ethics* 85: 4456–462. doi: 0.1007/s10551-008-9740-1.

Logkizidou, Maria, Paul Bottomley, Rob Angell, and Heiner Evanschitzky (2019). "Why Museological Merchandise Displays Enhance Luxury Product Evaluations: An Extended Art Infusion Effect." *Journal of Retailing* 95, no. 1: 67–82.

Luo, Xueming, and Chitrabhanu Bhattacharya (2006). "Corporate Social Responsibility, Customer Satisfaction, and Market Value." *Journal of Marketing* 70, no. 4: 1–18.

Marín Rives, Longinos, Salvador Ruiz de Maya, and Alicia Rubio Bañón (2009). "The Role of Identity Salience in the Effects of Corporate Social Responsibility on Consumer Behavior." *Journal of Business Ethics* 84, no. 1: 65–78.

Masè, Stefania, Elena Cedrola, and Genevieve Cohen-Cheminet (2018). "Is Artification Perceived by Consumers of Luxury Products? Results from an Experiment based on the Application of the Customer-Based Brand Equity Model." *Journal of Global Fashion Marketing* 9, no. 3: 223–236.

Masè, Stefania, Elena Cedrola, Cristina Davino, and Genevieve Cohen-Cheminet (2020). "Multivariate Statistical Analysis of Artification Effect on Customer-Based Brand Equity in Luxury Brands." *International Journal of Art Management* 22, no. 3: 55–66.

Menon, Satya, and Barbara E. Kahn (2003). "Corporate Sponsorships of Philanthropic Activities: When Do They Impact Perception of Sponsor Brand?" *Journal of Consumer Psychology* 13, no. 3: 316–327.

Mercer, Chris (2021). "Screaming Eagle, Harlan, Opus One Feature as Rare Napa Auction Begins." *Decanter.* https://www.decanter.com/wine-news/napa-auction-library-wines-screaming-eagle-harlan-opus-one-452939/.

Mishra, Saurabh, and Sachin B. Modi (2016). "Corporate Social Responsibility and Shareholder Wealth: The Role of Marketing Capability." *Journal of Marketing* 80, no. 1: 26–46.

Mowery, Lauren (2019). "What is Luxury Wine?" *Forbes.* https://www.forbes.com/sites/lmowery/2019/10/22/what-is-luxury-wine/?sh=12370fde3bc3.

Naletelich, Kelly, and Audhesh K. Paswan (2018). "Art Infusion in Retailing: The Effect of Art Genre." *Journal of Business Research* 85: 514–522.

Park, C. Whan, Bernard J. Jaworski, and Deborah J. MacInnis (1986). "Strategic Brand Concept-Image Management." *Journal of Marketing* 50, no. 4: 135–145.

Park, C. Whan, Sandra J. Milberg, and Robert Lawson (1991). "Evaluation of Brand Extensions: The Role of Product Level Similarity and Brand Concept Consistency." *Journal of Consumer Research* 18, no. 2: 185–193.

Park, Ji Kyung, Carlos J. Torelli, Alokparna Basu Monga, and Deborah Roedder John (2019). "Value Instantiation: How to Overcome the Value Conflict in Promoting Luxury Brands with CSR Initiatives." *Psychology & Marketing* 30: 307–319. doi: 10.1007/s11002-019-09498-4.

Peloza, John, and Jingzhi Shang (2011). "How Can Corporate Social Responsibility Activities Create Value for Stakeholders? A Systematic Review." *Journal of the Academy of Marketing Science* 39, no. 1: 117–135.

Passebois-Ducros, Juliette, Jean-François Trinquecoste, and Frédéric Pichon (2015). "Stratégies d'Artification: Le Cas des Vins de Prestige." *Décisions Marketing* 80, October-December: 109–124.

Phillips, Rod (2018). "Auction Napa Valley – A Lot More Than Bidding On Wine." *Nuvo Magazine.* https://nuvomagazine.com/palate/auction-napa-valley.

Pracejus, John, and G. Douglas Olsen (2004). "The Role of Brand/Cause Fit in the Effectiveness of Cause-Related Marketing Campaigns." *Journal of Business Research* 57, no. 6: 635–640.

Radley-McConnell, Melissa (2014). "Opus One's Second Wine – Overture." *Time to Un-wine-d.* http://timetounwine-d.com/opus-ones-second-wine-overture/.

Robillard, Hunter (2020). "The Ultimate Guide to Wine Auctions." *Vinovest.* https://www.vinovest.co/blog/wine-auctions.

Robinson, Jancis (2016). "That Paris Judgment 40 Years On." *JancisRobison.com.* https://www.jancisrobinson.com/articles/that-paris-judgment-40-years-on.

Saeidi, Sayedeh Parastoo, Saudah Sofian, Parvaneh Saeidi, Sayyedeh Parisa Saeidi, and Seyyed Alireza Saaeidi (2015). "How Does Corporate Social Responsibility Contribute to Firm Financial Performance? The Mediating Role of Competitive Advantage, Reputation, and Customer Satisfaction." *Journal of Business Research* 68, no. 2: 341–350. doi: 10.1016/j.jbusres.2014.06.024.

Saito, Yurikio (2012). "Everyday Aesthetics and Artification." *Contemporary Aesthetics* 0, no. 4: article 5. https://quod.lib.umich.edu/c/ca/7523862.spec.405/-everyday-aesthetics-and-artification?rgn=main;view=fulltext

Sen, Sankar, and C.B. Bhattacharya (2001). "Does Doing Good Always Lead to Doing Better? Consumer Reactions to Corporate Social Responsibility." *Journal of Marketing Research* 38, no. 2: 225–243.

Sen, Sankar, Bhattacharya, C.B., and Daniel Korschun (2006). "The Role of Corporate Social Responsibility in Strengthening Multiple Stakeholder Relationships: A Field Experiment." *Journal of the Academy of Marketing Science* 34, no. 2: 158–166.

Septianto, Felix, Yuri Seo, and Amy Christine Errmann (2021). "Distinct Effects of Pride and Gratitude Appeals on Sustainable Luxury Brands." *Journal of Business Ethics* 169: 211–224. doi: 10.1007/s10551-020-04484-7.

Shapiro, Roberta (2019). "Artification as Process." *Cultural Sociology* 13, no. 3: 265–275.

Shapiro, Roberta, and Nathalie Heinich (2012). "When is Artification?" *Contemporary Aesthetics* 0, no. 4: article 9. https://digitalcommons.risd.edu/liberalarts_contempaesthetics/vol0/iss4/9.

Sipilä, Jenni, Sascha Alavi, Laura Marie Edinger-Schons, Sabrina Dörfer, and Christian Schmitz (2021). "Corporate Social Responsibility in Luxury Contexts: Potential Pitfalls and How to Overcome Them." *Journal of the Academy of Marketing Science* 49: 280–303. doi: 10.1007/s11747-020-00755-x.

Silverstein, Michael J., and Neil Fiske (2003). "Luxury for the Masses." *Harvard Business Review* 81, no. 4: 48–57.

Simmons, Carolyn J., and Karen L. Becker-Olsen (2006). "Achieving Marketing Objectives through Social Sponsorships." *Journal of Marketing* 70, no. 4: 154–169.

Singh, Jatinder J., Oriol Iglesias, and Joan Manel Batista-Foguet (2012). "Does Having an Ethical Brand Matter? The Influence of Consumer Perceived Ethicality on Trust, Affect and Loyalty." *Journal of Business Ethics* 111, no. 4: 541–549.

Slater, Jeff (2013). "Details." *The Marketing Sage.* http://www.themarketingsage.com/details/.

Smith, Elizabeth (2015). "Opus One Winery Review." *American Winery Guide.* http://www.americanwineryguide.com/winery_reviews/opus-one-winery/906/.

Steinmetz, Katy (2016). "How America Kicked France in the Pants and Changed the World of Wine Forever." *Time.* https://time.com/4342433/judgment-of-paris-time-magazine-anniversary/.

Sun, Jennifer J., Silvia Bellezza, and Neeru Paharia (2021). "Buy Less, Buy Luxury: Understanding and Overcoming Product Durability Neglect for Sustainable Consumption." *Journal of Marketing* 85, no. 3: 28–43. doi: 10.1177/0022242921993172.

Taber, George M (2005). *Judgment of Paris.* New York: Scribner.

Tomasi, Gabriele (2012). "On Wines as Works of Art." *Revisita di Esthetica* 51: 155–174. https://doi.org/10.4000/estetica.1406.

Torelli, Carlos J., Alokparna Basu Monga, and Andrew M. Kaikati (2012). "Doing Poorly by Doing Good: Social Responsibility and Brand Concepts." *Journal of Consumer Research* 38, no. 1: 948–963. doi: 10.1086/660851.

Tsarenko, Yelena, and Dewi Tojib (2015). "Consumers' Forgiveness after Brand Transgression: The Effect of the Firm's Corporate Social Responsibility and Response." *Journal of Marketing Management* 31, no. 17–18:1851–1877.

van Leeuwen, Cornelius, Philippe Friant, Xavier Choné, Olivier Tregoat, Stephanos Koundouras, and Denis Dubourdieu (2004). "Influence of Climate, Soil, and Cultivar on Terroir." *American Journal of Enology and Viticulture* 55, no. 3: 207–217.

Vanhamme, Joëlle, and Bas Grobben (2009). "'Too Good to be True!' The Effectiveness of CSR History in Countering Negative Publicity." *Journal of Business Ethics* 85, no. S2: 273–283. doi: 10.1007/s10551-008-9731-2.

Vicard, Pauline (2021). "Define Fine Wine: An Open Collective Project." https://areni.global/research/ (accessed 3/25/2021).

Vickers, Marques (2021). *So You Think You Know Pacific Coast Wines? An Insider's Guide to West Coast Winemaking.* Herron Island, WA: Marquis Publishing.

Vilasanti da Luz, Victoria, Danielle Mantovani, and Marcelo Vinhal Nepomuceno (2020). "Matching Green Messages with Brand Positioning to Improve Brand Evaluation." *Journal of Business Research* 119: 25–40.

von Bonsdorff, Pauline (2012). "Pending on Art." *Contemporary Aesthetics* 0, no. 4: article 7. https://digitalcommons.risd.edu/liberalarts_contempaesthetics/vol0/iss4/7.

Voyeur, Benjamin G., and Daisy Beckham (2014). "Can Sustainability be Luxurious? A Multi-Method Investigation of Implicit and Explicit Attitudes Towards Sustainable Luxury Consumption," in

Advances in Consumer Research, edited by June Cotte and Stacy Wood, 245–250. Duluth: Association for Consumer Research.

Vukadin, Ana, Jean-François Lemoine, and Olivier Badot (2016). "Opportunities and Risks of Combining Shopping Experience and Artistic Elements in the Same Store: A Contribution to the Magical Functions of the Point of Sale." *Journal of Marketing Management* 32, no. 9–10: 944–964. doi: 10.1080/0267257X.2016.1186106.

Vukadin, Ana, Apiradee Wongkitrungrueng, and Nuttapol Assarut (2018). "When Art Meets Mall: Impact on Shopper Responses." *Journal of Product & Brand Management* 27, no. 3: 277–293.

Vukadin, Ana, Jean-François Lemoine, and Olivier Badot (2019). "Store Artification and Retail Performance." *Journal of Marketing Management* 35, no. 7–8: 634–661.

Wagner, Tillmann, Richard J. Lutz, and Barton Weitz (2009). "Corporate Hypocrisy: Overcoming the Threat of Inconsistent Corporate Social Responsibility Perceptions." *Journal of Marketing* 73, no. 6: 77–85.

Yoo, Dongho, and Jieun Lee (2018). "The Effects of Corporate Social Responsibility (CSR) Fit and CSR Consistency on Company Evaluation: The Role of CSR Support." *Sustainability* 10, no. 2956: 1–16. doi: 10.3390/su10082956.

Websites Consulted

https://en.opusonewinery.com/estate/ (accessed 4/26/2021).

https://en.opusonewinery.com/wine/ (accessed 4/16/2021).

https://festivalnapavalley.org/2021-summer-season/patron-dinner-at-opus-one1/ (accessed 5/4/2021).

https://luxurylaunches.com/fashion/hermes-makes-recycling-glamorous-with-its-petit-h-project.php (accessed 5/3/2021).

https://napagreen.org/wp-content/uploads/2021/04/Napa-Green-Frequently-Asked-Questions.pdf (accessed 5/12/2021).

https://napagreen.org/wp-content/uploads/2021/04/Media-Resources.pdf (accessed 5/12/2021).

https://napagreen.org/down-to-earth-month-going-green-energy-incentives-for-ev-chargers/ (accessed 5/12/2021).

https://napavintners.com/ (accessed 4/16/2021).

https://napavintners.com/napa_valley/appellations.asp (accessed 4/16/2021).

https://napavintners.com/napa_valley/community_stewardship.asp (accessed 4/23/2021).

https://oenogroup.com/vineyard/2608-2/ (accessed 4/26/2021).

https://www.finewinesinternational.com/producer/opus-one (accessed 4/15/2021).

https://www.bpdr.com/en/the-history/key-dates (accessed 3/18/2021).

https://www.chateau-mouton-rothschild.com/the-history/portraits/camille-sereys-rothschild (accessed 4/15/2021).

https://www.hermes.com/ca/en/story/245471-daniel-buren/ (accessed 5/3/2021).

https://www.sustainablewinegrowing.org/CCSW-certifiedparticipants.php (accessed 4/26/2021).

https://www.sustainablewinegrowing.org/performance-metrics.php (accessed 4/26/2021).

https://www.ttb.gov/wine/american-viticultural-area-ava (accessed 4/16/2021).

https://www.winegrowerscanada.ca/initiatives/social-responsibility/ (accessed 4/20/2021).

https://www.winegrowerscanada.ca/member-info/sustainable-practices/ (accessed 4/20/2021).

https://www.winesearcher.com/find/opus+one+napa+valley+county+north+coast+california+usa/2020/usa (accessed 4/14/2021).

Donna Senese, Darcen Esau

Chapter 12
Sustainable Transformative Wine Tourism: Applications in Experiential Educational Tourism

Introduction: Challenges for Transformative Sustainability

Wine and wine tourism producers are interwoven in a complex, mutually dependent ecosystem.[1] The industries share a dependence on sustainable social, cultural, and natural environments to advance the *quality turn* of their geographically indicated, place-specific products – wine and tourism experiences. The quality turn marks a shift away from Industrial-Fordist standardization-and-quantity orientation (Murdoch et al. 2000), and increasingly recognizes qualitative differentiation of products as a complex transformation (Parga-Dans and Gonzalez 2017) central to sustainability and tightly tied to sense of place (Fountain et al. 2020). A sustainable future in wine regions requires integrated economic, social, and environmental strategies (UNEP 2005). The process by which change occurs and adaptation takes place is central to the transformation necessary to ensure sustainability. In agricultural areas, identification of vulnerabilities and the adaptive capacities of overlapping industries such as wine production and tourism reveal a need to understand the changing nature of socio-economic resilience as a pathway to sustainability (Brouder 2017).

The complex context of environmental, cultural, and economic change in old world wine regions, such as Chianti in Tuscany, Italy, presents unique challenges. Wine producers promote typical products and traditional methods as markers of excellence to a traveling public eager to taste that typicality and tradition. The confounding question becomes: Can wine tourism that is dependent on tradition and typicality to mark quality adapt to change in ways that ensure transformative sustainability? This chapter presents the vulnerabilities of wine tourism and reviews the literature in transformative sustainable tourism to set the context for a case study of transformative sustainable wine tourism in a small estate in the Chianti wine region in Tuscany, Italy. Transformative sustainability of tourism involves a restructuring in the industry that reduces negative socio-ecological impacts (Fennell and Bowyer 2020) and acts as a catalyst for positive change including personal

1 We gratefully acknowledge receipt of a grant from the University of British Columbia Okanagan, the Go Global International Learning Programs Award, to complete this research.

https://doi.org/10.1515/9783110732757-012

growth, self-awareness, and well-being (Dillette et al. 2018). We present results of autoethnographies of experiential educational tourism along with a series of interviews with wine and wine tourism producers in the region to understand the possibilities of transformative and sustainable change in a traditional wine region.

Wine Region and Wine Tourism Vulnerabilities: Shocks and Stressors

Agroecological risks to wine production quality and the place images associated with that quality represent risks to the production of wine tourism. Many wine regions advance sustainability with varying levels of success (Mariani and Vastola 2015; Baird et al. 2018). The relationship between sustainability, wine production, and tourism has shown that exposure (Hira and Bwenge 2011), double exposure (O'Brien and Leichenko 2000), and multiple exposures to risk (Belliveau et al. 2006) are evident in wine and wine tourism regions. Slow change stressors that are gradual and non-linear (Lew 2014; Calgaro et al. 2014) and sudden shocks such as natural disasters (Cradock-Henry and Fountain 2019) pose risks to wine and tourism industries. For wine and tourism industries dependent on Geographical Indicators as a brand (Overton and Heitger 2008; Overton and Murray 2011), and especially for those that have tightly enforced appellation controls (Jones 2010), even greater vulnerabilities are suggested. For these wine industries, increasing capacities for adaptation in new and innovative ways is essential for sustainability (McIntyre, Senese, and Hull 2019).

Wine region sustainability has yielded considerable research (Jones 2010; Hannah et al. 2013; De Orduna and Mira 2010). Wine tourism is one tool used by the wine industry to diversify, increasing resilience against the vagaries of environmental, economic, and social change (Milich 2012; Carmichael and Senese et al. 2012). However, tourism itself is a vulnerable industry (Ritchie 2008; Becken et al. 2014) and the adaptive capacity of tourism in wine regions is questioned (Cradock-Henry and Fountain 2019; Fountain and Cradock-Henry 2020). For disaster preparation and recovery in tourism, pandemics were addressed in the literature when the Avian Flu and SARS pandemics created a flurry of research activity (Kuo et al. 2008). More than a year into the Covid-19 emergency, tourism scholars questioned the industry's vulnerability and ability to recover (Gossling et al. 2020; Zheng et al. 2020). Paths to sustainable tourism after Covid-19 have been proposed (Chang et al. 2020) as have strategies for recovery and revitalization (Zenker and Kock 2020), however, little specific interest in the vulnerabilities and adaptation potential of wine tourism has emerged with the exception of (Gilinsky 2020, and Wittwer and Anderson 2020). Given what is known about wine region vulnerability and the risks of over reliance on tourism to sustain wine industries, it is imperative to understand transformative sustainable change in the context of unprecedented global emergencies.

Sustainable Wine Tourism and Transformative Experience

Wine tourism appeared in the academic literature in the 1980s and continued to grow, especially in new world wine regions (Gilbert 1992; Dodd 1995). Eventually, attention turned to links between wine tourism and sustainability (Getz and Brown 2006; Carmichael 2005) where research linked wine tourism and sustained competitiveness (Hashimoto and Telfer 2003; Carmichael and Senese 2012). Study of overlapping industries, amenities, and services in wine regions then sought to understand the dynamics of agriculture and tourism services in sustainable ways (Ioannides 1995); and resilience emerged as a conceptual framework with the potential to understand sustainability (Berkes and Ross 2013; Folke 2006). However, there are few examples of the empirical application of resilience to the wine and tourism industries (Mozell and Thach 2014; Duarte Alonso and Bressan 2015). Leading scholars of agriculture (Kleinman et al. 2018) environmental studies (Holling 1973) have made significant contributions to what is now known about resilience and adaptive capacity in rural environments; however, specific sectoral work on wine regions and wine tourism has not as yet fully emerged.

Wine tourism has been shown to educate visitors about many issues, such as food security, food traditions and culture, and health and wellness (Hall and Baird 2014; Hull 2016), yet little attention is paid to the transformative nature of wine tourism. Many forms of tourism are thought to offer transformational potential (Reisinger 2013) for positive change. Not all tourism is seen as inherently transformational (Pritchard and Morgan 2013) and wine tourism in particular has only rarely been discussed as a transmodern tourism niche poised to enrich the idea of hopeful tourism (Senese 2016; Sigala 2020). In instances where reciprocal partnerships for co-learning among hosts and guests are made possible (Pritchard et al. 2011), the potential for transformative change exists. The need for sustainable transformative tourism in food consumption was argued by Fennell and Bowyer (2019) and transformative rural tourism was positioned as a tool for rural development in the midst of the global pandemic (Vidickiene et al. 2020), where the links between transformative tourism and regeneration were also clearly posited (Duxbury et al. 2020). In the context of a post-pandemic world, calls for transformation and regeneration in and through tourism production have been clearly sounded. Here the focus is not on sustaining the industry itself, but on re-imagining tourism as a tool for local well-being, revitalization, and sustainability (Duxbury et al. 2021: p. 4). Where transformative tourism meets the regenerative capacities of agroecological systems, as it does in wine regions, the potentials for moving beyond sustainability toward transformative action are self-evident.

A Case Study of Transformative Sustainable Wine Tourism: The Approach

We present a mixed methods qualitative case study of transformative, sustainable wine tourism from educational tourism experiences at Castello Sonnino International Education Centre in Montespertoli, Tuscany. We synergize autoethnography with student-led deliberative dialogs harvested through focus groups and in-depth interviews with wine and tourism industry experts. The autoethnographies are articulated by the course instructor and students, providing a multi-dimensional experiential dialog that reflects on key concepts of wine industry sustainability featured in the course. Interviews conducted with a variety of wine and tourism industry experts provide insight into sustainable practices and the culture of wine communicated to students as reciprocal transformational change. In-depth qualitative analysis of the data drilled down into the assessment of the sustainable transformations possible along the tourism-to-vineyard and farm-to-market value chain.

Qualitative analysis, and in-depth interviews in particular allow for co-creation of transdisciplinary knowledge, which is particularly important in sustainability research (Mauser et al. 2013). Ten semi-structured interviews were conducted with wine and wine tourism industry experts. Nineteen students who participated in the experiential course, living and working at the Castello Sonnino estate between April 29 and May 20, 2018, participated in focus groups at the end of their trip to reflect on their experiences. The autoethnography of experiential educational tourism by the instructor and students followed an approach outlined by Chang (2016: p. 46) that combines cultural analysis and interpretation with narrative details of experience and stories that are reflected upon, analyzed, and interpreted within a broad sociocultural context. Additionally, a detailed daily journal kept by the co-investigator is referenced that records impressions of repeated topics, emerging themes, and salient patterns (Chang 2016: p. 131).

Castello Sonnino, a History of Place and the Place of History in Wine Tourism Production

The quality of wine is evaluated by its connection to place and the unchanging geographic attributes that reflect *terroir*. In Italy, the demarcation of wine regions is performed through the DOCG system (Denominazione di Origine Controllato e Garantita, or Controlled and Guaranteed Denomination of Origin) that ties quality and authenticity to place. Chianti is a wine produced in Central Italy and a geographic region – home to eight sub-regions of wine. Castello Sonnino, which hosts the case study of this educational tourism experience, is a wine estate located in the smallest and newest Chianti DOCG, Montespertoli, a small municipality located approximately 20 kilometers south of Florence (see Figure 12.1).

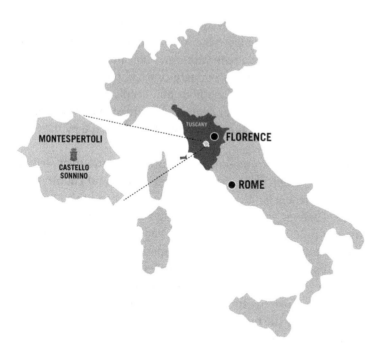

Figure 12.1: Map of Castello Sonnino located within Chianti Montespertoli, DOCG, Italy.

Castello Sonnino is a historic estate and a working farm of 150 hectares producing wine, market produce, grain, and olive oil. The Sonnino family has adopted the idea of a "living history to sustain the future" in development of an international education center on the estate for those committed to preserving the environment, culture, and the historical heritage for future generations (Camerana 2016: p. 5). Using the rich cultural life and landscape of Chianti, shaped by centuries of agrarian life in the Italian *mezzadria* system of sharecropping as a setting, the Sonninos have welcomed wine tourists since the 1990s, and experiential education tourists to the estate since 2013. The iconic Tuscan landscape of the *mezzadria* is composed of large merchant *villas* surrounded by a scattering of sharecropper *case coloniche* (farm houses) amidst mixed crop farming and woodland (Senese et al. 2016). The Sonnino *case coloniche* have been restored and repurposed to provide housing, classroom, and office space for students and professors engaged in experiential educational programs.

When the current owners, Caterina and Alessandro de Renzis Sonnino, took over the property in the mid 1980s, they restored and conserved the 17th century villa, its cellars, and vineyards. As winemaker, Barone Alessandro Sonnino[2] became

2 Barone Sonnino was unfortunately a victim of Covid-19 and passed away March 3, 2021. Together with their children Virginia and Leone, Baronessa Caterina de Renzis Sonnino continues their work to sustain Castello Sonnino.

a key part of the Montespertoli DOCG's renaissance. A classicist wine maker, Barone Sonnino emerged as a fashion-bucking conservator of wine tradition complemented by a modernization of international-style reds with new vineyards planted to Petit Verdot, Merlot, Cabernet, and Malbec. The seemingly contrary production of modernized wines with adherence to traditional methods and deeply held belief in *terroir* (Camuto 2016) produced a landscape that continued to attract a growing legion of wine tourists and supported a conviction to sustain that landscape by the Sonnino family.

At this juncture in the history of rural tourism in Tuscany, overtourism, led by mobs of tourists eager to experience the wine and food of the rural countryside, had threatened to erode the iconic landscape and lifestyle that had driven tourism development for decades (Vallone et al. 2020; Randelli and Martellozzo 2019). Overtourism in rural Tuscany produced multiple and overlapping vulnerabilities for wine producers who had come to rely on tourism to support preservation and maintenance of historic estates and wine production more generally. In this context, the Sonninos hoped to preserve the traditional heritage of the estate and continue to produce quality wines while providing travel experiences with the transformative potential to reconnect people with the natural environment as a core objective (Robinson 2021). The Sonnino family developed the idea of the international education center to diversify wine tourism and build resilience that supports wine production with sustainable transformative visitation.

Educational Tourism

In Italy, the interplay between wine tourism and transformational educational travel has its roots in the eco-gastronomic movement to focus on fresh, local, fair food and drink (Petrini 2003; Conway and Timms 2010; Miele 2008) from landscapes that are healthy, environmentally sound, and sustainable (Saxena et al. 2007). A similar discourse emerged from tourism communities where demand for experiential forms of travel drove farmers and wine makers outside of their primary industries into the world of hospitality, tourism, and education (Knowd 2006; Sonnino 2004). The synergy of these merging forces resulted in growing demand for transformative educational experiences in regions of wine and food production. Transformative tourism has its roots in Mezirow's (1991) theory of transformative learning thought to answer an intrinsic need to learn and consume in a manner that is fulfilling and highly personalized (Soulard et al. 2021). Wine is so profoundly rooted in its historical, cultural, and environmental origins that the educational opportunities for transformation toward conscientious consumption abound in a transdisciplinary manner.

Like other Canadian universities, the University of British Columbia in the Okanagan (UBCO) encourages students to engage with communities – locally and globally. While university mission statements contain a wealth of good intentions regarding community-based learning, global citizenship, and internationalization, less attention is paid to ensuring these experiences are transformative for the student and the host community. Our autoethnographic reflections are derived from experiences as a UBCO instructor of five international field courses and a student participant on Rural Sustainability: Wine, Food and Tourism in Tuscany held at Castello Sonnino. The learning objectives of the course include student reflection on the lived meaning of sustainability in the overlapping industries of wine and tourism and the methods and means of resilience to vulnerabilities in wine and wine tourism regions.

Results

Results of our qualitative analysis reveal three interwoven themes that demonstrate transformative and sustainable wine tourism and provide a framework for further discussion. The first theme to emerge is the central importance of the local wine and food supply chain. The second emergent theme is the important blend of traditional production methods with a process of modernization. And the final theme reveals the unique and important way that the local supply chains and the traditional and modernizing modes of production are embedded in the experience of the winescape as a public good creating a shared ecological vision.

Transformation Through Supply Chain Sustainability

Short and local supply chains help wineries become more sustainable while creating a transformational, unique experience for tourists. The Slow Food Presidia steered the wine tourism industry in Tuscany toward specialized agricultural products to meet tourist demand for rural experiences that are local and rooted in a traditional lifestyle (Senese et al. 2016). While globalization pushed many wine producers to a 'downscale strategy' of homogenized low-cost mass production, the opportunity for 'upscale strategies' that focus on exclusive experiences through locally-identified production (Overton and Murray 2011) is an important theme discussed by wine professionals in the study, many of whom noted the historical and cultural importance of short and local supply chains to the wine making and tourism experience and the influence of Robert Parker's point system in standardizing wine.

> Because that's what they [customers] know when you're talking about "points." And really the standardization of wine . . . a lot of the wine you could buy from the US or Canada they're trying to make it all taste the same. Industry Interview

> American demand impacts wine style-wise, that means very big picture, big structure, intensive colors, so very powerful wine. My taste, what I like is more elegance not more power, so you know we never went very well together with Mr. Parker They drink points instead of drinking wine. Industry Interview

In Tuscany, changing market demand resulted in an upscale strategy of importing oak barrels to meet global demand for mass-produced, standardized wines, to develop export markets. Consumer expectations meant importing more oak barrels and changing production methods to make a more French style of wine, often reluctantly.

> Barrels were only added to compete with French culture. Chianti does not use Oak, which is French. Industry Interview

> They've only been using French oak barrels since the 90s, as soon as you put Sangiovese in a French oak barrel, does that take away from the terroir? Industry Interview

> Oak barrels standardize taste . . . quality wine must be a true expression of the terroir.
> Industry Interview

Conversely, localized downscale strategies like using local chestnut to create wine barrels for the regional dessert wine, Vin Santo, results in a local, exclusive, and unique product for tourists to experience. Vin Santo is made from non-varietal grapes left to dry on racks before being pressed and placed in small barrels to age with a nice golden-brown color created by the local wood (Domizio and Lencioni 2011).

> Oak was not used until the 1990s. Chestnut – a local wood – was used for aging Vinsanto.
> Industry Interview

> . . . a way to express the terroir properly . . . (if) they found a way of aging wine in a barrel that was made from local materials they found . . . so when you try a wine from there, you can't get that taste anywhere else on Earth. Student Focus Group

Short, local supply chains are established through a circular economy for products like table wine sold in bulk at local stores called "Vino Sfuso," where regular local consumers bring their own containers to fill up on tap. The common vessel used to fill up wine at a Vino Sfuso is the uniquely bulbous shaped, and straw covered Chianti Fiasco that became synonymous with Tuscan wine. Most Tuscan producers had abandoned the Fiasco by the 1970s due to its association with low quality wine (Anderson 2019). Students in this study commonly purchased a Chianti Fiasco as a souvenir and used them to fill up wine at the local Vino Sfuso.

Supply chain sustainability occurs in many ways, including by the introduction of new production methods, for new markets (Bianchi 2011). It can also occur by going back to traditional supply chains, for instance using local (Chestnut) wood

for aging barrels, creating unique, local bottles (Chianti Fiasco), and enabling consumers to bring their own bottle to a Vino Sfuso to establish a relationship and familiarity with local producers. These types of changes can have long-term sustainable benefits for the wine destination, supporting the economic and the socio-cultural and environmental elements of that region (Sigala 2020). Transformational change developed through the supply side of a wine region (Senese 2016) and the symbiotic relationship between the destination and the tourist can be transformational for the tourist (Ateljevic 2020). The educational experiences allowed observation of the circular economy, and industry interviews demonstrate that by moving to a more sustainable local supply chain, there is an opportunity to develop transformational wine tourism through unique, memorable experiences.

Sustainable Production: Modes of Tradition and Modernization

The idea of sustainability in wine landscapes incorporates a dichotomous respect for heritage, traditional methods, and knowledge, while incorporating modernization and technology to meet consumer demand. Students in this case study gained a clear understanding of the importance of place in the production process (*terroir*) and, hence, the importance of sustainable best practices to produce quality wine and food products and protect local environments. Students learned the scientific process of making wine, and they also learned to appreciate the art and artistic expression of those processes. In this way, they became "cultural creatives," tourists that travel to find connection, seek meaningful experiences to develop personally and collectively (Ateljevic et al. 2016). To achieve transformational experiences, cultural creatives value what is slow, small, and local – especially food (Ateljevic 2020) and, in this case, wine.

Mechanization and technological advances in agriculture have accelerated landscape change in Tuscany since the 1950s (Randelli et al. 2014). The reintroduction of traditional farming systems with modern techniques in Tuscany, represents a sustainable example of human integration with nature (Gobattoni et al. 2015). With this "old meets new" approach to maintaining and respecting the traditional art of winemaking, wineries incorporate modernization and technology to ensure their operations remain sustainable while also enhancing the experience for the tourist.

Wine appreciation is enhanced by understanding the science and the art that goes into making a bottle of wine. Student experience in Tuscany revealed the notion that many winemakers view themselves as artisans:

> I liked how he makes wine to get an artistic expression of who he is. He's like "you're drinking my emotion" is a pretty cool line [said by the winemaker]. But to do that he mixes terroirs based on all the different qualities to make one best possible wine. Student Focus Group

I think one of the most important things for me was just learning what goes behind a bottle of wine because . . . when you learn the history behind that you learn to like the way it's changed, the socio-economics behind it, and the culture and the production and everything that goes into one single glass. I think it gives a lot more appreciation for what you're drinking. Student Focus Group

I mean I don't have any idea how to identify the flavors that I'm tasting. So, he just wanted us to experience it, you know, like I think that was really important too. Student Focus Group

Students also noted that among winemakers, sustainability of wine means respecting tradition and heritage, while also incorporating modernization and technology.

When I think of traditional knowledge . . . they [Tuscan Wineries] really take that and apply it to modern ways of winemaking, but they still try to maintain the integrity of the traditional knowledge as well. Student Focus Group

While visiting historic winery Castello di Fonterutoli, students observed the winery's balance between new technologies and traditional methods. For instance, they witnessed an ultra-fast technology that fills and labels a bottle of wine in exactly one second, enabling shipment to overseas markets on the same day as they receive the order.

We use "Just In Time" bottling so we don't have the expense of inventory. Industry Interview

The mix of tradition with the mix of Technology Fast bottling but also using gravity systems . . . using limestone in the ground, finding natural springs, and using the natural environment to their advantage. I felt like that was very very interesting. Student Focus Group

I found their methods really interesting because they kept very traditional methods and modernized the technology around it . . . like the super-fast bottling and having this system that can move the grape chute around but at the same time using ultra-traditional methods like gravity to crush their grapes. Student Focus Group

To balance the modern downscale production, Castello di Fonterutoli implements "upscale" strategies that utilize traditional methods to focus on the specificities of place and locally identified production (Overton and Murray 2011). The cellars are built into the landscape so that the natural limestone and underground spring water can help regulate the air and keep the cellar at a proper temperature. The implementation of more sustainable modes of production enable producers to promote these traditional production methods as a marker of excellence to wine tourists seeking a taste of that tradition.

We regulate the cellar naturally with natural water. Industry Interview

That's very interesting how they're using limestone to cool down the water. They are using the underground spring to naturally cool down the cellar I like how they're using the environment around them and like whatever they found in the ground was a big advantage.
 Student Focus Group

In the vineyard, many wineries use plots of land to experiment with traditional methods to make their process more sustainable. Students visited organic winery Tenuta di Valgiano, where they use traditional biodynamic farming practices to grow different varietals within the same plot and blend them to produce a wine that expresses a unique terroir. Castello Sonnino has also planted biodynamic plots to understand how this practice can be implemented on a larger scale. The biodynamic methods were described to visitors as traditional farming practices used to create a sustainable natural ecosystem within the vineyard that sequesters carbon in the soil, creating an active soil thriving with microorganisms. This reintroduction and modification of traditional farming systems blends with modern techniques to create a sustainable interaction between farmer and nature:

> We want to maintain traditional methods through modern technology. Grow natural grains with the vines. Maintain organic even as we grow.
> <div align="right">Industry Interview</div>

> They hand-picked everything and hand-separated the grape clusters. I think it was a very sustainable way to modernize by maintaining tradition but not becoming stagnant.
> <div align="right">Student Focus Group</div>

> The production method and the interesting techniques that are unique are the things that stood with me . . . like biodynamic farming and winemaking . . . hearing his whole explanation in the old ideology behind that definitely made that story stick with me . . . how to produce the wine and the unique techniques they use, the unique things that they do that make it really real.
> <div align="right">Student Focus Groups</div>

Wine tourism can educate visitors on the importance of traditional methods while simultaneously enabling the discovery and experience of these processes that have transformative potential. Incorporating modern technology, innovation, and methods is essential for sustainability; however, maintaining the traditional art of winemaking can enhance the experience for the tourist, especially the 'cultural creatives' looking for meaningful experiences.

The Winescape as a Public Good for Transformational Wine Tourism

The iconic image of Tuscany is that of varied, natural and cultivated landscapes, hillsides with villas perched atop, and small villages surrounded by olive trees and vineyards (Senese, Randelli, and Hull 2016). The experience of a wine region's natural surroundings plays an important role in the wine tourism experience and the fulfillment and emotional attachment that visitors develop for a region (Charters et al. 2009). Protecting the natural and cultural landscape is an essential component of the wine industry throughout Tuscany (Bianchi 2011) as there is an expectation from visitors of what the landscape, or "winescape" will look like (Carmichael

and Senese 2012). In Tuscany, the landscape is viewed as a commodity, a source of identity, and a public good – so much so that it has been declared a UNESCO World Heritage Site and has been instituted with very specific laws around new development, renovation, and land use (Randelli and Martellozzo 2018). Students commented on the landscape and wine as a shared public good in Tuscany:

> There's no [acting independently] for my brand . . . it's less about that and I think more about the story behind it. I guess it is more about the cooperation. I think it's really cool if one winery is doing something not to make their wine better than everyone else, but they do it because there is a social responsibility between one another. Student Focus Group

> For Tuscany . . . the whole landscape is a common good. I thought that was really interesting . . . because people who pass by see this landscape as something everyone can see if they pass by, and so it shouldn't be up to an individual house . . . even though someone lives there, people who pass by to see this house in that landscape and if he has some modern house, it changes the whole landscape and it seems selfish. Student Focus Group

The winescape is the single most important attribute influencing satisfaction when touring a wine region (Carmichael and Senese 2012), making it essential to preserve and protect this resource. This visual sense of place provides value for both those living in the region as well as those visiting, so it is important to ensure new development contributes and fits into the landscape (Di Gregorio 2017). Recognizing and protecting a unique landscape is also important because it can tie the brands of the region together (Flint and Golicic 2009), the way Tuscan wineries have an association with their landscape. Ecological vision is the way consumers associate specific images with a region (Gobattoni et al. 2015). Preserving this ecological vision of the winescape is paramount to the discovery, consumption, and experience of wine that holds transformative potential (Senese 2016). The association of the physical landscape to the wine itself was expressed in one interview:

> Wine is landscape in a bottle. It is the only food product you can package that transcends time and space. Industry Interview

Discussion and Limitations

Moving Forward: A Conceptual Framework for Transformative Sustainability in Wine Tourism

Results of our qualitative analysis reveal three interwoven themes that demonstrate transformative and sustainable wine tourism and provide a framework for further discussion (see Figure 12.2). In this case study and elsewhere, the visual sense of place (di Gregorio 2017) created by a winescape is the single most important attribute influencing visitors in wine regions (Carmichael and Senese 2012). Viewing the

Conceptual Framework of Transformative Sustainable Wine Tourism Experiences Formed and Shaped Out of the Winescape

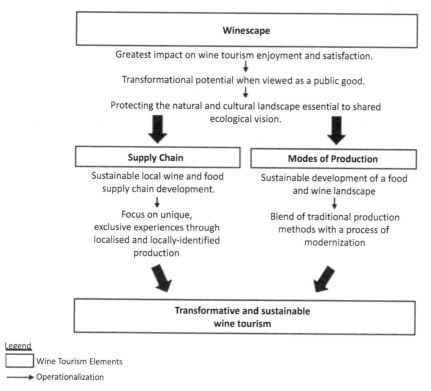

Figure 12.2: Conceptual framework of transformative sustainable wine tourism experiences formed and shaped out of the winescape.

winescape as a public good can protect the shared socio-ecological vision (Gobattoni et al. 2015) required to harness transformational sustainability in wine regions. The development of circular local supply chains also enable wine regions to progress exclusive visitor experiences through localized and geographically-identified production (Overton and Murray 2011). In our cases study, these unique and memorable educational experiences are rooted in a traditional lifestyle embedded in the winescape (Senese et al. 2016) to create transformational change for visitors and the host community. Sustained transformational change in food and wine landscapes, therefore, remains dependent on the interplay of anthropic and natural components (Valentin and Spangenberg 2000). The blend of traditional production methods with modernizing processes enhance visitor experience by presenting the visitor with the opportunity to discover and experience processes that have transformative potential for the wine industry itself. The goal of this research was to understand whether wine tourism can adapt to change in ways that ensure transformative sustainability.

The results have produced three interwoven themes that provide a theoretical framework for how transformative sustainable wine tourism experiences are formed and can be shaped out of the winescape.

Limitations and Future Research

During the course of this research, two areas have emerged as limitations to the scope of our project that could be explored further. First, the focal point for this research was Castello Sonnino, a historic estate in a traditional Chianti wine appellation area in Central Italy. Old world wine regions like Chianti are characterized by long-established and artisanal types of wine production methods (Banks and Overton 2010) that provide the opportunity to emphasize the traditional art of winemaking as a unique experience to visitors. While this research has demonstrated the transformational potential of maintaining the traditional art of winemaking, it is unknown how this experience would be achieved in a new world wine region, which lacks the same tradition and heritage (Elliot and Barth 2014). Future research may want to conduct a comparative analysis within a new world wine region using the same parameters.

Second, this research explored how cultural creatives seek meaningful experiences that can be developed both personally and collectively. The research demonstrated that university students visiting a wine region as educational tourists experience transformational change. However, further research could explore in more detail the personalized impact of this transformational change on individuals through longitudinal analysis among student visitors. Additionally, comparative analysis could be done with different segments of wine tourists, including different age groups and those traveling for non-educational purposes.

Discussion

Wine is among the most salient and defining markers of evolving landscapes, evolving economies and cultures, and is a cornerstone of tourism in Chianti. Using the Chianti case study, we have provided a framework for sustainable and transformative wine tourism showing that the foundational power of a shared, protected cultural and ecological landscape can support changing modes of production and supply chains. The human activities that produce wine mark the important interface between ecology, culture, and human systems, where human agency exists in a constant tension to adapt cultural practices of production and consumption to dynamic ecological and economic systems. Tourism emerges at Castello Sonnino, as it may elsewhere, as a synthesizing force that broadens understanding of the cultural identity, and ecological and economic circumstances of places that produces wine.

Adaptation to changing environments and economies have evolved over millennia among communities of wine and emerges uniquely, in place, and of place by using local traditional knowledge as a non-replicable cultural asset to build unique regional identities. Our results indicate that there is much to be learned about transformative sustainable landscapes, cultures, and economies by traveling to unique communities of the world where wine production is paramount in cultural practice. There is also much to be enjoyed through the consumption of products typical of the cultural experience of wine production. This illuminates wine tourism as a synergy of education, experience, pleasure, and local community that provides for its transformative potential.

Transformative tourism starts with understanding what is important to local communities, and industry, and then seeks to balance these values to make long-term sustainable futures. The iconic Tuscan landscape with its long-shuttered merchant *villas* surrounded by farm houses amidst mixed crop farming and woodland (Senese et al. 2016) produces a "differentiated countryside" of unique production and consumption spaces (Perkins, Mackay, and Espiner 2015). New economic activities have been incorporated into the winescape to commodify these amenities; however, this requires the protection and conservation of cultural and natural landscapes (Holmes 2012) to ensure the ecological vision is maintained. Wine tourism experiences are formed and shaped out of the winescape, and this case study demonstrated its transformational potential when viewed as a shared public good.

References

Anderson, Burton (2019). "Fate Is a Fiasco." *Jancis Robinson*. https://www.jancisrobinson.com/articles/fate-fiasco.

Ateljevic, Irena (2020). "Transforming the (Tourism) World for Good and (Re)generating the Potential 'New Normal'." *Tourism Geographies* 22, no. 3: 467–475.

Ateljević, Irena, Pauline Sheldon, and Renata Tomljenović (2016). "The New Paradigm of the 21st Century, 'Silent Revolution' of Cultural Creatives and Transformative Tourism of and for the Future." *Global Report on the Transformative Power of Tourism a Paradigm Shift Towards a More Responsible Traveller*: 12–20.

Baird, Tim, C. Michael Hall, and Pavel Castka (2018). "New Zealand Winegrowers Attitudes and Behaviours Towards Wine Tourism and Sustainable Winegrowing." *Sustainability* 10, no. 3: 797.

Banks, Glenn, and John Overton (2010). "Old World, New World, Third World? Reconceptualising the Worlds of Wine." *Journal of Wine Research* 21, no. 1: 57–75.

Becken, Susanne, Roché Mahon, Hamish G. Rennie, and Aishath Shakeela (2014). "The Tourism Disaster Vulnerability Framework: An Application to Tourism in Small Island Destinations." *Natural Hazards* 71, no. 1: 955–972.

Belliveau, Suzanne, Barry Smit, and Ben Bradshaw (2006). "Multiple Exposures and Dynamic Vulnerability: Evidence from the Grape Industry in the Okanagan Valley, Canada." *Global Environmental Change* 16, no. 4: 364–378.

Berkes, Fikret, and Helen Ross (2013). "Community Resilience: Toward an Integrated Approach." *Society & Natural Resources* 26, no. 1: 5–20.

Bianchi, Rossella (2011). "From Agricultural to Rural: Agritourism as a Productive Option." In *Food, Agriculture and Tourism*, 56–71. Berlin, Heidelberg: Springer.

Blair, Amanda J., Christina Atanasova, Leyland Pitt, Anthony Chan, and Åsa Wallstrom (2017). "Assessing Brand Equity in the Luxury Wine Market by Exploiting Tastemaker Scores." *Journal of Product & Brand Management*.

Brouder, Patrick (2017). "Evolutionary Economic Geography: Reflections from a Sustainable Tourism Perspective." *Tourism Geographies* 19, no. 3: 438–447.

Calgaro, Emma, Kate Lloyd, and Dale Dominey-Howes (2014). "From Vulnerability to Transformation: A Framework for Assessing the Vulnerability and Resilience of Tourism Destinations." *Journal of Sustainable Tourism* 22, no. 3: 341–360.

Camerana, B (2011). "Castello Sonnino 'Living History to Sustain the Future'." *A Plan for Academic Development*. Montespertoli, Italy.

Camuto, R. (2021). "The Passing of a Tuscan Gentleman." *Wine Spectator*.

Carmichael, Barbara (2005). "Understanding the Wine Tourism Experience for Winery Visitors in the Niagara Region, Ontario, Canada." *Tourism Geographies* 7, no. 2: 185–204.

Carmichael, Barbara A., and Donna M. Senese (2012). "Competitiveness and Sustainability in Wine Tourism Regions: The Application of a Stage Model of Destination Development to Two Canadian Wine Regions," in *The Geography of Wine*, 159–178. Dordrecht: Springer.

Chang, Chia-Lin, Michael McAleer, and Wing-Keung Wong (2020). "Risk and Financial Management of COVID-19," in *Business, Economics and Finance*: 102.

Chang, Heewon (2016). *Autoethnography as method*. Vol. 1. New York: Routledge.

Charters, Steve, Joanna Fountain, and Nicola Fish (2009). ""You Felt like Lingering . . ." Experiencing "Real" Service at the Winery Tasting Room." *Journal of Travel Research* 48, no. 1: 122–134.

Conway, Dennis, and Benjamin F. Timms (2010). "Re-branding Alternative Tourism in the Caribbean: The Case for 'Slow Tourism'." *Tourism and Hospitality Research* 10, no. 4: 329–344.

Cradock-Henry, Nicholas A., and Joanna Fountain (2019). "Characterising Resilience in the Wine Industry: Insights and Evidence from Marlborough, New Zealand." *Environmental Science & Policy* 94: 182–190.

Di Gregorio, Dante (2017). "Place-based Business Models for Resilient Local Economies." *Journal of Enterprising Communities: People and Places in the Global Economy* 11, no. 1: 113–128.

Dillette, Alana K., A.C. Douglas, and C. Andrzejewski (2018). "Yoga Tourism – a Catalyst for Transformation?" *Annals of Leisure Research* 22, no. 1: 22–41.

De Orduna, Ramon Mira (2010). "Climate Change Associated Effects on Grape and Wine Quality and Production." *Food Research International* 43, no. 7: 1844–1855.

Dodd, Tim H. (1995). "Opportunities and Pitfalls of Tourism in a Developing Wine Industry." *International Journal of Wine Marketing* 7, no. 1: 5–16.

Domizio, Paola, and Livio Lencioni (2011). "Vin Santo." *Advances in Food and Nutrition Research* 63: 41–100.

Duarte Alonso, Abel, and Alessandro Bressan (2015). "Resilience in the Context of Italian Micro and Small Wineries: An Empirical Study." *International Journal of Wine Business Research* 27, no. 1: 40–60. https://doi.org/10.1108/IJWBR-08-2014-0035.

Duxbury, Nancy, Fiona Eva Bakas, Tiago Vinagre de Castro, and Sílvia Silva (2021). "Creative Tourism Development Models towards Sustainable and Regenerative Tourism." *Sustainability* 13, no. 1: 2.

Elliot, S., and J.E. Barth (2014). "Crafting Brand Stories for New World Wine," in *Wine and Identity: Branding, Heritage, Terroir*, M. Harvey, L. White, and W. Frost, eds., 89–100. New York: Routledge.

Espiner, Stephen, Caroline Orchiston, and James Higham (2017). "Resilience and Sustainability: A Complementary Relationship? Towards a Practical Conceptual Model for the Sustainability–Resilience Nexus in Tourism." *Journal of Sustainable Tourism* 25, no. 10: 1385–1400.

Fennell, David A., and Emily Bowyer (2020). "Tourism and Sustainable Transformation: A Discussion and Application to Tourism Food Consumption." *Tourism Recreation Research* 45, no. 1: 119–131.

Flint, Daniel J., and Susan L. Golicic (2009). "Searching for Competitive Advantage through Sustainability: A Qualitative Study in the New Zealand Wine Industry." *International Journal of Physical Distribution & Logistics Management* 39, no. 10: 841–860.

Folke, Carl (2006). "Resilience: The Emergence of a Perspective for Social–ecological Systems Analyses." *Global Environmental Change* 16, no. 3: 253–267.

Fountain, Joanna, Steve Charters, and Laurence Cogan-Marie (2020). "The Real Burgundy: Negotiating Wine Tourism, Relational Place and the Global Countryside." *Tourism Geographies*: 1–21.

Fountain, Joanna, and Nicholas Cradock-Henry (2020). "Recovery, Risk and Resilience: Post-disaster Tourism Experiences in Kaikōura, New Zealand." *Tourism Management Perspectives* 35: 100695.

Getz, Donald, and Graham Brown (2006). "Critical Success Factors for Wine Tourism Regions: A Demand Analysis." *Tourism Management* 27, no. 1: 146–158.

Gilinsky Jr., Armand, Sandra K. Newton, and Rosana Fuentes Vega (2016). "Sustainability in the Global Wine Industry: Concepts and Cases." *Agriculture and Agricultural Science Procedia* 8: 37–49.

Gilbert, David C. (1992). "Touristic Development of a Viticultural Region of Spain." *International Journal of Wine Marketing* 4, no. 2: 25–32.

Gilinsky Jr., Armand, Judith Ford, Sandra K. Newton, and Deanna Brown (2020). "An Exploratory Investigation into Strategic Resilience in the US Wine Industry." *Journal of Wine Research* 31, no. 1: 35–48.

Gobattoni, Federica, Raffaele Pelorosso, Antonio Leone, and Maria Nicolina Ripa (2015). "Sustainable Rural Development: The Role of Traditional Activities in Central Italy." *Land Use Policy* 48: 412–427.

Gossling, S., D. Scott, and C.M. Hall (2020). "Pandemics, tourism and global change: a rapid assessment of COVID-19." *Journal of Sustainable Tourism*, 29, no. 1: 1–20.

Hall, C. Michael, and Tim Baird (2014). "Types of Innovation in Tourism Businesses: The case of New Zealand Wine Tourism," in *Handbook of Research on Innovation in Tourism Industries*. Cheltenham, UK: Edward Elgar Publishing.

Hall, Colin Michael, and Stefan Gössling, eds. (2013). *Sustainable culinary systems: Local foods, innovation, and tourism & hospitality*. New York: Routledge.

Hannah, Lee, Patrick R. Roehrdanz, Makihiko Ikegami, Anderson V. Shepard, M. Rebecca Shaw, Gary Tabor, Lu Zhi, Pablo A. Marquet, and Robert J. Hijmans (2013). "Climate Change, Wine, and Conservation." *Proceedings of the National Academy of Sciences* 110, no. 17: 6907–6912.

Hashimoto, Atsuko, and David J. Telfer (2003). "Positioning an Emerging Wine Route in the Niagara Region: Understanding the Wine Tourism Market and its Implications for Marketing." *Journal of Travel & Tourism Marketing* 14, no. 3–4: 61–76.

Hira, Andy, and Alexis Bwenge (2011). "The Wine Industry in British Columbia: A Closed Wine but Showing Potential." Simon Fraser University, British Columbia.

Holland, Tara, and Barry Smit (2010). "Climate Change and the Wine Industry: Current Research Themes and New Directions." *Journal of Wine Research* 21, no. 2–3: 125–136.

Holling, Crawford S. (1973). "Resilience and Stability of Ecological Systems." *Annual Review of Ecology and Systematics* 4, no. 1: 1–23.

Holmes, John (2012). "Cape York Peninsula, Australia: A Frontier Region Undergoing a Multifunctional Transition with Indigenous Engagement." *Journal of Rural Studies* 28, no. 3: 252–265.

Hull, John S. (2016). "Wellness Tourism Experiences in Mountain Regions: The Case of Sparkling Hill Resort, Canada." *Mountain Tourism*: 25–35.

Ioannides, Dimitri (1995). "A Flawed Implementation of Sustainable Tourism: The Experience of Akamas, Cyprus." *Tourism Management* 16, no. 8: 583–592.

Jones, Gregory V., and Leanne B. Webb (2010). "Climate Change, Viticulture, and Wine: Challenges and Opportunities." *Journal of Wine Research* 21, no. 2–3: 103–106.

Kleinman, P.J.A., Sheri Spiegal, J.R. Rigby, S.C. Goslee, J.M. Baker, B.T. Bestelmeyer, R.K. Boughton et al. (2018). "Advancing the Sustainability of US Agriculture through Long-Term Research." *Journal of Environmental Quality* 47, no. 6: 1412–1425.

Knowd, Ian (2006). "Tourism as a Mechanism for Farm Survival." *Journal of Sustainable Tourism* 14, 1: 24–42.

Kuo, Hsiao-I., Chi-Chung Chen, Wei-Chun Tseng, Lan-Fen Ju, and Bing-Wen Huang (2008). "Assessing Impacts of SARS and Avian Flu on International Tourism Demand to Asia." *Tourism Management* 29, no. 5: 917–928.

Lein, James K. (2016). *Futures research and environmental sustainability: Theory and method.* Boca Raton, FL: CRC Press.

Lew, Alan A. (2014). "Scale, Change and Resilience in Community Tourism Planning." *Tourism Geographies* 16, no. 1: 14–22.

Mariani, Angela, and Antonella Vastola (2015). "Sustainable Winegrowing: Current Perspectives." *International Journal of Wine Research* 7, no. 1: 37–48.

Markard, Jochen, Rob Raven, and Bernhard Truffer (2012). "Sustainability Transitions: An Emerging Field of Research and its Prospects." *Research Policy* 41, no. 6: 955–967.

Mauser, Wolfram, Gernot Klepper, Martin Rice, Bettina Susanne Schmalzbauer, Heide Hackmann, Rik Leemans, and Howard Moore (2013). "Transdisciplinary Global Change Research: The Co-creation of Knowledge for Sustainability." *Current Opinion in Environmental Sustainability* 5, no. 3–4: 420–431.

McIntyre, Julie, Donna Senese, and John S. Hull (2019). "Fruit forward? Wine Regions as Geographies of Innovation in Australia and Canada," in *Regional Cultures, Economies, and Creativity*, 21–44. New York: Routledge.

Mezirow, J. (1991). *Transformative dimensions of adult learning.* San Francisco, CA: Jossey-Bass.

Miele, Mara (2008). "Cittáslow: Producing Slowness Against the Fast Life." *Space and Polity* 12, no. 1: 135–156.

Milich, L.N. (2012). "Food and Wine Tourism in Post-war Lebanon." *WIT Transactions on Ecology and the Environment* 161: 231–241.

Mozell, Michelle Renée, and Liz Thach (2014). "The Impact of Climate Change on the Global Wine Industry: Challenges & Solutions." *Wine Economics and Policy* 3, no. 2: 81–89.

Murdoch, Jonathan, Terry Marsden, and Jo Banks (2000). "Quality, Nature, and Embeddedness: Some Theoretical Considerations in the Context of the Food Sector." *Economic Geography* 76, no. 2: 107–125.

O'Brien, Karen L., and Robin M. Leichenko (2000). "Double Exposure: Assessing the Impacts of Climate Change within the Context of Economic Globalization." *Global Environmental Change* 10, no. 3: 221–232.

Overton, John, and Jo Heitger (2008). "Maps, Markets and Merlot: The Making of an Antipodean Wine Appellation." *Journal of Rural Studies* 24, no. 4: 440–449.

Overton, John, and Warwick E. Murray (2011). "Playing the Scales: Regional Transformations and the Differentiation of Rural Space in the Chilean Wine Industry." *Journal of Rural Studies* 27, no. 1: 63–72.

Overton, John, Warwick E. Murray, and Glenn Banks (2012). "The Race to the Bottom of the Glass? Wine, Geography, and Globalization." *Globalizations* 9, no. 2: 273–287.

Parga-Dans, Eva, and Pablo Alonso González (2017). "'Marketing Quality' in the Food Sector: Towards a Critical Engagement with the 'Quality Turn' in Wine." *Geoforum* 85: 5–8.

Perkins, Harvey C., Michael Mackay, and Stephen Espiner (2015). "Putting Pinot alongside Merino in Cromwell District, Central Otago, New Zealand: Rural Amenity and the Making of the Global Countryside." *Journal of Rural Studies* 39: 85–98.

Petrini, Carlo (2003). *Slow food: The case for taste.* New York: Columbia University Press.

Pritchard, A., N. Morgan, and I. Ateljevic (2011). Hopeful tourism: a new transformative perspective. *Annals of Tourism Research,* 38, no. 3: 941–963.

Randelli, Filippo, and Federico Martellozzo (2018). *The Impact of Rural Tourism on Land Use. The Case of Tuscany,* no. wp2018_02.rdf. Universita'degli Studi di Firenze, Dipartimento di Scienze per l'Economia e l'Impresa.

Randelli, Filippo, Patrizia Romei, and Marco Tortora (2014). "An Evolutionary Approach to the Study of Rural Tourism: The Case of Tuscany." *Land Use Policy* 38: 276–281.

Randelli, Filippo, and Federico Martellozzo (2019). "Is Rural Tourism-Induced Built-up Growth a Threat for the Sustainability of Rural Areas? The Case Study of Tuscany." *Land Use Policy* 86: 387–398.

Reisinger, Yvette, ed. (2013). *Transformational Tourism: Tourist Perspectives.* CABI.

Ritchie, Brent (2008). "Tourism Disaster Planning and Management: From Response and Recovery to Reduction and Readiness." *Current Issues in Tourism* 11, no. 4: 315–348.

Robinson, Danielle (2021). "Rural Wine and Food Tourism for Cultural Sustainability." *Tourism Analysis* 26, no. 2–3: 121–133.

Saxena, Gunjan, Gordon Clark, Tove Oliver, and Brian Ilbery (2007). "Conceptualizing Integrated Rural Tourism." *Tourism Geographies* 9, no. 4: 347–370.

Senese, Donna M. (2016). "12 Transformative Wine Tourism in Mountain Communities." *Mountain Tourism: Experiences, Communities, Environments and Sustainable Futures*: 121.

Senese, Donna, Filippo Randelli, and John S. Hull (2016). "The Role of Terroir in Tourism Led Amenity Migration: Contrasting Effects in Tuscany and the Okanagan Valley of British Columbia," in *11th International Terroir Congress,* July, 116–123.

Senese, Donna, Filippo Randelli, John S. Hull, and Colleen C. Myles (2017). "Drinking in the Good Life: Tourism Mobilities and the Slow Movement in Wine Country," in *Slow Tourism, Food and Cities,* 214–231. New York: Routledge.

Sigala, Marianna (2020). "The Transformational Power of Wine Tourism Experiences: The Socio-Cultural Profile of Wine Tourism in South Australia," in *Social Sustainability in the Global Wine Industry,* 57–73. Cham: Palgrave Pivot.

Sonnino, Roberta (2004). "For a 'Piece of Bread'? Interpreting Sustainable Development through Agritourism in Southern Tuscany." *Sociologia Ruralis* 44, no. 3: 285–300.

Soulard, J., McGehee and Whitney Knollenberg (2021). "Developing and Testing the Transformative Travel Experience Scale (TTES)." *Journal of Travel Research* 60, no. 5: 923–946.

Tashakkori, Abbas, and Charles Teddlie, eds. (2010). *Sage Handbook of Mixed Methods in Social & Behavioral Research.* Thousand Oaks, CA: Sage.

UNEP (2005). *After the Tsunami: Rapid Environmental Assessment.* United Nations Environment Programme.

Valentin, Anke, and Joachim H. Spangenberg (2000). "A Guide to Community Sustainability Indicators." *Environmental Impact Assessment Review* 20, no. 3: 381–392.

Vallone, Cinzia, Alessandro Capocchi, Paola Orlandini, and Andrea Amaduzzi (2020). "Can the New Hospitality Model of Albergo Diffuso Solve the Overtourism Issue? The Case of Tuscany," in *The Overtourism Debate*. Bingley, UK: Emerald Publishing Limited.

Vidickienė, Dalia, Rita Vilkė, and Živilė Gedminaitė-Raudonė (2020). "Transformative Tourism as an Innovative Tool for Rural Development." *European Countryside* 12, no. 3: 277–291.

Wittwer, Glyn, and Kym Anderson (2020). *COVID-19's Impact on Australian Wine Markets and Regions*. No. 2020–03. University of Adelaide, Wine Economics Research Centre.

Zenker, Sebastian, and Florian Kock (2020). "The Coronavirus Pandemic–A Critical Discussion of a Tourism Research Agenda." *Tourism Management* 81: 104164.

Zheng, Yi, Edmund Goh, and Jun Wen (2020). "The effects of Misleading Media Reports about COVID-19 on Chinese Tourists' Mental Health: A Perspective Article." *Anatolia* 31, no. 2: 337–340.

Camilo Peña
Chapter 13
Wines and Subversive Art: A Conceptual Definition of Natural Wines

Introduction

With this chapter, I would like to highlight the notion of how art and sustainability can be connected and, in the specific context of wines, can further the move toward more sustainable wine production. I draw from concepts of street and subversive art to show how wine can be considered not only art, but also subversive art, in that it challenges the established norms and values that are seen as commonplace in the wine world.

By providing an additional analytical layer when assessing natural wines, this chapter builds from previous frameworks of wine as art and adds to the conceptualization of wines as an art form. In this case, when talking about natural wines, I argue that the construction of the natural wine discourse has certain key similarities with what street and urban art represent within the broader art world. Using this parallel, I will present an initial set of conceptual elements to define what natural wine is. I argue that three key features characterizing and defining subversive art are also evident in the natural wine movement: (1) the need to reclaim spaces (mainly from the producers'/winemakers' perspective), (2) rituals of resistance, and (3) an overall opposition to the mainstream/institutionalized status quo.

I argue that defining natural wines in this conceptual manner makes sense if one considers that nature is not just a physical term (as referring to vineyards and chemical processes) but also a social construction that provides humans with more than physical and tangible benefits. In the case of natural wines, nature provides a symbolic escape from what has become an overtly manipulated (by human hands) industry (Black 2013; Goode and Harrop 2011) and a return to the way wines were made in the past, in a more pristine way, reflective of what a wine grape is given its natural *terroir* (Legeron 2014; Ulin 2013).

Natural wines here will refer to those wines that are made with a minimum of human intervention (Goode and Harrop 2011) and that usually use organic and/or biodynamic processes in their vineyard operations (Legeron 2014). In a sense, I will consider natural wine here as the essence of what wine is supposed to be – fermented grape juice and nothing else – except for perhaps a bit of sulfites added during bottling (Ibid.). Thus, these natural winemakers do not use enzymes, acid, yeasts (only 'natural' yeasts present in vineyard and winery), fining agents, or other commonly used wine additives in the cellar; at the same time they (mostly) do not rely on certain physical interventions that have an impact on the flavor of the wine,

https://doi.org/10.1515/9783110732757-013

such as reverse osmosis, extraction through the use of enzymes, or filtration (Goode and Harrop 2011). Nevertheless, there is no clear definition or regulation of a natural wine and certain countries (and charters of natural wines) will have different regulations (e.g., the French might allow gross filtration, and some Italian charters will permit 50 mg/L of sulfites while others will only allow for up to 30 mg/L). It is here that I propose another way to integrate a new definition of natural wines across the board, not focused on vineyard/winery regulations but relying on the discursive-symbolic elements of the movement.

Nature as (Symbolic) Escape from the Human World

Nature has been conceptualized before in opposition to the human realm (Canniford and Shankar 2013; Soper 1995). Some, such as Castree and MacMillan (2001), propose nature as a social construction. For example, humans have reconstituted nature on every level, aided by technology and science, and so the notion of a 'pure' nature is no longer attainable or existent. Moreover, some argue nature is culturally constructed, thus one knows nature through systems of signification and meaning (Whatmore 1999). Nature can also be seen as an external place where everything can be forgotten and one can get away from all human reality (Arnould and Price 1993).

So following these different uses of nature, one can argue that there is not one nature but many, or as Macnaghten and Urry (1998) argue, there is not one nature but a series of contested natures constituted through socio-cultural processes and from which any type of nature cannot be separated. These authors present a view in which specific social practices produce, reproduce, and transform different natures. These practices are the means through which people have cognitive, aesthetic, and hermeneutic reactions to the signs and characteristics of nature. Such practices hold a set of principles, such as being discursively ordered, embodied, and spaced (Ibid.).

These contested natures have been evolving and changing in the western world since medieval cosmology, where abstracted and personified natures existed. Nature was seen as goddess, divine mother, and selective breeder, among other concepts, which varied depending on the shifting relationships between nature, God, and humanity. According to Lewis (1964), pre-Socratic Greek philosophers suggested the first proposal of a single and abstract nature (Macnaghten and Urry 1998). These versions of nature have been created and changed throughout human history and are thus the different natures that are socially and culturally constructed in particular contexts.

Soper (1995) aims to admit and hold in a productive tension both the cultural and biological (which she calls nature with an independent existence) perspective

of nature. As she puts it, "For while it is true that much of what we refer to as 'natural' is a 'cultural construct' in the sense that it has acquired its form as a consequence of human activity, that activity does not 'construct' the powers and processes upon which it is dependent for its operation" (Soper 1995: p. 249).

Overall, although one can see nature as a physical escape from the human world, the concept of nature as a symbolic space to escape the world of human intervention is considered. I follow Canniford and Shankar (2013) in examining the dualism between nature and humans as a historically constructed distinction fueled by socioeconomic and socio-cultural interests. This is not to demote or diminish the reality of physical/chemical processes, as some critique as one of the limitations of social constructions of nature (Shoreman-Ouimet and Kopnina 2015), but to highlight how, in this particular case, the views on nature reflect the social order in which they exist and the way in which one experiences nature in a particular context and situation, inevitably affected by current social organizations, worldviews, and habits (Vogel 2015).

So natural wines, although conventionally defined through the material use of nature – although no clear definition exists (Black 2013) – can also be defined through the perspective of nature seen through a socio-cultural lens, particularly one grounded in the idiosyncrasies of the wine world.

Natural Wine: A Conceptual Definition

Using the previous conceptualization of nature, a preliminary conceptual definition of natural wines comes into play, in which nature is considered a central figure in the winemaking process, and thus dictates the sensorial characteristics of the wine. Natural wines give nature precedence over the possible technological and human interventions that can impact a wine's sensorial profile.

Natural wine is seen by many as a response to the excessive industrialization of winemaking in an effort to go back to the pre-additives and pre-filtration eras of winemaking (Legeron 2014). There are different ways to define natural wines and many argue that the natural wine movement is not well defined and might take slightly different meanings depending on each country (Black 2013).

For many, the natural wine movement originated in France, with Jules Chauvet as its founding father (Goode and Harrop 2011). With wine being a central part of the French culinary and cultural identity, the natural wine movement has been advocating for a rejection of the anonymous mass-production of wine since the 1980s when natural wine bars already existed in Paris (Black 2013). Italians did not jump into the natural wine movement until the 1986 methanol scandal, which pushed the move toward quality wine production (Barbera and Audifredi 2012), and it wasn't until the early 2000s that the natural wine movement began to make an

entrance into the United States; for example, the first Natural Wine Week was held in San Francisco in 2009, when at the same time a number of natural wine bars and shops opened both in San Francisco and New York (Black 2013). Much of this movement has continued to expand throughout the world, having an impact both on how winemakers see wine production and on how consumers perceive wines; furthermore, it has brought up various environmental considerations that bring to light the need to improve the sustainability of certain winemaking methods (Goode and Harrop 2011).

While natural wine has been criticized due to its lack of a clear and consistent definition, I suggest a preliminary approach at defining natural wine not from a vineyard/winery perspective but from a conceptual and ideological one, such as the one mentioned in the first paragraph of this section. Additionally, I suggest that many of the characteristics found in subversive art in opposition to mainstream art, as described above, are similar to those represented in natural wines and their opposition to mainstream wines. I will start first with a brief overview of how wine has been conceptualized as art and then proceed to complement my preliminary definition of natural wines.

Wine and Art

Using Shapiro's (2007) definition and process of artification, that is, a series of processes that transform non-art into art, Joy et al. (2021) detailed the process of artification in the case of the fine wines of Bourdeaux and Burgundy and provided a conceptualization of how wine can be framed as art. Many of the processes and concepts identified by the authors in the process of artification of wine, as well as the heritagization of fine wines, can be paralleled in the case of natural wines. In particular, the process of heritagization and connecting of a place and history to a particular wine/brand is central to understanding why the natural wine movement, in search of authenticity and transparency in what is sold and served to wine consumers, opposes the standardization of wines.

Following Joy et al.'s (2021) detailed stages of the artification process of wine and the definition of process from Shapiro and Heinich (2012), I suggest the following example in terms of how natural wines in particular can follow a similar process of artification.

Susucaru Wine and the Artification of a Natural Wine

The example of Susucaru wine, a natural wine made by Belgian winemaker Frank Cornelissen from a range of native Sicilian grape varieties (e.g., Nerello Mascalese)

shows three key features of the artification process of a natural wine: (1) aspiration, (2) displacement/extraction, and (3) individualization of labor (Shapiro and Heinich 2012). Susucaru has seen its status rise in the natural wine world and is seen by many as an aspiration to reach for, similar to what happened with many Bourdeaux wines that were seen as the pinnacle of fine wines (Joy et al. 2021). This follows both the endorsement of the wine by celebrities and the media, as well as the cult status that it has achieved in the natural wine world, with some calling it a "legendary natural wine" (Cult Wine 2021).

The extraction or displacement of a production into another context (Shapiro and Heinich 2012) is also exemplified in Susucaru wine. In this case, with the endorsement of Susucaru wine by well-known celebrities in the food and entertainment world, such as rapper Action Bronson, the wine is no longer just a wine, but now also a product desired by many who watched Bronson's Vice Media show *"F*ck That's Delicious."* The wine indeed is hard to find, considering that Cornelissen's vineyard consists of only twenty-five hectares on Mount Etna (Adamson 2016). Both the process of displacement and of aspiration are reinforced when actors like Bronson express their love for the Susucaru; during his web show, Bronson said, "You saw my face when they brought the Susucaru out. I was like a little (. . .) kid, like my mom just bought the NBA Jam Tournament Edition. I been waiting for this Susucaru all my life. I love this one" (Ibid.).

The individualization of labor (Shapiro and Heinich 2012) is an additional process that is seen in the Susucaru wine (as well as in many other wines), where the winemaker takes most, if not all, of the credit for the product. In the case of Frank Cornelissen, he has gained a reputation to the point of being featured in *The New York Times* and mentioned in *Vogue* magazine (Asimov 2016).

Subversion and Art

Art has been a vessel for the counterculture to express its disconformity with the status quo. In many cases, this counterculture has been used by corporations to attract a certain (usually younger) niche of the population (Frank 1997). This co-optation of countercultural discourses has given rise to market responses such as community-supported agriculture (CSA), an initiative conceived as a countervailing market response to corporate co-optation of farming. Industrial and globally distributed products, as well as anonymous and distal relationships between farmers and consumers, are seen as conflicting with the values of sustainability. Consumers are encouraged to understand the impact of their choices beyond taste and health and are invited to think about ecological sustainability, biodiversity, and the preservation of small farms and rural ways of life (Thompson and Coskuner-Balli 2007).

In the case of subversive art, what differentiates it from other forms of art and from other forms of countercultural expression is a sense of subversion that has sometimes been accused of being illegal and labeled vandalism (Daniels 2016). One example of this can be seen in street and urban art, considered illegal and a vandalistic act in many countries, and thus (usually) forced to be practiced in a quick fashion and hidden from the public eye. In this way, this form of art is frowned upon by many.

Nonetheless, subversive art can be seen as a subcultural expression that challenges the dominant visual culture – for example, graffiti does this by being an aesthetic occupation of spaces, while urban street art repurposes those spaces (Armstrong 2005). By doing this, these subversive art forms contest and provide alternatives to the mainstream paradigms of the dominant visual culture. Graffiti and street art can be considered a form of cultural heritage, although it has slowly become more culturally and socially accepted (Bates 2014).

The aforementioned elements of subversive acts can also be seen in the natural wine movement: attracting a younger set of the population, expressing countercultural ideas, opposing elements of the mainstream, providing alternatives to the dominant visual (or, in the case of wine, sensorial) culture, and offering a way to cultural heritage although through means that are sometimes frowned upon by most of the dominant/mainstream population. In the following section, I will expand upon these ideas and discuss in further detail how natural wines can be paralleled to subversive art.

Wine and Subversion

Natural wines provide an escape from the traditional and mainstream methods of winemaking (Legeron 2014). Natural wines offer a return to what is considered the origins of how wine traditionally was made: through an artisanal, hands-on, no-additives process. Natural wine advocates are opposed to the use of additives, processing agents, and other such products; and argue that wine has increasingly become a standardized product, manufactured by large corporations in a process too concerned with quickly producing large quantities of the same recipe (Ibid.). Although many would argue that there is nothing wrong with more large-scale and industrialized production, some also criticize the fact that many of these corporations trick consumers by using the illusion of a farmer hand-picking grapes and a winemaker crafting wines by hand when this is no longer the case.

Opposing the Mainstream

Like natural wine and its opposition to mainstream winemaking, street art and, in particular, graffiti offered an alternative to what was seen as an extremely intellectual and institutionalized high-art scene (Kan 2001). In the case of natural wines, the natural wine movement has been considered in opposition to the traditional and growing industrial methods of wine production. In particular, as early as the 1980s, the natural wine movement in France was seen as a movement in opposition to the mass production of wine (Black 2013).

Natural wines provide alternative offerings, i.e., products and services not offered in the same volume and availability as their conventional or mainstream counterparts. These alternative products can be demanded by certain consumers unsatisfied with the status quo (Scaraboto and Fischer 2013). For Penaloza and Price (1993), it is ironic how, for some consumers, resistance implies getting *out of* the marketing system, while for others this resistance solicits an inclusion *in* the marketing system. In their paper, the authors gave, as examples of attempts to move outside the market, the African-American community protesting against a certain brand of cigarettes, and Native Americans' opposition to a brand of malt liquor using one of their tribal leaders' names on their bottles. As examples of consumers seeking inclusion in the marketing system, the authors mention African-, Hispanic-, and Asian-Americans being underrepresented in advertising and other marketing practices (Penaloza and Price 1993). This protest for inclusion in mainstream markets has also been studied in more recent articles (e.g., Scaraboto and Fischer 2013).

Holt (2002) argues that consumer emancipation is not achieved by consumption sovereignty via alternative and subversive uses of the marketplace. Consumers are reproducing the dominant capitalist ideology of postmodern economy even when they show creative anti-marketing characteristics, because their identity work is still located within the marketplace as opposed to other spheres of life (Holt 2002). Something similar is seen in Kozinets (2002), when consumers attending the Burning Man Festival seem to temporarily be emancipated from but ultimately cannot totally escape from a market in which they are still using sign games and social logics. Nevertheless, Thompson (2004) contends the argument brought forward by these authors, based in postmodern theory, uses a modernist worldview by adhering to a perceived metaphor of *outside* and *inside* a marketplace, whereas postmodern theorists argue the social world does not organize itself neatly along categorical divisions such as those presented in modernist social theory (Haraway 1997). Thus, no clear limit exists between the marketplace and emancipatory spaces (Thompson 2004). The case of natural wines further proves this argument in that it is an alternative space and a continuation of mainstream marketplaces (wine markets) and therefore can be (and was) born from within current marketplace structures.

One different oppositional stand to capitalism is seen in the study of consumer movements such as anti-advertisement, anti-GE (genetic engineering), and

anti-Nike movements presented by Kozinets and Handelman (2004). The authors present this as opposed to Holt (2002) in that they describe a consumer resistance of a type that is sanctioned by the market, and fuels and rejuvenates the market. For Kozinets and Handelman (2004), differentiation is needed between consumer movements that seek counterculture based in style and those that seek to undermine the consumerist ideology. Another difference between these two types of movements is the prevalence of self-discipline and restraint from individuals seeking to contribute to a collective good (seen in movements following a voluntarily simplistic lifestyle, e.g., ecofeminist communities (Dobscha and Ozanne 2001)), as opposed to the individualistic essence seen in movements that focus on hedonism, therapy, and freedom (e.g., Kozinets 2002).

In line with these differences between types of consumer movements, Hond and Bakker (2007) argue that movements might tend toward deinstitutionalization of norms and practices when there is a more radical activism and fear of co-optation (Thompson and Coskuner-Balli 2007a). On the other hand, reformative or less radical activist groups might go more toward reinstitutionalization than deinstitutionalization; these groups will usually be the ones advocating for more corporate social responsibility, and focusing on assessing how companies are implementing socially and environmentally friendly improvements (Hond and Bakker 2007).

Furthermore, the market and the consumer are not always seen in oppositional terms, such as when consumer and marketer join forces to enact resistance against state and religious institutions (Karababa and Ger 2011). Karababa and Ger (2011) argue that for a consumer's resistance to be successful, an alliance between the individual and an institution within the public sphere is necessary. Such alliances are also seen in processes of opposition to cultural and aesthetic repression, when, for example, music consumers join forces with institutions such as the Internet (Giesler 2008). Other market actors that can also be considered in these dynamics include science and medicine (Thompson 2004) and religion (Sandikci and Ger 2010). Following Karababa and Ger (2011), the natural wine movement can be seen as a series of interactions and alliances between consumers and networks of market actors that have an impact on consumer resistance and the creation/transformation of new alternative markets.

Reclaiming Spaces

This characteristic of subversive art and natural wines, the reclaiming of spaces, comes mostly from the practice and needs of winemakers and producers. Nonetheless, when consumers make an informed choice of what type of wine they purchase, they are themselves contributing to the reclaiming of spaces.

Natural wines offer a return to more traditional wine growing and winemaking methods. Organic farming, which borrows from many traditional indigenous ways of working the land, emerged in the 1940s; while biodynamic agriculture, also borrowing from indigenous knowledge, has been around since the 1920s. Only recently have these two methods of farming gained more traction in the wine world. These methods have a reclaiming sense in that they provide farmers with the tools and knowledge to grow their crops without the need for products sold by big corporations. They also provide the means for farmers to grow a crop in a safe environment where they can have their families present without worrying about the potential dangers of lots sprayed with pesticides.

In this sense, similar to what graffiti provides to young writers and artists (Armstrong 2005), natural wine methods provide a way for farmers to reclaim the spaces they inhabit and work in. Additionally, whereas many mainstream wine landscapes will offer the prototypical vineyard view, vineyards under a natural winemaking method will focus more on the health and ecosystem/holistic approach of their processes than on the aesthetics of their layout. This is also a socio-political statement in that many natural winemakers no longer want to continue using the established and approved processes and will oppose the use of products offered by big corporations, which are often aided by governments (Gillam 2013). This opposition has also been fueled by lawsuits and controversy around the health impacts of working in vineyards where pesticides are routinely used (Wasley and Chaparro 2015). There is also a similar opposition between what many Latin American graffiti artists focus on – the political and social critiques in their art – (Daniels 2016) rather than on the plain aesthetic of their work.

Rituals of Resistance

Diamond (1982) refers to rituals of resistance that contribute to the transformation of society by expressing and creating the consciousness of those who no longer want to continue living through the current social and political context. The author talks about how theaters have become no longer just theaters but also social arenas for these rituals of resistance (e.g., through the theater of the absurd, street "theater," or political "theater"). In a similar fashion, the wine world, which uses distinctive characteristics of theater performances to attract consumers (Joy et al. 2018), is no longer just a theater where a script is followed (beautiful landscapes, pristine nature) but also a contested arena where the use of technology and the methods used in working the land become scrutinized (Black 2013).

These rituals of resistance are evidenced in the various alternative approaches that natural winemakers bring to the forefront, such as focusing on manual labor as opposed to an over-reliance on technology, implementing riskier modes of

production that are more environmentally sustainable (Smith Maguire 2018), limiting or completely reducing the number of additives used in the cellar (Legeron 2014), keeping the number of interventions/manipulations (e.g., filtration) to a minimum (Goode and Harrop 2011), and overall being accepting of and appreciating different and sometimes funkier sensorial expressions of wine (Black 2013).

All these rituals of resistance perform an action that opposes what is being done in the mainstream winemaking world. In this sense, natural winemaking has similarities with the avant-garde art scene: both are clearly marked by elements of nonconformity (Wiseman 2007). Natural wine, as well as avant-garde and subversive art, embodies the actions arising from the dissatisfaction with the status quo and looking for a way to emancipate from its institutionalized forms.

The wine world has been regularly working with a top-down approach, where wine preferences are largely dictated by those whose voices have been accepted as the experts and knowledge-keepers of the wine world and where certain acclaimed *terroirs*, only accessible to a select few, are seen as undemocratic tools used by the upper members of the wine establishment to maintain their privileged positions (Goode and Harrop 2011).

Conclusion

By presenting how natural wines fit into the conceptualization of the artification of wines (Joy et al. 2021), and how the movement and concept of natural wine can be interpreted by considering nature as a social construct and through three overall characteristics of subversive art – opposing the mainstream, reclaiming spaces, and rituals of resistance – I have provided a preliminary conceptual definition and characterization of wine that goes beyond the traditional definition based on vineyard and cellar practices; natural wines are those in which nature is considered a central figure in the winemaking process, one that dictates the sensorial characteristics of the wine. Natural wines give nature precedence over the possible technological and human interventions that can impact a wine's sensorial profile. Natural wines emerge from the natural wine movement, one that opposes dominant mainstream wine practices, proposes the reclaiming of spaces, and operates through rituals of resistance.

Whereas wine has been framed as art before, here I have provided the first conceptualization of a particular type of wine as a specific art form. The natural wine movement aims to remove the veil of secrecy that many have criticized in the wine industry (for example, the fact that many conventional wines have multiple additives but few wine bottles include the ingredients used in its production). Just as the original intention of subversive art was to express its nonconformity with the mainstream art scene, natural wine offers an alternative to those that distrust the current wine world status quo.

Future Implications

This characterization can be expanded upon and used for further theorization as well as for a better understanding of this new and upcoming niche within the global wine marketplace. Natural wines are still in the early stages of being defined and characterized in a more standard way – at least, that is what many in the industry would say. Perhaps with these sorts of products and movements, it is best not to define them in the conventional manner, but rather to look at alternative ways to characterize the elements that surround them.

In theoretical terms, this work provides an additional layer of what Joy et al. (2021) refer to as the artification of wines and opens the discussion to the analysis of a relatively new wine movement. Furthermore, this proposed conceptual definition of natural wines provides a preliminary approach to new ways of defining and understanding new alternative marketplaces and movements that might not be easily defined through more conventional methods.

Many have criticized and reduced the natural wine movement to just a temporary fad, a sham, or even a fraud, and have equated the term with fault-ridden and low-quality wines (Goode and Harrop 2011). This sort of reaction, similar to the one that urban and subversive art originally produced in the most traditional and snobbish art circles, might be driven by a lack of understanding of what the movement wants to bring into the wine world. With this proposed conceptual definition, and the parallel with subversive art forms, practitioners might have a better understanding of the natural wine movement and thus a better grasp of what the movement and its actors (producers and consumers) offer to and demand from the wine marketplace. Just as wine is not a drink for everyone, natural wine might not be the wine of preference for all.

This brings us to a final implication. With the understanding that this wine movement comes from and relates to different values and ideas than those prevalent in the mainstream wine world, more attuned perhaps with the urban art scene, this work provides a tool for wine companies and regions to inform their branding and marketing endeavors when thinking of exploring the world of natural wines.

References

Adamson, Claire (2016). "Rapper Avoids Bling Wine for Natural Option," *Wine-Searcher*.

Armstrong, Justin (2005). "The Contested Gallery: Street Art, Ethnography and the Search for Urban Understandings," *AmeriQuests* 2(1).

Arnould, Eric J., and Linda L. Price (1993). "River Magic: Extraordinary Experience and the Extended Service Encounter," *Journal of Consumer Research*, 20(1): 24–45.

Asimov, Eric (2016). "The Evolution of a Natural Winemaker," *The New York Times*, https://www.nytimes.com/2016/08/31/dining/organic-wine-frank-cornelissen-sicily.html.

Barbera, Filippo, and Stefano Audifredi (2012). "In Pursuit of Quality. The Institutional Change of Wine Production Market in Piedmont." *Sociologia Ruralis* 52(3): 311–31, https://doi.org/10.1111/j.1467-9523.2012.00567.x.

Bates, Lindsay (2014). "Bombing, Tagging, Writing: An Analysis of the Significance of Graffiti and Street Art," University of Pennsylvania, https://repository.upenn.edu/cgi/viewcontent.cgi?article=1552&context=hp_theses.

Black, Rachel E. (2013). "Vino Naturale: Tensions between Nature and Technology in the Glass," in *Wine and Culture: Vineyard to Glass*, ed. Rachel E. Black and Robert C. Ulin. London: Bloomsbury Academic, 279–94.

Canniford, Robin, and Avi Shankar (2013). "Purifying Practices: How Consumers Assemble Romantic Experiences of Nature." *Journal of Consumer Research* 39(5): 1051–69.

Castree, Noel, and Tom MacMillan (2001). "Dissolving Dualisms: Actor-Networks and the Reimagination of Nature," in *Social Nature: Theory, Practice and Politics*, ed. Noel Castree and Bruce Braun. Boston: Blackwell, 208–24.

Cult Wine (2021). "2018 Frank Cornelissen Susucaru Rosso." *Cult Wine*. https://cultwine.co.nz/products/2018-frank-cornelissen-susucaru.

Daniels, Jennie Irene (2016). "Intervenciones En La Calle, Intervenciones En El Aula: El Arte Urbano Quiteño." *Hispania* 99, no. 2: 246–57.

Diamond, Stanley (1982). "Subversive Art." *Social Research* 49(4): 854–77.

Dobscha, Susan, and Julie L. Ozanne (2001). "An Ecofeminist Analysis of Environmentally Sensitive Women Using Qualitative Methodology: The Emancipatory Potential of an Ecological Life." *Journal of Public Policy & Marketing* 20(2): 201–14.

Frank, Thomas (1997). *The Conquest of Cool: Business Culture, Counterculture, and the Rise of Hip Consumerism*. Chicago, IL: The University of Chicago Press.

Giesler, Markus (2008). "Conflict and Compromise: Drama in Marketplace Evolution." *Journal of Consumer Research* 34(6): 739–53.

Gillam, Carey (2013). "U.S. Tax Dollars Promote Monsanto's GMO Crops Overseas: Report." *Reuters*. https://www.reuters.com/article/us-usa-gmo-report-idUSBRE94D0IL20130514.

Goode, Jaime, and Sam Harrop (2011). *Authentic Wine: Toward Natural and Sustainable Winemaking*. Berkeley and Los Angeles: University of California Press.

Haraway, Donna (1997). *Modest_Witness@Second_Millennium FemaleMan?_Meets_OncoMouseTM: Feminism and Techno-Science*. New York: Routledge.

Holt, Douglas B. (2002). "Why Do Brands Cause Trouble? A Dialectical Theory of Consumer Culture and Branding." *Journal of Consumer Research* 29(1): 70–90.

Hond, Frank den, and Frank G.A. de Bakker (2007). "Ideologically Motivated Activism: How Ctivist Groups Influence Corporate Social Change Activities." *Academy of Management Review* 32(3): 901–24.

Joy, Annamma, Russell W. Belk, Steve Charters, Jeff Jian Feng Wang, and Camilo Peña (2018). "Performance Theory and Consumer Engagement: Wine-Tourism Experiences in South Africa and India," in *Consumer Culture Theory, Volume 19*, ed. Samantha N.N. Cross, Cecilia Ruvalcaba, Alladi Venkatesh, and Russel W. Belk. Bingley, UK: Emerald Publishing Limited, 163–87. http://www.emeraldinsight.com/doi/10.1108/S0885-211120180000019010.

Joy, Annamma, Kathryn A. LaTour, Steve John Charters, Bianca Grohmann, and Camilo Peña-Moreno (2021). "The Artification of Wine: Lessons from the Fine Wines of Bordeaux and Burgundy." *Arts and the Market* 11(1): 24–39.

Kan, Koon-Hwee (2001). "Adolescents and Graffiti." *Art Education* 54(1): 18–23. http://www.jstor.org/stable/3193889.

Karababa, Eminegül, and Güliz Ger (2011). "Early Modern Ottoman Coffeehouse Culture and the Formation of the Consumer Subject." *Journal of Consumer Research* 37(5): 737–60.

Kozinets, Robert, and Jay M. Handelman (2004). "Adversaries of Consumption: Consumer Movements, Activism, and Ideology." *Journal of Consumer Research* 31(3): 691–704.

Kozinets, Robert V. (2002). "Can Consumers Escape the Market? Emancipatory Illuminations from Burning Man." *Journal of Consumer Research* 29(1): 20–38.

Legeron, Isabelle (2014). *Natural Wine: An Introduction to Organic and Biodynamic Wines Made Naturally*. London and New York: Cico Books.

Lewis, C.S. (1964). *The Discarded Image: An Introduction to Medieval and Renaissance Literature*. Cambridge: Cambridge University Press.

Macnaghten, Phil, and John Urry (1998). *Contested Natures*. New York: Sage.

Penaloza, Liza, and Linda Price (1993). "Consumer Resistance: A Conceptual Overview." *Advances in Consumer Research* 20(1992): 123–28.

Sandikci, Özlem, and Güliz Ger (2010). "Veiling in Style: How Does a Stigmatized Practice Become Fashionable?" *Journal of Consumer Research* 37(1): 15–36.

Scaraboto, Daiane, and Eileen Fischer (2013), "Frustrated Fatshionistas: An Institutional Theory Perspective on Consumer Quests for Greater Choice in Mainstream Markets." *Journal of Consumer Research* 39(6): 1234–57.

Shapiro, Roberta (2007). "What Is 'Artification'?" *Sociedade e Estado* 22(1): 135–51.

Shapiro, Roberta, and Nathalie Heinich (2012). "When Is Artification?" *Contemporary Aesthetics*, Special Vol.

Shoreman-Ouimet, Eleanor, and Helen Kopnina (2015). "The Social Construction of Nature," in *Culture and Conservation: Beyond Anthropocentrism*. New York: Routledge, 45–63.

Smith Maguire, Jennifer (2018). "Taste as Market Practice: The Example of ' Natural ' Wine," in *Consumer Culture Theory, Volume 19*, ed. Samantha N.N. Cross, Cecilia Ruvalcaba, Alladi Venkatesh, and Russel W. Belk, Bingley, UK: Emerald Publishing Limited, 71–92.

Soper, Kate (1995). *What Is Nature?* Cambridge, MA: Blackwell Publishers Inc.

Thompson, Craig J., and G. Coskuner-Balli (2007). "Countervailing Market Responses to Corporate Co-Optation and the Ideological Recruitment of Consumption Communities." *Journal of Consumer Research* 34(2): 135–52.

Thompson, Craig J. (2004). "Marketplace Mythology and Discourses of Power." *Journal of Consumer Research* 31(1): 162–80.

Ulin, Robert C. (2013). "Terroir and Locality: An Anthropological Perspective," in *Wine and Culture: Vineyard to Glass*, ed. Rachel E. Black and Robert C. Ulin, London and New York: Bloomsbury Academic, 67–84.

Vogel, Steven (2015). *Thinking Like a Mall: Environmental Philosophy after the End of Nature*. Cambridge, MA: MIT Press.

Wasley, Andrew, and Amanda Chaparro (2015). "French Wine Industry's Love Affair with Pesticides Blamed for Worker Health Problems." *The Guardian*. https://www.theguardian.com/sustainable-business/2015/oct/29/france-wine-pesticides-organic-workers-vineyards-lawsuits-cancer.

Whatmore, Sarah (1999). "Culture-Nature," in *Introducing Human Geography*, ed. Paul Cloke, Philip Crang, and Mark Goodwin. London: Arnold, 4–11.

Wiseman, Mary Bittner (2007). "Subversive Strategies in Chinese Avant-Garde Art." *The Journal of Aesthetics and Art Criticism* 65(1): 109–19.

Kathryn A. Latour, Annamma Joy
Chapter 14
The Artification of Hospitality: Elevating Service to Luxury Status

Introduction

In 2014, The Beaumont, a five-star hotel in London, debuted "Room," a sculpture *cum* hotel suite created by the British artist Antony Gormley. Starkly angular and imposingly cave-like, the suite features shuttered windows that envelop the guest in what Gormley has described as a "total blackout" (Howarth 2014). At £2,500 per night, the suite is neither for the faint of heart nor the light of wallet (*Financial Times* 2015).

Hoteliers once routinely purchased art in bulk from manufacturing companies to decorate their walls (e.g., tasteful yet bland images of city streets, scenic vistas, and still lives). The Beaumont example above suggests a change in how high-end hoteliers view art. Paris-based art consultant Alex Toledano, whose clients include Ritz-Carlton hotels, says that hotel designers realized that many of their art acquisitions could be used "not only to tell an interesting narrative about their properties, but also [to] make their experience more memorable" (*Financial Times* 2015).

Luxury is characterized by high quality, high price, scarcity, uniqueness, aesthetics, heritage, and superfluousness (Dubois et al. 2001); and alignment with the arts has been associated with increased perceptions of rarity and value (Chailan 2018). Art is a cornerstone to many luxury brands (Saito 2012) and the "artification" of brands such as Louis Vuitton, Chanel, Prada, and others suggests that art offers a unique way to appeal to the luxury consumer (Kapferer 2014). Kapferer (1997) explains that "Luxury defines beauty; it is art applied to functional items," and emphasizes that luxury products as art forms bring more psychological satisfaction, like esteem to the owner, than functional utility.

It has been observed that the business worlds of art and luxury are growing closer every day (Fillis 2011; Schroeder 2005). The luxury hotel market was estimated at around $153 billion in 2015 and, before the pandemic, was projected to soar to $194 billion by 2021 (Park and Ahn 2021). However, the luxury hotel market continues to seek ways to both elevate the hospitality experience and distinguish specific venues from a crowded field (Godey et al. 2016).

While hoteliers note the importance of art to create ambience (Rhodes 1981), our focus is on how art can delineate the experience as a means of making a high-end hospitality stay truly distinct. Our research builds on experience design research wherein cues within the environment help create a sense of place, such as the use of the Blue-Gold at the Ritz Paris and the Chinese lions outside the Peninsula Hotels. To

https://doi.org/10.1515/9783110732757-014

underscore the importance of this concept, The Rosewood Hotels & Resorts, a luxury chain, has trademarked its Sense of Place philosophy, given its role as an essential element of its identity in which they state that each of the properties reflects the hotel's particular location, history, and culture (Godfrey 2020).

In a review of the academic research on luxury hotels, Chu, Tang, and Luo (2016) found that most research employed quantitative methods, and that there was little foundational development of topics relevant to luxury hotels. Conceptual articles are useful to encourage debate, develop theories, and induce empirical research (Bowen and Sparks 1998). While some hoteliers have embraced the use of art to differentiate their product offerings, the process of artification has not been addressed – we found no articles on artification and luxury hospitality in the business databases. In order to fill that research gap, we define, discuss, and review research on artification and apply it to the luxury hospitality industry.

We present the artification of luxury as a broader process in the historical development from a product to a service model in hospitality (Ahn, Park, and Hyun 2018; Wirtz, Holmquist, and Fritze 2020); and we review research on the *art infusion effect*, where the mere presence of art connotes value and luxury to products and distinguish the artification process. We build on extant research identifying the importance of place and space in the process of artification, relating those aspects that create the customer experience in artified retail settings in Louis Vuitton stores (Joy et al. 2014) to the hospitality industry. We tease out the potential benefits, as well as the risks, luxury hoteliers face when considering deploying artification to increase their consumer appeal. In conclusion, we discuss both practical opportunities for the hospitality industry as well as future research opportunities for hospitality academics.

History of Luxury: From Product to Service to Experience

Many business scholars have argued that there is a need to progress from the industrialized "make and sell" product-centric approach to one that is more experiential (Carbone and Haeckel 1994; Pine and Gilmore 1998; Carbone 2004). At the beginning of the 20th century the focus was on the production of high-quality goods. Wirtz, Holmquist, and Fritze (2020) discuss how services marketing in the 1970s emerged from the goods-centric focus, and how in the decades since, the services field has moved toward a more experiential focus. They lament, however, that the field of luxury services has remained largely outside the realm of academic investigation in this area.

Some studies in the hospitality literature suggest that luxury services may be missing the mark. Bernstein (1999) reports on focus groups of luxury hotel guests

and finds that many attributes that the hotel had presumed were luxurious were in fact viewed by guests as merely convenient and functional. Mattila (1999) finds that the physical structure and environment are more important in forming guests' perceptions of luxury than personalized services such as butlers. Designing a hotel experience is by its very nature a bidirectional or enactive process (Goldhagen 2017) where the firm and customer interact in a "servicescape" (Bitner 1992). It is therefore essential to understand how artful design and customer experiences interact.

Wirtz, Holmquist, and Fritze (2020) suggest that luxury services should be viewed specifically as extraordinary hedonic consumption activities, which raises the inevitable question: What elements might be most beneficial toward creating luxurious experiences? We propose that artification allows hospitality to transcend from aesthetically pleasurable into actual luxury (see Figure 14.1).

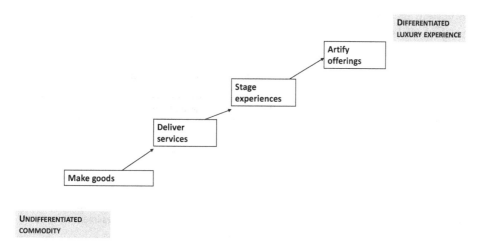

Figure 14.1: Progression of economic value to market.

Art Infusion Versus Artification

The art infusion effect occurs when the positive connotations associated with art, such as luxury and sophistication, spill over to products or services associated with the art. This effect was originally identified by Hagtvedt and Patrick (2008) where they showed that higher evaluations occurred when products, such as a soap dispenser, placed art on the label (versus no art). Chailan (2018) reports that 53.6% of all luxury brands in Italy and France used some sort of art infusion techniques in their brand management. In a review article, Ana, Apiradee, and Nuttapol (2018) found over 230 citations for Hagtvedt and Patrick's art infusion study, which they identify as one of the dominant theoretical pillars in the field of arts and branding. Researchers have investigated issues such as how artwork can enhance communications

and perceptions of products. Lee, Chen, and Wang (2015) found the art infusion effect to be particularly strong with higher priced luxury items, and Naletelich and Paswan (2018) found the effect less influential with non-luxury products.

In this chapter, we differentiate between the more immediate effects of art infusion and the longer-term process of artification, though the two are closely connected. The process of artification, through which something that is not art becomes art (Shapiro 2007), demands shifts in perspective, such that the focus is on creation rather than production, producers become artists, products become artwork, and observers become audiences. We discuss important aspects of this process in the next section.

Artification is relatively new concept to business marketers. Kapferer (2014) introduced the term for luxury brands, and it has since been applied to fashion products and places. We conducted a search for academic business articles on artification using Goggle, ABI/Inform, and EBSCO, that yielded only eight articles in total and only one in a tourism-related context. Table 14.1 contains the citation, context, method, and summary of those papers.

Table 14.1: Academic research articles on artification in business and hospitality.

Cite	Context	Method	Main findings
Artification			
Kapferer (2014).	Luxury brands-/ products LV, Chanel	Conceptual	Review, apply to luxury brands.
Vukadin., Lemoine and Badot (2019).	Madura Retail stores-Paris	Field experiment	Artification increases image but not profits.
Masè Cedrola, Davino and Cohen-Cheminet (2020).	LV bag	Scenario-based online experiment	Active collaboration between art/brand necessary for positive impact on loyalty.
Bargenda (2020).	Banking services	Qualitative interviews	Art association benefits provider's image through history/authenticity.
Gravari-Barbas and Jacquot (2019).	Paris flea market	Qualitative interviews	Artification an important aspect for repositioning and expanding flea market.
Julia-Sophie (2018).	Fashion brands	Qualitative interviews fashion experts	Art adds authenticity to brand, and when art is integrated into full value chain increases brand equity.

Table 14.1 (continued)

Cite	Context	Method	Main findings
Ana, Apiradee and Nuttapol (2018).	Bangkok mall	Mall intercept survey	Art influenced hedonic and symbolic, not utilitarian values associated with mall shopping experience.
Vukadin, Lemoine and Badot (2016).	Retail	Conceptual	Artification is costly, needs to fit within the organization's objectives. Finding right metrics key as many art effects might occur low awareness.
Retail – Art Infusion			
Logkizidou, Bottomley, Angell and Evanschitzky (2019).	Hand bag	Experiment	Displaying items like a museum (vs traditional store display) viewed as more luxurious.
Joy, Wang, Chan, Sherry and Cui (2014).	LV stores	Qualitative interviews	Identifies dimensions of how customers interact/experience art/retail environments.
Chailan (2018).	Luxury brands in France and Italy	Micro-process analysis	Identified different strategies linking brand activities to art.
Dion and Arnould (2011).	45 luxury stores in Paris	Qualitative interviews	Artistic director diffuses aesthetic design into stores, magic and awe.

Artification in the context of the hospitality industry has long been active if not explicitly studied as such. The La Colombe d'Or in Saint Paul de Vence, France, is perhaps among the first widely recognized examples of active collaborations between artist and hotelier, with works on display by such renowned artistic luminaries as Miro, Braque, Leger, and Calder, among others; and some artists stayed at the property, often in exchange for food or lodging (*Financial Times* 2015).

The study of the incorporation of art into the service experience has primarily occurred within the retail context (and is often published using the term "art infusion"). We expanded our search to included articles mentioning art infusion and luxury in the context of services and three more articles appeared (see bottom of Table 14.1).

The artification and art infusion in services articles range from very involved field studies to more sterile on-line surveys using fictitious scenarios. Research methods involve surveys, experiments, and in-depth interviews. The impact of art on consumer experience may occur at both conscious and unconscious levels (Vudakin et al. 2016). As artification is a complex organizational process involving changing perspectives, it is difficult to study since contexts may make generalizability difficult. In spite of these limitations, several important findings have emerged. First, that the

art infusion effect observed with products carries over to retail services (Ana et al. 2018; Joy et al. 2014; Dion and Arnould 2011). Second, the artification concept has been effectively used to describe the elevation of brands to higher luxury status (Kapferer 2014; Chailan 2018). Third, the effect is different than cobranding effects in that the consumer doesn't necessarily have to enjoy the art or artist for the provider to see some of the positive benefits of the association (Julia-Sophie 2018). Fourth, the benefits of artification might not result in short-term financial benefits but instead impact perception and image which may make it more appealing to the luxury sector (Vudakin et al 2019). Fifth, the design/display of the art has important implications (Logkiziduo et al. 2019; Joy et al. 2014), which we will build on later in this chapter as we identify how artification can be infused into the hotel experience.

The Process of Artification

The effects of art infusion on consumers are immediate, but the actual process of artification is more extensive and involves a change in how the organization and the customer come to view the product/service (in our case moving from a hotel to becoming an artistic expression). Shapiro (2019) lists the following stages of artification and we provide examples of how luxury hoteliers have started to embrace these aspects:

1. *Aspiration* – the movement of objects or events into the sphere of art. Within hotels this represents changing how wall art is perceived; for example, rather than being seen merely as a decorative element on a wall, it becomes an object deserving of the term "art." Part of this process involves educating guests about the origins of the work. For example, to complement the Art Basel experience, the Miami Marriott Marquis has offered pop-ups on the property to educate guests about its art and festival, thus combining space and art to create an ideal learning environment.

2. *Displacement* – siting an object out of context to reveal the possibilities of circulation, renaming, exchange, and the like (Shapiro 2019). Suri (2019) reports a survey by the non-profit Americans for the Arts in which 72% of correspondents reported that they enjoy arts in 'non-art' venues including hotels. Having artwork normally on view in a museum instead on display in a hotel is a natural displacement; and some hospitality spaces have gone to even greater lengths by designing outdoor spaces to display art. Dorado Beach, a Ritz Carlton property in Puerto Rico, features works of art throughout its golf course, including graffiti-adorned golf carts by muralist Sofia Maldonado and fluttering Bhutanese prayer flags installed by artist Zaida Goveo at the edge of the nearby Pterocarpus Forest. As reported by Art Acacia (2019) some hotels partner with museums, foundations, or in-house curators to devise inside and external spaces saturated with art.

3. Renaming – codifying a new status via a different name, for example, when the term "fashion" was replaced for a specific segment of the fashion industry by the far more specific "haute couture" (Joy et al. 2014). The Park Hotel in Amsterdam has created "The Gallery Zone" to inspire guests with the work of emerging artists. In collaboration with local galleries and artists, The Gallery Zone presents the work of a notable emerging artist every two months. The exhibitions are exclusive to the hotel's gallery. The term "gallery zone" itself reflects the collaboration of art galleries/artists and hotel spaces.

4. Institutionalization – an imprimatur or acknowledgment from legitimate sources of a given item or event's status. Art that has been exhibited in museums, or merely owned by museums, has greater value than art relegated to homes, storage, or corporate offices. To be perceived as legitimate in the context of art, luxury brands must be perceived as "disinterested" and "without an instrumental economic agenda" (Holt 2002) and "of the art world" (Massi and Turrini 2020). Having an art museum or installation in a hotel can meet such standards, provided the embrace of art displays is not seen as a money-making venture. For example, Canadian entrepreneur Zita Cobb returned to her home, the remote Fogo Island, to create the luxury hotel the Fogo Island Inn; she further established the Shorefast Foundation, which provides micro-loans for small businesses, supports ocean sustainability initiatives, and works to restore the island's unique architectural landmarks. A focus on the arts has been a constant for her foundation which hosts international artist-in-residence programs. British artist and writer Liam Gillick, an early artist-in-residence, noted to a reporter from *Artworld* (2019): "It's interesting to see art here dealing with production, not consumption" (Brown 2019).

5. Conflation of art with non-art – as seen in the Art Deco, Arts and Crafts, and Bauhaus movements, items such as buildings, furniture, clothing, and other utilitarian objects became perceived as art via their respective aesthetic functions. Even the choice of creating a space echoing a given artistic movement, such as a hotel whose architectural design serves as an homage to Minimalism, Art Moderne, or Brutalism, highlights a definition of space and how that space encompasses art as embodied by a given movement. As a further example, the Joali Maldives Resort, described as among the first immersive art hotels, focuses on art inspired by and incorporating elements of nature. Chosen by the Istanbul-based art and design firm No LaB (Dao 2019), works are located in both private rooms and common areas. These include Misha Kahn's Under-Water Corals, which can only be seen underwater, and Pork Hefer's Manta Ray Tree House, which houses the property's experiential dining concept. Embracing art as essential to its identity has given the resort a unique appeal to lovers of contemporary art.

6. Evaluation – by the many journalists, art critics, and other writers, collectors, juries, art exhibitions, art gallery and museum staff, and corporate staff in charge of art acquisitions who shape artists' profiles, and who are often more broadminded

in their tastes than academicians of earlier decades. Not surprisingly, artist recognition, including digital artists, has increased in the age of social media. For hotels, having their designs and artworks featured in magazines such as *Architectural Digest* represents recognition of their form as a work of art. Guests of the 21C Museum Hotels, a hotel group developed by two art collectors, will find art everywhere: the restaurant and bar, the in-room video art channel, elevator lobbies, and hallways. This hybrid hotel concept, coupling the traditional concept of a hospitality space with an art museum space, has garnered praise from such notable outlets as *Condé Nast Traveler* and *The New York Times*, which described it as "one of the pioneering examples of bridging the worlds of art and hospitality" (Hospitalitynet 2017).

7. *Aesthetic formalization* – an understanding of the process of artification by drawing on an established art form such as the visual and theatrical arts (Shapiro 2019). The Conrad Indianapolis has "Collection" suites featuring signed pieces by Salvador Dalí, Pablo Picasso, William John Kennedy, and Andy Warhol. Each suite is devoted to a different art genre, including contemporary, surrealism, modernism, and pop art. The suites include expertly curated furnishings from designers like Eero Saarinen and Jonathan Adler (*Elle Decor* 2019).

8. *Formal roles* – the formalization of roles such as theater director, choreographer, and couturier (Shapiro 2019). In the context of hotels, such formal roles would be those of the art curator or art director. Dianne Vanderlip, curator at the ART hotel in Denver, employed a very particular approach in creating her hotel's collection: "The first criterion was that every work was truly museum quality, that it could proudly be part of any first-rate art collection . . . With that standard guiding our efforts, we gathered an ensemble of contemporary artworks that would provide guests with unique and unexpected opportunities to enjoy those works" (Suri 2019).

9. *Intellectualization* – discourse related to a given object or activity becomes more formalized and concretized; in the context of hotels, having artists discuss their works on-premise is an example of such activity. For example, the salon at the Adolphus Hotel in Dallas, Texas, has become a gathering place for art event series and salon-style talks on topics ranging from architecture to automobiles. The salon features local Texas art curated by Lucia Simek of Dallas' acclaimed Nasher Sculpture Center (Dao 2019).

10. *The reorganization of 'time' or 'duration'* – performances, events, or objects gain longevity once they transition to becoming art, and thus also gain legitimacy. Once an item or activity accrues cultural currency through artification, investing time in its production and preservation becomes appropriate. For example, Masaru Watanabe, general manager at the Palace Hotel in Tokyo, suggested in an interview that enhancing guest experience is a key motivation for investing time, effort, and money in hotel art; showcasing and curating local work and culture has also been part of his strategy from the outset: "We told [our curators] that all pieces must complement the

hotel's overall design, a concept centered on the exquisite beauty of the nature surrounding the property, and also the rich culture of Japan in general . . . We 'educate' guests about art . . . just as a gallery would" (Razavi 2016).

Benefits of Artification and Affordances of Place for Luxury Brands

Sotheby's has recently developed an art and luxury curriculum; instructor Federica Carlotto noted that "Art and luxury have a long history of influencing each other to create timeless, aspirational experiences" (Grassi 2019). Commonalities between luxury hospitality and the art world make for a mutually beneficial relationship (Jin and Cedrola 2017); each has a system of shared values and aspects for attracting the luxury consumer: authenticity, aesthetics, artisanal experts, exclusivity, heritage, scarcity, and aura.

Artification merges the various contact points with which a brand can develop a relationship with art, from philanthropy and arts sponsorship to creative collaboration with artists (Mase et al. 2020). Such merging appeals to luxury brands can be a means to sidestep commoditization, such that a brand can be perceived as belonging to the spheres of art and culture as well as commerce, which in turn lends mystique to the brand (Kapferer 2014).

Artification can highlight the emotional and sensory aspects of a luxury brand. Luxury fashion brands use artification strategies to stress the importance of traditional handcrafted and artisanal methods and intuitive expertise to create a sense of authenticity (Kapferer 2014). Maintaining exclusivity is currently one of the biggest challenges for luxury firms, as it is incompatible with the logics of volumes and market expansion (Kapferer 2012). Being hand crafted, artworks are also scarce and rare as opposed to commodified and mass-produced pieces. Associated with the aura (halo) concept is that of sacredness, a characteristic of artworks. In ancient times, art and luxury shared the same places of worship (temples, churches, pagodas, and pyramids) (Kapferer 2012). These types of intangible benefits are more paramount for luxury brands than for ordinary brands (Koronaki, Kyrousi, and Panigyrakis 2018). Koronaki et al. (2018) found that arts-based initiatives have an emotional value for consumers.

Luxury Brand Artification and the Meaning of Space: From Retail to Hospitality Spheres

Incorporating artistic elements into retail design has focused on three aspects: (1) design/architectural (layout, merchandising); (2) sensorial/ambient (music, scents,

lighting); and (3) social elements (interactions with/between customers and employees) (Vukadin et al. 2016). In the context of artified stores, Kapferer (2014) found that artification leads to a more luxurious and exclusive brand image. Dion and Arnould (2011) and Joy et al. (2014) both find that artistic elements within a design can add perceived value to the shopping experience. Joy et al. (2014) in particular demonstrates how the aspects of artification can be infused into retail design.

The recognition that art can elevate retail experiences has influenced many luxury brands to incorporate art – in some cases including actual brand-identified museums – into their commercial venues. For example, the fourth floor of the Chanel store in Ginza, Japan, is dedicated to art exhibitions. Christian Dior and Louis Vuitton each have branded art museums in France, as Prada has in Italy. Chailan (2018) finds that French and Italian luxury brands that partnered with the arts are perceived by consumers as more special and rare. It is not surprising then that luxury companies such as Cartier, Prada, Gucci, and Armani have embraced the 'luxury as art' model (Okonkwo 2007). Collaborations with local art and support for the arts have led some to coin the luxury houses of Prada and LVMH as modern-day Medicis (Grassi 2019), which effectively serve as patrons of the arts.

While some hotel industry leaders question whether luxury fashion brands can run hotels (Hariela 2019; Verdon 2019), we posit that their expertise in mastering artification in their retail spaces makes them exceptionally suited to extend their portfolios to incorporate hospitality. As Joy et al. (2014: p. 347) recount: "By overtly embracing art as an integral element of its commercial core, the luxury industry giant Louis Vuitton has reinvented itself as a hybrid institution, part luxury fashion store and part museum gallery, creating what we term a 'M(Art)World' – a market that contains art within its very identity." In 2010, LVMH introduced LVMH Hotel Management, to run its hospitality businesses (https://www.lvmh.com/news-documents/press-releases/lvmh-creates-lvmh-hotel-management/): 46 luxury hotels, including six Bulgari hotels; along with restaurant, train, and river cruise properties, including New York's 21 Club, and the Orient Express and Royal Scotsman trains. In 2006, the group developed a test-market hotel, the Cheval Blanc Courchevel to define their hotel concept of experiential luxury. They have since opened multiple Cheval Blanc hotels (which they call 'Maisons'), with more planned in Paris, London, and Beverly Hills. Each Maison has its own signature color palette and scent. For example, the Courchevel's color is taupe "to transport Cheval Blanc to [the] natural surroundings of the French Alps" (https://www.chevalblanc.com/en/maison/courchevel/travel-diaries/art-design/) and its signature scent is a spicy Eastern fragrance that appears throughout the hotel in various forms, such as candles and diffusers. The artification is seen on the website, which focuses on the Art of Emotion (https://www.lvmh.com/houses/other-activities/cheval-blanc/): "Celebrating a delicate alchemy between tradition and innovation, local architecture and timeless elegance, our Maisons blend bold design and contemporary inspirations with local

craftsmanship . . . Cheval Blanc Paris pays tribute to Art Déco heritage and French savoir-faire and craftsmanship."

As Olivier Lefebvre, Head of Hotel Activities, LVMH Hotel Management, states on the LVMH website (created in 2006) devoted to Cheval:

> Cheval Blanc is based on four core values, the sum of which is unique in the world of hospitality. Craftsmanship, with a sense of detail pushed to extremes and painstaking groundwork on the product itself. Exclusive privacy, because the number of rooms is purposefully kept to a minimum. Creativity, which means that traditional codes are reinterpreted with boldness and modernity. And finally, the Art de Recevoir [the Art of Receiving] and its thoughtful approach to service, which gives a unique character to each stay.

Lefebvre specifically references boldness and modernity, and providing guests with a stay elevated by "a unique character."

Artified Design and Customer Response: Key Elements of Distinction

Joy et al. (2014) conducted an ethnographic study of the LV retail properties in Hong Kong as a means to understand how consumers react to these artified settings and identify key elements within them that provide distinction. First these researchers found that there needed to be a tangible aspect of the design as a symbol of the brand's durability. In the LV stores this was found in the very architecture of the design, which made the stores look like shimmering glass boxes alive with light. The researchers term this luxurious aspect "*Luxecture*" which extends to the public sculpture, ornamentation, and technology used in the retail space. In the LV stores, the consumers commented on the glass architecture, with one describing the store's beautiful façade as "a jewel in itself" (p. 351). In Table 14.2, we can see how this idea of sculpture is being employed at the Cheval Blanc, where large mirrored horses guard the Maison, and inside special artist-designed bears provide a distinctive element, such as the "Kanye Bear" statue designed by Takashi Murakami that greets guests at the front entrance. We see this aspect occurring in other luxury hotels as well – the image from the Dolder Grand in Zurich shows their outdoor art experience from artist Nicki de Saint Phalle, as a sense of art and place combined.

Joy et al. (2014) employ the term "*Luxemosphere*" to describe the prestigious and luxury universe created by the LVMH brand. Architect Peter Marino, who designed the LV Hong Kong stores, was also the creative force behind the Cheval Blanc Maisons in Paris and Beverly Hills. At a Hong Kong LV flagship store, he created staircases alive with ever-changing digital screens that dazzled customers. In Beverly Hills, LV had a boutique ten-room pop-up hotel in the space where the new Beverly Hills Cheval Blanc will stand, featuring artists such as Sol LeWitt, Jeff

Koons, and Alex Israel; Marino reports that the art theme will carry over to the new property (Dobson 2020). Part of the *"Luxemosphere"* dimension is incorporating art into the experience in ways that intrigue and entertain. The Cheval Blanc Paris has art integrated into all aspects of the property, as seen in the dining room, pictured in Table 14.2. In 2015, New York-based art dealer Lio Malca – who represents artists such as KAWS, Warhol, and Jean-Michel Basquiat – renovated a hotel property, Casa Malca, in Tulum, Mexico (https://www.casamalca.com/en/) specifically so guests could enjoy "luxury and art in the same location" (Brara 2019); note the Keith Haring print wallpapers in the hotel bar (Table 14.2). The property also features a KAWS sculpture in the lobby, and an immersive light installation provides a backdrop for the ground-floor pool.

Lighting is a critical aspect in the artification of retail, with Joy et al. (2014) labeling this aspect *"(De)Luxe: Luminosity and art."* Luxury products are envisioned in terms of luminosity and beauty (Kapferer 2014). LV retail consumers described the store as "sparkling" and reveled in the sophisticated use of light to connote exclusivity and excitement in the space. The Cheval Blanc Courchevel spa similarly uses lighting in dramatic ways (see Table 14.2). The Peninsula Hotel launched a "Love Art at the Peninsula Hong Kong" initiative in 2014, which offered public art experiences led by contemporary artists such as Tracey Emin and Richard Wilson on the hotel grounds. The hotel's arts program has continued to expand in the following years, including a conversation series with artists from Hong Kong and abroad, guided trips to galleries and museums around the city, and a traveling exhibition appearing at all Peninsula properties titled "Art in Resonance," comprising immersive installation works by Janet Echelman, Iván Navarro, Timothy Paul Myers, and the Shanghai-based artist and architect Zhi-gang Lu of MINAX collective (Brara 2019). The MINAX exhibition is featured in Table 14.2, showcasing its creative use of lighting with art and space seamlessly integrated.

Incorporating art objects into the retail experience to create an aesthetic appeal is referred to as *"Luxedesigners"* by Joy et al. (2014); the authors note the effectiveness of LV's collaborations with such artists as Takashi Murakami to add style and modernity to the brand experience. The importance of creating an aesthetic feel in various aspects of hotel and resort properties can be seen in Table 14.2. The Ritz Carlton, Toronto, incorporates aesthetics in a uniquely different way, with the painter Jacqueline Poirier as its official artist in residence. The artist hand-paints hyper-realistic trompe l'oeil chargers on display and in use by guests throughout their dining rooms. Poirier refers to her plate art, fittingly, as 'plart,' and to herself as the Crazy Plate Lady (https://thecrazyplatelady.com/about/).

The importance of *"Authenticity"* to the luxury retail experience was noted by LV Hong Kong customers (Joy et al. 2014: p. 134): "Each item is a testimony to the devotion of the artisan, along with his/her creativity." Many luxury hospitality brands broadcast and highlight their authenticity through partnerships with local artists. The Cheval Blanc properties partner with artists in the community. The

Andaz Scottsdale Resort & Bungalows in Arizona has an artist-in-residence program in partnership with the Cattle Track Art Compound, an artist community founded in 1936. Local artists, jewelers, potters, and performers lead classes on the property and other interactive events for guests, introducing them to a cornucopia of local community offerings.

Joy et al. (2014) identifies the service aspect as key to making artification possible in the LV retail experience, which they term *"Luxescape: curatorial attention and service."* Curation and knowledgable partners set the brand experience apart. These aspects are implicit in the Cheval Blanc identity, as noted on the website:

Inspired by the spirit of LVMH and its love for contemporary innovation, Cheval Blanc revisits the codes of ultra-luxury hospitality with bold modernity. This unique approach to service leads to made-to-measure works of art and design, transforming every Maison into a living gallery. This celebration of creativity and quest for constant reinvention extends from art and design, to thoughtful service gestures aiming to make our guests' stays that much more exquisite.

The artist as service provider in hotels is a means of giving guests specialized attention. The small boutique Ace Hotel New York, for example, is known for its art programming – its property in New York City has a particularly idiosyncratic residency. Every Sunday, an artist is invited to spend the night at the hotel and then reveal a new artwork in the morning (Art Acacia 2019). Art and design institutions such as the Museum of Art & Design, Eyebeam Art + Technology Center, and Printed Matter are regular partners of the hotel.

The final important dimension of the retail artified experience, as identified by Joy et al. (2014), is *"LuxeArt foundation: luxury brand as patron for the arts,"* previously addressed in our discussion of Prada and LVMH's partnerships with a wide range of artists. As seen in the example of the Ace Hotel, hotel groups continually search for ways to incorporate and support local artists.

Consumer experiences in the LV retail stores are co-created through narratives of what Joy et al. (2014) deemed important experiential elements: architecture, interior decoration, cutting-edge technology, designer mystique, service personnel, and explicit connections to avant-garde art. All these elements are on display in LVMH's Cheval Blanc luxury destinations, and in a range of other high-end hospitality spaces as shown in Table 14.2.

Table 14.2: Dimensions of artified retail experience in hotels.

	LVMH	Other Hotel Examples
Luxetecture:	Cheval Blanc Courchevel 	Dolder Grand in Zurich, Niki de Saint Phalle, Le Monde (1989)
Luxemosphere:	Cheval Blanc, Courchevel 	The Keith Haring-themed bar below: Casa Malca, Tulum

Table 14.2 (continued)

	LVMH	Other Hotel Examples
(De)Luxe: luminosity and art	Cheval Blanc Spa, Courchevel	MINAX's "The Wonder Room" installation at The Peninsula Hong Kong
Luxedesigners: creating aesthetic experiences via contemporary art objects	Cheval Blanc Pool Maldives	Ritz Carlton, Toronto

Discussion

The purpose of this chapter has been to introduce artification to both describe the current elevation of luxury hospitality as well as provide research insights into how artification can be incorporated into future luxury hotel design. We begin this section by discussing the practical aspects of artification and the associated risks and benefits for hospitality operators. We then turn our attention to conceptually integrating the artification and M(Art) design work to help set an agenda for future hospitality research. We discuss several potential research areas for investigation.

Practical Implications

As we have demonstrated, high-end luxury hotels have become artified with their use of space devoted to art, thus elevating the experiential luxury aspects of guest stays. Overall, we have highlighted the benefits of artification. There are noteworthy risks hoteliers face when they engage in the artification process – such development can be not only costly in time and money, but also potentially narrow the target customer demographic; the more unique a given art installation is, the more niche it can become. Not every consumer with a hunger for exclusive, and even confrontational, experiences wants to spend the night in a hotel suite often described as sepulchral (British sculptor's Antony Gormley's "Room," discussed in the introduction). On the flip side, however, if the brand does not go "all in" and accept the artification as part of its overall brand strategy, it might not receive the potential benefits (Masè et al. 2020).

Context in terms of place and time is also critical when evaluating artification. There may be destinations that are more open to artified experiences, such as Miami with its Art Basel experience. Other destinations may be a more difficult sell for artification. Not all collaborations between art and luxury hospitality have been successful. The Guggenheim Las Vegas at the Venetian closed its doors in 2002, just fifteen months after opening; its sister museum at the resort shut down only six years later (Peterson 2008). While the company recognized the intangible benefit of having a world-class museum under its roof, the opportunity cost where it could receive higher revenue per square foot won out. We suggest that artification is becoming more relevant in the 21st century as hoteliers seek to differentiate themselves and appeal to a younger, more daring clientele. In a more modern take on artification, the Cosmopolitan luxury resort in Las Vegas offers Art-o-matic machines (repurposed cigarette vending machines produced by artist Clark Whittington) that dispense small handmade works of art and jewelry to intrigued hotel guests. The hotel also displays works of art that fit their edgy image: "What happens behind closed doors? Just the right amount of wrong."

The Las Vegas Guggenheim example highlights another potential issue: The art museum was not well integrated into the experience (many guests when surveyed were unaware of its existence), and visitors found the fee to enter the museum off-putting (Braun-LaTour, Hendler, and Hendler 2006). Hospitality managers must balance entry costs with accessibility; do they wish to stress exclusivity (the art is only available to paying guests) or inclusivity (anyone can enter the gallery off the street to view exhibitions)? The issue with making art accessible to all can be seen in the Bellagio's lobby, which features "Fiori di Como," Dale Chihuly's massive $10 million, 2,100 square-foot blown-glass sculpture of flowers riotously in bloom on its ceiling, alive with light and deeply saturated color. On any given day, in pre-pandemic numbers, as many as 20,000 visitors came to gaze up at the sculpture, with some lying on the floor for a more panoramic view. Unsurprisingly, the

sculpture is high on many lists of top Las Vegas attractions (Padgett 2013). But if a guest is trying to make their way through a crowded lobby, 20,000 people will inevitably detract from the experience. Many hotels, among them Wynn Las Vegas and the Cheval Blanc Courchevel Hotel in the French Alps, limit accessibility to art to their paying guests. Balancing the competing needs of inclusivity versus exclusivity is an ongoing and thorny concern. The French Sofitel hotels and resorts chain addresses this in an interesting way, where the public art is available for sale – if you like what you see, you can take it home with you, and thereby enjoy a truly exclusive experience (Razavi 2016).

Another concern is staff education at art-infused properties, since having an original Warhol behind the front desk will not necessarily enhance the guest experience unless staff members are themselves knowledgeable about the artist. The Royal Monceau Raffles Hotel in Paris not only has its own gallery, it also has a team of art concierges on staff: doctoral students who are available to craft individually tailored itineraries for guests eager to explore the city's little-known galleries and cultural idiosyncrasies on their own, rather than join the hordes in the queue for the Louvre (*Daily Telegraph* 2018).

Luxury hotels are seeking to develop brand stories and narratives (Ryu et al. 2018) and art lends an opportunity to make such narratives unique. Martin Gerlier, curator of the Sofitel Bangkok Sukhumvit's onsite S Gallery, in an interview said, "For me, art is what really defines the luxury hotel experience. We are providing access to artwork as a service to our guests" (Razavi 2016). The Saint Kate Arts Hotel in Milwaukee, as its name implies, has infused its origin story into the art nature of the property. As its website states: "The name Saint Kate gives nod to Saint Catherine, the patron saint of arts and the original champion of the creative process, and then spins around and walks firmly in a bold, modern new direction" (https://www.saintkatearts.com).

The Lanesborough Hotel in Knightsbridge used art as part of its redesign process. The Lanesborough focused on sourcing art from the 1830s and earlier to create the type of environment of the wealthy English family living in London at the time (*Financial Times* 2015). Thus, the hotel features paintings by 18th century masters such as Sir Joshua Reynolds, as well as military and hunting scenes – precisely what one might expect to see on the walls of a Georgian mansion. Such artwork provides a narrative of authenticity for the guests and speaks to the heritage aspect of the hotel.

Hoteliers seeking to distinguish their properties will find intertwining their brand with art to be an effective approach, whether featuring art from the past as an expression of heritage, or the present through the audacious originality of contemporary creations. Further, they will find their brand narratives enhanced, with the potential to offer guests more personally meaningful experiential opportunities, and thus a deeper, more emotional connection to luxury. Art and commerce need not be in conflict; each can serve to elevate the other.

Conceptual Implications

The artification literature had been primarily focused on the sociological process from which a commodity good becomes viewed as a work of art. The art infusion research has focused on how the very presence of artwork can uplift consumer evaluations. Joy et al.'s (2014) work demonstrated how art can be integrated into the consumer retail experience. In Figure 14.2 we integrate these different perspectives with the lighter elements representing aspects of the artification process and the darker elements coming from the retail design work. Quadrant A represents the aspects that operators need to consider in their architectural and experience design, such as lighting. Quadrant B represents aspects operators need to incorporate into their organizations, such as charitable elements or naming new features to their offerings. Quadrant C is the one in which artification and design show the most collaboration, with curation adding uniqueness and authenticity to the offering. Quadrant D represents how external agents view the operator, and whether it is being recognized for its artistic achievements.

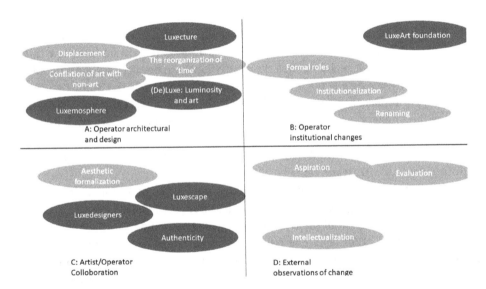

Figure 14.2: Integration of artification and M(Art) retail design.

Quadrant A builds on the architectural and experience design research, and hospitality researchers might consider what elements are most effective in creating an artified experience. Researchers might explore how often the art design needs to be changed, recognizing that larger installations may remain for decades whereas smaller pieces and ambient factors such as lighting can be changed more frequently. The best location for art within the hotel, as well as how to balance

inclusive/exclusive experiences should be considered in the overall design. Researchers might consider investigating *what type* of artist collaboration is most effective (Quadrant C) – local artists that highlight the unique *terroir* of the hotel destination or world-renown artists that will capture broad interest? Researchers could study how best to integrate cultural changes within the organization to highlight artification (Quadrant B). Investigating how the external world views and shapes the artification process is an important concept and may involve finding new measures of success. For example, the Las Vegas Guggenheim was seen as a failure when evaluated from the perspective of revenue per square foot, but if measured by number of media articles, or critical acclaim, the project may have been viewed more positively.

Future Research Directions

This chapter helps to create a foundational understanding of artification and how it can be effective in elevating the luxury guest experience. Future research might consider how art enhances/detracts from other types of servicescape design factors. Other researchers might investigate the similarities/differences between art collaborations and cobranding – for instance, the Fairmont Hotels have teamed up with Lexus. How might a brand decide which type of collaboration is most effective?

Given that art infusion effects are more immediate than the social impact of artification, researchers can study the impact of art on guest reactions in real time. However, studying the effects of a property becoming artified may be more difficult. Finding the right metrics to identify the positive impact of art on the guest experience is key. Braun-LaTour et al. (2006) found that while many guests appreciated having the Guggenheim under the roof of the Venetian, this fact was missed in traditional survey measures. In addition, other researchers have found the art effects may benefit an image but not result in short-term revenue gain (Vudakin et al. 2019). Researchers might consider following a property before and after artification to identify potential benefits as well as risks.

References

Ahn, J., J.K. Park, and H. Hyun (2018). "Luxury product to service brand extension and brand equity transfer." *Journal of Retailing and Consumer Services* 42: 22–28.

Alberge, D. (2015). "Luxury hotels becoming fine art spaces." *Financial Times*. https://www.ft.com/content/59d78f94-6d06-11e5-8171-ba1968cf791a (accessed 1/31/2021).

Ana, V., W. Apiradee, and A. Nuttapol (2018). "When art meets mall: Impact on shopper responses." *Journal of Product and Brand Management* 27(3): 277–293.

Art Acacia (2019). "Art in hotels: Luxury or necessity." https://medium.com/@inna_13021/art-in-hotels-luxury-or-necessity-d1c367bf18c8\ (accessed 1/31/2021).

Bargenda, A. (2020). "The artification of corporate identity: Aesthetic convergences of culture and capital." *Qualitative Market Research* 23(4): 797–819. doi: http://dx.doi.org.proxy.library.cornell.edu/10.1108/QMR-12-2017-0182.

Braun-LaTour, K.A., F. Hendler, and R. Hendler (2006). "Digging deeper: Art museums in Las Vegas?" *Annals of Tourism Research* 33(1): 265–268.

Bernstein, L. (1999). "Luxury and the hotel brand: Art, science, or fiction?" *Cornell Hotel and Restaurant Administration Quarterly* 40(1): 47–53.

Bitner, M.J. (1992). "Servicescapes: The impact of physical surroundings on customers and employees." *Journal of Marketing* 56(2): 57–71.

Bowen, J.T., and B.A. Sparks (1998). "Hospitality marketing research: A content analysis and implications for future research." *International Journal of Hospitality Management* 17(2): 125–144.

Brara, N. (2019). "Here are 8 breathtaking luxury hotels around the world where art is a big part of the allure." https://news.artnet.com/art-world/8-art-filled-hotels-around-the-world-1619722?utm_content=buffer9c052&utm_medium=social&utm_source=pinterest.com&utm_campaign=buffer (accessed 1/31/2021).

Brown, K. (2019). "How a $41 million luxury hotel is sustaining an ambitious arts and ecology initiative on a remote Canadian island." *Artnetnews*. https://news.artnet.com/art-world/fogo-island-arts-1563967 (accessed 1/31/2021).

Carbone, L.P. (2004). *Clued in: How to keep customers coming back again and again*. Upper Saddle River, NJ: Prentice Hall.

Carbone, L.P., and S.H. Haeckel (1994). "Engineering customer experiences." *Marketing Management* 3: 8–19.

Chailan, C. (2018). "Art as a means to recreate luxury brands' rarity value." *Journal of Business Research* 85: 414–423.

Chu, Y., L. Tang, and Y. Luo (2016). "Two decades of research on luxury hotels: A review and research agenda." *Journal of Quality Assurance in Hospitality and Tourism* 17(2): 151–162.

Dao, D.Q. (2019). "10 luxury hotels where you can find stunning contemporary art." *Forbes*. https://www.forbes.com/sites/dandao/2019/07/08/10-best-hotels-contemporary-art/?sh=363bfa13fea5 (accessed 1/31/2021).

Dion, D., and E. Arnould (2011). "Retail luxury strategy." *Journal of Retailing* 87(4): 502–520.

Dubois, B., S. Czellar, and G. Laurent (2005). "Consumer segments based on attitudes toward luxury: empirical evidence from twenty countries." *Marketing Letters* 16(2): 115–128.

Dobson, J. (2020). "The future of Beverly Hills: from A Gucci restaurant to a Cheval Blanc hotel and more." *Forbes*. https://www.forbes.com/sites/jimdobson/2020/04/29/the-future-of-beverly-hills-from-a-gucci-restaurant-to-a-cheval-blanc-hotel-and-more/?sh=618d10bb12d2 (accessed 1/31/2021).

Dubois, B., S. Czellar, and G. Laurent (2005). "Consumer segments based on attitudes toward luxury: Empirical evidence from twenty countries." *Marketing Letters* 16(2): 115–128.

Elle Decor (2019). "16 breathtaking art hotels that double as galleries." https://www.elledecor.com/life-culture/travel/g8630790/art-gallery-hotel/ (accessed 1/31/2021).

Fillis, I. (2011). "The evolution and development of arts marketing research." *Arts Marketing* 1(1): 11–25.

Godey, B., A. Manthiou, D. Pederzoli, J. Rokka, G. Aiello, R. Donvito, and R. Singh (2016). "Social media marketing efforts of luxury brands: Influence on brand equity and consumer behavior." *Journal of Business Research* 69(12): 5833–5841.

Godfrey, S. (2020). "Luxury hotels and a 'sense of place': The branding imperative." *Hospitality.net*. https://www.hospitalitynet.org/opinion/4097060.html (accessed 1/31/2021).

Goldhagen, S.W. (2017). *Welcome to your world: How the built environment shapes our lives.* New York: HarperCollins.

Grassi, A. (2019). "The real reason why luxury fashion brands love the art world." *Fast Company.* https://www.fastcompany.com/90337292/the-real-reason-why-luxury-fashion-brands-love-the-art-world (accessed 1/31/2021).

Gravari-Barbas, M., and S. Jacquot (2019). "Mechanisms, actors and impacts of the touristification of a tourism periphery: The Saint-Ouen flea market, Paris." *International Journal of Tourism Cities* 5(3): 370–391.

Hagtvedt, H., and V.M. Patrick (2008). "Art infusion: The influence of visual art on the perception and evaluation of consumer products." *Journal of Marketing Research* 45(3): 379–389.

Hariela, D. (2019). "Bulgari, Armani, Versace: why luxury fashion brands open hotels as more get into the game." https://www.scmp.com/lifestyle/fashion-beauty/article/3006568/bulgari-armani-versace-why-luxury-fashion-brands-open (accessed 1/31/2021).

Holt, D.B. (2002). "Why do brands cause trouble? A dialectical theory of consumer culture and branding." *Journal of Consumer Research* 29(1): 70–90.

Hospitality.net (2017). "How two famous art collectors founded a growing luxury hotel brand." *Hospitality.net.* https://www.hospitalitynet.org/news/4083934.html (accessed 1/31/2021).

Howarth, A. (2014). "Antony Gormley creates a giant metal sculpture you can sleep in." *dezeen.com.* https://www.dezeen.com/2014/06/11/antony-gormley-room-giant-man-sculpture-beaumont-hotel-london/ (accessed 1/31/2021).

Jin, B., and E. Cedrola (eds.) (2017). *Fashion branding and communication: Core strategies of European luxury brands.* New York: Palgrave Mcmillan.

Julia-Sophie, J. (2018). "Art as strategic branding tool for luxury fashion brands." *Journal of Product and Brand Management* 27(3): 294–307.

Joy, A., J.J. Wang, T.S. Chan, J.F. Sherry, and G. Cui (2014). "M(Art)worlds: Consumer perceptions of how luxury brand stores become art institutions." *Journal of Retailing* 90(3): 347–364.

Kapferer, J-N. (1997). "Managing luxury brands." *Journal of Brand Management* 4: 251–260.

Kapferer, J-N. (2012). "Abundant rarity: The key to luxury growth." *Business Horizons* 55(5): 453–462.

Kapferer, J-N. (2014). "The artification of luxury: From artisans to artists." *Business Horizons* 57: 371–380.

Koronaki, E., A.G. Kyrousi, and G.G. Panigyrakis (2018). "The emotional value of arts-based initiatives: Strengthening the luxury brand–consumer relationship." *Journal of Business Research* 85: 406–413.

Lee, H-C, W-W Chen, and C-W Wang (2014). "The role of visual art in enhancing perceived prestige of luxury brands." *Marketing Letters* 26: 593–606.

Logkizidou, M., P. Bottomley, R. Angell, and H. Evanschitzky (2019). "Why museological merchandise displays enhance luxury product evaluations: An extended art infusion effect." *Journal of Retailing* 95(1): 67–82.

Masè, S., C. Cedrola, C. Davino, and G. Cohen-Cheminet (2020). "Multivariate statistical analysis of artification effect on customer-based brand equity in luxury brands." *International Journal of Arts and Management* 22(3): 55–66.

Massi, M., and A. Turrini (2020). *The artification of luxury fashion brands.* New York: Palgrave MacMillan.

"Masterpieces on Show; Luxury Travel; Check–in desk? You'll find it right under the work by Warhol: The new art of staying in a luxury hotel." *Daily Telegraph,* January 24, 2015: 28.

Mattila, A. (1999). "Consumer's value judgments: How business travelers evaluate luxury-hotel services." *Cornell Hotel and Restaurant Administration Quarterly* 40(1): 40–46.

Naletelich, K., and A.K. Paswan (2018). "Art infusion in retailing: the effect of art genres." *Journal of Business Research* 85: 514–522.

Okonkwo, U. (2007). *Luxury fashion branding.* New York: Palgrave MacMillan.

Padgett, S. (2013). "Chihuly's art blossoms at Bellagio and beyond." *Las Vegas Review Journal.* https://www.reviewjournal.com/entertainment/arts-culture/chihulys-art-blossoms-at-bellagio-and-beyond/ (accessed 1/31/2021).

Park, J., and J. Ahn (2021). "Editorial introduction: Luxury services focusing on marketing and management." *Journal of Retailing and Consumer Services,* forthcoming.

Peterson, K. (2008). "Vegas, say goodbye to Guggenheim." *Las Vegas Sun,* April 10, https://lasvegassun.com/news/2008/apr/10/vegas-say-goodbye-guggenheim/.

Pine, B.J., and J.H. Gilmore (1998). "Welcome to the experience economy." *Harvard Business Review* 76: 97–105.

Razavi, L. (2016). "The new way to shop for art: at luxury hotels." *Harper's Bazaar.* https://www.harpersbazaar.com/culture/travel-dining/a17392/how-luxury-hotels-art-galleries-of-the-future/ (accessed 1/31/2021).

Rhodes, D. (1981). "The fine art of selecting fine art for hotels." *Cornell Hotel and Restaurant Administration Quarterly,* November: 62–64.

Ryu, K., X.Y. Lehto, S. Gordon, and X. Fu (2018). "Compelling brand storytelling for luxury hotels." *International Journal of Hospitality Management* 74: 22–29.

Saito, Y. (2012). "Everyday aesthetics and artification." *Contemporary Aesthetics,* Special Volume 4.

Schroeder, J.E. (2005). "The artist and the brand." *European Journal of Marketing* 39(11/12): 1291–1305.

Shapiro, R. (2007). "What is "artification"?" *Sociedade e Estado* 22(1): 135–151.

Shapiro, R. (2019). "Artification as process." *Cultural Sociology* 13(3): 265–275.

Suri, C. (2019). "An art Museum in your hotel lobby." *New York Times.* https://www.nytimes.com/2019/08/01/travel/an-art-museum-in-your-hotel-lobby.html (accessed 1/31/2021).

Tully, R. (2017). "How hotels are using art to attract experiential guests." https://www.hotel-online.com/press_releases/release/how-hotels-are-using-art-to-attract-experiential-guests/ (accessed 1/31/2021).

Verdon, J. (2019). "Brands become hoteliers to connect with customers in a new way." https://www.uschamber.com/co/good-company/launch-pad/why-brands-are-opening-hotels (accessed 1/31/2021).

Vukadin, A., J. Lemoine, and O. Badot (2016). "Opportunities and risks of combining shopping experience and artistic elements in the same store: A contribution to the magical functions of the point of sale." *Journal of Marketing Management* 32: 944–964.

Vukadin, A., J. Lemoine, and O. Badot (2019). "Store artification and retail performance." *Journal of Marketing Management* 35(7–8): 634–661.

Wirtz, J., J. Holmquist, and M.P. Fritze (2020). "Luxury services." *Journal of Service Management,* forthcoming.

List of Contributors

Linda Armano is a Marie Curie Fellow at Ca' Foscari University of Venice in the Department of Management, and at the University of British Columbia in the Faculty of Management. Her current investigation looks at the mines in the Northwest Territories of Canada and in Italian jewelry stores that sell Canadian diamonds in Italy. Her recent publications are: *The Alpine Mining Culture. Self-representation of Professional Miners* (Aracne Editrice), "Doing Well While Doing Good. How the Hybrid Business Model Promotes Sustainability in the Fashion Industry" (co-authors Annamma Joy, Camilo Peña), in *Journal of Business Anthropology*; "Encoding Values and Practices in Ethical Jewelry Purchasing: A Case History of Ethical Luxury Consumption" (co-author Annamma Joy), in Coste-Maniere, Miguel Angel Gardetti (eds), *Sustainable Luxury and Jewellery* (Springer Nature).

Russell W. Belk is York University Distinguished Research Professor and Kraft Foods Canada Chair in Marketing, Schulich School of Business, York University. A fellow, past president, and Film Festival co-founder in the Association for Consumer Research, he has a number of awards, including the Paul D. Converse Award, and two Fulbright Fellowships. He is a Fellow in the Royal Society of Canada and has received the Sheth Foundation/Journal of Consumer Research Award for Long Term Contribution to Consumer Research. He is a prolific writer and has over 700 publications. His research involves the extended self, meanings of possessions, collecting, gift-giving, sharing, digital consumption, and materialism.

Taylor Brydges is a Research Principal at the Institute for Sustainable Futures, University of Technology, Sydney and incoming Postdoctoral Research Fellow at the Centre for Urban Environments, University of Toronto, Mississauga. Her research investigates sustainability and the circular economy in the fashion industry. She holds an HBA in Urban Studies and an MA in Human Geography from the University of Toronto, Canada, and a PhD in Human Geography from Uppsala University, Sweden.

Darcen Esau is a market researcher specializing in both consumer behavior and sensory evaluation. He completed his master's at the University of British Columbia, Okanagan where he studied the sensory experience of wine and how this impacts consumer decision making. In the spring of 2018, Darcen lived at Castello Sonnino where he studied sustainable transformational wine tourism and continues to conduct academic research with partners at UBC Okanagan, Thompson River University, and Mount Royal University. Darcen is part-owner and head of research at TasteAdvisor, which developed a white-labelled wine tourism platform that helps wine regions recommend wine, wineries, events and experiences, all based on an individual's personal preferences. He also conducts consumer and market research studies on wine through his company, Terroir Consulting.

Bianca Grohmann, MBA, PhD, is Professor of Marketing and Concordia University Research Chair in Consumer Psychology and Visual Marketing, and principal investigator at the Laboratory for Sensory Research at Concordia University. Her research focuses on consumer psychology, branding, and sensory marketing, with an emphasis on the influence of visual, olfactory, gustatory, and haptic brand elements on consumers' product and brand evaluations.

Pierre Guillet de Monthoux directs the Stockholm School of Economics Art Initiative where he is Professor at its Center for Arts, Business, and Culture. He has held professorships in general management at Stockholm University, Sweden, and in philosophy and management at Copenhagen Business School, Denmark. He is docent at Åbo Akademi, Finland, and currently teaches at Artem Nancy in France.

https://doi.org/10.1515/9783110732757-015

Henri Hagvedt is Associate Professor at Boston college. His primary research interests are in aesthetics and visual/sensory marketing, including topics such as visual art, product and promotional design, and luxury branding. His research has appeared in *Journal of Marketing Research*, *Journal of Marketing*, *Journal of Consumer Research*, *Journal of Consumer Psychology*, *Journal of the Academy of Marketing Science*, *International Journal of Research in Marketing*, *Journal of Retailing*, *NeuroImage*, and *Personality and Social Psychology Bulletin*, among others. He was recognized as an MSI Young Scholar in 2015, currently serves on the editorial review boards of *Journal of Consumer Research*, *Journal of Marketing*, and *Journal of Consumer Psychology*, and is an AE at *Journal of the Academy of Marketing Science* and *Journal of Retailing*.

Claudia E Henninger is Senior Lecturer in Fashion Marketing Management, with a research interest in sustainability, the circular economy, and more specifically, collaborative consumption, in the context of the fashion industry. Her work has been published in the *European Journal of Marketing*, the *Journal of Fashion Marketing & Management*, and the *International Journal of Management Review*, and she has edited a variety of books on sustainable fashion, including *Sustainability in Fashion – A Cradle to Upcycle Approach* (Palgrave). Claudia is the Chair of the Academy of Marketing's SIG Sustainability.

Celina Jones is Lecturer in Fashion Technology, with specialist knowledge and expertise on the impact and innovative advances of various textile and garment production processes on the environment. Since completing her interdisciplinary EPSRC funded PhD, exploring biomimicry for alternatives methods of traditional textile production, Celina has a record of success in obtaining research funding from Industry and UKRI, and a continuing trajectory of high-quality output with experts in the field. This is demonstrated in her recent involvement on the work package for the EPSRC funded RE3 (Rethink, Resource & Recycling) and recent publication in *RSC Advances* with leading experts in the fields of fiber and textile technology, chemistry and physics.

Robert V. Kozinets is the Jayne and Hans Hufschmid Chair of Digital Cultural Research at, University of Southern California's Annenberg School for Communication and Journalism, and Marshall School of Business. He has authored and co-authored numerous articles and chapters on the intersection of technology, media, brands and consumers including seven books. He also likes to paint.

Kathy LaTour is Associate Professor of Services Marketing and Banfi Vintners Professor of Wine Education and Management at the School of Hotel Administration, S.C. Johnson College of Business, Cornell University. Kathy's research takes a consumer psychological perspective toward how marketers should approach branding, experience design, communications, and loyalty programs. She uses both experimental designs and in-depth interview techniques to better understand consumer behavior, fusing macro cultural and micro psychological dimensions to her research. Her major research focus has been on the complexity of human memory. Kathy's current emphasis is on the wine and luxury industries.

Laurie A. Meamber is Associate Professor of Marketing, School of Business, George Mason University. Her research focuses primarily on the intersections of aesthetics, marketing, consumption, and the arts in consumer culture. Her work has appeared in *Consumption, Markets & Culture*, *Journal of Business Research*, *Marketing Theory*, *Advances in Consumer*

Research, among other publications. She is the Co-Editor for *Arts and the Market*, and serves on the editorial advisory board for *Consumption Markets & Culture*. At George Mason, she is affiliated with the Center for Retail Transformation, the Business for a Better World Center, and the Institute for a Sustainable Earth.

Aurelie Le Normand is a lecturer in fashion CAD at the School of Materials, University of Manchester and teaches a variety of units across the B.Sc. Fashion Business programs relating to buying and merchandising, fashion CAD and fashion communication. Aurelie has an industry background and worked as a designer for well-known organizations in the United Kingdom. Aurelie's design work is recognized for challenging the perception of fashion as a means of design innovation.

Camilo Peña is a doctoral candidate at the University of British Columbia. His PhD dissertation studies the concept of sustainability in the wine industry. He has published in *Journal of Wine Research, Journal of Business Anthropology, and Arts and the Market*. He has also contributed to several books on topics of wine, sustainability, consumer behavior, and marketing, including: *Research in Consumer Behavior, Consumer Science and Strategic Marketing: Case Studies in the Wine Industry* (Elsevier), *Sustainability in Fashion* (Springer), and the *Routledge Handbook of Wine Tourism*.

Susan Rowley is a curator at the Museum of Anthropology and Associate Professor in the Department of Anthropology at the University of British Columbia. Her research focuses on repatriation, collaboration, representation, material culture studies, intellectual property rights, and access to cultural heritage.

Donna Senese is Associate Professor of Geography at the University of British Columbia, Okanagan Campus, and Associate Dean of Students in the IK Barber Faculty of Arts and Social Sciences. She has a PhD in Geography and Environmental Studies at the University of Waterloo. Dr. Senese has research and curricular interests in the geographies of agricultural and wine tourism at the intersect of rural sustainability, vulnerability and resilience thinking at the landscape scale. She is a member of UBC's Centre for Environmental Impact Assessment, the UBCO Interdisciplinary Graduate Studies Sustainability Theme, the UBC Wine Research Centre, Kwantlan Polytechnic University's Institute for Sustainable Food Systems, and is Founding Director of the Sonnino Working Group, an international transdisciplinary research and writing collective with curricular and research interests in food and wine tourism and rural sustainability.

John F. Sherry, Jr. is Herrick Professor of Marketing Emeritus at the University of Notre Dame. He studies brand strategy, experiential consumption and retail atmospherics, with an emphasis on ritual, aesthetics, placeways and gift giving. Sherry is a Fellow of the Association for Consumer Research, the American Anthropological Association and the Society for Applied Anthropology. He is a past President of the Association for Consumer Research and the Consumer Culture Theory Consortium, and a former Associate Editor of the *Journal of Consumer Research*. Sherry has edited and written 10 books, and authored more than 100 widely reprinted articles and chapters. He has won awards for his scholarly work and poetry. He now devotes much of his time to arts-based research and experimenting with alternative genres of representation.

Amanda Sorensen is a PhD student and Research Assistant in the College of Information Studies at the University of Maryland. Amanda holds an MA in anthropology and museum studies from the University of British Columbia. Her research focuses on cultural heritage databases, museum exhibitions, collaborative museology, and material culture studies.

Linda Lisa Maria Turunen is a post-doctoral scholar at Aalto University School of Business. Her research interests and specialization lie in brand management and consumer behavior, particularly in the context of luxury fashion brands and perceived luxuriousness, luxury second-hand and vintage, fashion resale and sustainability. She has published several papers in major international journals, such as *Journal of Business Research*, *Journal of Product and Brand Management*, *International Journal of Consumer Studies*, and contributed to various book chapters as well as popularized her research through the national press. She holds a PhD from University of Vaasa, and has been granted the title of docent, Fashion and Marketing research in University of Turku, Finland.

About the Editor

Annamma Joy is Professor of Marketing at the Faculty of Management, UBC. Her research spans the domains of art, fashion and fine wines. She has won several awards for her research, the most recent being the Louis Vuitton and Singapore management university award (second place) for best paper at the Luxury brand conference in 2018. Her work has been published in the *Journal of Consumer Research*, *Journal of Consumer Psychology*, *Journal of Business Research*, *Consumption, Markets and Culture*, *Journal of Consumer Culture*, *Cornell Hospitality Quarterly*, *Tourism Recreation Research*, *Journal of Wine Research* and *Arts and the Market*.
She has several chapters in handbooks on consumption and marketing. She is currently editing two books on the related topics of artification, sustainability and digitalization in art, fashion and wine.

https://doi.org/10.1515/9783110732757-016

List of Figures

https://doi.org/10.1515/9783110732757-017

List of Tables

https://doi.org/10.1515/9783110732757-018

Index

https://doi.org/10.1515/9783110732757-019